The Colonial Printer

BY

LAWRENCE C. WROTH

DOVER PUBLICATIONS, INC.
New York

Published in Canada by General Publishing Company, Ltd., 30 Lesmill Road, Don Mills, Toronto, Ontario.

Published in the United Kingdom by Constable and Company, Ltd., 3 The Lanchesters, 162-164 Fulham Palace Road, London W6 9ER.

Bibliographical Note

This Dover edition, first published in 1994, is an unabridged republication of the revised and enlarged second edition of the work first published in 1938 by The Southworth-Anthoensen Press and reprinted in 1964 under the *Dominion Books* imprint of The University Press of Virginia. This Dover edition is reprinted by special arrangement with The University Press of Virginia, Box 3608, University Station, Charlottesville, Virginia 22903.

Library of Congress Cataloging-in-Publication Data

Wroth, Lawrence Counselman, 1884–1970.
 The colonial printer / by Lawrence C. Wroth.
 p. cm.
 Originally published: 2d ed. Charlottesville, Va., Dominion Books, [1964, c1938].
 Includes bibliographical references (p.) and index.
 ISBN 0-486-28294-5
 1. Printing—United States—History—17th century. 2. Printing—United States—History—18th century. 3. Printing industry—United States—History—17th century. 4. Printing industry—United States—History—18th century. I. Title.
Z208.W95 1994
338.8'2616862'097309032—dc20
 94-32382
 CIP

Manufactured in the United States of America
Dover Publications, Inc., 31 East 2nd Street, Mineola, N.Y. 11501

TO THE MEMORY

OF

LEONARD LEOPOLD MACKALL

BIBLIOGRAPHER AND HISTORIAN OF LETTERS

CRITIC, GUIDE, AND FRIEND

Contents

Description of Plates

[ix]

Description of Plates

Description of Plates

of the first roman letters of native manufacture used in a publication in English America. This type was the work of one of the Germantown founders, Jacob Bay or Justus Fox. From the original newspaper in the Harvard College Library.

PLATE XVI 107

THE TYPE CREDITED TO JOHN BAINE & Co., made in Philadelphia about 1789 for Dobson's edition, 1790–1797, of the first American edition, in eighteen volumes, of the *Encyclopædia Britannica*. See the concluding paragraph of Chapter XII.

PLATE XVII 114

A PORTION OF THE FIRST COPYRIGHT LAW OF NEW YORK set in a letter cast by Adam Mappa of New York for Thomas Greenleaf's edition of the collected *Laws of the State of New York*, New York, 1792.

PLATES XVIII AND XIX 114

THE TYPE OF BINNY & RONALDSON shows itself a finished product in their specimen book of 1812, the first to be printed in the United States. The English Roman was a modern face partaking of the worst features of the period, but the Pica Roman, No. 1, showed the maintenance of tradition in a transitional face popular today with many printers under the name "Oxford." The English Roman is reproduced through the courtesy of the Columbiad Club of New Haven, which published in 1937 a facsimile of the specimen book; the Pica Roman has been set from type for the purposes of this illustration.

PLATE XX 124

A PAPER MILL IN OPERATION. From J. J. Lalande, *L'Art de faire le papier*, Paris, 1761.

PLATE XXI 206

A DECORATED BINDING BY JOHN RATCLIFF, who worked in Boston from 1663 to 1682, the first binder of English America whose work has been identified. From a photograph courteously loaned for use in the first edition of this book by William Gwinn Mather, Esq., upon whose copy of Increase Mather's *A Call from Heaven*, Boston, 1679, this binding is found.

[xi]

Description of Plates

PLATE XXII 207

A DECORATED BINDING BY WILLIAM PARKS, printer and book-binder of Annapolis and Williamsburg. From the John Carter Brown Library copy of *The Charter of William and Mary College*, Williamsburg, 1736.

PLATE XXIII 212

A VOLUME OF THE CELEBRATED AITKEN BIBLE of Philadelphia, 1781–1782, the first English Bible to be printed in America. This binding, in full green morocco, is the work of a craftsman of skill and taste, who maintained European standards of workmanship. It was probably accomplished by Robert Aitken himself, or by his daughter Jane, both of them remembered as competent binders. From the Susan Inches copy in the John Carter Brown Library.

PLATE XXIV 276

A TITLE-PAGE WITH RULED BORDER FROM THE FIRST HALF OF THE CENTURY BY WILLIAM PARKS of Annapolis and Williamsburg, illustrating the qualities of balance, restraint, and vigor found in the best work of the colonial printers. The free, open, undecorated title-page of the later century is well illustrated by the title-page shown on Plate x. From the copy of the book found in the John Carter Brown Library.

Drawings in the Appendix

PLATE A 298

THE PRESS AND ITS PARTS. This is the press called by Moxon the "old fashion'd" English press, and by Stower, the "Common Press." Comparison with Plate VI shows it to be the sort of press employed by Isaiah Thomas. This was doubtless the style of press generally used in the colonies. Drawn and names of parts applied by Ralph Green. Certain features of the construction, for example, the manner in which the forestay supports the carriage, appear more clearly in the side elevation shown in Plate C. The functions of all these parts are fully defined in Moxon's *Mechanick Exercises*, I. 37–74.

Description of Plates

Preface

THE proprietor of the colonial American printing house was an English provincial printer who established and conducted his earlier presses at a time when the practice of typography everywhere was at its lowest point as regards aesthetic accomplishment. Toward the end of his period, in the mid-eighteenth century, he saw the printing craft undergo a sound but briefly maintained revival in taste and in mechanical practice. He was fortunate in knowing only the beginning of that easy descent into the Sheol of early nineteenth-century typography that followed this period of superior craftsmanship, but even so he lived long enough to have part in the general falling away from virtue, and to see his work affected by the insipidity of this period of decadence. If these generalizations concerning the characteristic features of his time be allowed, they place the colonial printer in a class from which we should expect little that is pleasing in typographical form. Too often, it must be said, our lack of high expectation in this particular is realized by his actual performance, but when we recall that the matter which came from his press embodied the social, religious, and political thought of our country in the years of gestation, we are willing to tolerate its lack of distinction in typographic quality.

It is not always necessary, however, to exercise the easy forgiveness suggested by the considerations just set down, for in the work of an occasional master craftsman — let us think, when we say this, of Franklin, William Goddard, Lewis

Preface

Timothy, James Parker, William Parks, or Jonas Green—we find now and then a display of taste and of thoughtfulness in design as well as of skill in execution that compel from us delighted encomium. To these qualities must be added, as evidenced by several of the folio collections of provincial statutes, the ability to conceive nobly and to execute with skill the printing of extensive and important books. Admiration for another characteristic possesses us at the sight of such monumental, though homely, productions of the press, as the Eliot Indian Bible and the Ephrata Martyr Book, so that not seldom, with the style of one group and the size of the other in mind, we find ourselves astonished at the work the colonial printer was capable of accomplishing. Born of our concern with the matter of his product and of our occasional delight in its form, comes finally an abiding interest in this geographically isolated printer and in the problems of his craft in the pioneer communities where he labored.

It is proposed to bring together in the following pages a number of facts relating to this printer's activities, and by the correlation of these to attempt a reconstruction of the physical aspect of his establishment as well as to affirm the general conditions under which it functioned. In the sections that follow, therefore, we shall deal with the tools and materials of the colonial printer's trade; that is, with his press, his type, his ink, and his paper, and when these have been examined, we shall go on to discuss his shop procedure, the labor conditions that confronted him, the nature of his product, and the remuneration he received for his efforts.

Preface

The English bibliographer and historian of letters, properly enough, has been so taken up with problems of distinctively literary importance and with high matters in general that the provincial press of Great Britain has not been examined from the point of view that has engaged my interest in this study. It may be, however, that in this presentation of a picture of the colonial American establishment, the characteristic features of the English provincial office have been shown by reflection. The obvious differences need not be specified.

This investigation of the colonial American printing trade is not to become an essay in bibliophilism, but it is difficult now and then in writing on the subject to repress the feeling of superiority that the lover of books must experience when he thinks of the mere reader of books, the heedless and complacent lover of literature. To love the contents of a book and to know and care nothing about the volume itself, to love the treasure and to be unmindful of the earthen vessel that loyally holds and preserves it, is to be only half a lover, deaf to a whole series of notes in the gamut of emotion. The book-lover, more richly endowed, broods over the hand that fashioned the volume he reads, and, like the Tramp Royal, he goes on till he dies observing "the different ways that different things are done," the materials, the processes, the how and what and why of the ancient mysteries of printing, paper making, type founding, ink making, press building, and binding. Because of this quality of sympathy there comes to him a greater abundance of enjoyment, and he is able to smile

Preface

when the half-lover says harsh things about his doddering interest in the outsides of books, and attributes to him ignorance of their matter. God save us from the hearty, windy fellows who say, "I had just as lief read an author in a poor edition as a good one." One is ashamed for such as these, for the incompleteness of their spiritual perceptions, for their imperfect realization of the humanity that breathes from type and paper and binding, for their blindness to the process of artistic selection and rejection that underlies the making of a book.

The study here presented formed originally a short chapter that considerations of economy compelled the publishers to omit from my *History of Printing in Colonial Maryland.* It was expanded somewhat and read at the winter meeting of the Bibliographical Society of America at New Haven on December 29, 1922. Later, on the invitation of the Grolier Club, its scope was very much enlarged, the whole subject was reëxamined, and several aspects of the craft previously neglected were brought into the discussion. In the intervening years I have been in consultation with everyone from whom I could hope to obtain information on the matters discussed. In this assiduous mendicancy, I have received material comfort from Wilberforce Eames, Henry L. Bullen, George S. Godard, Miss Margaret Bingham Stillwell, Charles L. Nichols, Clarence S. Brigham, Alexander J. Wall, Thomas J. Holmes, Leonard L. Mackall, Andrew Keogh, A. S. W. Rosenbach, Miss Ruth S. Granniss, and George Simpson Eddy. Information and assistance have been received from

Preface

the Library of Congress, the Henry E. Huntington Library, the John Carter Brown Library, the Grolier Club Library of New York City, the New York Public Library, the Historical Society of Pennsylvania, the American Antiquarian Society, and the Maryland Historical Society, as well as from other persons and institutions specifically mentioned in the text and in the notes. Portions of the chapter on "The First Presses" appeared in their present form in *Printing, A Short History of the Art*, edited by R. A. Peddie, published in London in 1927 by Grafton & Co., to whom I express thanks for the courtesy which permits their use in this book. In bringing the work to an end, I am pleasantly aware of the debt I owe my assistants, past and present, in the John Carter Brown Library, to Mrs. Raymond Newton Watts, Miss Gertrude L. Annan, Miss Catherine C. Quinn, and Miss Marion W. Adams, who have given me generous help and encouragement in the task in more ways than it is possible to specify. I am grateful also to George Wyllys Benedict, of Brown University, who led me into still waters at a stormy season in the book's progress, and to R. L. Rusk, of Columbia University, who gave me important practical suggestions in the matter of exposition. It would not be fair to make George Parker Winship in any measure responsible for the study, but the opportunity to read it at New Haven in its earlier form and the suggestion that it be elaborated came from him, and this evidence of interest in the project has been followed consistently by advice and assistance in particular instances. Accordingly such readers as find pleasure in the book that has

Preface

thus come into being will join the author in thanking Mr. Winship for his encouragement of the undertaking.

LAWRENCE C. WROTH.

The John Carter Brown Library,
 1 *October*, 1930.

Preface to the Second Edition

THE revision of this book for its second edition has enabled me to enlarge several of its sections as well as to correct or modify certain specific statements or conclusions with which, upon a critical reading after seven years, I found myself dissatisfied. Happily for my peace of mind there were few downright errors recognized in the course of this reading, so that my task has been mainly the pleasant one of recording newly acquired information or of expanding topics which seemed somewhat too summarily treated in the earlier text. New facts have been embodied which change the position of Maryland in the chronology of the presses, and the important additions to our knowledge of the typographical history of South Carolina made in 1933 by Douglas C. McMurtrie have been incorporated in the narrative. A considerable further enlargement has been made of the chapter on "The First Presses" by extending the period of its inclusiveness to the year 1800. I was led to that course by the realization that so far as the printing craft is concerned the last two decades of the century are much more closely related to the colonial period of the nation than to the industrial era just then about to open. By carrying the story into the decades following the Revolution I have been enabled to include statements concerning the origins of the press in Florida, Maine, Western Pennsylvania, Kentucky, Tennessee, Ohio, and Mississippi, marking the advance of printing to the extreme southern, northern, and western

Preface

boundaries of the territory then forming the United States or soon to come within its domain.

One may not write of the press in the post-Revolutionary period of the eighteenth century without feeling immense obligation to certain earlier writers on the subject, to Reuben Gold Thwaites, for example, whose *Ohio Valley Press* led the way into unexplored country; to William Nelson, whose *Notes toward a History of the American Newspaper* is a rich store of obscure facts left uncompleted at the death of its author but published (Volume I) in 1918 through the enthusiasm for American typographical history of Charles F. Heartman; to Clarence Saunders Brigham, whose *Bibliography of American Newspapers* is so broadly conceived in plan, so finely detailed in execution that any present-day investigation in American literary history must inevitably use it as a point of departure; to Douglas C. McMurtrie, whose studies of American printing origins form a contribution to typographical history as important as they are numerous. Nor should one forget in this connection the helpfulness of the great general *American Bibliography* of Charles Evans, and of Sabin's *Dictionary of American Books*, now happily concluded after long years of labor by its editors — Joseph Sabin, Wilberforce Eames, and R. W. G. Vail. I should like also to acknowledge especially the kindness of Clarence Saunders Brigham, who has made specific contributions from his own unpublished notes on American newspapers and has searched for me with gratifying results certain rare newspaper files in the American Antiquarian Society. I am indebted also to

[xxii]

Preface

Rutherfoord Goodwin, of Colonial Williamsburg, Inc., who has given me permission to quote from an unpublished study on the paper mill of William Parks. The Connecticut State Library has continued the same effective service I learned to depend upon when the late, and very greatly lamented, George S. Godard was its distinguished head. Miss Margaret Bingham Stillwell has passed on to me information acquired through her wide foreign correspondence. The interest in the subject of Robert W. G. Vail has made it inevitable that I should appeal to him frequently in the course of my writing. The specific and important contribution made by Ralph Green to the chapter on the Printing Press is acknowledged more fully in another place. I owe thanks also for many suggestions to Lathrop C. Harper, whose years of absorption in Americana have made him a storehouse of knowledge on that and related subjects. I have reserved until last the expression of my gratitude to Dr. J. Hall Pleasants, of Baltimore, and Arthur Trader, of Annapolis, who turned over to me the discoveries they made in the Maryland Land Office which have enabled me, here and elsewhere, to make an important correction in the date of the first printing in Maryland.

Despite the gratification I experience in seeing this book brought out in a trade edition, there is a natural regret on my part at the severance of its fortunes from the control of the Grolier Club. No greater satisfaction can come to a bookman in this country than the publication of his work by that association of scholars and collectors. My own relationship with it through this book has been such as to give me the

Preface

pleasantest memories. I wish, finally, to thank the present publishers for their belief, expressed significantly by the book now before the reader, that this study deserves a wider circulation than it could attain as the publication of a private club.

<div align="center">

LAWRENCE C. WROTH.

</div>

The John Carter Brown Library
 9 *July* 1937

SUPPLEMENTARY NOTES: In 1953 the Rhode Island Historical Society acquired by purchase unique copies of the first and second Rhode Island imprints so far recognized, namely, *A Letter from John Hammett to John Wright: Giving an Account why John Hammett turned from the Baptists to the Quakers; also why he turned back again* (Newport, James Franklin, 1727) and Hammett's *Vindication and Relation* (Newport, 1727; described on page 22 as the earliest Rhode Island book). A textual comparison of the two items makes clear the precedence in publication of the undated *Letter* over the *Vindication*. Poor Robin's *Rhode-Island Almanack* for 1728 was probably the third Rhode Island imprint of 1727. See Bradford F. Swan, "Two Rhode Island Imprints of 1727," *Rhode Island History*, Vol. 12, April, 1953.

A copy of the Southack map, the second to be recorded, was acquired by the John Carter Brown Library, Providence, in 1942. This JCBL specimen is an earlier state of the map than that in the Public Record Office (see p. 285).

The Colonial Printer

THE COLONIAL PRINTER

I

Introduction

IT hardly need be said that the learned and painstaking works on the history of printing composed in the past three centuries have been engaged in by their authors as studies in the culture of a place or period rather than as exercises in pure antiquarianism. There is no greater degree of interest inherent in an old printing press than in a spinning wheel of the same period; it is the difference in the spiritual implications of the two machines which keeps the one alive in men's minds while the other stands cold and stark in the museum or gathers dust in the attic. It is the position of the printing craft as a spiritual force which continues to lead men to compile its lore, to write the lives of its exemplars, to trace the spread of its practice from town to town, from country to country, and from continent to continent, and even, as in the present work, to study the very tools and materials with which its service to civilization has been accomplished. A study of this last sort, indeed, ought to contribute no little to an understanding of the larger significance of the craft in its relation to the life of a given place and period. It concerns itself with things rather than with ideas, but while examining outward and visible signs, one sometimes attains a clear vision of inner meanings, achieves a fine comprehension of the power and influence of things, of people, and of institutions. If the present book, with this truth in mind, be regarded as a discussion of certain fundamental aspects of cultural history (and so it has been conceived by its author), it is important at its beginning to bring back to mem-

ory the intellectual aspects of the colonial period in English America.

That part of the North American continent which lies between Mexico and the St. Lawrence was settled by men of a race that had for its rich inheritance Shakespeare, Plato, Moses and the Gospels, but the laws that inevitably set back the cultural development of a colonized people so operated in the new land that while the English parent stock was producing Milton and Dryden, Fuller, John Locke, the Carolinian divines, the eighteenth-century essayists and poets, the American adventurers were breeding pioneers and a race of prophets of only local distinction. The reason is too obvious for remark; whatever comment is made should be in the way of tribute to the virility of man's spiritual and intellectual instinct. Thrown into conflict with rude natural forces, fighting, ploughing, hewing wood and drawing water, the colonial American yet retained the desire and found the means to build churches and schools, to learn history and the law, and to become an adept in political theory and practice. Though there were few flowers upon the intellectual tree of the colonies yet were the roots continuously mulched and the hardy trunk kept trimmed and straight by the hand that remembered its heritage.

The boundaries of the cultural groups of the colonies followed in the main the natural geographical divisions of the country; that is, of New England, the Middle Colonies, and the Southern Colonies, each with a constantly shifting frontier reaching back and touching the older settlements with something that kept the intellectual mass in a state of fluidity, inhibiting in it fixation of motive and expression whenever this seemed likely to come into being. Of the stable groups, the centers of influence were respectively Massachu-

Introduction

setts, Pennsylvania, and Virginia. Homogeneous racially, the New England people possessed a common religious heritage in the Old Testament ideals of Puritanism, while the difficult soil of the country caused the people to turn generally to the sea as the natural path to prosperity. In the middle colonies was early formed a people whose religious characteristics were as varied as the racial stocks that composed it—the English, the Dutch, the Catholic Irish, the Scotch-Irish, and the German. In this section, the common economic interests of the group were found in the tillage of rich fields of grain and in the development of industries. In the southern colonies, where the effort to sustain life required less vigorous exertion than elsewhere in the country, lived a people hardly less mixed in racial strains, though of different constituents, professing adherence to the Church of England, the Roman Catholic Church, and various separatist bodies growing out of the Reformation in Western Europe. Here, too, were agriculturists, but in this case devoted to the production of rice, tobacco, and cotton, and here was to be found a social division between a poor yeomanry and a slave-holding aristocracy. Out of the conditions imposed by heredity and circumstances, there came into being in this section a people lacking the gravity of the New Englander and the solid thriftiness of the Pennsylvanian, but possessing a light sanity and a grace of living peculiarly its own.

These in a broad sense are the features of the picture. It is too much our custom to attribute differences in type to simple and obvious causes—the character of the New Englander, for example, to his Puritanism, of the Southerner, to his milder creed. Nothing is so simple as this in a world where climate and soil and the conditions of sustaining life interplay with spiritual forces and racial heredity to mould the character-

The Colonial Printer

istics of groups of men. Reflection leads one to stand silent before this mystery of the ethnic process, to accept, in this instance of it, the fact of differences without attempting glibly to weigh and evaluate causes.

In any study of the American scene, political, literary, or social, it is important to remember concerning the New England people that the necessity of defense against the Indian and the activities by means of which they gained their living, grouped them in towns to a much greater degree than was the case with the inhabitants of the middle and southern colonies, where the farm and the plantation early became the economic unit, and the county, rather than the town, the focus of political organization. In both sections the necessity that faced the inhabitants for many weary years was to secure food, clothing, and shelter by means of continuous physical exertion. The early New Englanders, though, came hither provided with an intellectual interest in the related problems of the soul's salvation and the desirability of moulding a commonwealth of true believers alone. The necessity of wrestling continually with the practical aspects of these questions inevitably nurtured the desire for learning, and just as the development of the spirit and form of scientific inquiry was handed on to the modern world by those mediaeval schoolmen who disputed the "eternal generation of the Son of God," so the light of intellectual inquiry was kept burning in the American settlements by sectarians, in New England and elsewhere to a lesser degree, who were always seeking and proclaiming their own interpretations of the will and the way of God with men.

The intellectual process of the New Englander was kept tempered, though its edge was frequently dulled, by the activity of his spiritual obsession. The habit of town life, the

Introduction

town meeting, the congregational meeting, encouraged the transmission of ideas from man to man and from father to son. The literary results of this intellectual ferment are most maligned by those who know them least. The theological treatises, the sermons, the controversial matter generally, not to mention certain other remarkable productions, have a profounder significance in our cultural and political history than they are usually credited with. Parrington writes vigorously on this point in these sentences from *The Colonial Mind:* "That our colonial literature seems to many readers meager and uninteresting, that it is commonly squeezed into the skimpiest of chapters in our handbooks of American literature, is due, I think, to an exaggerated regard for esthetic values. Our literary historians have labored under too heavy a handicap of the genteel tradition — to borrow Professor Santayana's happy phrase — to enter sympathetically into a world of masculine intellects and material struggles. They have sought daintier fare than polemics and in consequence mediocre verse has obscured political speculation, and poetasters have shouldered aside vigorous creative thinkers. The colonial period is meager and lean only to those whose 'disedged appetites' find no savor in old-fashioned beef and puddings." One need not settle down to a course of reading along the line suggested by these words to be willing to believe them true.

The glorious thing about the spiritual life of New England was that it had its heretics. If the Puritan spirit spoke through John Cotton, it was replied to, as the horn soars above the drum, by Roger Williams, whose *Bloudy Tenent of Persecution* sounded, for the first time in America, an enlargement of man's spiritual horizons through the doctrine of liberty of conscience as a natural right of man. Though

the witchcraft persecution had its learned and godly champions, it was one of these, Increase Mather, whose bold recantation brought that madness to an end. One is revolted sometimes by the repetition of the familiar charges against the intellectual and spiritual life of New England. While bigotry, intolerance, and spiritual complacency unquestionably existed among its people, there was never a time in the history of that section when men of sturdy independence were lacking to oppose by word and virile pen the expositors of the ancient stupidities. No more can be said of any age of any people. Some witty person has said that "the Middle Ages were not quite so Doresque as they were painted"; in New England, too, despite thunderings from pulpit and bench, the sun still rose and set in splendor, the Spring came like a tender girl, and children played in dooryards gay with flowers.

These elements, religion, town life, and the commercial pursuits inherent in group existence, produced a higher intellectual level in New England than elsewhere in the colonies. Even so, there was to be found in the southern and middle colonies a superior economic and social class in which education was achieved as a matter of course. The Maryland and Virginia gentleman or merchant could write his name and read his book with as much readiness as the New Englander. Somewhere in his house he had a shelf or two or a whole case of books in which the predominant tone was less religious, perhaps, than political or literary. Though his community lacked a well-developed educational system, he succeeded in giving his sons a decent amount of learning, and when he could afford the cost, he sent them abroad for a year or more of study. Maryland and South Carolina, despite small populations, had each during the eighteenth century more young men entered at the Inns of Court than the whole

Introduction

of New England for the same period. Sons of Catholic families went occasionally from Maryland to the college of the English Jesuits at St. Omer in Flanders. Virginia had its college at Williamsburg. Both colonies sent young men to Edinburgh for their medicine and to the English universities for their divinity. The result of this pilgrimage to the sources of learning on the part of a privileged few was the creation of an outstanding small group of lawyers, doctors, and churchmen allied with a moderately well-educated class of great and small gentry, though the people as a whole were less interested in education, and had fewer opportunities to become familiar with its advantages, than the people of New England. And this instructed upper class of the southern colonies wore its education with a difference. To the New Englander, learning was a duty and a privilege; to the Virginian, it was an ornament, a source of pleasure with a utilitarian aspect that enabled him to exchange ideas with distant neighbors at court house or church, at race track or tavern, and rendered him eligible for service in the Assembly, or on the quorum and the vestry.

Special investigations in the past few years have worked a change in opinion as to the general cultural state of the country against which, as a background, the activity of the press must be seen if the study of it is to be regarded as anything more than an aspect of antiquarian interest. It has always been known to careful students that the colonists possessed books in fair numbers even before the general establishment of the American press, and that facilities for adding to them through importation were provided early and maintained effectively throughout the period. These features of colonial life have attained wider understanding, as far as New England is concerned, by the publication of such works

The Colonial Printer

as George E. Littlefield's *Early Boston Booksellers*, Worthington C. Ford's *The Boston Book Market*, Thomas Goddard Wright's *Literary Culture in Early New England*, and Vernon L. Parrington's *The Colonial Mind*. Certain portions of Philip Alexander Bruce's *Institutional History of Virginia* point to conditions existing in the Old Dominion hardly different in kind from those that prevailed in New England, though, for reasons already spoken of, inevitably different in degree. In his *Provincial Society*, James Truslow Adams has so interpreted the social history of the entire colonial group as to show that a moderate degree of literary culture was widespread throughout the country, even though its spirit could not be thought of as having penetrated deeply the ranks of the people. The bookseller as a tradesman distinct from the printer came upon the scene in the person of Hezekiah Usher, of Boston, about the year 1647, and the importation thereafter of books from England as a regular feature of commerce was hardly affected by the output of the American press until late in the eighteenth century. The colonial gentleman's library was very weak in the possession of American printed books, so weak, indeed, that one must wonder whether the product of the local presses was not regarded in the light of homespun. Certainly the pride of possession was in the imported book. The issues of the printing houses of the provincial capitals, eagerly sought today by scholar and collector, were too often crowded from the shelves by those stately calf-bound volumes, and sets of volumes, from the London stationer that now form the familiar lumber of the country house library.

But whatever the components of these collections may have been, their possession was not confined to the individuals of any one section of the country. No one whose way

Introduction

has led him to the examination of wills and inventories in various colonies has failed to be impressed by the presence in them of collections of books, itemized or otherwise, standing up bravely in the lists of more material possessions. Between Cotton Mather with 3000 volumes in 1728 in Massachusetts, and William Byrd with 3500 a decade or so later in Virginia, there were innumerable individuals in the several colonies with their "twenty bokes," clad in dull sheep or polished calf, whose literary interests lent urbanity to their communities. The specimens of prose and verse found in the *Virginia Gazette* and in the *Maryland Gazette* indicate a close reading of the British and classical writers by the gentlemen who composed them, and testify, furthermore, to the possession of a cultural equipment that enabled these contributors, in imitating and adapting, to infuse their writings with the feeling of the original sources of their inspiration. These essayists and poets of the Chesapeake Tidewater, though they spoke it softly, spoke the same language that Addison and Pope employed with clear and sure enunciation.

It was in these communities, sometimes rude, nearly always poor, busy about material things, but intellectually alert, that there came into being a life so sharp in its contrasts, so replete with the elements of conflict, and so full of color and rude pageantry as to provide for us, its inheritors, a study of endless fascination. It is as a factor in this vivid and eager life, coeval with its beginnings, that the press engages our interest in the ensuing pages.

II

The First Presses of the Colonies

IT is doubtful whether the seventeenth-century American felt strongly the need of his community for a printing press. The government, it is true, had employment for the press in the promulgation of laws and proceedings, the clergy had need of it in the spreading abroad of their several interpretations of the gospel, and all men could have used it in the printing of business forms, newspapers, and advertisements. But there was a race of scribes in the land that took care, in a measure, of the government and of the men of business, and the clergy could call upon their co-religionists or upon their literary agents in London for the publication of sermons and controversial tracts. Proclamation by word of mouth was not yet outmoded as a method of publishing laws, news, and advertisements, and in cases of special importance where time was not a feature, the London printing houses could be called upon by government and people for the necessary services. Whether he was born to the country or newly come out from England, the tradition of the colonial American was English, and at this period the press had not become an essential factor in the life of the normal English community. It should be emphasized here that the spread of typography in America was coeval with the diffusion of the art which took place in England after the removal of the restrictions upon printing in the last decade of the seventeenth century. Since the year 1586 the hand of authority by several enactments had confined printing to London, York, and the Universities, and in the century that followed the first inhibitory acts, the dwellers in English provincial cities had known the press only as an outside agency. In

The First Presses of the Colonies

1693, the terms of the last press restriction act became final-
ly inoperative, and in the following generation printing
began to be practised as a matter of course in the provincial
cities of England. At the time of the expiration of the restric-
tion act, however, presses were already in operation in four
American towns. Cambridge, Boston, St. Mary's City in
Maryland, and Philadelphia had presses at work for vary-
ing terms of years before that condition could be found in
Liverpool, Birmingham, and Leeds. The first New York press
was established in the very year that the inhibitory act dis-
appeared from the English statute book. The spread of the
art to other American towns occurred in the same generation
that saw it penetrate the life of the English provinces. Be-
cause of these circumstances one can easily realize that the
demand for the press in seventeenth-century America did not
arise from a sense of deprivation on the part of the people.
They had, indeed, to learn its full uses even after its estab-
lishment, but the fact that five towns possessed presses at the
time and under the conditions just spoken of shows that they
were aware of its potentialities and anxious to make use of
its obvious convenience in the life of the community.

It was essential to the well-being of the printers who first
took up their occupation in the several colonies that they
be government men, or at the least, men not inimical to the
government. They might count upon a certain amount of
profit from job work, newspapers, sermons, and occasional
literary pieces of a more ambitious character, but the con-
tract to print the assembly business with its definite task and
definite remuneration provided a certainty of maintenance
that they recognized as the essential element in their success.
This was the work that brought printers to towns where pub-
lication of the other sort in profitable quantity was hardly to

be counted on, and it was the need for this service by the government that more than anything else fostered the growth of printing in English America.

The first press to begin operation in English America was set up in Cambridge, Massachusetts, in the year 1639. The last press to be established in one of the thirteen original colonies was that which James Johnston brought from Great Britain to Savannah in the year 1762 for the service of the colony of Georgia. In the intervening century and a quarter more than one hundred master printers had been at work in twenty-five towns, and in the year that Johnston set up his printing house in the thirteenth colony about forty presses were in active operation throughout the country. The press had become in this epoch the rival of the pulpit as a vehicle of ideas, and the story of its beginnings in the American communities has interest of peculiar quality for those who love to keep in memory the spiritual struggle of that pioneer people, ever employed, though without conscious purpose, in the prolonged creation of a national culture.

It is because the formation of this American culture has been carried on independently in distinct, geographically defined groups that, in the outline of printing beginnings now to be presented, sectional relationships have been emphasized rather than the chronological order of the first establishments in the several colonies. In its place at the end of this chapter will be found a chronological table to satisfy the natural desire of man to know the order of events, but in the table that immediately follows, chronology has given place to lines of influence, genealogically presented, and cold priority has yielded to spiritual affinity.

The Diffusion of Printing Through the Original Thirteen Colonies, Louisiana, Florida, Maine, Mississippi, The Middle and The Far West

BRITISH ISLES

Cambridge, Mass.
(*Stephen Daye*, 1639)

Boston, Mass.
(*Marmaduke Johnson*, 1674)
(*John Foster*, 1675)

Philadelphia, Pa.
(*William Bradford*, 1685)

Jamestown, Va.
(*William Nuthead*, 1682)

St. Mary's City, Md.
(*William Nuthead*, 1685)

Annapolis, Md.
(*Dinah Nuthead*, 1696)

Williamsburg, Va.
(*William Parks*, 1730)

Newbern, N. C.
(*James Davis*, 1749)

Rogersville, Tenn.
(*George Roulstone and Robert Ferguson*, 1791)

New York, N.Y.
(*William Bradford*, 1693)

Woodbridge, N. J.
(*James Parker*, 1754)

Charleston, S. C.
(*Thomas Whitemarsh*, 1731)
(*George Webb* 1731)
(*Lewis Timothy*, 1733)

Baltimore, Md.
(*Nicholas Hasselbach*, 1765)

Pittsburgh, Pa.
(*John Scull and Joseph Hall*, 1786)

Lexington, Ky.
(*John and Fielding Bradford*, 1787)

Cincinnati, Ohio
(*William Maxwell*, 1793)

Wilmington, Del.
(*James Adams*, 1761)

St. Augustine, Fla.
(*John Wells and Charles Wright*, 1783)

Charleston, S. C.
(*Eleazer Phillips, Jr.*, 1731)

Savannah, Ga.
(*James Johnston*, 1762)

New London, Conn.
(*Thomas Short*, 1709)

Newport, R. I.
(*James Franklin*, 1727)

Portsmouth, N. H.
(*Daniel Fowle*, 1756)

Dresden, Vt., now Hanover, N. H.
(*Alden and Judah Padock Spooner*, 1778)

Westminster, Vt.
(*J. P. Spooner and Timothy Green*, 1780)

Falmouth, now Portland, Me.
(*Benjamin Titcomb and T. B. Wait*, 1785)

FRANCE

New Orleans, La.
(*Denis Braud*, 1764)

MEXICO

Monterey, Cal.
(*Unknown printer*, 1833)
(*Agustin Vicente Zamorano*, 1834)

MEXICO ?

Santa Fé, New Mexico
(*Ramón Abreu*, 1834)

UNKNOWN ORIGIN

Detroit, Mich.
(*John McCall*, 1796)

Fort Hill, Miss.
(*Andrew Marschalk*, 1797 or 1798)

The Colonial Printer

The New England Presses
Massachusetts

It is probable that the earthly and utilitarian incentives commonly found underlying the origins of the press in the several colonies were not entirely absent from the motives that induced the Reverend Jose Glover to procure a press and letters in England and to embark this precious freight upon the *John*, of London, when he set out with his family for Massachusetts in the month of July, 1638. Though the benefit of the College and the propagation of the Faith were unquestionably important considerations in the dissenting minister's mind when he determined to set up a printing press in Cambridge,[1] the project seems nevertheless to have been in the nature of a private venture not entirely dissociated from the idea of gain, whether in money or in esteem. The equipment belonged to Mr. Glover, and, as one of the consequences of his death on the voyage hither, the first printing press of English America came to Massachusetts as part of his personal estate, in the possession of his widow. With the Glover household on board the ship *John* was Stephen Daye, a locksmith, with whom Mr. Glover had contracted for the operation of the press, and the autumn of 1638 saw the little printing house set up and ready for service in a dwelling in Cambridge secured for the printer and his family by the new owner of the equipment. It was probably late in 1638 or early in 1639 that "The Freeman's Oath," the first issue of the press in English America, was printed for the greater ease of the Massachusetts officials. No copies are known to exist of this piece, or of the supposed second issue of this famous press, William Peirce's *Almanack for the Year 1639*.

The First Presses of the Colonies

In the ensuing years the Corporation for Propagating the Gospel in New England, generally referred to as "The New England Company," undertook an extensive missionary propaganda by means of the printed word. London was the natural center of its publishing operations, but the desire to print the Bible in the Indian tongue at the place where, from the translator's standpoint, that object could be most fittingly accomplished, led in the year 1659 to the sending of additional typographical equipment to Cambridge in the form of a second press and other fonts of letters. *The Whole Booke of Psalmes*, the first book printed in the English colonies of which a copy is known to exist, had been published in 1640; various catechisms, secular laws, college publications, almanacs, sermons, and controversial tracts had been coming year by year from the press. Now, in 1660, after twenty years of activity, the printing of the Bible, translated into the Indian tongue by John Eliot, was begun by Samuel Green and carried to completion by him and Marmaduke Johnson. The New Testament appeared first in an edition estimated at 1500 copies; in 1663, two years later, 1000 copies of the work known familiarly as the "Eliot Indian Bible" came from this small, and, according to modern notions, inadequately equipped establishment, the culmination of a courageous effort on the part of the translator and the printers.

We shall find the name of the second Cambridge printer in the imprints of many American books of the ensuing two centuries. The descendants of Samuel Green took to printing as their family craft, and their establishments in Massachusetts, Connecticut, Maryland, and Virginia stood for the best in the typographical ideals of their respective periods until the death of Jonas Green the second, fifth in descent from Samuel, occurred in Annapolis in 1845. A generation before the line

[17]

of printers of this family became extinct, its importance in the cultural life of the nation had been recognized by a discriminating New England writer. "The typographers of America," said this anonymous proto-historian of American printing, "and all who respect how much indebted we are to the printing press for the diffusion of knowledge, will ever respect the name of Green. For mine own part, I experience a sensation similar to what I feel when I read the history of the family of the Medici — parva componere magnis." [2]

The secular intrusion into the business of the press in America began with the setting up of an independent establishment in Cambridge by Marmaduke Johnson in 1665. After more than one effort, Johnson, in 1674, secured grudging permission from the General Court to remove his press to Boston. This act accomplished, the printer died and gave opportunity to John Foster, the purchaser of his equipment, to establish in that city, in 1675, the third American press. The unwillingness of the General Court to permit Johnson's removal to Boston had arisen from distrust of that printer's character and from the prevailing fear of the general diffusion of printing, hitherto in Massachusetts kept well within the bounds of ecclesiastical authority. One can hardly credit this body with a foreknowledge of what shortly occurred; that is, the practical extinction of the press in Cambridge through this establishment of a rival printing house in the busy, commercial town on the other side of the Charles River. A native-born American and a graduate of the College, Foster was also a printer of versatile accomplishment, who illustrated more than one of his publications with cuts of his own making that must always have interest among American primitives. Notable among these were the map of New England that appeared in Hubbard's *Narrative of the Trou-*

The First Presses of the Colonies

bles with the Indians in New-England, Boston, 1677. One feels a certain satisfaction that a native school of book illustration arose at this early period in the American printing industry, but the satisfaction is somewhat tempered in intensity by the reflection that printed books had been nobly illustrated in Mexico more than a century before English America saw the first of Foster's praiseworthy but crude efforts.

The American press had been in operation half a century before a genuine periodical journal, as we understand the term today, issued from any of the shops. On September 25, 1690, appeared *Publick Occurrences both Forreign and Domestick*, a small folio of two leaves with a colophon on page three, reading: "Boston, Printed by R. Pierce, for Benjamin Harris, at the London-Coffee-House. 1690." This sheet was headed "Numb. I.," and was announced for monthly publication, but it was issued without license and met with immediate suppression by Governor and Council. Nevertheless, its publication must be regarded as marking the commencement of American journalism. Fifteen years after this inauspicious beginning, *The Boston News-Letter*, April 24, 1704, published by authority and "Printed by B. Green," came from the press under the management of John Campbell, the local postmaster. With varying fortunes and changes of name this journal continued publication until the year 1776, "the first newspaper," Mr. Evans says, "continuously published in what is now the United States of America."

The fact that so much of the writing of early New England worthies was intended primarily to influence English opinion made it expedient that the works of many of them should be sent to England for publication. Most of the Eliot Indian tracts, the two series of King Philip's War narratives,

The Colonial Printer

the controversial writings of John Cotton, the *Magnalia* of Cotton Mather are some of the important and picturesque writings that saw the light in England instead of in the land of their origin. And though there were circumstances that rendered unlikely the publication in Cambridge of the chief writings of Roger Williams, one cannot help wishing that the lofty contribution to liberal thought he made in his *Bloudy Tenent* of 1644 had been an issue of the most notable colonial American press. His *George Fox Digg'd out of his Burrowes*, the least amiable of his writings, alone of his large output found publication in America, issuing from the press of Boston in 1676. A notable exception to the custom of sending important political documents to England for publication is found in the *Declaration of former Passages ... betwixt the English and the Narrowgansets.* This pamphlet, of Cambridge, 1645, commonly called "The Narragansett Declaration" was not only an important political document in the eyes of contemporaries, but it continues to hold interest today as the first historical publication of the American press.

Connecticut

For many years after the beginning of printing in Cambridge, the Massachusetts press continued to take care of such printing of other New England colonies as was not sent to the London shops. The official printing of the colony of Connecticut[3] was for a long period put into the hands of Samuel Green in Cambridge, and later confided to Samuel and Bartholomew Green, his sons, of Boston. This association led the Governor and Council to turn to the Green family when, in 1708, it was determined, on Governor Saltonstall's motion, to seek a resident printer for Connecticut. The

The First Presses of the Colonies

first offer of the post was made to Timothy Green, of Boston, the grandson of Samuel, of Cambridge, but not wishing to give up, as he expressed it without very much originality, "a certainty for an uncertainty," this printer declined to remove himself to the neighboring colony. The offer was accepted, however, by Thomas Short, of Boston, who was engaged at a salary of fifty pounds a year to print the current Connecticut Assembly business. Short moved to New London in the spring of 1709, where sometime in the month of June he issued two pieces that contend for the distinction of priority as the earliest Connecticut imprints. These were: a broadside entitled *A Proclamation for a Fast*, ordered on June 15, 1709, and probably printed immediately afterwards; and, *An Act [for Making and Emitting Bills of Publick Credit]*, passed on the eighth of June of that year. The evidence seems to point to the money act as the first of these in order of publication. The most notable imprint that resulted from Short's three years of service in Connecticut was *A Confession of Faith*, known popularly as the "Saybrook Platform," New London, 1710, a work of such extraordinary local interest as to call for an edition of 2000 copies. Thomas Short died in 1712, and was succeeded in office by the Timothy Green whose fears four years earlier had not permitted him to undertake a post of uncertain stability. For more than a century the sons, grandsons, and great-grandsons of this craftsman continued to print at New London, New Haven, Hartford, and other Connecticut towns. There was no newspaper established in Connecticut until James Parker, on April 12, 1755, began in New Haven the publication of *The Connecticut Gazette*.

The Colonial Printer

Rhode Island

The first printer of Rhode Island[4] was James Franklin, who as master and relative appears in a distinctly unamiable light in the *Autobiography* of his brother Benjamin. In the year 1722, James Franklin had got into trouble with the Boston authorities for matter of an alleged seditious character published in the *New England Courant*. It is probable that never after his term of imprisonment and conflict did he feel at ease in the town of his birth, and when his brother John, a tallow chandler of Newport, urged his removal to that city and backed up the invitation with encouragement from several prominent citizens of the place, he determined to take his press thither and begin anew. The first known imprints from a Rhode Island press were two pieces he issued at Newport in the year 1727; namely, *John Hammett's Vindication and Relation: Giving an Account, of his separating from the Baptists, and joining the Quakers*, and Poor Robin's *Rhode-Island Almanack, for the Year 1728*. He continued his activities until his death eight years later, when Ann Franklin, his widow, assumed charge of the business and, except for the help of her son, James Franklin, Jr., from 1748 until his early decease in 1762, carried it on alone until her death in 1763. During the latter half of this year she took as partner Samuel Hall, who succeeded her in the business. The elder James Franklin established, in 1732, *The Rhode-Island Gazette*, but this first newspaper of the colony had only a short life. It was reserved for Ann Franklin and her son, in 1758, to begin the publication of *The Newport Mercury*, a newspaper that continues to appear today after 172 consecutive years of publication. In 1762 William Goddard, in partnership with Sarah, his mother, began his no-

The First Presses of the Colonies

table career by setting up as printer in Providence. His success was not what he thought it should be, but after his removal to New York, in 1765, Sarah Goddard continued the business successfully until its sale to her associate, John Carter, in the year 1768. In later years her daughter, Mary Katherine Goddard, made a notable success of the newspaper and the printing house which, as her brother's partner—and scapegoat, it sometimes seems—she conducted in Baltimore throughout the trying days of the Revolutionary War. Sarah and Mary Goddard and Ann Franklin provide excellent examples of that all but forgotten type, the colonial business woman who, as a matter of course, assumed charge of the affairs laid down because of death or other reasons by a husband or a son.

New Hampshire

New Hampshire[5] was indebted for its first press to Daniel Fowle's resentment against the punishment meted him by the Massachusetts Assembly in 1754. In that year, while the House was deliberating the passage of an excise act, a pamphlet entitled *The Monster of Monsters*, by Thomas Thumb, Esq., was hawked through the streets of Boston, and when its contents were found to reflect upon the conduct of the Assembly, its supposed printer, Daniel Fowle, was brought to the bar of the House for examination. As the result of this trial, conducted somewhat irregularly, the pamphlet was burned by the hangman, and Fowle was reprimanded, jailed, and ordered to pay the costs of the proceedings. The account of the incident is found in Fowle's own pamphlets, entitled *A Total Eclipse of Liberty*, printed by him in 1755, and *An Appendix to the Late Total Eclipse of Liberty*, printed as his

farewell to Boston in 1756. He had been urged in the intervening months to settle in Portsmouth, New Hampshire, and thither he removed in July or August of that year.

New Hampshire printing annals are unusual in that the first printer of that province has left a record of his beginnings. In the unique Library of Congress copy of the second issue of Ames's *Almanack for the Year 1757*, printed by Fowle in Portsmouth, the printer has set out in type the following statement: "The first Printing Press set up in Portsmouth, New Hampshire, was on August 1756; the Gazette publish'd the 7th of October; and this Almanack November following." It does not appear that Fowle intended this statement as a complete record of the early weeks of his Portsmouth venture. It is known, for example, that "proposals" for the publication of the *Gazette* were printed, and so, in the present state of our knowledge, we must think of that prospectus as the first New Hampshire imprint. *The New Hampshire Gazette* of October 7 was the second of which a record exists, and if the printer had been a bit more definite, we could with certainty name the *Almanack* as the third. As a matter of fact, he brought with him from Boston to Portsmouth a partly finished job in the form of Jonathan Parsons's collection of seven sermons, entitled *Good News from a Far Country*. On November 4, 1756, he announced in his journal that he was waiting for paper from London to complete the printing of the last two sermons. The book appeared with a Portsmouth, 1756, imprint, and there is to be considered the probability that it may have been completed early in November, sometime before the *Almanack* was published. The careful examination of this probability by Charles L. Nichols, however, leaves in little doubt the priority in publication of the almanac.

The First Presses of the Colonies

Save for an interval of ten years in which Fowle was assisted by his nephew, Robert Fowle, he continued his press alone until his death in 1787. His newspaper, *The New Hampshire Gazette*, appeared first on October 7, 1756.

Vermont

When Alden Spooner went from New London to Dresden, now Hanover, New Hampshire, in the fall of 1778, that town, geographically a part of New Hampshire, situated in a strip of debatable land between the contiguous states, had recently become part of the political district known as Vermont.[6] On this account Spooner is claimed often as Vermont's first printer. One of the reasons that influenced Congress in its refusal to admit Vermont into the confederation of states was its assertion of sovereignty over the strip of territory east of the Connecticut River, and a year after Spooner's coming to Dresden, that town found itself relinquished by Vermont to become finally a part of the State of New Hampshire. Thus Spooner may be claimed, and justly, as a New Hampshire printer. One may resolve the question by saying that the geographical area known as Vermont has no claim on Spooner as its first printer, but that Vermont, the body politic, may rightly call him her proto-typographer. There exists his bill for services to the State from October 15, 1778, to June 1, 1779, and during the greater part of this time the town of Dresden had been considered a part of the political entity known as Vermont. On October 15, he entered in his account a charge for printing 250 blank commissions for the State of Vermont, and on October 27, he charged the State for 100

proclamations and 300 election sermons. The Thanksgiving Proclamation, dated October 18, 1778, and entered on Spooner's account under date of October 27, may have been the first issue of the Dresden press to follow the blank form that has been mentioned. A single known copy of this piece is found in the library of Dartmouth College. The probable second issue seems to have been the election sermon preached by Eden Burroughs, entitled *A sincere Regard to Righteousness and Piety, the sole Measure of a true Principle of Honor and Patriotism*. The bill to the State for the sermon was dated October 27, 1778, but its printing was arranged for by the Assembly on October 9, nine days earlier than the day on which the Thanksgiving Proclamation was drawn up in the Council. It is possible that its publication may have been earlier than that of the Thanksgiving Proclamation. The newspaper that Spooner began in Dresden early in May, 1779, came into being three months after that town had become once more a part of New Hampshire.

It did not always happen in our colonial scene that a newly-established press found itself so promptly called upon to serve the political aspirations of its community as was the case of the Vermont press of Dresden. At the time of its establishment, the so-called "New Hampshire Grants Controversy" was at its height. The sovereignty of the territory of Vermont had been long in dispute between New York and New Hampshire. In 1777, the people of Vermont, crying "a plague on both your houses," set up their own government, and in the brief year of its existence the little press at Dresden issued five, and possibly more, pamphlets or broadsides designed to fortify the claim of the new Republic of Vermont to a separate corporate existence.

I have spoken heretofore of the Spooner press as if its sole

representative were Alden Spooner, whereas the firm that controlled it was composed of the brothers Judah Padock and Alden Spooner. Some of the imprints carry both names, others only that of Alden. There is, in truth, reason to doubt that Judah Padock Spooner was engaged in the Dresden business in person, but at any rate, when the Dresden press closed late in 1779 and the Vermont authorities sent again to New London for a printer, it was Judah Padock Spooner and Timothy Green who received the appointment. There is found a charge, dated November 1, 1780, against the State by this firm, located in Westminster, Vermont, for eighty Thanksgiving Proclamations, and there seems to exist good reason for believing that the first Vermont newspaper, *The Vermont Gazette*, issued from this office on December 14 of the same year. At any rate we must think of Westminster as the place of origin of the press in what is now the State of Vermont.

Maine

When Benjamin Titcomb and Thomas B. Wait began printing in Falmouth, now Portland, Maine,[7] in 1785, that territory, known as the District of Maine, was still a part of Massachusetts. It is said that their newspaper, the *Falmouth Gazette* (afterwards, when the name of Falmouth became Portland, called the *Cumberland Gazette*) was instituted to advocate the separation of the District from the parent state to which it had too long served as a frontier colony. This at least is the motive that used to be ascribed to the project, but recent writers on Maine bibliography have nothing to say as to the influence of the paper upon the negotiations which led to the act of separation in 1820. An examination of the product of the early Portland press, however, convinces one

that it served consistently the Maine community in further-
ing its ambition for separate statehood.

It seems clear enough that the earliest issue of the press of
Titcomb & Wait was the newspaper, the *Falmouth Gazette
and Weekly Advertiser*, which began publication on the first
day of January, 1785. The order of the separate publications
of the Portland press is somewhat uncertain, but of the three
imprints recorded for the year 1785 one assumes that the ear-
liest was a broadside, headed *Falmouth February 2, 1785*,
which gave notice of a local meeting. The other two pieces,
equally ephemeral in character, were dated October 5 of the
same year. It has been stated more than once, on the author-
ity of a note in Williamson's comprehensive *Bibliography
of Maine*, that "probably the earliest pamphlet printed in
Maine" was William Hazlitt's *Discourse on the Apostle
Paul's Mystery of Godliness . . . By Bereanus Theosebes*,
printed in 1786. But it is certain from the plain statement of
advertisements that the earliest book or pamphlet to come
from the Maine press was Daniel Fenning's *Universal Spell-
ing-Book*. This work of social utility was announced as "now
in press" in the *Falmouth Gazette* of March 2, 1786, and on
June 22 of that year it was advertised in the same paper, by
that time called the *Cumberland Gazette*, as "Now ready for
Sale at this Office." The contender for the title of first Maine
book, the Hazlitt *Discourse*, missed that distinction by about
two weeks. The book was advertised, in the issue for June 29,
1786, as "Now in the Press, and next Monday will be pub-
lished." *Weatherwise's Almanack for 1787* was advertised
as about to be published some months later, specifically, in
the *Cumberland Gazette* of December 1, 1786.

A more important establishment than the Portland office
of Titcomb & Wait was that which Peter Edes set up at Au-

gusta in 1795. Edes had previously intended going into business with Wait when he began printing in Portland in 1785, but an opportunity offering to set up in Boston at that time, he gave up the plan. When he returned to the idea of an establishment in Maine ten years later, he had acquired a degree of reputation and of skill in his craft which gave importance to his Augusta press.

The Press in the Middle Colonies
Pennsylvania

It was with something of a flourish that the first press of the middle colonies announced itself to its clientage. A young English printer named William Bradford, a journeyman and son-in-law of the Quaker printer, Andrew Sowle, of London, came into touch with persons who directed his thoughts toward the establishment of a press in Philadelphia,[8] the center of the recently founded Friends' colony. In the year 1685, the *Kalendarium Pennsilvaniense* bore an announcement in which William Bradford, its printer, asserted that "after great charge and trouble, I have brought that great Art and Mystery of Printing into this part of America." Thus was begun the typographical art in a community where, during the eighteenth century, the press was to attain an unusual significance, steadily overtaking in interest and in bulk of production the publishing activities of Massachusetts, and surpassing in these particulars the output of any other colony. Here, in the Quaker colony, was the crucible of colonial America, here the conflict of races and creeds and of political difference was at its sharpest, here were wealth, education, and an enlightened people. Here, too, were the political

leadership of New Jersey and Delaware and an economic connection so close as to make the three at times take on the semblance of a single colony. The Bradfords, Franklin, Bell, the Sowers, the German Baptists at Ephrata, the Dunlaps, Goddard, the Halls, and other printers in and near Philadelphia expressed in type the active intelligence of the community. Through the enterprise of William Bradford and William Rittenhouse, a paper-making business was begun in Pennsylvania in 1690 that early gave this colony preëminence in the manufacture of a commodity essential to the printing trade, and in Philadelphia, in the last quarter of the eighteenth century, type founding assumed the proportions of a national industry. These industrial activities and the later importance of Philadelphia as the seat of the Continental Congress and the Constitutional Convention were not without influence in determining that city as the focal point of American typographical interest in the second half of the eighteenth century.

William Bradford gave offence to the Quaker council of Pennsylvania by permitting Samuel Atkins, the editor of his first publication, the *Kalendarium* of 1685, to refer to William Penn as "the Lord Penn." The Quaker rulers, including Penn himself, looked uneasily at the existence of a press in the colony, and Bradford, for his part, disdained to walk delicately in the presence of God's regents. Until he removed perforce to New York in 1693, he suffered frequent interference from the hierarchy. It is probable that his successor in Philadelphia, the Dutch printer Reinier Jansen, came there in 1699 simply as the agent of Bradford. The son of Reinier Jansen, known as Joseph Reyners carried on the business for a year in succession to his father. In 1712, the name of Andrew Bradford, son of William, began to

The First Presses of the Colonies

appear upon the issues of the Philadelphia press. The father never returned to Philadelphia as a place of residence, but for many years Andrew Bradford remained its chief printer. He was displaced from this eminence only by the superior skill, knowledge, and shrewdness of Benjamin Franklin, who brought to the exercise of his trade the qualities of mind and spirit that afterwards carried him to congresses and courts. On December 22, 1719, Andrew Bradford began, with that day's issue of *The American Weekly Mercury*, the first newspaper to be published south of Boston. The *Mercury* was issued continuously by Bradford until his death in 1742, and after that event his widow, Cornelia Bradford, carried on the journal for four years.

New York

In the closing decade of the seventeenth century George Keith, always in the opposition, succeeded in creating a schism among the Friends of Philadelphia, where, at that time, he was acting as superintendent of schools. Among his sturdiest partisans was William Bradford the printer, from whose press came, in 1692, Keith's broadside entitled, *An Appeal from the twenty-eight Judges to the Spirit of Truth*. Bradford was imprisoned straightway on the charge of printing seditious matter and, under the old Parliamentary press restriction act of 1662, of publishing a pamphlet to which he had failed to affix his name as printer. The high gods must have laughed when the Quakers brought this charge, for in England they of all men had excelled in evading this provision of the act. In defending Bradford, Keith drove the dagger of this inconsistency straight at their breasts, but the armor of self-righteousness prevailed even against ridicule.

The Colonial Printer

The magistrates were not to be turned aside from their determination to break up the Keith-Bradford alliance, and when Bradford succeeded in gaining his freedom, he accepted the inevitable, and betook himself to New York in May or June of the year 1693, having previously been appointed, on April 10, public printer of that colony, hitherto without a press. In *New-England's Spirit of Persecution transmitted to Pennsilvania*, printed by Bradford in 1693, is found the story, from the standpoint of the malcontents, of the trial of Keith and his contumacious associates.

One determines only with difficulty and with ultimate uncertainty the order of Bradford's imprints in 1693, the inaugural year of printing in New York City.[9] In a concise presentation of the facts of Bradford's removal to New York, followed by a list of the imprints of his first year in that city, Wilberforce Eames has left the order undetermined, though he has suggested a probable arrangement with which, in the face of the existing uncertainty, there can be no quarrel. There seems absolutely no possibility of determining the place of publication, whether in Philadelphia or in New York, the city of refuge, of *New-England's Spirit of Persecution transmitted to Pennsylvania*, or of *A Paraphrastical Exposition on a Letter from a Gentleman in Philadelphia to his Friend in Boston*. Mr. Eames places these in his list in the order named as Numbers 1 and 2, and after them, three separately printed acts of the New York Assembly of the autumn of 1692.[9a] These five titles are without imprint, and immediately following them, as Number 6, is an act of the tenth of April, 1693, with the year incorrectly printed in its heading as "1694." It bears the imprint "Printed and Sold by William Bradford, Printer to King William and Queen Mary, at the City of New-York, 1693." It begins with a sheet marked

The First Presses of the Colonies

"B," so that in all probability it followed in order of printing Number 5, which bears the signature "A." This act of April 10, 1693, seems to be the first piece printed in New York bearing the name of printer and the place and date of publication.

It seemed for some time that one of the principal uses of Bradford's new stand was to be a vantage ground from which he and George Keith might sling printed invective at the Pennsylvania authorities, but as soon as the spleen was out of his system, Bradford applied himself industriously to the building up in New York of a successful and important printing business. From this shop came the first printed series of assembly proceedings to be published in any of the colonies, and in succession, many significant governmental and literary productions. He began on November 8, 1725, the first New York newspaper, *The New York Gazette*, and continued its publication until 1744. Bradford was the initiator of printing in two of the greatest of the American colonies, the virtual founder of paper making in America, and the progenitor of a family of printers who continued the practice of the craft for a century and a half after his first establishment of the Pennsylvania press in 1685.

Bradford's rescue from the Pennsylvania authorities had been effected by the appearance in Philadelphia of Benjamin Fletcher, bearing a royal commission as governor of the Quaker colony as well as of New York, where he had already been actively engaged in administrative affairs. In February, 1693, he had conducted a successful punitive expedition against a force of French and Indians threatening the frontier. Whether, as has been said, Governor Fletcher's tenderness for the harassed Philadelphia printer arose from his desire to have the proceedings of that expedition recorded in

print is a matter of opinion, but at any rate one of the publications of Bradford's New York press of 1693 was the story of that effective campaign told in Nicholas Bayard's *Narrative of an attempt made by the French of Canada upon the Mohaques Country*. If the vanity of a royal governor was the cause of the establishment of the New York press, the outcome seems for once to have justified the existence of that vice.

New Jersey

Before 1754 the governmental and other printing work of New Jersey[10] was executed by William Bradford, of Philadelphia and New York, or by Andrew Bradford, of Philadelphia, always with one or the other of these cities named in the imprint as place of publication. A permanent New Jersey press was established about the year 1754, when James Parker, a printer of New York, and later of New Haven, set up in his native town of Woodbridge the first independent printing office of the colony. The earliest Woodbridge imprint of which a record remains seems to be *The Votes and Proceedings of the General Assembly of the Province of New Jersey ... April 17, 1754 ... June 21, 1754*, printed by James Parker in 1754. It was not until 1758 that Parker was appointed government printer, and in the meantime the greater part of the New Jersey official work had continued to be sent to Philadelphia for execution by the younger William Bradford. The first permanent New Jersey newspaper was *The New Jersey Gazette*, begun at Burlington by Isaac Collins on December 5, 1777, and removed by its publisher a few months later to Trenton, where it continued to be issued with poor success until 1786.

The story of New Jersey printing origins, however, does

The First Presses of the Colonies

not rest upon these well-understood incidents in the life of James Parker. There exist, to puzzle bookmen doubtless, two sets of session laws of the Assembly, with dates many years earlier than 1754, bearing respectively the names of Perth Amboy and of Burlington, the New Jersey capitals, in their imprints. The acts of 1723 claim on their title-page to have been "Printed by William Bradford in the City of Perth Amboy, 1723." The acts of 1727–28 bear an imprint which reads, "Burlington: Printed and Sold by Samuel Keimer, Printer to the King's Most Excellent Majesty, for the Province of New Jersey, MDCCXXVIII." It is known that Franklin and Samuel Keimer spent about three months in Burlington in 1727, or early in 1728, for the purpose of printing an issue of paper money provided for in an act of Assembly of December, 1727, and furthermore, that they took with them a copperplate press "contrived" by Franklin for the job. Keimer was well paid for the contract, and it may be assumed that he found it worth while to move his letterpress printing press to Burlington for the purpose of printing the laws of the session in that town. Until this time, the New Jersey laws with the one exception mentioned, had been issued with the imprint of New York or of Philadelphia, and it seems reasonable to believe that this set too would have borne a Philadelphia imprint if Keimer had not actually had a press at hand in Burlington. This assumption is strengthened by reminding ourselves that in the year 1723 a Perth Amboy imprint had appeared with the name of William Bradford as printer. Various explanations, some of them fantastic, have been urged to account for the temporary removal of Bradford's press to Perth Amboy, but it has been generally overlooked that in 1723, as well as in 1728, the Province of New Jersey put out an issue of paper money. The conclusion that

follows upon mention of this fact is that, as William Bradford was doing the official printing of New Jersey at this time, he was probably given also the contract for making the notes in question. To prevent fraud on the part of the printer in the handling of these bills, or loss by robbery, certain cautionary provisions of the act of 1723 would have made it almost imperative that he work, as Keimer found it expedient to do later, under the observation of commissioners appointed to represent the government. As a paper money job was one of unusual profit for the printer, it is not difficult to think of Bradford moving a press and appurtenances from New York to Perth Amboy to meet the requirements of the commissioners, and, after the money had been finished, of printing there an edition of the recent Assembly statutes. At any rate, we have the coincidence that in these two years, 1723 and 1728, when paper money was printed for New Jersey by outside printers, volumes of newly-made statutes appeared bearing in their imprints the names of New Jersey towns. There is little doubt that the statutes of 1728 were actually, as their imprint said, printed in Burlington by Samuel Keimer, and if we assume for the sake of argument that Bradford was the printer of the paper money of 1723, the analogy between the two cases leads us to the conclusion that the statutes of 1723 were in truth printed, as their title-page declares, in Perth Amboy by William Bradford. This line of reasoning, though not irrefragable, is strong enough to lead one to fix the year 1723 as marking the first operation of the printing press on New Jersey soil.

The First Presses of the Colonies

Delaware

The three counties of Delaware[11] looked upon Philadel-
phia as their metropolis, and until 1761, the printing of the
colony was performed by various establishments in that city.
In that year an English-born printer, James Adams, went
out from the shop of Franklin & Hall and opened a print-
ing house in Wilmington, the chief town of Delaware. Here,
Isaiah Thomas says, he established a newspaper called *The
Wilmington Courant*, but later investigators have been un-
able to find traces of the existence of that journal. The first
separate imprint to issue from his press is sometimes said to
have been *The Child's New Spelling-Book*, Wilmington, 1761,
but there seems no reason save the arbitrary one of alphabeti-
cal order to give that title priority over Evan Ellis's *Ad-
vice of Evan Ellis to his Daughter when at Sea*, or *The Mer-
chant's and Trader's Security*, both of which are also adver-
tised by Adams in the *Pennsylvania Gazette* for November
5, 1761. *The Child's New Spelling-Book*, however, seems cer-
tainly to have preceded Thomas Fox's *Wilmington Almanack
for 1762*, for it is advertised for sale in that publication. Three
copies of the *Almanack* and a single copy, acquired by the
John Carter Brown Library in 1932, of what is conceded to
be the Evan Ellis broadside already mentioned are now
known to exist. With the information at present available it
is not easy to say which of these was the earlier, but at any
rate there remain in actual copies these two titles from the
first year of Delaware printing. The truth is that the differ-
ence in time of issue between the four Wilmington titles of
1761 would at best have been extremely slight. Adams did
not announce his move to Wilmington until September 4,
1761. Two months later, on November 5, he advertised as

ready for sale the four titles of which we have spoken. It is to be observed that he does not say in his advertisement that either the *Child's New Spelling-Book* or the *Merchant's Security* were of his printing, but simply that they had lately been published and were for sale by him. If it is not absolutely certain, in the absence of copies, that he was the printer of those two, we must fall back upon the *Almanack* and the moralized *Advice of Evan Ellis* as representing our knowledge of the first year of Delaware printing.

The first Delaware newspaper to attain permanency was *The Delaware Gazette*, established in June, 1785, and published at the Wilmington office of Jacob A. Killen.

The Southern Group
Virginia—The First Attempt

Before the establishment of the Bradford press in Philadelphia in the closing days of the year 1685, an attempt had been made to introduce the art of printing into Virginia.[12] In 1682, John Buckner, a merchant and landowner, had brought to Jamestown a printer named William Nuthead. The press was set up and the printer began immediately to compose the acts of an Assembly not long adjourned. In the meantime he printed "several other papers," of which the nature is not known, and pulled proofs of two sheets of the acts. At this stage a flurry of alarm seems to have seized the Governor and Council. The printer and his patron were abruptly called before the Council and bound over to let nothing pass the press "until the signification of his Majesties pleasure shall be known therein." Several months later a new governor came out to Virginia bearing the royal order

The First Presses of the Colonies

that "no person be permitted to use any press for printing upon any occasion whatsoever"—a complete and unqualified prohibition of printing in the colony. The mandate was effective: it was nearly fifty years later, in 1730, that William Parks began the operation in Williamsburg of the first permanent Virginia printing press.

Maryland

It was early in the year 1684 that Lord Howard of Effingham reached Virginia with the order prohibiting printing in his government. It is not certainly known what was the next move of the harassed printer who was thus forbidden the practice of his craft, but something more than a year later we encounter him comfortably settled in a neighboring colony. In November, 1685, as shown upon a manuscript statement of account made out to a government official, payment was recorded of "Wm Nuttheads bill" for 1650 pounds of tobacco. In October, 1686, we find these words in an act of the Maryland Assembly for paying the public charge of the province: "To Wm. Nutthead Printer five Thousand five Hundred and fifty pounds of Tobaccoe." If these payments were rewards for past services, as seems probable, it would mean that the Nuthead press had been established in St. Mary's City, the Maryland capital, sometime before November, 1685.[13]

The position of St. Mary's City as the third town and Maryland as the second colony in which a permanent press was established rests upon the cash entry of November, 1685, just referred to, and upon the existence of a blank form, *This Bill bindeth me* [blank spaces for names] *County in the Province of Maryland*, filled in with the name of a citizen of

The Colonial Printer

St. Mary's County and the date August 31, 1685. The discovery in 1934 of this form and the cash account entry necessitated a restatement of the previously accepted chronology in which the press of William Bradford of Philadelphia had been given position immediately after those of Cambridge and Boston. For as Bradford was still in London in August, 1685, and as he published his first work, the *Kalendarium Pennsylvaniense*, sometime between December 28, 1685 and January 9, 1686, it seems clear enough that William Nuthead's press is entitled to the place in the list formerly held without challenge by the Philadelphia printer.

In addition to this blank form and a group of similar forms of varying dates there remains only a single imprint from the Maryland press of William Nuthead, though evidences of his residence in St. Mary's City and of his occupation there as a printer from 1685 until his death in 1695 are very clearly written in the provincial records. During the Protestant Revolution of 1689, the successful anti-Catholic and anti-Proprietary party issued two printed documents: *The Declaration of the Reasons and Motives for the Present Appearing in Arms of their Majesties Protestant Subjects in the Province of Maryland*, and *The Address of the Representatives of their Majestyes Protestant Subjects in the Provinnce of Mary-Land*. No copy has been found of the Maryland edition of the *Declaration*, but a London reprint of it, a folio in four leaves, "Licens'd, November 28th, 1689," bears the following colophon: "Maryland, Printed by William Nuthead at the City of St. Maries, Re-printed in London, and Sold by Randal Taylor near Stationers Hall, 1689." Of the broadside *Address*, on the other hand, there remains in London, in the Public Record Office, a copy with an imprint that declares its origin in the words, "Maryland printed by order of

The First Presses of the Colonies

William Nuthead was succeeded by his widow Dinah, who, with her family and her press, followed the government in its removal from St. Mary's City to Annapolis, the new capital on the Severn. Here Dinah Nuthead gave bond for good behavior and received in return the Governor's license to print. Though she seems to have produced nothing important in content or size, there remain five blank forms which are attributed to her Annapolis press. Dinah Nuthead, unless we include Mrs. Glover, the owner of the equipment of the first Cambridge press, was the first of a long line of women distinguished in American typographical annals. Of the work of her successor, Thomas Reading, there remain several examples, including two editions in folio of the collected laws of the province. John Peter Zenger began his career as master printer in Maryland in 1720, some seven years after the death of Reading. After another period in which no printer had residence in Lord Baltimore's province on the Chesapeake, William Parks came to Annapolis in 1726 and, encouraged by statute, reëstablished the printing business of the colony on a firm and enduring basis. His genuine enthusiasm for newspaper publication resulted in his beginning, in 1727, *The Maryland Gazette*, the first newspaper to be published south of Pennsylvania. The first printing house to be set up in Baltimore was brought to that city from Philadelphia in 1765 by Nicholas Hasselbach, a former journeyman in the shop of Christopher Sower, the Elder. His earliest imprint was a book of forty-seven pages by one John Redick, of Pennsylvania, entitled *A Detection of the Conduct and Proceedings of Messrs. Annan and Henderson at Oxford Meeting-House, April 18, 1764.* The title-page of the single known copy of this first Baltimore book is without date, but it is be-

lieved the book was printed soon after the date of its preface, February 12, 1765. Other printers came to Baltimore in the ensuing years, but it was only with the coming of William Goddard and the beginning of his *Maryland Journal*, on August 20, 1773, that the press is found firmly established in a city then becoming one of the most important commercial centers of the country.

Virginia – The Permanent Establishment

It has already been told that the first effort at the establishment of a press in Virginia[14] in 1682 was frustrated by governmental interference, and the printer Nuthead compelled to remove to the neighboring province of Maryland. Nearly fifty years later Maryland repaid her debt for the services of Nuthead when William Parks, her public printer, opened in Williamsburg in 1730 a branch house that soon became the more important of his offices. In 1732, Parks was appointed public printer of Virginia, the first person to hold that office. This eminent individual had conducted printing shops and newspapers in Ludlow, Hereford, and Reading, in England, and at Annapolis, in Maryland. He was a man of excellent public spirit, who possessed as well a pretty taste in *belles-lettres*. The issue of his American presses has in consequence of these qualities a distinction not always found in the utilitarian production of the colonial printer. His earliest Virginia imprints of 1730 were *The New Tobacco Law*, *The Acts of the Virginia Assembly for the May Session of 1730*, and a commercial manual known as *The Dealer's Pocket Companion*. No copies of these works are known, so that it is impossible to give their exact titles. In the same year, however, Parks printed at Williamsburg Governor William

The First Presses of the Colonies

Gooch's *Charge to the Grand Jury* and John Markland's *Typographia, an Ode on Printing*. The first of these has distinction as the earliest extant Virginia imprint; the second as the first American contribution to the literature of typography. One copy of each is known to exist at the present time. Parks established *The Virginia Gazette* in 1736, and continued it until his death in 1750. He built and operated a paper mill at Williamsburg, and in other ways made himself one of the most important American printers of his day. He was succeeded in his office of public printer of Virginia by his journeyman, William Hunter.

South Carolina

The government of South Carolina[15] offered in May, 1731, the sum of £1000 currency of the colony, about £175 sterling, as aid to the first printer who should remove to distant Charleston. An awkward situation arose when soon thereafter three printers appeared in Charleston, one of them, Eleazer Phillips, Jr., of Boston, brought by the Commons House of Assembly, the other two, Thomas Whitemarsh, of Philadelphia, and George Webb, of uncertain previous residence, coming on their own initiatives in response to the government offer. It should be said at this point that Webb left the colony, or died, before the award was made in the next year; that Phillips and his estate received the subvention of £1000 currency; and that Whitemarsh was paid, in response to his petition, the sum of £200 as a bounty. This printer, indeed, had earned the good will of the Council, the members of which, clearly good sportsmen, had challenged unsuccessfully the Lower House to a contest of a sort not authorized by the Code of the Duel, nor, I believe, found else-

where in the history of American typography. This was simply that an identical piece of copy be given for printing to the favored printer of each legislative chamber, "and then," said the cartel of the Council, "we shall judge who can the best serve the Publick." But alas for romance: the stodgy members of the Lower House ignored the challenge and insisted upon the payment of the subvention to the young printer from Massachusetts.

Eleazer Phillips, Jr. died in July, 1732. Thomas Whitemarsh, his successor in office, was one of Franklin's journeymen, sent out under a partnership agreement that began two days after his arrival in Charleston on September 29, 1731. This printer had little better fortune than Phillips, for he, too, as Isaiah Thomas says, "was very soon arrested by death." Franklin charged him with certain books on March 14, 1733/34, but at that time Whitemarsh had been dead for six months.

The printer who came to Charleston at the same time as Phillips and Whitemarsh must be regarded, in any account of South Carolina printing origins, as of greater interest than the other two, even though his name is not found on book or newspaper after the year of his arrival in Charleston. This individual was George Webb, a printer whose connection with South Carolina had never been mentioned by bibliographer or historian until in March, 1933, Douglas C. McMurtrie published in *The Library* an account of several printed pieces found by him in the Public Record Office, London, among them a pamphlet of six pages, bearing the imprint, "Charles Town, Printed by George Webb," and a broadside without imprint but with typographical features which relate it to the establishment that printed the pamphlet. Both these pieces, furthermore, can be dated with rea-

sonable safety a few weeks earlier than the earliest known publication of Thomas Whitemarsh, discovered by Mr. Mc-Murtrie at the same time. The Webb pamphlet, *Anno Quinto Georgii II. Regis. At a Council . . . Tuesday October 19, 1731*, is without date in its imprint, but the governor's "permission," printed at the end, is dated "Nov. 4, 1731." The broadside proclamation attributed to Webb carries the same date. These two pieces would in the natural course have appeared earlier than the broadside, headed *Charlestown, South-Carolina*, which Thomas Whitemarsh "at the Sign of the Table-Clock on the Bay" issued at some time after the date of signature printed on the document, that is, "this 27th Day of November, 1731." Unless contradictory evidence turns up, therefore, George Webb must hereafter be regarded as South Carolina's first printer and the printed Council Proceedings just described as his first book. Webb's identity is uncertain, but it is not unreasonable to suppose that he was the same George Webb whom Franklin described in 1727 as under articles of indenture to Samuel Keimer of Philadelphia. At some time in 1728, this Webb became free of his articles and negotiated for editorial employment with both Franklin and Bradford. A George Webb, Gent., was employed by the Virginia Assembly to prepare the laws for publication by William Parks in February, 1728, and more than once was appointed to that task in succeeding years. This same individual edited *The Office and Authority of a Justice of Peace*, printed by Parks in Williamsburg in 1736. Maintaining the chronological order, we next find in Charleston, in 1731, the George Webb in whom we are just now particularly interested. A "Mr. Webb" was associated with William Parks in his Annapolis printing office in 1736. There are discrepancies in such dates, places, and circumstances as

are here mentioned which might be difficult to remove if one intended to affirm dogmatically that these several references pointed to the same individual. We must satisfy ourselves with saying that South Carolina's first printer of 1731, so far as is now known, was George Webb, and that this individual may conceivably have been one or all of the Webbs we have seen associated with the press in one or another capacity in Philadelphia, Williamsburg, and Annapolis in the period 1727–1736. The George Webb of Philadelphia, by the way, as appears in a later chapter, was "sometime of Oxford," though an indentured servant.

As we have seen, the official printer to the colony under the act of 1731, Phillips, and the semi-official printer, Whitemarsh, died, successively, in 1732 and 1733. The vacancy resulting from the death of Whitemarsh was soon filled by the arrival in Charleston of Lewis Timothy, the son of a French Protestant refugee, who had taken shelter in Holland at the time of the revocation of the Edict of Nantes. Lewis Timothy learned printing in Holland, and acquired there an estimable wife. Later he emigrated to Philadelphia, became one of Franklin's journeymen, and the first librarian of the Philadelphia Library Company. The story is carried forward by a passage in the *Autobiography* in which Franklin writes: "In 1733 I sent one of my journeymen to Charleston, South Carolina, where a printer was wanting. I furnish'd him with a press and letters, on an agreement of partnership, by which I was to receive one third of the profits of the business, paying one third of the expense. He was a man of learning, and honest but ignorant in matters of account; and, tho' he sometimes made me remittances, I could get no account from him, nor any satisfactory state of our partnership while he lived. On his decease, the business was continued by his

The First Presses of the Colonies

widow, who, being born and bred in Holland, . . . not only sent me as clear a state as she could find of the transactions past, but continued to account with the greatest regularity and exactness every quarter afterwards, and managed the business with such success, that she not only brought up reputably a family of children, but, at the expiration of the term, was able to purchase of me the printing-house, and establish her son in it." The subject of this encomium, Elizabeth Timothy, died in 1757. At the time of her death, the business had been conducted for seventeen years in the name of her son, Peter Timothy.

The first South Carolina imprints that can be traced, in addition to those already specified as coming from the presses of George Webb and Thomas Whitemarsh, were the newspapers established by Whitemarsh and his rival from Boston. Eleazer Phillips, Jr., seems to have begun, in January, 1732, *The South Carolina Weekly Journal*, which he conducted for six months or so between that time and his death. No copy of this newspaper has been found. On January 8 of the same year Thomas Whitemarsh began publication of *The South-Carolina Gazette*. Ceasing with his death in September, 1733, this paper was reëstablished by Lewis Timothy in 1734. Until the discovery by Mr. McMurtrie of the six-page pamphlet issued by George Webb in 1731, the earliest book to come from the South Carolina press was believed to be *An Essay on Currency, Written in August, 1732*. It was printed by Lewis Timothy at Charleston in 1734, and a single copy in the Charleston Library seems to be all that remains of the issue. The first South Carolina imprint of more than ordinary consequence was Nicholas Trott's *Laws of the Province of South Carolina*, printed notably well by Lewis Timothy in Charleston in 1736.

The Colonial Printer

North Carolina

Like the first printer of Virginia, the proto-typographer of North Carolina[16] is remembered as a man of unusual public spirit and of praiseworthy accomplishment. James Davis came from Virginia to Newbern, North Carolina, in 1749, possibly after serving an apprenticeship with Parks in Williamsburg. He was appointed public printer at an annual salary, and in this office he remained until the year 1777. His first imprint, dated 1749, seems to have been *The Journal of the House of Burgesses . . . September 26 . . . October 18, 1749.* In August, 1751, Davis began the publication of *The North Carolina Gazette*, a journal that continued to be issued for about eight years. In 1764, he made another journalistic effort with *The North Carolina Magazine*, and it is probable that this continued with moderate success until the earlier name was resumed in 1768. During the later years of his business activity, Davis had a rival in the person of Andrew Steuart, who came from Philadelphia to Wilmington, North Carolina, in 1764, received part of the public business through the influence of the Governor, began a newspaper, and died in 1769, after a brief period of success.

Georgia

Until the year 1763, the printing of the colony of Georgia[17] was executed in London or at Charleston in the neighboring colony of South Carolina. The colony was established in 1732 under the auspices of a group of men, among them James Oglethorpe and the first Earl of Egmont, who had studied with advantage the science of colonization as evolved from the experience of their predecessors in English Amer-

The First Presses of the Colonies

ica. It is somewhat to be wondered at that the press was not set up immediately by the enlightened promoters of the Georgia settlement, but a discussion of their failure to do the expected thing in this particular would lead us far afield. It was only in the session of March, 1762, that the Assembly passed an act for the encouragement of James Johnston, "lately arrived in this province from Great Britain," as printer to the government at an annual salary of £100 sterling. We know little of Johnston's activities until the appearance on April 7, 1763, of the first number of *The Georgia Gazette*. With the usual suspension during the Stamp Act troubles, this newspaper continued until the year 1776, when the impending Revolution made its publication impossible in this far southern outpost of the English colonies. On January 30, 1783, Johnston began newspaper publication again with *The Gazette of the State of Georgia*. Soon afterwards the old name, *The Georgia Gazette*, was resumed, and the journal continued until 1802, when its proprietor announced that his age and poor health made its further publication impossible.

No one has offered a satisfactory explanation of the absence of dated Savannah imprints for the year following March 4, 1762, unless Mr. McMurtrie's assumption be correct that Johnston, during this period, was awaiting the arrival of his equipment from England. Johnston was in Savannah when, on the day named, the act for his encouragement was passed, and even at this time there was plenty of work at hand. It was not until June 2, 1763, however, that he began advertising in the *Georgia Gazette* a series of printed acts of Assembly. The first of these in date of passage was *An Act to prevent stealing of Horses and neat Cattle*, passed in March, 1759, and it is this piece that must perforce be regarded as the first Georgia imprint other than a newspaper.

The Colonial Printer

Louisiana

The first press to begin operation in Louisiana[18] was set up in New Orleans in 1764. In this year, before the cession of Louisiana to Spain and England had been consummated, the French governor asked the home authorities to grant permission to "le Sieur Braud negociant" to establish at his own expense a printing office in the City of New Orleans. One learns from the petition that Braud, while awaiting the arrival of type and other articles of equipment ordered from France, had already set up a press, probably a copperplate printing press, and had been usefully employed in printing paper money from an engraved plate. The Governor answered for his intelligence and zeal, and approved his plea for the exclusive right to print and to sell books in the colony. The granting of Braud's request was the last monopoly conceded by the French government in Louisiana. It is probable that as the result of this petition the Braud press soon began its activities. The earliest known New Orleans imprint, a historically interesting and important broadside first recorded by Douglas C. McMurtrie, was the tragic *Extrait de la Lettre du Roi*, announcing the cession of the country to Spain. Its imprint reads "De l'Imprimerie de Denis Braud, Imprimeur du Roi." It is without date, but it bears the handwritten endorsement of the chief clerk of the local council, dated New Orleans, September 16, 1764. At the very beginning of the Spanish occupation of Louisiana, Braud came into conflict with the new government. Late in 1768, there came from his press the *Memoire, des Habitans et Négocians de la Louisianne, sur l'Evenement du 29. Octobre 1768*. Its colophon reads, "A La Nlle. Orléans. Chez Denis Braud, Imprimeur du Roi. Avec permission de Mr. l'Ordonnateur. M.DCC.-

The First Presses of the Colonies

LXVIII." The action that this lengthy document sought to justify was the expulsion of the Spanish governor, Antonio de Ulloa, by the uneasy French colonists, and its printing brought Braud before Alexander O'Reilly, when that warrior came to New Orleans some months later as the governor of a colony then indubitably Spanish. He was let off punishment on his plea that, as royal printer for the colony, he had been without option as to what should pass his press when copy came to him, as this had come, bearing the official signature of the *ordonnateur*. Indeed, the value to the new government of a printing establishment seems to have been well understood by O'Reilly, and it is probable that even had his excuse been less good, Braud would have suffered a very light penalty. During the period 1764–1770, some twenty titles, several of them pamphlets of considerable size, are known to have come from this busy press. The earliest imprint of the second New Orleans printer, Antoine Boudousquié, bears the year 1777 as its date. The first newspaper recorded as having been issued in that city is the *Moniteur de la Louisiane*, which probably began publication in March, 1794, under the auspices of the printer Louis Duclot.

Florida

The first press of Florida,[19] still a British province, was established by John Wells, a native-born printer of Charleston whose original loyalty to the patriot cause had been unable to withstand the occupation of his city by the British in the closing years of the War. So outspokenly Tory had been his newspaper, the name of which he changed at this juncture to the *Royal Gazette*, that the withdrawal of the British forces suggested his own flight as a prerequisite of liberty and

The Colonial Printer

the pursuit of his business career. Early in 1783, he is found in St. Augustine, where, in association with his brother, Dr. William Charles Wells, a precursor of Darwin in the promulgation of the theory of evolution, he began the publication of the *East-Florida Gazette*, a newspaper known to exist today only in the three numbers found in London in the Public Record Office, those for March 1, May 3 and 17, 1783. The issue number of the earliest of these specimens indicates that publication began on February 1, 1783.References in the Savannah and Charleston newspapers make it clear enough that this journal continued publication until March 22, 1784, attaining something over a year of life. It could not, indeed, have carried on much longer than this, for in June, 1784, the Spanish authorities took over Florida in pursuance of the treaty by which England had ceded Florida to Spain. Sometime in 1784, William Charles Wells betook himself to London and a life of success in his profession, and John, the printer, joined the exodus of American loyalists from East Florida to English possessions in the West ·Indies. John Wells was one of the many exiles from Florida who found shelter and a living in the Bahama Islands. In Nassau, he continued his career as a newspaper publisher. His letters to George Chalmers, Bahama government agent in London, preserved in the John Carter Brown Library, show him many years later actively engaged in newspaper publishing and government printing. It should be added that they show him also a man of intelligence in public affairs and, one judges, of high integrity and worth. He died in Nassau late in the year 1799. For a while after his death, the *Bahama Gazette* was, its imprint read, "Published by the Friends of John Wells, for the Benefit of his Heirs."

There arises in connection with the *East-Florida Gazette*

The First Presses of the Colonies

a perplexing mention of a printer not previously, or later, I believe, known to historians. The imprint of that paper for March 1, 1783, says that it was printed "by Charles Wright for John Wells, jun." There seems to be available no information about a printer named Charles Wright in Florida or elsewhere, and John Wells himself was a practical printer whose name appears alone in the imprint of two books later to be mentioned. The situation would be easier to explain if the prepositions of the imprint had been transposed; if that statement had read "printed for Charles Wright by John Wells, jun.," we might suggest that the Charles Wright concerned was the brother of Sir James Wright, royal governor of Georgia, and brother also of Jermyn Wright, with whom he came to East Florida upon the outbreak of the revolutionary troubles in Sir James's government. Charles and Jermyn Wright lived prominently in Florida, and, though they seem to have turned their abilities in several directions, there is no evidence that either of them was a printer. But in view of the explicit statement of the *Gazette* imprint we have the circumstance that the earliest printer mentioned in connection with East Florida is this Charles Wright, who thereafter disappears from typographical history.

In the course of his brief Florida interlude John Wells printed, over his own name, two books of considerable interest. One of these, Samuel Gale's *Essay II, On the Nature and Principles of Public Credit*, was the second in a series of four elaborate economic discussions which later appeared under that author's name in London in the year 1784–1787. This second essay of the group was written in St. Augustine and there, in 1784, put into print by Wells but not published. In a notarial document printed as part of it, Gale asserted that between 100 and 120 copies were being printed, not for sale

or publication, but to be sent to learned persons in England for comment. The book, therefore, was to be regarded as manuscript, and the author's theories were not to be considered as having been made public by the fact of this appearance of them in print. This is a curious instrument, unlike anything else in the early history of American publishing. Indeed, the sight of this Gale book gives the bibliographer a certain tensing of the faculties which warns him that he has before him something of unusual interest, in this case, it proves, something that has not yet had a historian. The book is so excessively scarce, furthermore, that collectors stay awake of nights thinking about it.

The date of the notarial document in the *Essay II* is March 31, 1784, and on that day, its author affirmed, the printing of his book was almost finished. It seems likely that the book was off the press, though never published in this Florida edition, somewhat earlier than the other book John Wells is known to have printed in St. Augustine, for that other book, the *Case of the Inhabitants of East-Florida*, contains as the last of a long appendix of documents a communication to the Assembly by Governor Tonyn, dated March 25, 1784. It is probable that the book was not written until after this date, but its text, exclusive of the documents, is very short and the whole work could have been quickly put together and printed. In view of the closeness of these dates, therefore, there must remain a small degree of uncertainty on this question of priority between the two books. The *Case of the Inhabitants* is a presentation of the claim of the Florida people to compensation for the losses they were about to sustain through the cession of their country to Spain. Like the presses of Louisiana and of Vermont, this short-lived Florida press found itself called immediately to the service of its

The First Presses of the Colonies

community in a moment of stress and emotion. The departure
of Wells from St. Augustine meant the cessation of printing
in Florida for a long term of years. Its resumption in 1821
by Richard Walker Edes, son of Peter Edes, first printer of
Augusta, Maine, is part of the story of the nineteenth-century
press.

Mississippi

It was by chance that a further extension of the press into
southern territory occurred in the closing years of the eight-
eenth century. An officer of the United States Army, Andrew
Marschalk, took with him to the fort at Walnut Hills, now
Fort Hill, near Vicksburg, Mississippi,[20] a small press for his
personal use. There in 1797 or 1798, he printed a ballad by
William Reeves entitled *The Galley Slave*. No copy is known
of this, the only work of *belles lettres* recognized as the ear-
liest issue of an American press. Marschalk was soon per-
suaded to move to Natchez and to take up seriously a busi-
ness in which he afterwards became eminent. There, early
in 1799, he printed a separate *Law for the establishment of
the Militia of the Missisippi Territory*, and, later in the same
year, the *Laws of the Missisippi Territory*. Sometime in 1800,
according to the dates and issue numbers of remaining copies,
Benjamin M. Stokes began at Natchez the publication of the
Mississippi Gazette, the first newspaper of the territory.

The Westward Expansion
Western Pennsylvania

The final advance of the press in the United States in the
eighteenth century was its passage, accompanying the great

migrations, into the country beyond the Alleghanies. This westward movement was led by John Scull and Joseph Hall, two young Philadelphia printers, who set up their press in Pittsburgh[21] in 1786, and, on July 29 of that year, began the publication of the *Pittsburgh Gazette*. The town from which this paper took its name, since become one of the great cities of the world, numbered at that time but three hundred inhabitants, but its situation at the point where the Monongahela and the Alleghany Rivers join their waters to form the Ohio, had predestined it to be the gateway to the Ohio country since the establishment at that spot of Fort Duquesne by the French a generation earlier. The earliest extant issue of the press of John Scull, or of Scull & Boyd, as the firm became when Joseph Hall died, was the *Pittsburg Almanac for 1788*.

Kentucky

The printers of the country showed themselves as fully charged with the pioneer spirit as any men of their day. Not content to stand in the gateway, they followed close upon those who opened the new districts to settlement. In this place we need mention only the strategic points they occupied in their advance. In July, 1786, the town of Lexington, Kentucky,[22] voted a free lot to John Bradford as encouragement in the establishment of a printing house in a community just then intent upon separation from Virginia. The record of the transportation of Bradford's press and letters by wagon over the mountains to Pittsburgh, down the Ohio to Maysville, by pack horse southward to Lexington is one of the best remembered stories of the westward migration of the press. In the journey across country from Maysville to Lexington, the type, as Bradford wrote, "fell into pi," so that when his

brother, and practical assistant, Fielding Bradford, became ill at the critical moment, the troubled printer had great difficulty in bringing out on August 11, 1787, the first issue of the *Kentucke Gazette*. So far as yet determined, the earliest issue of Bradford's press in the form of a book was *The Kentucke Almanack for 1788*, first advertised for sale on January 5, of that year, but announced as "preparing for the Press" as early as October 13, 1787.

Tennessee

The operations of the press in the Southwest, or what was then the Southwest — the territory south of Kentucky, west of North Carolina, and east of the Mississippi — began with the coming of George Roulstone and Robert Ferguson, experienced printers and newspaper publishers from North Carolina, to a little village of the present state of Tennessee[23] called Hawkins Court House, now Rogersville. This situation seems to have been merely a *pied à terre* for the printers until the new capital, Knoxville, then being laid out, should be ready for its inhabitants. At Hawkins Court House, the two printers issued on November 5, 1791, the *Knoxville Gazette*. Eleven months later the establishment was removed to the town for which the *Gazette* was named. The first imprint of this press other than its newspaper, so far as is known, was the *Acts and Ordinances of the Governor and Judges, of the Territory of the United States of America South of the River Ohio*. This piece, without imprint, has been identified by Mr. McMurtrie as coming from Roulstone's press at Knoxville in 1793.

The Colonial Printer

Ohio and Michigan

The press in Ohio[24] was instituted through the initiative of William Maxwell, who went to Cincinnati in 1793 after a brief career as the proprietor of a printing shop in Lexington, Kentucky. On November 9, 1793, Maxwell began *The Centinel of the North-Western Territory*. It is said that the first book to issue from the Cincinnati press was the significant volume he printed in 1796, *The Laws of the Territory of the United States North-West of the Ohio*. No good reason exists for doubting that this was the first book of the Northwest Territory, but probably not far behind it in time of issue comes *An Act passed at the First Session of the Fourth Congress of the United States . . . the Seventh of December, 1795*, printed by John McCall in Detroit in 1796. Except for this little book, a few blank forms, and a charge against him in a merchant's account book, nothing is known about John McCall, whence he came, whither he went, what he did in Michigan[25] or elsewhere after his operation of a press in that place in 1796.

All these western presses were remarkable for the extent of their participation in the problems of the communities in which they were placed. They served the immediate local needs of the expanding communities and took part in the struggles for individual statehood of the new territories. Into the discussion of the current constitutional affairs of the new union of states they entered vigorously, making it clear that the western communities were not segregated colonies but an integral part of the nation. No section of the country has greater reason for pride in its pioneer press than that which we now call the Middle West, the Far West of the post-colonial period.

*The First Press in Each Colony in Order of Establishment, 1639–1798

Colony	Town	Year	Printer	First Certain Imprint Other than a Newspaper	Year
Massachusetts	Cambridge	1639	Stephen Daye	[The Freeman's Oath]	1639
Maryland	St. Mary's City	1685	William Nuthead	[A blank form]: This Bill bindeth me . . . (August)	1685
Pennsylvania	Philadelphia	1685	William Bradford	Kalendarium Pennsylvaniense (December)	1685
New York	New York City	1693	William Bradford	Anno Regni, etc. The 10th of April 1694 [1693] An act for raising six Thousand Pound, etc.	1693
Connecticut	New London	1709	Thomas Short	An Act [for Making and Emitting Bills of Publick Credit	1709
Rhode Island	Newport	1727	James Franklin	[A Letter from Hammett to Wright]	1727
Virginia	Williamsburg	1730	William Parks	[The New Tobacco Law]	1730
South Carolina	Charleston	1731	George Webb	Anno Quinto Georgii II . . . At a Council . . . October 19, 1731	1731
North Carolina	Newbern	1749	James Davis	Journal of the House of Burgesses . . . September 26 . . . October 18, 1749	1749
New Jersey	Woodbridge	1754	James Parker	The Votes and Proceedings of the General Assembly of the Province of New Jersey . . . April 17, 1754 . . . June 21, 1754	1754
New Hampshire	Portsmouth	1756	Daniel Fowle	[Proposals for the publication of a Weekly Gazette] / Ames's Almanack for the Year 1757	1756
Delaware	Wilmington	1761	James Adams	The Wilmington Almanack for 1762	1761
Georgia	Savannah	1762	James Johnston	An Act to prevent stealing of Horses and neat Cattle. March, 1759.	1763
Louisiana	New Orleans	1764	Denis Braud	Extrait de la Lettre du Roi a M. Dabbadie Directeur Général	1764
Vermont	Westminster	1780	Judah Padock Spooner & Timothy Green	[A Thanksgiving Proclamation]	1780
Florida	St. Augustine	1783	John Wells & Charles Wright	Gale's Essay II on Public Credit / Case of the Inhabitants of East Florida	1784
Maine	Portland	1785	Benjamin Titcomb & Thomas B. Wait	[A broadside]: Falmouth February 2, 1785	1785
Kentucky	Lexington	1787	John & Fielding Bradford	The Kentucke Almanack for 1788	1788
Tennessee	Rogersville	1791	George Roulstone & Robert Ferguson	Acts of the U.S.A. South of the Ohio	1793
Ohio	Cincinnati	1793	William Maxwell	Laws of the U.S. North-West of the Ohio	1796
Michigan	Detroit	1796	John McCall	An Act of the Fourth Congress, Dec. 1795	1796
Mississippi	Fort Hill	1798	Andrew Marschalk	The Galley Slave	1798

*The list given here of first presses and of first imprints is to be accepted only with the qualifications set out in the text of the foregoing chapter.

The First Permanent Newspaper in Each Colony in Order of Establishment, 1704–1800

Colony	First Permanent Newspaper	Year	By Whom Established
Massachusetts	The Boston News Letter	1704	John Campbell
Pennsylvania	The American Weekly Mercury	1719	Andrew Bradford
New York	The New York Gazette	1725	William Bradford
Maryland	The Maryland Gazette	1727	William Parks
South Carolina	{ The South Carolina Weekly Journal } { The South Carolina Gazette }	{ 1732 } { 1732 }	{ Eleazer Phillips, Jr. } { Thomas Whitemarsh }
Rhode Island	The Rhode Island Gazette	1732	James Franklin
Virginia	The Virginia Gazette	1736	William Parks
North Carolina	The North Carolina Gazette	1751	James Davis
Connecticut	The Connecticut Gazette	1755	James Parker
New Hampshire	The New Hampshire Gazette	1756	Daniel Fowle
Georgia	The Georgia Gazette	1763	James Johnston
New Jersey	The New Jersey Gazette	1777	Isaac Collins
Vermont	The Vermont Gazette	1780	J. P. Spooner & Timothy Green
Florida	The East Florida Gazette	1783	Charles Wright for John Wells
* Delaware	The Delaware Gazette	1785	Jacob A. Killen
Maine	The Falmouth Gazette	1785	Benjamin Titcomb & Thomas B. Wait
Kentucky	The Kentucke Gazette	1787	John & Fielding Bradford
Tennessee	The Knoxville Gazette	1791	George Roulstone & Robert Ferguson
Ohio	The Centinel of the North-Western Territory	1793	William Maxwell
Louisiana	Moniteur de la Louisiane	1794	Louis Duclot
Mississippi	The Mississippi Gazette	1800	Benjamin M. Stokes

*For comment upon The Wilmington Courant, see page 37 of the foregoing text.

The Colonial Printing House

CONSIDERATION of the shop equipment, or, as it was called in the language of the trade, the "printing house," of the colonial printer provides entertainment for the antiquarian and instruction for the amateur of books. The sight of a skilled workman plying his tools is one of the experiences that sweeten life, and it would be pleasant if in these pages we could follow a manuscript through all the processes of the printing shop until it was turned out a finished and bound volume for the reader's delectation, observing the several mechanical problems that arose in its progress and studying the means employed for their solution. There is no royal road, however, to an understanding of the intricate though orderly processes of these establishments. Any brief and non-technical account of printing-house operations invariably leaves the reader almost where he began with regard to the very matters of detail that cause him the most trouble to comprehend.[1] No attempt will be made here, therefore, to give instruction in the art of printing, but rather, more simply, to represent the physical equipment of the colonial American printing house, keeping in mind always that a greater understanding of a man and of his work comes with knowledge of the tools he employs in the daily practice of his craft.

Press and Appurtenances

There seem to have been recognized in the colonies three types of printing office, differentiated by quantity rather than by kind of equipment, and designated in the common speech

of the craft as "one press," "two press," and "three press" shops. In the tables on pages 63 and 65 are given lists of the shop equipment in establishments of each of these classes. The one-press shop is presented there through the medium of a letter that Franklin, in 1753, wrote his London correspondent, William Strahan, bespeaking a complete equipment for a nephew whom he intended setting up in business in New Haven. It should be said that except for small differences, this was the amount of equipment, "the utensils for printing," which Samuel Green listed in 1662 as the property of the Corporation, sent over in 1659 to expedite the printing of the Indian Bible. For a picture of the two-press establishment, the normal shop from which issued an impressively large part of the printed matter of the period, an average has been taken of the materials listed in the inventories of William Rind of Williamsburg, Anne Catharine Green of Annapolis, and John Holt of New York. The inventory of the firm of Franklin & Hall, made at the dissolution of the firm in 1766, provides the list of equipment for the exceptional shop of the three-press class maintained by that famous house.[2] The still larger shops of the later years of the century, represented by the establishments of Christopher Sower, Jr., of Germantown, and Isaiah Thomas, of Worcester, are somewhat beyond the range of an analysis that deals only with the normal printing house of the pre-Revolutionary period.

Certain small but essential articles of printing-house equipment are omitted from the list on page 63 for the reason that these implements are not invariably specified in the inventories examined. In one or another of the documents in question, however, are mentioned poles for drying paper, reglet in indeterminate quantity, gutter sticks, side sticks, shooting sticks, quoins, planes, letter racks, case racks, cutting presses,

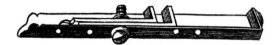

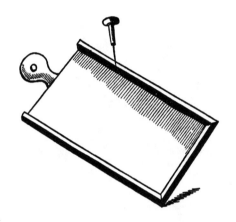

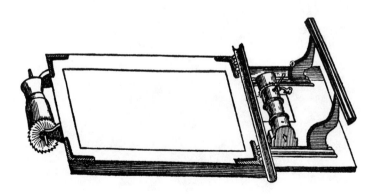

PLATE I

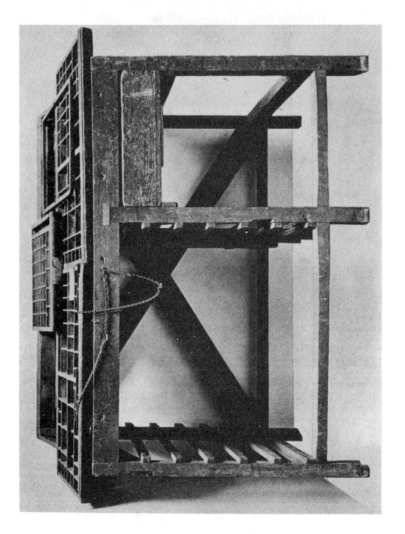

Plate II

The Colonial Printing House

book presses and other instruments for bookbinding, lye troughs, and wetting troughs. Save for the implements of bookbinding, all of these articles were common necessities of every shop, to be found in a number or quantity proportionate to the type of shop examined. The fact that few of these

Equipment of the Colonial Shops

	One Press	Two Press	Three Press
Presses	One	Two, with extra friskets and tympans	Three
Blankets	Two pairs		
Ballstocks	Two pairs	Four pairs	
Chases	Three pairs, the biggest, demi	Ten	Fifteen
Galleys	Two folio, each with four shies Four quarto	Seventeen royal demi and quarto as well as sliding galleys and three-column galleys for newspaper work	Three folio Eight quarto Seven small quarto
Frames (i.e., stands for type cases — single and double)	[Four]	Eight	Thirteen
Composing sticks	Two	Eight, both wood & iron	Six
Imposing Stones	[One]	Two	Two
Cases	[Eight]	Twelve pairs single and double	Eighty-five (some old and shattered)
Letter boards		Eleven	Sixteen (only ten serviceable)

pieces of "furniture" were mentioned in the list of equipment ordered by Franklin for his nephew's one-press shop means simply that all of them except the bookbinding implements could be manufactured locally by the village cabinet maker. Furthermore, it is known from a later letter that Franklin intended to supply some of the equipment for the New Haven shop from his own superfluous stock of printing-house furniture.

In the dictionaries of common use, and in the glossaries attached to various works on printing, especially to the pro-

totype, the "stockfather," of them all, Moxon's *Mechanick Exercises*, of 1683, the uses of all the articles named in these lists of equipment can be found fully described. Perhaps no comment is required here beyond the hazarding of a guess that the "sliding" galley found in our two-press shop was probably the "slice" galley, common then and now, with a bottom in the form of a board that slides in and out of its frame to facilitate the deposit of a heavy page of type upon the imposing stone. It must be remembered always, in thinking of the old-time galleys, that they were of the sizes requisite to contain only single pages of type in the folio, the quarto, and the small quarto formats. The matter of the early book was set at once in its page form without the intermediation of the proving galley. The long tray of twenty-four inches we know today as a "galley," from which our "galley proofs" take their designation, is an article of later evolution.[3] (Plates I, II and III.)

Letter Fonts

There occurs a quickening of interest in our minds when, through the medium of another group of lists, we pass to consideration of the sizes and quantities of type employed in the business of the colonial printers. As before, it proves convenient to use in the table on page 65 the rough classification provided by the terms "one press," "two press," and "three press" shops. In our chapter on "Type and Type Founding," there is to be found a discussion of the kinds of type employed in the colonial establishments of the three classes designated. The tabulation that follows is simply a sort of stock-taking, by weight and sizes, of the amounts of letter to be found in active concerns of the period.

The Colonial Printing House

Printing Type in the American Shops

One Press	Two Press	Three Press
		383 brevier, much worn
		282 brevier, serviceable
	600 bourgeois (badly worn)	663 bourgeois, serviceable
	200 bourgeois	
300 long primer with sorts for an almanac	400 long primer	436 long primer, serviceable
	390 small pica	318 small pica, much worn
300 pica		421 pica, much worn
100 great primer		223 great primer, serviceable
300 English	360 English	334 English, much worn
		502 English, serviceable
60 double pica		158 double pica, serviceable
50 two line English		91 double English serviceable
40 two line great primer		
30 two line capitals		
20 quotations		
Brass rules		
Factotums		
Flowers, etc.		70 flowers
Head & tail pieces		
	300 sorts	159 sorts
(1200 lbs.)	(2250 lbs.)	(4040 lbs.)
(These were the fonts ordered from London by Franklin for his nephew.)	*(This is the amount in the Green establishment— 2250 lbs. The average for the three shops of Rind, Green, and Holt was only 1600 lbs.)*	*(From the Franklin & Hall inventory.)*

Monetary Value of Plant

The value in terms of money of the three classes of printing establishments represented in the lists here given is a matter of some interest.[4] Taking them in normal order, we find that the "little print'g house," presumably new, which Sir William Keith proposed to purchase for Franklin, about the year 1724, was to cost £100 sterling. When Franklin sent

The Colonial Printer

Thomas Whitemarsh to South Carolina in 1731 under a silent partnership agreement, he charged him on his Ledger with "a printing house and materials £80 0 0," stated in sterling money. The cost of the one-press shop Franklin ordered from England for his nephew in 1753, comprising a new press and new Caslon type, is found to be about £75 sterling. From these figures we may conclude that the average value of a new one-press shop in the period 1724 to 1753 was approximately £85 in sterling money. There is little difference found in the value of the printing houses of the entire colonial period if the condition and length of service of the presses and fonts are given consideration in the calculations. The press and equipment that the Reverend Jose Glover carried to Cambridge in 1638 is supposed to have cost something more than £49, but it is not known whether the equipment was new in whole or even in part. It is certain, however, that the well-worn printing house of Marmaduke Johnson, at the time of his death at Boston in 1674, was inventoried at £50, exclusive of the "book Bynders Press & tooles" which appear in the list at £6. The much-used equipment of Thomas Short of Connecticut, including the binding implements at £3, was appraised in 1712 at £48 sterling. Nearly sixty years later, Isaiah Thomas agreed to purchase Zachariah Fowle's one-press printing house for the sum of £53 and some odd shillings.

By averaging the inventoried appraisals of the three printing houses that we have already thrown together to form a composite two-press colonial establishment, we find the value of the equipment of the hypothetical shop to be £107 currency. At the time these inventories were made, however, Mrs. Green's equipment was very much worn through long use, and one of John Holt's presses had been damaged by

The Colonial Printing House

fire. Because of these considerations one is justified in assuming £125 currency to be a more nearly correct valuation of a two-press printing house in normal working condition. If fifty per cent may be taken as the normal premium of sterling over the currencies of the various colonies in the mid-eighteenth century, this sum may be restated at £83 sterling money.

The inventoried value of the large but well-worn establishment of Franklin & Hall representing, in 1766, three presses and more than 4000 pounds of type, was £313 10s. currency, or £184 10s. sterling at seventy per cent, the normal sterling premium over Pennsylvania money during the period of the partnership. In 1753, William Hunter paid the executors of William Parks of Williamsburg the sum of £359 currency, or, as we know more exactly in this case, £288 sterling, for "sundry printing materials."[5] The accounts of the estate fail to itemize the equipment for which this relatively large sum was exchanged, but an examination of the number and character of the works issued by Parks is sufficiently clear evidence that this Williamsburg shop was one of the larger and more adequately equipped establishments of the period.

If one wished to point a moral in the presentation here of these lists of equipment and in their evaluation in money, he would turn to the printing house of the two-press shop for his text. It was with this meagre equipment, and with an amount of labor and ingenuity inversely proportional to its scantiness, perhaps, that the normal colonial printer carried on a lively business in book, job, and newspaper publishing. The sum of £83 sterling in the mid-eighteenth century was, roughly calculated, the equivalent of two thousand dollars in terms of our own currency. Any well-established job printer of the present day would consider himself impoverished if his equipment were cut down to a money value relatively as

low as that of the materials here enumerated. The same man, with power presses and type-setting machines at his command, would throw up his hands if he were asked to duplicate some of the notable issues of colonial establishments of this type. It was by the economical and skilful use of such equipment as this that Lewis Timothy's *Laws of South Carolina*, Parks's *Collection of all the Acts of Virginia*, Jonas Green's *Laws of Maryland*, the Mennonite Martyr Book, the Eliot Indian Bible, the Sower German Bible of 1743, and a score of other monumental works, some of them hideous to the eye, others composed and impressed in the grand manner of the masters of typography, were issued almost as a matter of course from the dingy and ill-lighted shops of a pioneer country.

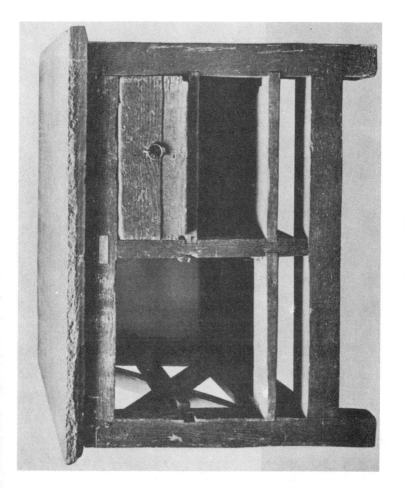

PLATE III

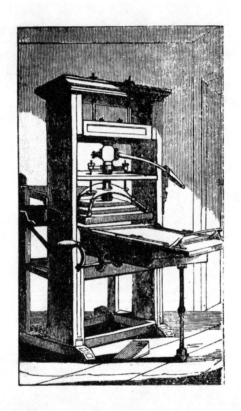

PLATE IV

IV

The Colonial Printing Press

NO single article of equipment used by the colonial American printer has been more casually treated in designation and in description than the all-important wooden printing press with which he and his European predecessors worked from almost the earliest days of printing. The press of the American shop is usually loosely referred to by those who write of it as being either of the "Blaeu" or the "Ramage" type. Further definition is left discreetly to the reader, who, usually, is just as discreetly satisfied with the terms employed. In the ordinary sense, it makes little difference which of these presses he used, but while we are studying the antiquarian aspects of the colonial printer's trade, it is well to determine, as nearly as may be done, the character of his principal implements. To do this is especially pertinent in the present case, inasmuch as the press he used was certainly not of the Ramage variety, and if it was the Blaeu press,[1] it was so modified in the characteristic features of that machine as hardly to deserve the name in designation.

The Ramage Press not of the Period

The date of the earliest employment of the Ramage press in this country is difficult to determine. As it happens, however, the difficulty is not a matter of embarrassment to the colonial historian, for it was not until sometime between 1795 and 1800, at the very close of the period, that Adam Ramage came from Scotland to take up his residence and trade in Philadelphia.[2] Just how soon after his arrival he began to build the improved press that has caused his name to be re-

membered is not certain, but it is clear that the popular machine he devised could not have been a feature in the printing shop of the colonial period. We can leave the Ramage press out of the present discussion with a free mind, and return later to a brief description of it as one of the inventions that heralded a better day for the printer whose life carried him into the new century.

The Blaeu Press versus the Common Press

It is advisable to refrain from dogmatic assertion in discussion of the Blaeu press for the reason that while we know what it was, it is not easy to be sure what it was not. Moxon has given a full description of all its parts, but neither Moxon nor anyone has given a description of the "old fashion'd" press used in England long before the Blaeu press was heard of, and, if we may believe the evidence, long after the Dutch machine had ceased to interest the English printer. In Moxon's opinion, the Blaeu press was so superior to the earlier machine that he felt impelled for the "Publick benefit" to urge its adoption by the printers of his day, but in taking for granted contemporary knowledge of the difference between the two types of machine, he justifiably forgot posterity and failed to point out clearly the nature of the improvements to be found in the new press. He complicated the matter further by omitting from his picture of the earlier press the mechanism of rounce, winch, and girt barrel, specifically known as the "rounce," by means of which the carriage was moved in and out beneath the platen. But those who deduce from this omission that the rounce was invented by Blaeu, that before his day the heavy carriage was moved by pushing and pulling, and that all presses showing the rounce are Blaeu presses,

The Colonial Printing House

betray imperfect knowledge of the earlier history of the printing press. As early as the year 1507, a hundred and thirteen years before the supposed date of invention of the Blaeu machine, the first of the several printers' marks used by Badius Ascensius of Paris represented a press on which was clearly shown a rounce with a pressman in the act of moving the carriage by its agency. Furthermore, in a series of pictures of sixteenth-century presses brought together and reproduced by Falconer Madan, the rounce is seen to be an almost invariable feature of the mechanism. It is also to be observed in these representations that the part of the press (called for obvious reasons the "hose") which houses the spindle of the screw below the threaded portion, and serves to guide and stabilize the vertical motion of spindle and platen, is nearly always in the form of an upright, oblong wooden block with squared sides. This feature will be spoken of later in the discussion.[3]

The rounce mechanism that becomes the central feature of this discussion was simply a horizontal windlass extending from side to side of the press beneath the "plank" or floor of the carriage.[4] Midway of its axle was a drum upon which were wound two leather straps, or "girts," running thence in either direction the length of the carriage. The free end of one of these straps was attached to the hind edge of the plank; of the other, to the frame of the graphically named "coffin," the receptacle for the type form that rode near the front and on top of the carriage. To adjust the carriage, or technically, to "set the rounce," so that the type form, under different conditions and for each of the two pulls necessary for the printing of one side of a sheet, should come exactly beneath the platen, was a task of some nicety. From Moxon's animadversions it is known that in the old-fashioned press

the setting of the rounce was accompanied by labor, inconvenience, and uncertainty of result, because when the slack of the girts had been taken up it was necessary to make their free ends fast to the plank and to the coffin by the primitive method of nailing. The damage to the wooden work caused by the repeated driving and drawing of nails provided, moreover, a constant and unavoidable factor of wear and tear on the machine. In the Blaeu press the setting of the rounce was accomplished more effectively and with less labor, for in this machine, drums fitted with ratchets were fixed approximately in the positions at either end of the carriage where in the old press the girts had been fastened by nails. (Plate i.) By means of this device the pressman could take up the slack in the girts and quickly set his rounce for a movement of whatever distance was required for the job in hand. This feature and the iron "hose," next to be discussed, seem to embody the chief mechanical improvements found in the new press, for the gallows, or movable rest for the tympan, and the gutter to carry off the water from the tympan, were mere newfangled "gadgets," conveniences not based upon improved mechanical ideas.

In the Dutch press, the structure of the "hose" that stabilized the spindle at the moment of pressure and so prevented the slurring of the type impression seems to have been regarded by Moxon as an advance toward mechanical perfection. It has already been pointed out that in the earlier presses the hose was in the form of "a long, square box, or block of wood, through which is turned a hollow cone, fitting the conical or tapering part of the spindle." The spindle was held firmly in the hose by means of the "garter," a sort of iron collar fixed in the inner surface of the hose and fitting around a groove in the spindle. In the Blaeu press the hose

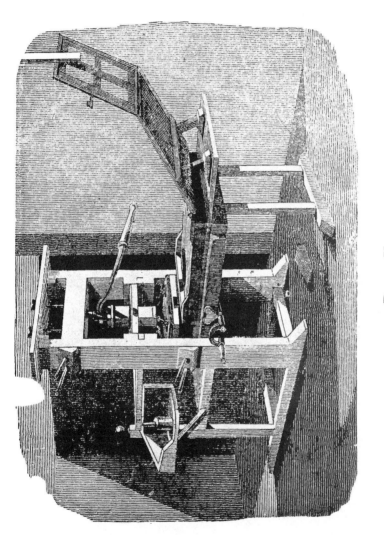

PLATE V

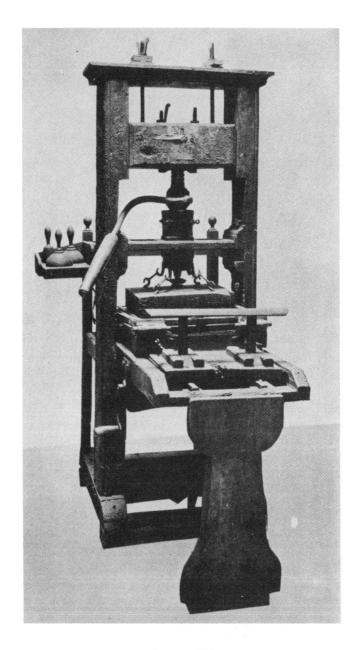

PLATE VI

The Colonial Printing House

no longer bears the shape that its name suggests; it is no longer what in modern parlance is called a sleeve. In this improved machine the hose and its garter take the form of an iron yoke, shown in the reconstruction on Plate IV more clearly than through the medium of verbal description. The English printers of the eighteenth and early nineteenth centuries, Johnson records in his *Typographia*, found the box hose of the older press a better agency for the steadying of the spindle than the iron yoke of the Dutch press, but it is significant that in the chief principles of construction, the hose of the improved Ramage press of the early nineteenth century was nearly that of the Dutch press approved by Moxon. This feature of the Dutch machine was not indeed of Blaeu's invention, for it is seen in the presses used by Christopher Plantin, who died in 1589, a generation or more before Blaeu took up the avocation of press building. It was probably found as a general thing in the Low Country presses and taken from them by Blaeu as a matter of course. But whatever the origin of the hose in the form of an iron yoke, its presence on the Blaeu press as shown in the cuts of Moxon, Luckombe, and Johnson was the chief visible feature distinguishing it from the old-fashioned English press.[4] In our Appendix appears a series of drawings made for this book by Mr. Ralph Green in which are graphically displayed the differences between the so-called Blaeu press and the old-fashioned press which are discussed in the foregoing paragraphs.

After reading Moxon's description of the Blaeu press one concludes that the rigid iron hose and the improved rounce mechanism were the more important appliances that made it superior, in his judgment, to the old-fashioned press he despised as "a makeshift slovenly Contrivance." It may have been neither of these features, however, that gave the im-

ported machine its superiority, but, more simply, the finer workmanship of the Dutch joiner and smith; it may have been indeed, that its superiority lay in all those prescriptions as to the different varieties of wood to be used, the directions as to dovetailing and mitering, the careful fitting of the iron parts, the bevelling, the squaring, the grooving, and the exactness of measurement that Moxon insists upon and for which he gives specific directions, passed over impatiently by the general reader.

It has already been said that the superior features of the Dutch press were urged very strongly by Moxon, who dismissed the old-fashioned press as being unworthy of the effort required to describe it. Thirty years later we find James Watson of Edinburgh commenting upon the old English press in terms as strong as those employed by Moxon. "One new-fashion'd Dutch Press," he writes, "is worth half a Score of such. . . . I my self have known a Press of the new Make brought hither from Holland, work near Twenty Years, and in all that time neither Smith nor Joiner call'd for to her; . . . I beseech you, as you are tender of your own Interest, to bring Home your Presses from Holland; or make them here, after the Fashion of that Country." [5] With the best authorities urging the use of the Blaeu press and with its general employment in the Low Countries as an example to the British printer, it is difficult to understand his failure to make greater use of the improved machine, for as a general rule he was not prejudiced against the products of his neighbor's ingenuity. In the seventeenth century he made greater use of Dutch type than of the letters of English founders; Dutch paper was regularly purchased, and many engravers were brought from the Low Countries to exercise their skill in the illustration of English books. The Dutch and the

The Colonial Printing House

Flemish indeed were the schoolmasters of the English in the arts and industries for a long period, but for some reason the Dutch press never was made to feel at home in England. One may not say, so long afterwards, whether the reason for this apparent blindness to his own interests was the insular conservatism of the English printer, the motive of economy, or a genuine and well-considered preference for the simpler structure of the old-fashioned machine.

We have the evidence of Moxon that when he was writing, in 1683, the old-fashioned press was "generally used here in England." In 1713, James Watson, writing of conditions in the Scotch printing houses, recorded the fact that "Our Presses are now generally of the old English Fashion, which they were not formerly." The press that Benjamin Franklin worked at in Watts's shop in London, in 1726, now in the Smithsonian Institution, was of the old-fashioned type. The clouds seem to lift for a time when Luckombe gives a cut of the Blaeu press in his book, published in 1770, and, as if intimating that the Blaeu machine had at last come into general use writes that "the old sort, till of late years, were the only Presses used in England." But Luckombe's testimony is unreliable because throughout the technical portion of his book he copies Moxon verbatim with only an occasional paraphrase, and one suspects these words to be a paraphrase of Moxon's statement, "The old fashion is generally used here in England." If we accept Luckombe's substituted clause at its full meaning, however, and agree that in 1770 the Blaeu press had at last taken root in England, we are soon in difficulties, for in 1808 Stower describes and pictures under the caption, "The Common Press," nothing other than the old-fashioned machine contemned by Moxon a century and a quarter earlier, and says in his text that this type of

press has been generally used for more than fifty years. In 1824, Johnson described an "improved wooden press" as having been in "general use in this country [England] for more than the last century." This press, too, as shown in Johnson's cut, seems to possess only the features of the press known as "old fashion'd" in Moxon's day. Reflection upon the evidence derived from these works does not enable one to isolate any period of years in which the Blaeu press attained consistent usage by the printers of the British Isles.[6] (Plate v.)

It is sometimes thought that the "common press" and the "improved wooden press" described by Stower and Johnson were, as these writers themselves seem to have believed, improved forms of the Blaeu press. The improvement in the Stower and Johnson presses, however, as compared to the "old-fashioned press," which Moxon despised, must have lain in the factor of superior construction rather than in their employment of the mechanical features just described as differentiating the Dutch machine, that is, the hose in the form of an iron yoke, and the ratchet and roller mechanism for taking up the slack of the girts in setting the rounce. In their essential principles of construction and operation, these were presses of the old-fashioned kind known in England before Moxon urged the adoption there of the Dutch, or Blaeu, machine. The "hose" of the press described by Stower and Johnson is a sleeve in the form of an oblong wooden box, and the girts of the rounce are attached to the plank by nails, or preferably (and here is an advance over the ancient practice), by thumbscrews. Either the Blaeu press had never been adopted to any extent by English printers up to this time or it had been tried by them and found wanting. It is not a question of their wisdom or their lack of it, but simply of the fact, and the evidence seems to show the fact to be that for two

The Colonial Printing Press

centuries the English printer continued to distrust the Blaeu press as a foreign invention. If we may believe the evidence of our eyes in examining the pictures of the press which Stower and Johnson describe as the common press of their time, it was still misunderstood and distrusted by him when all types of wooden press were suddenly relegated to the lumber room by the Stanhope and the other iron presses that came into being in the early years of the nineteenth century. One of the drawings by Mr. Green in our Appendix shows the common wooden press of Stower and names its essential parts.

The American colonial printer used the materials and machinery he had been taught to work with in the English shops. There remain among the relics of the period the press used by Isaiah Thomas, now in the American Antiquarian Society at Worcester; the so-called "Stephen Daye press," in the Vermont Historical Society at Montpelier; the press of Peter Edes, formerly in the Public Library of Bangor, Maine; the James Franklin press in the Massachusetts Mechanics Charitable Association in Boston; two Ephrata Monastery presses, one belonging to the Historical Society of Pennsylvania, now displayed by the Franklin Institute, Philadelphia, the other the property of the Ford Museum, Dearborn, Michigan. And we have, too, the woodcut representation of a press, incredibly poor in drawing, which ornamented the title-page of *Samuel Saurs Calender* of Chestnut Hill, 1792. All these presses are of the type described by Moxon as the old-fashioned press, "a makeshift slovenly contrivance," lacking the iron hose in the form of a yoke and the improved rounce mechanism, though the Ephrata presses, imported from Germany, it is said, show some modification of the common, "old-fashioned" English press. The hind end of the plank shows too, in such of this group of presses as I have seen, innumerable nail holes re-

sulting from employment of the older method of taking up the slack of the girts. It is hardly to be doubted that these examples represent the type of press generally used in the colonial American shops. (Plate vi.)

Franklin's Proposed Improvement

One may suspect that even the greatly improved press Moxon described was far from being a faultless mechanism. Conviction of the truth of this suspicion forces itself upon us in reading the old writer's directions for setting up the press, and his later prescriptions for its successful operation. Yet with all its imperfections and with the greater imperfection of the old English press, there seem to have occurred few improvements in either so long as the wooden printing machine continued to be used. A factor of importance in the satisfactory operation of the press was the smoothness with which the carriage,[4] bearing the type forms, moved in and out beneath the platen. Fastened to the underside of the carriage were the "cramp irons," two parallel rows of iron lugs, transversely set, which, in the movement of the carriage, ran upon longitudinal, parallel metal "ribs," or tracks, supported by the "winter" and by a frame, or "stay," with the floor as its base. In their passage back and forth, the cramp irons bore upon the ribs, face to face, at right angles to their length, and Moxon tells us that "the upper sides of these Ribs must be purely Smooth-fil'd and Polish'd and the edges a little Bevil'd roundish away, that they may be somewhat Arching at the top; because then the Cramp-Irons Run more easily and ticklishly over them." And it is found to be true that when the Isaiah Thomas press was constructed nearly a century later it was equipped with ribs that were "somewhat Arching

The Colonial Printing Press

at the top," though in the meantime at least one printer had perceived and endeavored to correct the fundamental mechanical error present in this feature of the carriage movement. It was Franklin who, ordering a press for his nephew in 1753, wrote to William Strahan of London with this admirable suggestion:

"If you can persuade your press-maker to go out of his old road a little, I would have the ribs made not with the face rounding outwards, as usual, but a little hollow or rounding inwards from end to end; and the cramps made of hard cast brass, fixed not across the ribs, but longways, so as to slide in the hollow face of the ribs. The reason is, that brass and iron work better together than iron and iron. Such a press never gravels; the hollow face of the ribs keeps the oil better, and the cramps, bearing on a large surface, do not wear, as in the common method. Of this I have had many years' experience." [7]

The Operation of the Old Wooden Press

With all the clumsiness of action that characterized the wooden press, whether of the old English type or of the Dutch model, one is astonished to learn of the amount of daily work it was capable of performing. Its relatively high production rate seems to have been attained by the skill of the workman set to overcome the deficiencies of the tool. Nothing so astonishes the reader of Moxon's meaty pages as to learn that scientific motion study, one of our modern fetishes, was an old story in the seventeenth-century printing shops. To produce a single impression of type on paper, there were required thirteen distinct processes involving a bewildering number and variety of set and coördinated movements

on the part of the two workmen serving the press. The hourly product of a single press served by two men was, in theory, in a well-organized office, no less than a "token," or 240 sheets, printed on one side with two pulls to the form, and in order to approximate this stint throughout a long working day, a rigid discipline of their movements was required of the men working at press. In a working day of ten hours a press continuously served with no changing of forms could theoretically turn out ten tokens, or 2400 sheets, printed on one side. Inevitably the ordinary shop routine in a day of ten hours would reduce this number to a normal output of eight tokens, but the figure shows at least the admirable speed at which skilful men could operate a machine that we too condescendingly regard as a rackety and clumsy contrivance.[8] In spite of the apparent crudity of the old wooden press, it deserved the respect that Moxon bespoke for it, in its Dutch form at least, as "a Machine invented upon mature consideration of Mechanick Powers, deducted from Geometrick Principles."

Certain paragraphs from Moxon's book explain the processes gone through by two pressmen working at the old wooden press. They are interesting and pleasant to read:

"We will suppose now two Press-men going in the Morning to their train of Work: The one they distinguish by the name of First, the other his Second, these call one another Companions: The First is he that has wrought longest at that Press, except an Apprentice, for he must allow any Journeyman though new-come that stile: Generally the Master Printer reposes the greatest trust upon his care and curiosity for good Work; although both are equally liable to perform it.

"All the priviledge that the First has above the Second is, that the First takes his choice to Pull or Beat the agreed stint

The Colonial Printing Press

first: And that the Second Knocks up the Balls, Washes the Forms, Teizes Wooll, and does the other more servile Work, while the First is imploid about making Register, ordering the Tympan, Frisket, and Points, &c. or otherwise Making Ready the Form, &c.

"The First now takes his spell at Pulling: For the First and Second take their spell of Pulling and Beating an agreed number of Tokens: Sometimes they agree to change every three Tokens, which is three Hours work, and sometimes every six Tokens; that they may both Pull and Beat a like number of Tokens in one day.

"Under the general notion of Pulling and beating is comprised all the operations that is in a train of work performed by the Puller and the Beater: For though the Puller Lays on Sheets, Lays down the Frisket, Lays down the Tympans and Frisket, Runs in the Carriage, Runs out the Carriage, takes up the Tympans, Takes up the Frisket, Picks the Form, Takes off the Sheet, and Lays it on the Heap, yet all these Operations are in the general mingled and lost in the name of Pulling. And as in Pulling, so in Beating; for though the Beater Rubs out his Inck, Slices it up, Destribute the Balls, peruses the Heap, &c. yet all these Operations are lost in the general name of Beating. Thus they say the First or the Second is Pulling; or, the First or the Second is Beating; though they are performing the different Operations aforesaid: unless upon particular occasions the respective Operations are particularly nam'd.

"As there are many Operations conjunct to Pulling, and Beating, so the Press-man performs them with various Set and Formal Postures and Gestures of the Body." (Plate VII.)

Here follow ten pages specifying innumerable operations of hand, eye, and brain that the curious may read with in-

terest and profit. One feels, after studying this portion of Moxon's book, even superficially, that the only difficult thing in the pressman's task was the doing of it.[8]

Press Building in the Colonies

It is probable that until well after the middle of the eighteenth century the printing press remained among the articles the American printer was compelled to import from or through England. Isaiah Thomas says that Christopher Sower, the Elder, of Germantown, made his own presses as early as 1750, but Sower was a universal mechanic who practised some sixteen trades, including those of the preacher and the doctor. It is likely that he made his own presses, but there is no reason to believe that he made presses for other printers or took up to any extent the manufacture of printing machinery as a commercial enterprise. If it were true that he had extended his activities beyond the doors of his own shop, we probably should not have found Franklin, in 1753, ordering a press from England for the nephew whom he proposed setting up in New Haven. It is probable that the difficulty of machining the iron screw essential to the operation of the press compelled the American printer to send for the chief implement of his trade to a country where such mechanical operations were a commonplace of industry. An advertisement in the *Maryland Gazette* for August 12, 1762, gives us another example of this particular inconvenience that the American printer was compelled to undergo. "Last month," Jonas Green announced, "we received by the ship *Eagle*, from London, a very good and compleat New Printing Press, made by Mr. Davenport, this week's Gazette being her *first* work; the old one is now almost worn out with Age, and hard labour

The Colonial Printing Press

in the Public Service." Green had a job of great importance and size before him at this time. Earlier in the summer he had obtained from London several new fonts of Caslon type, and with the aid of these and of the new press he was able to make Bacon's *Laws of Maryland*, finished in 1765, one of the small group of notably fine typographical productions of colonial America.

A change in the American printer's procedure was about to take place. The year 1769 saw not only the first American type cast by Abel Buell of Connecticut, but as well witnessed the making of the first press ordered by an American printer from an American craftsman. The bookmen of Connecticut may recall with satisfaction that the type in question was cast at Killingworth, and that a few months later the press was built at New Haven. An item in the *Massachusetts Gazette and Boston Weekly News-Letter* of September 7 tells us that "Mr. Isaac Doolittle, Clock & Watch-maker, of New-Haven, has lately compleated a Mahogany Printing-Press on the most approved Construction, which, by some good Judges in the Printing Way, is allowed to be the neatest ever made in America and equal, if not superior, to any imported from Great-Britain: This Press, we are told, is for Mr. William Goddard, of Philadelphia, Printer." The truth of this announcement, made in the interests of the non-importation policy, was confirmed a few months later when Goddard advertised that he had recently purchased "an elegant Mahogany Press, made by an ingenious watchmaker, at New Haven."[9] The phrase employed in the announcement of Doolittle's achievement, "the neatest ever made in America," seems to indicate a previous activity in press building in this country, but whether there existed such an activity beyond the occasional building of presses for their own use by Sower

and other ingenious printers, it is difficult to determine. All
that can be said in regard to this question is that the building
of a press for William Goddard of Philadelphia by Isaac
Doolittle of New Haven in September, 1769, is the begin-
ning, so far as the known facts show, of press building as an
industry in English America.

It is clear that soon after this event the building of print-
ing presses became general throughout the country. In 1775,
presses were being manufactured in Philadelphia and in Hart-
ford, and soon afterwards in various American cities. In Story
& Humphreys's *Pennsylvania Mercury* for April 7, 1775, ap-
pears an advertisement in which John Willis, cabinet- and
chair-maker, and Henry Vogt, white- and blacksmith, an-
nounce that in addition to their other business they propose
"to execute any orders" for printing presses, cases, frames,
screws, chases, composing sticks, etc. "Specimens of our work,"
they conclude, "may be seen at the printing offices of Alex-
ander Purdie, Esq., Williamsburg, Virginia; Mr. Aitken, Mr.
Bell; and the Printers of this paper, &c. in Philadelphia." In
an obituary notice in the *Gazette of the State of South Caro-
lina* for June 24, 1778, Peter Timothy of Charleston referred
to his partner, Nicholas Boden, "to whose Industry and Skill"
he owed "the Building of the first Carolina Printing Press."
A notice in the first issue of the *Fayetteville Gazette*, North
Carolina, August 24, 1789, informs readers that the press
upon which the paper was printed had been manufactured
locally by Messrs. Burkloe & Mears. On January 6, 1792,
the *American Apollo* of Boston announced that its current
issue had been printed on "the first complete Printing-Press
ever made in this town—the wood-work was made by Mr.
Berry, and the iron-work by Mr. McClench." One may in-
terrupt the narrative for a moment at this point to admire the

The Colonial Printing Press

appropriateness of the name "McClench" for a worker in iron, a vigorous, gripping name that calls up a vision of the pincers, the vise, and the wrench. In the *New Jersey Journal* (Elizabethtown) for June 1, 1796, "John Hamilton, Printing Press Maker" inserted an advertisement, dated April 19, in which he affirmed that he had supplied many New Jersey and New York printers with presses of a very good quality that he could make for others on three weeks' notice at a cost of seventy-five dollars each.

Ramage and Clymer Presses – The New Era

Instances have been cited here in sufficient number to make it clear that after the year 1775, the American printer need no longer be vexed by the inconvenience of sending to England to secure a new printing press. It is likely that these presses of local make continued to follow the lines of the "old fashioned" machines with which the shops were already equipped, for we hear of no improvement in the mechanism of the press until, at the very close of the century, the Ramage press came to the attention of the trade. The name of Adam Ramage appears in the Philadelphia City Directory for the first time in the year 1800, and in this year his name is found for the first time also in the accounts of Matthew Carey. It was not until after the beginning of the new century, about the year 1807, that he began improving his finely built presses by enlarging the diameter of the screw to such an extent as to double the impressing power of the platen, though the new development decreased somewhat the speed of operation. It is said that the change was rendered necessary by the hairline types that began, following their adoption by Didot and Bodoni, to come into use in the early years of the century. At

The Colonial Printer

some period of his career Ramage provided his wooden press with springs that returned the bar to rest and raised the platen above the carriage after each impression. In the earlier presses, even in those of the Blaeu variety, the raising of the platen and the return of the bar seem to have been accomplished by what Ronald B. McKerrow describes as the "natural spring of the bar, aided by the compression of the packing in the tympan." Ramage's wooden press improvements were only a small part of his achievement. His numerous inventions for the improvement of the iron press established his fame as one of the great press builders of the first half of the nineteenth century.[10]

Curiously, William McCulloch, the Philadelphia printer who, anticipating a second edition of the *History of Printing*, supplied Isaiah Thomas with copious notes on the Pennsylvania printers and their associated craftsmen, has nothing to say about Adam Ramage in his brief account of Philadelphia press builders. He mentions George Clymer, who, about the year 1807, invented the Columbian Iron Press, but only to say that the invention was so little known to him, in 1815, that he could not give a description of its principles. It is almost certain that it was years after 1800 before either the Ramage or the Clymer presses became effective agencies in the life of the American printer. We may think of the printer of the colonial period as working with a press that was better constructed than the printing machine of the early sixteenth century, but which differed from it in no sense in mechanical principles, and very little in the amount of labor required for its operation.[11]

PLATE VII

(2)

10 Therefore his people unto them
 have hither turned in,
 and waters out of a full cup
 wrung out to them have been.
11 And they have sayd, how can it be
 that God this thing should know,
 & is there in the highest one
 knowledge hereof also?
12 Loe, these are the ungodly ones
 who have tranquillity:
 within the world they doe increase
 in rich ability.
13 Surely in vaine in purity
 cleansed my heart have I.
14 And hands in innocence have washt,
 for plagu'd am I dayly:
 And every morning chastened.
15 If I think thus to say,
 thy childrens generation
 loe then I should betray;
16 And when this poynt to understand
 casting I did devise,
 the matter too laborious
 appeared in mine eyes.
17 Vntill unto the sanctuary
 of God I went, & then
 I prudently did understand
 the last end of these men.

(3)

18 Surely in places slippery

R 3

these

PLATE VIII

V

Type and Type Founding of the Colonial Period

The English Background

IN the year 1637, a Star Chamber Decree prescribed that only four persons in England should be allowed to maintain letter foundries at any one time, and the activity of these foundries was limited by a further prescription as to the number of apprentices that each might employ.[1] Although these inhibitions were removed and reimposed several times before the final expiration of the press restriction act in 1693, there does not seem to have been any great increase in the number of English foundries either during those periods when the law was inoperative or in the century following its repeal. "Notwithstanding this liberty," Reed writes, "the number of founders during the eighteenth century appears rarely to have exceeded the figure prescribed by the Star Chamber Decree of 1637, and occasionally to have been less." The consequence of this repression of the craft of letter founding was the inevitable stagnation and dearth of ideas that ensues in any trade wherein is lack of competition. During the first quarter of the eighteenth century, the chief foundries were those conducted by the Andrews and James families, and even when enriched by type cast from matrices procured from Holland, the normal product of these establishments was exceedingly poor. The English printers customarily purchased a great deal of type directly from the Dutch foundries, and Reed asserts that "There was probably more Dutch type in England between 1700 and 1720 than there was English." The irregularities of casting, the infelici-

ties of design that appear in the types employed by the American printer in the first half of the century, are not therefore to be considered as evidence of provincialism or of poverty, for these defects are to be noticed in the letters used in many of the more elaborate productions of his English contemporary. Before they were able to effect a notable change in the appearance of the pages they printed, both the English and the American printer perforce had to wait until the second quarter of the century was drawing to its close and the letters cast by William Caslon had displaced the inferior type which filled their cases. (Plate VIII.)

The Effect of Caslon on Colonial Printing

In this country, as in England, it is likely that much Dutch type was used. There exist, for example, many issues of the press in the decade from 1730 to 1740 in the printing of which there was employed a face distinctly better than the common, yet lacking the regularity and distinction of Caslon's letters. Whether these were from a Dutch foundry or whether they were simply new types from an English house is a question that might well engage the spare moments of an expert in the refinements of design. It would be an interesting, but not an important, subject for investigation to determine when and by whom Caslon's fonts were first used in America — interesting, because the Caslon faces impressed their individuality on the issues of the printing offices of this country so deeply that to many of us a colonial book means, at first hearing, a book printed in Caslon type, with the familiar typographical flowers and factotum initials forming a severe but fitting ornamentation to the text. It was only in the second half of the century, however, that the use of the

new faces became general in America, for although Caslon began cutting his punches in 1720, and although from 1724 onward his fonts were in use by some of the great London printers, yet it was only in 1734 that he issued his first specimen sheet, and after this event that there began the slow process of penetration by which his letters found their way into the cases of the English provincial offices. The investigator is not likely to meet much Caslon type in American books of a date earlier than 1740, but when in his search he opens a page composed in the new letter, after turning over many printed in an inferior face, he realizes the meaning of the phrase, "friendly to the eye," that Mr. Updike's quotation, pleasantly reiterated, has made familiar to us. (Plate IX.)

The fact that Caslon's faces had great vogue in American colonial offices after 1750 does not mean that only type from his foundry was used during the second half of the century, for Caslon's care in the details of cutting and casting revived in the British Isles the forgotten skill of the craft, and before long other foundries in London and in Glasgow were producing letters very much like his in appearance and quite as serviceable in the forms. It is not to be doubted that some of these new faces, especially those of Alexander Wilson of Glasgow, were purchased by American houses,[2] so that those of us who have always thought of "Caslon" and "colonial" as synonymous terms in the description of letter-press printing must learn, if we wish to speak with authority, to distinguish with greater nicety the characteristic designs of the different British founders.

The Colonial Printer

The Cost of Type

The printer of colonial America reckoned as one of the recurrent difficulties of his trade the necessity of keeping replenished the three or four fonts of type that were essential to the conduct of his business. During the early years of his period, as has been intimated, even the English printer was not able to secure easily new fonts of letters or even the necessary "sorts," and later, when the Caslon, the Wilson, the Martin, and other foundries were turning out excellent type in quantity, the cost of the fonts and of their transportation was a serious item in the calculations of the distant American craftsman. Franklin's bill from Caslon for a font of brevier for newspaper use was £57 17s. 6d.; the lesser printer sufficiently ambitious to make similar purchases must have writhed in spirit at the thought of laying out every few years hard money to this amount.[3] It was a happy day, therefore, when the American printer saw that type founding had become a settled industry in his country, and the fumbling efforts of the first founders towards this achievement must have been watched anxiously by the craft. Until the year 1775, however, only a small degree of success could be boasted of by the native founder, but, awaiting happier results, the printer could feel always that there was hope, and that, in the meantime, the quality and the conditions of supply of the imported faces were steadily improving.

Type Sizes Available

There occurred during the period of the colonial printer's activity a noteworthy increase in the number of type sizes available for his use. In the table shown below is repeated

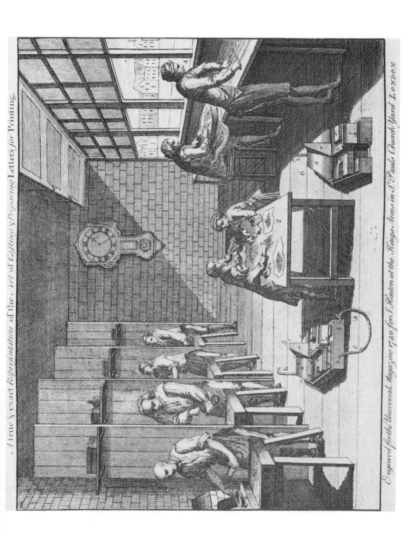

A true & exact Representation of the Art of Casting & Preparing Letters for Printing.

Engrav'd for the Universal Magazine 1750 for J. Hinton at the Kings Arms in S.t Pauls Church Yard LONDON.

PLATE IX

PIETAS

ET

GRATULATIO

COLLEGII CANTABRIGIENSIS

APUD NOVANGLOS.

BOSTONI-MASSACHUSETTENSIUM

TYPIS J. GREEN & J. RUSSELL.

MDCCLXI.

Plate X

Type and Type Founding

Luckombe's comparison, made in 1770, of the type faces possessed by a well-established English printer in Moxon's day, roughly the period of the introduction of printing in the colonies, with the fonts that might be employed by his own contemporaries.[4]

Moxon's List, 1683	*Luckombe's List,* 1770
French Canon	French Canon
Two Lines English	Two Lines Double Pica
Double Pica	Two Lines Great Primer
Great Primer	Two Lines English
English	Two Lines Pica
Pica	Double Pica
Long Primer	Paragon
Brevier	Great Primer
Nonpareil	English
Pearl	Pica
also	Small Pica
Small Pica (*not recomended by Moxon because of its likeness to Pica*)	Long Primer
	Bourgeois
	Brevier
	Minion
	Nonpareil
	Pearl

If we turn now to a comparison of the cases of the American printers of the two periods under consideration, we shall find that they, too, had taken advantage of the more greatly varied output of the eighteenth-century British foundries. Isaiah Thomas says that after the original Cambridge press materials had been added to by types sent out by the Corporation in 1659 for the printing of the Indian Bible, the cases contained the following sizes of roman letter, only three less in number, it will be recognized, than were employed by a well-equipped printer in the London shops of relatively the same period:

The Colonial Printer

Cambridge Press, 1663

Double Pica	Small Pica
Great Primer	Long Primer
English	Brevier
Pica	Nonpareil

In several inventories of American printing equipment drawn up about the year 1770, there are named, all told, fourteen sizes of types.[5] It is important to remember, however, that none of these inventories contained all of the sizes that make up the whole. For the convenience of those to whom the old names are meaningless, the closest modern equivalents, according to the American point system, are given in the following table:

American Presses, circa 1770

Old name	Modern equivalent according to the point system
12 Line Pica ⎱ 8 Line Pica ⎰	⎰ 12 or 8 times the size of a 12 point ⎱ body
French Canon	48 point
Great Primer Canon or Two Line Great Primer	36 point
Double English	28 point
Double Pica	24 point
Great Primer	18 point
English	14 point
Pica	12 point
Small Pica	11 point
Long Primer	10 point
Bourgeois	9 point
Brevier	8 point
Nonpareil	6 point

From these lists we learn that the English printer between the years 1683 and 1770 was benefited by an increase from eleven to seventeen in the number of type sizes available for his use, and that in the same period the American cases showed

Type and Type Founding

an increase of six sizes over the eight which were found in the Cambridge press. Two of these new sizes in the American cases, the twelve and the eight line pica, were simply multiples of the pica size, used for titles and display and found in only one inventory, so that the increase to be taken account of was really of four sizes only—the French canon, two line great primer, double English, and bourgeois. Unquestionably it was poverty rather than lack of occasion for the use of the newer letters that compelled the American printer to content himself with only the essential sizes, dispensing with the paragon, the minion, and the pearl, which were procurable in this later period from the English foundries.

In comparison with this table, it is interesting to turn to an article by Francis Hopkinson in Matthew Carey's *American Museum* for May, 1787, dated July 31, 1786, in which it is suggested that in literary composition the several emotions of joy, earnestness, passion, and agitation be expressed by various sizes and faces of type. In setting this ingenious essay Carey made use of fourteen type sizes, of which twelve were in roman, one in italic, and one in black letter. He did not mention long primer and pica, but as he certainly possessed these, we can think of him as having in his cases at least sixteen available sizes. Of sizes not in use in the earlier list given above, we find him using minion, nonpareil, and pearl, small types of great usefulness in modern times for notes and for matter to be set in compressed style.

Such was the scarcity of type in this pioneer country that even when a printer had in his cases only small and worn fonts of half these size varieties, his type stood for a value in money equal to and often greater than the combined worth of all the other articles of his printing equipment.

The Colonial Printer

The Learned Alphabets

Isaiah Thomas says of the Cambridge press that its cases included a small amount of Greek and Hebrew letter. Hebrew letter, indeed, was used in the Bay Psalm Book of 1640, and at least one word printed in Greek letter is found in a marginal note in Increase Mather's *Wo to Drunkards*, printed by Marmaduke Johnson in Cambridge, 1673. In this same year the Cambridge press of Samuel Green also made use of Greek and Hebrew letters in printing Urian Oakes's *New-England Pleaded with*. Such variety was rare in the colonial printing houses.

In 1728, William Parks transliterated the Greek words on the title-page of Holdsworth's *Muscipula*, and as late as July 2, 1764, Jonas Green transliterated certain Greek words quoted in the *Maryland Gazette*, and in a note said: "Greek. But we have no Greek types." Three years before this time, though, J. Green & J. Russell, printers of Boston, were able to set a poem of several stanzas in Greek type in their *Pietas et Gratulatio Collegii Cantabrigiensis*, an excellently printed work, showing, I believe, the first extensive use of Greek letter by a colonial press. The influence of the university everywhere on the book trade of its period is so well understood that I hesitate to point to such an obvious evidence of it as is found in the circumstances here related. This influence sometimes brings about anomalous situations, as when, according to E. Ph. Goldschmidt in his *Gothic and Renaissance Bookbindings*, the principal fifteenth-century commercial binderies were located in the university towns of Europe rather than as neighbors to the great printing establishments, which normally sought the mercantile centers for their operations. It should be said that the Greek types employed in

Approving Heaven smiles on his arms,

And bids them conquer round the globe :

At their approach the slaves of France,

With trembling joy, welcome the day,

That dawns subjection to a British King.

These fertile fields of Britain's sons,

With blood the Gallic Hydra drench'd ;

Till George, indignant pour'd his wrath :

His vengeance aiming at the heart

Untouch'd till now, and all the monster quell'd.

PLATE XI

ABEL BUELL,
of Killingworth in Connecticut, Ieweller and Lapidary, begs leave to aequaint the Public, and the Printers of the Several Colonies, that he hath difcovered the art, and hath alreday entred upon the Bufinefs of founding Types, which as Soon as he can furnifh himfelf with Stock, will fell for the fame price at which they are purchafed in LONDON; in which Bufinefs he hopes for the Encouragement of the Printers, and all American Patriots.

PLATE XII

Type and Type Founding

the *Pietas et Gratulatio*, a poem addressed by Harvard men of letters to George III on his accession, were not the property of Messrs. Green and Russell, the printers, but of the College, to which these and a font of Hebrew characters had been presented in 1726 by Thomas Hollis, of London, a persistent patron of the institution at Cambridge. This was the first and only use of the Greek front, which was destroyed when the College Library was burned in 1764.[6] (Plate xi.)

Type Founding and Politics

Type making as an industry in the colonies had its rise in that period of the country's fortunes when the taxation policy of the British Ministry forced from the Americans the form of reprisal that defines itself in the term by which it was known; that is, the term "non-importation." To say this does not mean that there existed a direct relationship of cause and effect between the non-importation agreements and the rise of the industry. Abel Buell, who initiated type casting in this country, was experimenting with his punches and moulds for a year or two before the non-importation action of 1769, and the second Christopher Sower, who began to cast German letter from imported matrices in 1770, customarily brought in his types from Germany, rather than from England, when he had need to replenish his fonts. It was a coincidence, perhaps, that the industry began to show its head in this critical time, but there can be little doubt that its subsequent growth was accelerated by the non-importation fervor of the decade preceding the Revolution.

The Colonial Printer

Some General Considerations

The practice of type founding in the western world goes back to the beginning of the typographic art in Mexico in the sixteenth century. In the year 1550, Juan Pablos, the first Mexican printer, contracted with Antonio de Espinosa of Seville, afterwards a printer of Mexico, to enter his shop in the capacity of type founder, and there is every reason to believe that the agreement was carried out as intended. In the records of the Mexican Inquisition for the later years of the century appears evidence that among the printing craftsmen who succeeded Pablos and Espinosa were men skilled in the founding of type, and, furthermore, that the printers possessed and used punches, matrices, moulds, and other tools and materials of type founding. This condition of affairs means that the Mexican printer of the sixteenth century was carrying on the tradition of the typographical establishments of Europe, where at this period type founding had not yet fully achieved identity as a separate industry. But gradually, at different times in different places, the type founder left the employment of the printer to set up a specialized business of his own, with the result that by the beginning of the seventeenth century it was recognized everywhere that a new and distinct industry had arisen. More than two centuries later, type founding returned to the printing house with the invention of the combined casting and composing machine, but throughout the American colonial period printers in all lands, having given over the practice of making their own letters, were entirely dependant upon the foundries for the renewal of their fonts. The nature of things made it impossible that this industry should thrive in any place except in or near great cities where its product would be in demand by

Type and Type Founding

many printers, and neither in Mexico nor in English America could the business be supported by the few and scattered printers of the colonial period. The type founders remained in Europe, and the printers of America of the late seventeenth and the eighteenth century continued to import their letters at the cost of much money, delay, and difficulty. We first hear of a successful avoidance of this necessary procedure when Francisco Xavier de Ocampo, an engraver of the Mint, successfully cast a font of type for a Mexican printer in 1770. The birth of the industry in English America occurred at almost the same moment. It is only as a matter of curious interest, not of significance, that, before taking up the story of type founding in English America, one refers to the fact that from 1705 to 1727 the Jesuit missionaries of Paraguay printed several books with type made of tin and, reputedly, cut and cast by the ingenuity and marvelous imitative skill of the Indians of their missions.[7]

The making by printers of single letters, or the casting of "sorts," to meet the emergencies of the job in hand is not to be regarded here as an aspect of that type-founding industry of which we are seeking the origins. Franklin relates that while putting Keimer's equipment in order at Philadelphia in 1727, or soon thereafter, he made matrices of lead, using old types as punches, and from these, in a mould of his own contrivance, cast successfully in lead such letters and sorts as were missing from the font. The elder Christopher Sower is said to have met the exigencies of his shop in a similar fashion. Not all printers were equally resourceful. As one of his reasons for failing to complete the Mohawk Book of Common Prayer in 1769, Weyman offered somewhat peevishly the excuse that his establishment did not have "the Command of a Letter Makers founding-House to suit our-

selves in ye particular Sorts required such as g's, k's, y's, &c., &c., . . ." When Hugh Gaine took over the printing of this book, however, it went forward without delay, but we do not know whether the needed sorts were cast in his shop or imported from London.[8] At any rate, this emergency casting of letters was an achievement well within the power of a cunning printing-shop craftsman, and as such it was a very different thing from the making of a font of type of sufficient size and quality to be used effectively in the printing of a book or newspaper. The Mexican font of Xavier de Ocampo seems indisputably to have been a complete, locally made font of letter, and in describing the origins of the industry in English America we shall be looking for founders who are cutting and casting fonts of the normal size and degree of completeness. So much is necessary by way of definition.

The Beginnings of a New Craft in the Colonies—Abel Buell

In the year 1768, a young Connecticut silversmith and lapidary, Abel Buell of Killingworth, began of his own interest in mechanical handicraft to make experiments in the cutting and casting of type. With his first letters he set a small advertisement, intended for newspaper publication, in which he announced that he had already entered upon the business of casting printing type. No appearance of this specimen in the columns of a newspaper has been found, but the stick of type containing the advertisement was sent to the Reverend Ezra Stiles of Newport by Buell's friend, Dr. Benjamin Gale of Killingworth. The proof that Dr. Stiles caused to be taken from this little square of type was hailed by Gale as "the

Type and Type Founding

first Proof struck by American types." This precious bit of paper has disappeared, but we have still an almost equally interesting relic of the experiment. As soon as he had taken a proof from these types, Dr. Stiles transmitted them to Dr. Chauncy of Boston, who, "to gratify my own curiosity," as he wrote, in his turn asked Edes & Gill to take some proofs from the new letters. One of these proofs he sent to Dr. Stiles and it remains to this day with his letter dated May 8, 1769, among the Stiles Papers at Yale University. An examination of this first American type specimen (Plate XII) shows its letter to be pica, or twelve point in size, crudely cut and badly lined, but a letter of the first interest in the story of type-founding origins in the United States.

Buell did not stop with this partial achievement. He set to work anew and produced a much more usable letter of the long primer, or ten point size. In October, 1769, he presented to the Connecticut Assembly a petition for aid in the establishment of a foundry, printed in letters from his recently completed font. A copy of this document, printed in black ink, is in the Yale University Library. The original signed copy of Buell's memorable petition, shown here in facsimile, facing page 100 (Plate XIII), is preserved in the Connecticut State Library, "Connecticut Archives, Industry, II, 137." It is in red ink.

The committee appointed to consider Buell's petition reported themselves satisfied that "he hath Discovered the Art of Letter Founding; & that he is capable of makeing Instruments necessary for the proper Apparatus of Letter Founding . . ." It was then recommended that upon giving bond, Buell should receive a loan of £100 from the Public Treasury "Conditioned that . . . he pursue makeing the necessary Apparatus for Letter Founding, for the space of one year . . .

and doth not depart from this Colony to Inhabit elsewhere, within the space of seven years from the date of said Bond. . . . And in case said Buell pursues the business of makeing Materials for the purpose afores^d in a laudable manner for the space of one Year as afores^d that there be then paid out of the Publick Treasury unto s^d Buell one other £100 . . ." With certain modifications the Assembly adopted this report. The first £100 was loaned to Buell, who in the meantime had removed to New Haven, prepared to enter upon the business of type founding.

Unhappily the fates were averse to Buell's success at this time. As I have told elsewhere, financial troubles and a general instability of purpose led him to engage for the next decade in many occupations, but among these type founding was not numbered. It was only in 1781 that he applied himself to the task of supplying Thomas and Samuel Green, of New Haven, and Timothy Green, of New London, with type of his own making, which, though poor enough, was yet more readable than the worn and battered letters that the wartime stringency had compelled most American printers to keep in their cases. There is only circumstantial evidence and the best tradition that this type, recognizable in the publications of several Connecticut printers, was made by Abel Buell. The question will not be argued here, for by the time this use of Buell's letter occurred, type making had become an accomplished fact in other parts of the United States. His type of 1781 has become of interest, therefore, only to those who are interested in its maker. One may claim for Buell, though, that the initiation of type founding as a separate industry in English America must be attributed to him even though he failed of complete achievement in establishing the new manufacture.[9]

TO THE HONORABLE THE GENERAL ASSEMBLY OF THE COLONY OF CONNECTICUT, Convened at New-Haven the Second Thursday of October AD 1769:

The Memorial of ABEL BUELL of Killingworth Humbly sheweth;

That your Memorialist having Experienc'd the Great Goodnefs of this Honorable Affembly, for which he Begs Leave to render his moft Grateful Tribute of thanks, and to Affure them from a Grateful Senfe of their Clemency he has made it his unwearied Study to render himfelf Ufeful to the Community in which he lives and the American Colonies in general, and by his Unwearied application for a number of months paft has Difcover'd the Art of Letter-Founding; And as a Specimen of his abilities Prefents this Memorial Imprefs'd with the Types of his Own manufacture, and whereas by an Antient Law of this Colony, this Affembly were Gracioufly Pleafed to Enact that any one who fhould make any Ufeful Difcoveries fhould Receive an Encouragement there-for from this Honorable Affembly; and as the Manufacture of Types is but in Few hands even in EUROPE, he humbly Conceives it to be a moft Valuable Addition to the American Manufacture, and as the Expence of erecting a Proper Foundery will be Great and beyond the abilities of your Memorialift, he humbly hopes for Encouragement from this Affembly Either by Granting him the Liberty of a Lottery for Raifing a Sum Sufficient to enable him to carry on the fame, or in fome other way as to this Honorable Affembly may feemmeet; and your Memorialift as in duty Bound fhall ever Pray.

Abel Buell

PLATE XIII

Type and Type Founding

It becomes necessary at this point "to labour a distinction," as the old writers would say, between type cast in America from imported matrices and type cast here from matrices for which the punches had been cut by native or resident artisans. I believe that when the Connecticut Committee which recommended the loan to Buell specified that he should occupy himself for a year in "makeing the necessary Apparatus for Letter Founding," they meant that he should cut punches and make matrices for various fonts during this period. They had previously convinced themselves that he was "Capable of makeing Instruments necessary for the proper Apparatus of Letter Founding," and I interpret their words as meaning that Buell had mastered and proposed to practise all the processes of the art. Until someone should have attained this comprehensive mastery, the industry could not be considered as begun. So far as Buell is concerned, it does not seem likely that Gale and Stiles and Chauncy and the Connecticut legislature, all keen advocates of native industries, would have shown such eagerness in forwarding his efforts if he had simply acquired a set of imported moulds and matrices and taught himself the mechanical process of pouring the molten metal and ejecting the finished letter. An examination of his product, furthermore, indicates clearly that the designing and the cutting of the letter was the work of a prentice hand, and although Xavier de Ocampo, who made the type for the Mexican book of 1770, was less of a prentice hand than Buell in these respects, his product, too, indicates a lack of complete mastery in the making of punches and matrices. These two founders, one feels, practised all the processes of type manufacture.

We have seen that Franklin in his youth was capable of casting sorts by a rough and ready method, and we know that

late in life, in the year 1785, with an equipment purchased in France, he set up his grandson Benjamin Franklin Bache as a type founder in Philadelphia. In the intermediate years he seems to have proposed for himself a similar venture. Writing to William Strahan on July 4, 1744, he says, "I am much obliged to you for your care and pains in procuring me the founding tools; though I think, with you, that the workmen have not been at all bashful in making their bills." This reference to what we may suppose was a set of type-founding tools is the only suggestion met with that Franklin intended, at any time in his earlier life, to set up the business of letter casting in America. If he succeeded in his project it must have been in slight degree, for we find him continuing to order type from England for himself and for others. At any rate, based on the possession of foreign-made implements, the effort could not be considered as the beginning of a native American industry in the sense that the phrase is used in this narrative of origins.[10] With this distinction in mind, we are able to pass to the consideration of other attempts at the establishment of a type-founding industry in English America.

David Mitchelson and the Mein & Fleeming Type

A month or so before Buell presented his petition to the Connecticut Assembly there appeared in the *Massachuetts Gazette* for September 7, 1769, the announcement that Mr. Abel Buell of Killingworth had made himself master of the art of founding type for printing. The writer of this article on American industries went on with the information that "Printing types are also made by Mr. Mitchelson of this

Type and Type Founding

Town [Boston], equal to any imported from Great-Britain; and might by proper Encouragement soon be able to furnish all the Printers in America at the same Price they are sold in England." It has been supposed that David Mitchelson, working for the printing firm of Mein & Fleeming, of Boston, cast the anachronistic "modern" face that appeared after 1766 in the publications of this firm, but the more extended the investigation into the claim for Mitchelson as an American type founder, the greater becomes the conviction that its evidence rests solely upon the newspaper paragraph that has been quoted. The so-called specimen sheet shown in Plate xiv is, it seems clear, a printer's advertisement rather than a type founder's specimen. But in entering a counter to the claim made for Mitchelson, one need not be dogmatic. Confirming evidence may yet be found of the truth of that newspaper reference to his activities. The fact that John Mein, of Mein & Fleeming, was engaged in 1769 in type-casting researches of such a nature as to cause alarm to Abel Buell and his alert patrons[11] seems to indicate that the firm with which Mitchelson is said to have been connected was taking advantage of his knowledge of processes to establish at this time a foundry for the casting of type.

Sower and his German Letters

The next venture in type founding in English America that must be taken account of occurred in Germantown, Pennsylvania, about the year 1770. At this time the second Christopher Sower was making plans for the issue of a third American edition of the work that had been notably produced for the first time by his father in 1743; that is, the Bible in the German language and letter. Weary of the

[103]

Boston New-England.

S P E C I M E N

o f

MEIN and FLEEMING's Printing Types.

Rempublicam, Quirites, vi-
tamque omnium veſtrum, bo-
na, fortunas, conjuges, libe-
roſque veſtros, atque hoc do-
micilium clariſſimi imperii,
fortunatiſſimam pulcherrim-
amque urbem hodierno die,
deorum immortalium ſummo
erga vos amore, laboribus,
conciliis, periculis meis, ex
ſ

Rempublicam, Quirites, vitamque omnium veſtrum, bona, fortunas, conjuges, liberof-
que veſtros, atque hoc domicilium clariſſimi
imperii, fortunatiſſimam pulcherrinanque
urbem hodierno die, deorum immortalium
ſummo erga vos amore, laboribus, conciliis,
periculis meis, ex flamma atque ferro, ac
paene ex faucibus fati ereptam, ac vobis con-
ſervatam ac reſtitutam videtis. Et ſi non ni-
nus nobis jucundi atque illuſtres, ſunt ii dies,
quibus conſervamur, quam illi quibus naſci-
mur: quod falutis certa letitia eſt, naſcendi
incerto conditio: et quod ſine ſenſu naſci-
mur, cum voluptate ſervamur : profecto,
quoniam illum, qui hanc urbem condidit,
ad deos immortales benevolentia famaque
fuſtulimus: eſſe apud vos poſteroſque veſtros

que omnium veftrum, bona, fortunas, conjuges, liberofque veftros, atque hoc domicilium clariffimi imperii, fortunatiffimampulcherrimamque ur- bem hodierno die, deorum immorta- lium fummo erga vos amore, labori- bus, conciliis, periculis meis, ex flam- ma atque ferro, ac paene ex faucibus fati ereptam, ac vobis confervatam ac reftitutam videtis. Et fi non mi-

Rempublicam, Quirites, vitamque om- nium veftrum, bona, fortunas, conjuges, liberofque veftros, atque hoc domicilium clariffimi imperii, fortunatiffimam pul- cherrimamque urbem hodierno die, deo- rum innmortalium fummo erga vos, a- more, laboribus conciliis periculis meis, ex flamma atque ferro, ac paene ex fau- cibus fati ereptam, ac vobis conferva- tam ac reftitutam videtis. Et fi non

☞MEIN and FLEEMING execute all forts of **PRINTING WORK** in the beft and moft reafonable manner, and with the utmoft expedition.

PLATE XIV

difficulties of importing type from Germany, he conceived the project of casting in his own establishment enough letter to keep standing the entire work, and to this end he placed a set of imported matrices and moulds in the hands of his journeyman Justus Fox, and laid upon him the responsibility of casting the vast quantity of *fraktur* necessary for his purpose. The first fruit of his intention is found in *Ein Geistliches Magazien*, a religious periodical that was issued more or less regularly by Sower during the years 1764 to 1772. Number 12, Part II, of this magazine, issued late in 1771 or early in 1772, was printed from newly cast type, and it bore a colophon that described the foregoing letter press as "Gedruckt mit der ersten Schrift die jemals in America gegossen worden." The exact date of this publication is of secondary interest in this discussion for the reason that we have here a letter cast from imported matrices, and therefore, according to the distinction that has been insisted upon, not a type of American manufacture. Sower's venture in type founding is nevertheless important in our story because it gave his journeymen, Justus Fox and Jacob Bay, the opportunity and the incentive to learn the more intricate fundamental processes of an art in which they soon went on to proficiency.

The First Work with American Types – Jacob Bay and Justus Fox

In April, 1772, Sower employed Jacob Bay, a newly arrived Swiss silk weaver, to assist Justus Fox in the work of casting type for the great Bible. After two years' service, Bay left Fox and set up for himself as a type founder near by in Germantown. It is recorded by William McCulloch that

Type and Type Founding

hereupon Bay "cast a number of fonts, cutting all the punches, and making all the apparatus pertaining thereto, himself, for Roman Bourgeois, Long Primer, etc." Fox remained in Sower's employ where, in addition to his routine of casting *fraktur* for the great Bible of 1776, he cut and cast a certain amount of roman letter on his own initiative.

The tradition as to these activities preserved for us by William McCulloch seems to stand the test of independent investigation. On January 23, 1775, in one of the non-importation resolutions of the Pennsylvania Convention, it was "Resolved unanimously, that as printing types are now made to a considerable degree of perfection by an ingenious artist in Germantown; it is recommended to the printers, to use such types in preference to any which may be hereafter imported." Even at the time of the passage of this resolution, McCulloch assures us, Fox and Bay each claimed the honor implicit in its terms. If uncertainty existed to this degree contemporaneously with the action, how shall we resolve it today?

This much is certain, though. Native-made type was being manufactured in quantity in Germantown in the year 1775, and on April 7 of that year appeared the first number of *Story & Humphreys's Pennsylvania Mercury*, wherein the publishers addressed their readers in a short article that must be regarded as one of the fundamental documents in the history of American type founding. It is shown on Plate xv in a photographic reproduction from the copy of this newspaper preserved in the Harvard College Library.

A month or so after the publication of this announcement, when Ezra Stiles had occasion to transcribe in his diary a passage from the Story & Humphreys newspaper, he added the following note: "Extracted from the Pennsylva Mer-

cury, whose first No was pub. the 7th of April last: printed with types of American Manufacture. The first Work with Amer. Types: tho' Types were made at N. Haven . . . years ago." For the reason that Dr. Stiles was one of the earliest patrons of Abel Buell's type-founding venture and, as well, a person possessing real perception of the importance of American industries, his observation on the subject of type-founding priority carries a certain amount of weight, though he could not be expected to speak inerrantly on this or on any other matter. If, however, he meant by the comment which has been quoted that the *Pennsylvania Mercury* was the first published work known to him printed in roman letter cut and cast in English America, we can only say that his information was as full on this point as any that we possess in a time of vastly better opportunity for a full survey of the possibilities.

The types that the publishers of the *Mercury* spoke of in their announcement as examples of the "rustic manufactures" of America deserved more than this damnation by faint praise. The important thing was, and this the publishers appreciated, that American-made letters were there to be spoken of at all. Even so, more might have been said of their physical form, for, though far from perfect in detail, they composed agreeably enough in the page, and taken individually, they showed that the tradition of the craft had been understood and carried on by these rural practitioners. One would give something to possess a copy of *The Impenetrable Secret*, that book which was advertised in the *Mercury* for June 23, 1775, as "Just Published and Printed with Types, Paper and Ink, Manufactured in this Province." Here, doubtless, was the first completely American book, and, strangely enough, no copy of it seems to have been preserved.

THE PRINTERS beg leave to acquaint their Subfcribers and the Public, that the TYPES with which THIS Paper is printed are of AMERICAN manufacture, and fhould it by this means fail of giving fuch entire fatisfaction to the judicious and accurate eye, they hope every patriotic allowance will be made in its favour, and that an attempt to introduce fo valuable an art into thefe colonies, will meet with an indulgent countenance from every lover of his country.--------We are fenfible, that in point of elegance, they are fomewhat inferior to thofe imported from England, but we flatter ourfelves that the ruftic manufactures of America will prove more grateful to the patriot eye, than the more finifhed productions of Europe, efpecially when we confider that whilft you tolerate the unpolifhed figure of the firft attempt, the work will be growing to perfection by the experience of the ingenious artift, who has furnifhed us with this fpecimen of his fkill, and we hope the paper will not prove lefs acceptable to our readers, for giving him this encouragement.

We beg leave further to obferve, that as one of the eaftern mails is now difpatched from Bofton, in fuch time as to arrive here on Thurfday (inftead of Saturday as formerly) we have judg'd it expedient to change our day of publication to Friday, by which alteration we expect to have an opportunity of furnifhing the moft early intelligence from that interefting quarter. We truft this will be a fufficient apology for making that only deviation from the affurances given the public in our propofals, nor will any other alteration be admitted unlefs manifeftly tending to the advantage and entertainment of our Subfcribers.----We return thanks to thofe gentlemen in this and the neighbouring provinces, who have kindly countenanced our intentions, and obligingly affifted us by taking in fubfcriptions, &c. for the PENNSYLVANIA MERCURY and UNIVERSAL ADVERTISER, and would beg them ftill to continue fuch their friendly offices, and thofe who have not yet fent us their lifts of fubfcribers names will pleafe to tranfmit them and the Papers fhall be immediately forwarded.

PLATE XV

The ancient Roman lawyers diſtinguiſhed between *poſtulatio*, *delatio*, and *accuſatio*. For, firſt, leave was deſired to bring a charge againſt one, which was called *poſtulare*: then he againſt whom the charge was laid, was brought before the judge: which was called *de-ferre*, or *nominis delatio*: laſtly, the charge was drawn up and preſented, which was called the *accuſatio*. The accuſation properly commenced, according to Pædianus, when the *reus* or party charged, being interrogated, denied he was guilty of the crime, and ſubſcribed his name to the *delatio* made by his opponent.

In the *French* law, none but the Procureur general, or his deputies, can form an accuſation, except for high-treaſon and coining, where accuſation is open to every body. In other crimes, private perſons can only act the part of denouncers, and demand reparation for the offence, with damages.

In *Britain*, by Magna Charta, no man ſhall be impriſoned or condemned on any accuſation, without trial by his peers, or the law; none ſhall be vexed with any accuſation, but according to the law of the land; and no man may be moleſted by petition to the king, &c. unleſs it be by indictment or preſentment of lawful men or by proceſs at common law. Promoters of ſuggeſtions, are to find ſurety to purſue them; and if they do not make them good, ſhall pay damages to the party accuſed, and alſo a fine to the king. No perſon is obliged to anſwer upon oath to a queſtion whereby he may accuſe himſelf of any crime.

ACCUSATIVE; in the Latin grammar, is the fourth caſe of nouns, and ſignifies the relation of the noun on which the action implied in the verb terminates; and hence, in ſuch languages as have caſes, theſe nouns have a particular termination, called *accuſative*: as, *Auguſtus vicit Antonium*, Auguſtus vanquiſhed An-

ariſt could conceal all theſe blemiſhes among the ſtrokes of his work; but when it was to be formed into cups or precious vaſes, they always choſe the acentetum which had no flaws or blemiſhes.

ACEPHALI, or ACEPHALITÆ, a term applied to ſeveral ſects who refuſed to follow either John of Antioch, or St Cyril, in a diſpute that happened in the council of Epheſus, were termed *Acephali*, without a head or leader. Such biſhops, alſo, as were exempt from the juriſdiction and diſcipline of their patriarch, were ſtyled *Acephali*.

ACEPHALI, the levellers in the reign of king Henry I. who acknowledged no head or ſuperior. They were reckoned ſo poor, that they had not a tenement by which they might acknowledge a ſuperior lord.

ACEPHALOUS, or ACEPHALUS, in a general ſenſe; without a head.

The term is more particularly uſed in ſpeaking of certain nations, or people, repreſented by ancient naturaliſts and coſmographers, as well as by ſome modern travellers, as formed without heads; their eyes, mouths, &c. being placed in other parts.

Such are the Blemmyes, a nation of Africa near the head of the Niger, repreſented to be by Pliny and Solinus; *Blemmyes traduntur capita abeſſe, ore et oculis pectore affixis.* Cteſias and Solinus mention others in India near the Ganges, *ſine cervice oculos in humeris habentes.* Mela alſo ſpeaks of people, *quibus capita et vultus in pectore ſunt.* And Suidas, Stephanus Byzantinus, Vopiſcus, and others after them, relate the like. Some modern travellers ſtill pretend to find acephalous people in America.

Several opinions have been framed as to the origin of the fable of the Acephali. The firſt is that of Tho-

PLATE XVI

Type and Type Founding

In the absence of exact knowledge, it seems a futile effort to attempt the attribution of the *Mercury* type to one or another of its probable makers. That is was cast by Bay or by Fox it is reasonably fair to assume, for there remains no trace of any other founder in the neighborhood of Philadelphia in the years from 1772 to 1775. Even though he is said to have been making roman type at this time, Fox must still have been busily employed in casting *fraktur* for Sower's Bible. Bay, on the other hand, was at work as early as 1774 in his own foundry, occupied with his own devices. The letter that was used in the *Mercury* was superior in execution to a letter of the same size and face used six years later in the index of the McKean edition of the *Acts of the Pennsylvania Assembly*, a book for which Fox is said to have made the type. If, therefore, one is inclined to award to Jacob Bay the distinction of having cast the letter for the "first Work with American Types," one must be quick to admit that because of the tenuity of the antecedent reasoning no wreath of laurel ever rested more precariously on victor's head.

What is of especial interest in this matter is that the efforts of these two founders did not cease with the production of a few fonts of type. At the sale of the Sower establishment in 1778 each of them purchased certain of the type-founding tools and materials of his former master, and one learns from McCulloch of various fonts that Fox and Bay produced in the next few years. The most important of the fonts cast by Fox seems to have been that employed in a book previously mentioned, the *Acts of the Pennsylvania Assembly*, printed by Francis Bailey in 1782. One finds the type in which the text of this book is printed to be a sturdy, well-designed, distinctive letter, a creditable enough work from the hand of a self-taught artist. In the year 1794, he found time in the

midst of his ink-making activities to cast some sorts for Matthew Carey, and he continued the business of type founding to some extent until his death in the year 1805, when his equipment was sold to Samuel Sower of Baltimore. Jacob Bay, too, is known to have cut fonts of type for various printers before he sold his materials in 1792 to Francis Bailey, formerly one of the chief patrons of his foundry. It is said that he cast the type used in Bailey's newspaper, *The Freeman's Journal*, and that he cast a font of pica for Dunlap; it is known with certainty that he was selling type to Matthew Carey in 1785. McCulloch tells us many of these details from his own recollection and others from information acquired by him from the lips of close relatives of Fox and Bay. He asserts that in 1814 he himself was using a quantity of Fox's type which he and his father before him had printed from for twenty-six years. When this printer mentioned to Binny that the letters cast by Fox excelled even his in wearing quality, the great founder replied tartly, and with the professional's scorn for the self-taught craftsman, that they were in the beginning so "devilish ugly," the longest use could not mar their deformity.[12]

Other Founders of the Eighteenth Century

We have come now to the conclusion of the story of native American type-founding origins. When Archibald Binny came to America in the year 1795 he brought with him the knowledge and the tools that enabled him to establish the manufacture of type on a basis which soon made it one of the most successful and secure of American industries. Between the appearance in Philadelphia in 1775 of the first usable font of roman letter, and the coming of Binny to that city

twenty years later, there had emigrated to the United States several professional founders whose training served to discipline the work of the native craftsmen and to prepare the way for the greater development that was soon to occur.

The New Era—John Baine and Grandson in Co.

The first and most important of these pre-Binny founders was John Baine, who, as "John Baine and Grandson in Co.," issued a specimen sheet in Edinburgh in 1787, and very soon afterwards, about 1789, transferred the business of the firm to Philadelphia. The elder Baine was by no means an obscure individual. As early as 1742, he had joined with Dr. Alexander Wilson and established a foundry for the purpose, say Bigmore & Wyman, "of improving the art of printing by a new stereotyping process." Their efforts in this direction fell so far short of success that the partners soon turned their attention to the work of casting letters in the ordinary way. The establishments they set up in St. Andrews and Glasgow were the earliest letter foundries of Scotland. The partnership was broken up about 1749, and for some years Baine remained in Ireland where he had previously gone on the business of the firm. Returning to Edinburgh he continued as typefounder part of the time in partnership with his grandson, until his removal thence to Philadelphia between 1787 and 1789. It is said that he was preceded to this country by the grandson, who brought with him a complete type-founding equipment. The coming of the Baines, mature and experienced craftsmen, marked the beginning of a new period in American type founding. The Baines must have worked with intense in-

dustry during the years before the death of the elder in 1790, for they soon established themselves as the leading American type founders. When Thomas Dobson, the Philadelphia printer, began in 1790 the serial publication of the American issue of the third *Encyclopaedia Britannica*, a monumental undertaking of eighteen volumes that took seven years to finish, it was to the Messrs. Baine that he turned for his type, and from them that he secured the excellent letter in which the great book was printed. In the same year that saw the beginning of this publication Matthew Carey brought out the first American edition of the Douay version of the Bible. In his *List of Editions of the Holy Scriptures, printed in America previous to 1860*, page xxviii, O'Callaghan cites an advertisement on the cover of the *American Museum* for December, 1789, in which it was affirmed that the type for Carey's Bible had been especially cast by the Baine foundry, and, corroborative of this, there is found in Carey's accounts a statement from John Baine & Co. for a large font of small pica supplied in the months of November and December, 1789, and January, 1790. It is to be observed that Carey made no purchases from Bay and only a single purchase of a few sorts from Fox after his first dealings with the Baines in 1789.[13]

In the absence of clear evidence, one hesitates to assert that there existed the relationship of cause and effect between Dobson's plans for reprinting the *Encyclopaedia*, or Carey's plans for printing a Douay Bible, and the coming to Philadelphia of John Baine and his grandson. It may, indeed, have been coincidence that brought these competent founders to the city of the United States in which, just at that juncture, the *Encyclopaedia*, the largest American production until then undertaken, was being planned, but it would not be a

Type and Type Founding

matter of great surprise to learn one day that Dobson, its publisher, or Carey, a publisher with several ambitious projects in mind, or both these enterprising men, had sought out the Baines with the assurance of regular and remunerative employment in the event of their removal thither. In any case, their work (Plate xvi) was of a superior quality to anything previously done in the country, and from their coming dates type founding in the United States as a large-scale industry.

Franklin and Benjamin Franklin Bache

It could not be supposed that Franklin's interest in printing type would subside, even though there seems to have been no result in the form of new letters from the founding equipment he purchased from England in 1744. During the stringency of the Revolution, on October 11, 1779, he wrote from Passy to one of his American correspondents, Mrs. Elizabeth Partridge: "I thank you for the Boston Newspapers, tho' I see nothing so clearly in them as that your Printers do indeed want new Letters. They perfectly blind me in endeavouring to read them. If you should ever have any Secrets that you wish to be well kept, get them printed in those Papers. You enquire if Printers Types may be had here? Of all Sorts, very good, cheaper than in England, and of harder Metal. I will see any Orders executed in that way that any of your Friends may think fit to send. They will doubtless send Money with their Orders. Very good Printing Ink is likewise to be had here . . ." A few years after this letter was written, Franklin took a more active step toward improvement of the types used in America when he prevailed upon François Ambroise Didot to take into the celebrated Didot foundry his grandson Benjamin Franklin Bache, who

already possessed some knowledge of type casting from an earlier association with one of the Fourniers. In April, 1785, young Bache cut his first punch, and only a few months later, with a foundry purchased from Fournier of Paris, he and his grandfather returned to Philadelphia. The Bache foundry, as it came to be called, seems to have been conducted by Franklin himself until the grandson, as the old gentleman wrote, should take his degree and get clear of the college, but about the year 1787, the hopeful youth entered on his own behalf upon the career of printer and type founder. About the year 1790 he issued a specimen sheet in which were shown some of the types cast by him from his French matrices, but despite his exceptional advantages, Bache failed to attain success as a type founder. McCulloch tells us that he "soon relinquished that business for printing." With Baine and Bache added to the ranks of the native founders, however, the American type-casting industry had reached a respectable position at the beginning of the last decade of the eighteenth century.[14]

Adam Mappa of New York

Hitherto the making of type in America had centered about Philadelphia, but, in 1789, Adam Mappa,[15] a Dutch founder, brought with him to New York, where he set up in business, an elaborate equipment upon which tradition has placed a valuation of £3500. For a few years he met with success. There appears the following interesting reference to the venture of the first New York type founder in the introduction to Thomas Greenleaf's edition of the *Laws of the State of New York*, published in 1792:

"The Types and Paper were manufactured in this State—

Type and Type Founding

anxious to give public Satisfaction, and fearing, after the Publication of his Proposals, that the Types therein proposed to print this Work upon would not hold out good to the End, the Editor engaged Mr. Mappa, of this City, an ingenious Type-Founder from Holland, to cast a new Fount for it, which unavoidably delayed the Publication for near two Months. However disagreeable this Delay may have been to the Subscribers (as well as to the Editor, who suffers most by it) it is to be presumed, that the Consideration of giving Encouragement to the Manufactures of our State, will more than compensate. The Types are not so perfectly Regular as those from the London Foundries, which have been improving for Centuries—but, no Cash went to London for them—and our infant Manufactures ought to be encouraged, that they also may improve."

As would be expected, Mappa's letters, certainly the fonts shown in the Greenleaf *Laws*, are Dutch in style. (Plate XVII.) They are not impressive in design and one is led to compare them unfavorably with the letters of Baine and with Mappa's earlier work in Delft, shown in his specimen sheet of 1785, now preserved in the Typographical Library and Museum of the American Typefounders Company. In February, 1794, he advertised his plant for sale. Thereafter he engaged in other business, and his punches and matrices were eventually bought by Binny & Ronaldson.

The type-founding industry of the United States, through native and foreign genius, had reached the stage of development that has been indicated in the foregoing relation when Archibald Binny came to Philadelphia in 1795. Its development from that time to the present is a story that falls to others to relate. Happily it is the history of an industry in the product of which there has prevailed, along with the

qualities that make for commercial success, a genuine desire for beauty and for purity of design and honesty of workmanship. (Plates xviii and xix.)

recovered by the overſeers aforeſaid, in their names, before any juſtice of the peace of the county of Albany, and when ſo recovered ſhall be retained by the ſaid overſeers, to be applied to the ſpecial purpoſe of conſtructing bridges in the ſaid Colonie, and after ſuch bridges ſhall be completed, to improving and amending the ſaid ſtreet or highways, in ſuch manner as the ſaid over-ſeers ſhall, from time to time, deem proper.

C H A P. LIV.

An ACT to promote Literature.

Paſſed 29th April, 1786.

WHEREAS it is agreeable to the principles of natural equity and juſtice, that every author ſhould be ſecured in receiving the profits that may ariſe from the ſale of his or her works; and ſuch ſecurity may encourage perſons of learning and genius to publiſh their writings, which may do honour to their country and ſervice to mankind.

I. *Be it enacted by the people of the ſtate of New-York, repreſented in ſenate and aſſembly, and it is hereby enacted by the authority of the ſame,* That the author of any book or pamphlet, being an inhabitant or reſident in theſe United States, and his or her heirs and aſſigns, ſhall have the ſole liberty of printing, publiſhing and vending the ſame, for the term of fourteen years, to commence from the day of its firſt publication in this ſtate; and if any perſon or perſons within the ſaid term of fourteen years as aforeſaid, ſhall preſume to print or re-print any ſuch book or pamphlet within this ſtate, or to import or introduce into this ſtate for ſale, any copies of ſuch book or pamphlet, re-printed beyond the limits of this ſtate, or ſhall knowingly publiſh, vend, utter or diſtribute the ſame, without the conſent of the proprietor thereof in writing, ſigned in the preſence of two credible witneſſes; every ſuch perſon or perſons ſhall forfeit and pay to the proprietor of ſuch book or pamphlet, double the value of all the copies of ſuch book or pamphlet ſo re-printed, imported, diſtributed, vended or expoſed for ſale, to be recovered by ſuch proprietor in any court of law in this ſtate, proper to try the ſame.

Authors of books and pamphlets to have the ſole right of printing and publiſhing them, for 14 years.

Provided neverthelefs, That no author, aſſignee or proprietor of any ſuch book or pamphlet, ſhall be entitled to take the benefit of this act, until he or ſhe ſhall duly regiſter his or her name, as author, aſſignee or proprietor, with the title of ſuch book or pamphlet, in the office of the ſecretary of this ſtate, who is hereby empowered and directed to enter the ſame on record.

Author's name and title of the book to be regiſtered.

II. *And be it further enacted by the authority aforeſaid,* That at the expiration of the ſaid term of fourteen years, in the caſes above-mentioned, the ſole right of printing and diſpoſing of any ſuch book or pamphlet in this ſtate, ſhall return to the author thereof, if then living, and his or her heirs and aſſigns, for the term of fourteen years more, to commence at the end of the ſaid firſt term; and that all and every perſon or perſons who ſhall re-print, import, vend, utter or diſtribute in this ſtate any copies thereof, without the conſent of ſuch proprietor obtained as aforeſaid, during the ſaid ſecond term of fourteen years, ſhall be liable to the ſame penalties, recoverable in the ſame manner as is herein before enacted and provided.

Author, if living at the expiration of the 14 years, entitled to the ſame privilege other 14 years.

III. And whereas it is equally neceſſary for the encouragement of learning, that the inhabitants of this ſtate be furniſhed with uſeful book at reaſon-

PLATE XVII

Quousque tandem abutere, Catilina, patientia nostra? quamdiu nos etiam furor iste tuus eludet? quem ad finem sese effrenata jactabit audacia? nihilne te nocturnum præsidium palatii, nihil urbis vigiliæ, nihil timor populi, nihil consensus bonorum omnium, nihil hic munitissimus habendi senatus locus, nihil horum ora vultusque moverunt? patere tua consilia non sentis? constrictam jam omnium horum conscientia teneri conjurationem tuam non vides? quid proxima, quid superiore
ABCDEFGHIJKLMNOPQRSTUVWXY
1234567890

Quousque tandem abutere, Catilina, patientia nostra? quamdiu nos etiam furor iste tuus eludet? quem ad finem sese effrenata jactabit audacia? nihilne te nocturnum præsidium palatii, nihil urbis vigiliæ, nihil timor populi, nihil consensus bonorum omnium, nihil hic munitissimus habendi senatus locus, nihil horum ora vultusque moverunt? patere tua consilia non sentis? constrictam jam omnium horum conscientia teneri conjurationem tuam non vides? quid proxima, quid superiore nocte egeris, ubi fueris, quos convocaveris, quid consilii ceperis, quem nos-
ABCDEFGHIKLMNOPQRSTUVWXYZ

PLATE XVIII

Quousque tandem abutere, Catilina, patientia nostra? quamdiu nos etiam furor iste tuus eludet? quem ad finem sese effrenata jactabit audacia? nihilne te nocturnum præsidium palatii, nihil urbis vigiliæ, nihil timor populi, nihil consensus bonorum omnium, nihil hic munitissimus habenbi senatus locus, nihil horum ora vultusque

ABCDEFGHIJKLMNOPRSTUWXYZ

1234567890

ENGLISH ITALIC.

Quousque tandem abutere, Catilina, patientia nostra? quamdiu nos etiam furor iste tuus eludet? quem ad finem sese effrenata jactabit audacia? nihilne te nocturnum præsidium palatii, nihil urbis vigiliæ, nihil timor populi, nihil consensus bonorum omnium, nihil hic munitissimus habendi senatus locus, nihil horum ora vultusque moverunt? patere tua consilia non sentis?

ABCDEFGHIJKLMNOPRSTUVWXYZ

Plate XIX

VI

Printing Ink

IN the year 1747, Benjamin Franklin received a letter from Jonas Green in which the Annapolis printer wrote that he required "some varnish (a bottle by the post) and 4 or 5 Pound of Lampblack." In these words is found an order for the ingredients of printing ink; that is for varnish, or linseed oil boiled with rosin, and for lampblack, the impalpable soot derived from the smoke of carbonaceous substances. It was not a particularly small order, either, for lampblack is a bulky stuff, and in this letter to his friend, supporter, and agent, Green was asking for about a third of a barrel of the pigment needed in mixing the ink to be used in his shop.[1]

Local Manufacture of the Ingredients

The question as to the habitual character of the practice suggested by Green's words now presents itself for examination. It is doubtless true in large measure, as Isaiah Thomas writes, that the ink used by the colonial printer was chiefly imported, ready-made, from England, but there is evidence in plenty that this custom was not invariable in all places and at all times. Thomas records an exception to his statement in the practice of Rogers & Fowle of Boston, who almost alone in that historian's knowledge of the mid-eighteenth-century printers, were capable of making good printing ink. It is known, too, that Franklin counted the mixing of ink among the innumerable duties he was required to perform as the factotum of Keimer's Philadelphia shop in 1723. It is not safe to affirm too emphatically that the ingredients he em-

ployed in the operation were of native manufacture, but it seems possible to support an assumption to this effect by satisfactory evidence. At any rate, it was only ten years later that Franklin, now a man of affairs and acting on his own account, purchased from one Nathaniel Jenkins, for the sum of thirty-five pounds, an already existing "lampblack house." In 1756, Anthony Armbruester, then in partnership with Franklin, rented this lampblack house, or another, for the period of a year. Isaiah Thomas mentions the making of lampblack and printing ink among the sixteen trades (more generous writers put the number at thirty), engaged in by Christopher Sower, the Elder, of Germantown, and continued in these particulars by the second Christopher Sower, printer and type founder of the second generation. We can be reasonably sure of the correctness of this information as far as it relates to the younger Sower, for among the effects of his forfeited estate, sold in 1778, the appraisers found an engine and other articles "in the Lam black house." This early and presumably continuous connection of the Pennsylvania printers with lampblack houses can mean only that they were making, for themselves and probably for others, one at least of the essential ingredients used in their trade. It is certain that in 1747, when Franklin received Jonas Green's order for lampblack, he was selling this commodity to numerous printers throughout the colonies, and that along with his trade in the pigment went an equally active business in the sale of the essential varnish.[2]

The other ingredient of printing ink, the varnish with which the lampblack is mixed, is simply "flaxseed," or, more familiarly, "linseed" oil boiled with rosin to a state of viscidity. There is evidence of the culture of flax for the purpose of making linen in the very early days of the New England

Printing Ink

and Virginia colonies. In 1640 the Massachusetts and Connecticut legislative bodies had reached the point of encouraging its growth by enactment. In 1662 the Virginia Assembly encouraged by bounties the making of linen from domestic flax, and in a later year made it mandatory. At one time or another most of the colonies with agricultural and industrial interests made special efforts to introduce this useful plant and to improve the quality of the linen manufactured from its fibrous stalk. Because of its German and Irish agriculturalists, Pennsylvania was particularly successful in its efforts to these ends; linen was being made at Germantown in 1692, and in 1729 this colony exported to Ireland and Scotland nearly 1800 bushels of flaxseed. Doubtless here and elsewhere, the expressing of the useful linseed oil was undertaken as a matter of course as soon as flaxseed began to be obtainable in quantity. Certainly oil mills were erected at an early period. In *Some Letters and an Abstract of Letters from Pennsylvania*, London, 1691, C. Pickering wrote home from the province, "An Oil-Mill is erecting to make Coal and Rape-Seed-Oyle, &c." About the year 1742 an oil mill was built in the Ephrata Cloister, and when a fire visited the industrial section of that institution in 1747, it destroyed, among other buildings, "a skillfully built oil-mill, with stones the like of which none before existed in America, besides a large store of oil, and above 500 bushels of flaxseed." One may reasonably infer from these words that other mills with cruder stones had existed before this exceptionally fine establishment was erected at Ephrata.[3]

With Franklin and Armbruester and the Sowers making lampblack, and the Bruderschaft and, by inference, others, making linseed oil, the ingredients of printing ink, locally manufactured, were procurable in Pennsylvania from a rel-

atively early time in the eighteenth century. While Isaiah Thomas's statement may be taken as correct so far as it related to New England, for he is seldom caught out on facts that came within the scope of his personal observation, it is certain that the need of importing ready-mixed ink did not rest so heavily upon the printers of the middle colonies as upon those of other sections.

The Process of Making Varnish

It is not cause for wonder that the printer should want to purchase his ink ready mixed at as early a period as he could with convenience; for the making of it, as Moxon wrote, was "as well laborious to the Body, as noysom and ungrateful to the Sence, and by several odd accidents dangerous of Firing the Place it is made in." The English printers on this account generally bought the commercial product, and if their work turned out to be poor in impression, satisfied their consciences by blaming the ink maker. In telling how the ink should be made in order to ensure the best results, Moxon turns as usual to the practice of the Dutch, whose printing and equipment were invariably the models of excellence held up by this schoolmaster of English printing. We may think of some of our colonial printers as following Moxon's directions, which are given here in sense though not at length.

The ink maker is to procure old linseed oil with a little rosin in it, even though it is cheaper to use train oil with a great deal of rosin, a combination that "by its grossness, Furs and Choaks up a Form, and by its fatness hinders the Inck from drying; so that when the Work comes to the Binders, it sets off," and furthermore the superfluity of rosin causes the ink to turn yellow. He is not to spare labor and fuel in boil-

ing it to a proper consistency, nor effort in clearing it. Putting the pigment into the varnish while it is boiling hot tarnishes the "brisk and vivid black complexion" of the ink, so that the lampblack must be added after the mass has cooled, or preferably rubbed in on the ink block at the time of use; and of course the printer must not stint himself in the amount of lampblack used if he wants a good sharp impression from his letter.[4]

The ink maker found it necessary to exercise great care to prevent setting fire to his oil during the boiling over an open oven. It is said that Christopher Sower used to boil his oil in a meadow in order to keep the evil odor away from the houses of the community, but the danger of burning down his whole establishment was of course the important consideration that led him to seek the open for this process. During the boiling it was necessary to skim the mass frequently and to put the rosin in slowly, a ladleful at a time, and when the mixture was thick enough to pull stiffly, the varnish might be considered as made. Litharge was put in from time to time to clarify the mixture and, when cool enough, the whole was strained through linen cloths. With the necessity of this laborious process before him, only the most conscientious or economical printer could remain indifferent to the opportunity of purchasing his ink ready mixed, or at least, as we have seen Jonas Green doing, of purchasing the necessary varnish and lampblack for mixing on the block at the time of use.

Ink Making as an Industry

The alternative to purchasing ink from abroad, ready mixed, or to mixing the locally made varnish and lampblack lay in buying the ready-mixed product from an American

manufacturer. It is not with the intention of claiming priority for Justus Fox of Germantown that I point to his regular conduct of this business. It is probable, indeed, that Franklin and the Sowers were selling ink to printers at an early period in the history of their establishments, and actually the Franklin *Account Books* show an occasional sale of printing ink in keg or cannister by the Philadelphia printer. Franklin's chief interest, however, was in supplying the materials of printing ink rather than the finished product, and it is only in 1792, when Justus Fox, the versatile printer, engraver, type founder, and ink maker of Germantown, began to sell ink by the keg to Matthew Carey that we recognize for the first time in the United States the specialist manufacturer of printing ink. Throughout the closing decade of the century, Fox was regularly engaged in making summer and winter ink and in selling it in keg and pot to Matthew Carey and to other printers of the middle colonies.[5]

Rubbing Ink in the Shop

The process of mixing ink, or of "rubbing" the black into the varnish, was a commonplace of printing-house practice. The specialist ink manufacturer was early established in England, but Moxon, writing in 1683, intimated that better results were to be obtained by the neglect of his product in favor of the practice of mixing the ink on the block as it was needed for the day's work. In a country where the printer could depend upon a regular and uniform supply of the manufactured ink, this was doubtless a counsel of perfection, but in colonial America, where importation was subject to the divine will and to innumerable permutations of human factors, Moxon's advice, perforce, was frequently followed,

Printing Ink

especially by printers working at a distance from the larger towns. It is likely that many printers, as a matter of course, but from necessity rather than from choice, kept a supply of lampblack and varnish on hand for emergencies or for special needs. The firm of Franklin & Hall spent a good round sum for English-made ink in the eighteen years of its existence, but in the same period the books show a consumption of some ten barrels of lampblack, purchased at the rate of 5 shillings a pound.[6] Aside from the emergency value of the practice, a printer might prefer to mix his own ink for such excellent reasons as the superiority of product thus obtained, as a means of occupying the spare time of apprentices, or as one of the many cash economies it behooved him to practise.

Certainly the printers of the middle and southern colonies who looked to Franklin as their agent of supply, and some in New England as well, were of the same mind as Jonas Green in this matter of the purchase of locally made lampblack and varnish rather than of ready-mixed imported ink. The gallon of varnish at 10 shillings sent by Franklin to Thomas Whitemarsh in Charleston, South Carolina, in 1732, the pound of lampblack at 5 shillings sent to Thomas Fleet of Boston ten years later, and the larger measures of these commodities supplied by him to James Franklin of Newport, Jonas Green of Annapolis, James Parker of New York, and other printers of the colonies are evidence that the practice by the American printer of mixing his own ink was habitual in character in this period of his activity.

VII
The Paper of the Colonies

IF Jonas Green, as it seems from the letter quoted in the
preceding chapter, was dependent upon the manufactur-
ers of Pennsylvania for the ingredients of printing ink,
he and the printers of the middle colonies, generally, relied
upon the mills of that province for much of the paper used
in their business.[1] In that same informative letter from Green
to Franklin occurs a sentence that may be taken as expressing
a general condition of the time and section. "I wish," wrote
the Maryland printer, "I could get another Parcel of Paper
from Philadelphia;—Mr. Daniel Rawlings is gone up the
Bay in a schooner,—and would bring some Paper for me. . . .
If you could send me such a parcel as before I'll get you a
large Bill of 40 or 45£ Sterling.—My paper sinks fast; we
now use 3 or 4 Reams a week. I have about 450 or 460 good
Customers for Seal'd Papers and about 80 unseal'd."[2] From
the juxtaposition of the last sentence to those that contained
the request for paper, we may assume that its writer was ask-
ing for lightweight newspaper stock; his finer book papers,
it is known, were customarily imported from England or
Holland, or to speak more exactly, from Holland through
England.

It must be understood that the paper made in colonial
America, especially in the early days, was not the finest in
quality. The word "handmade" has a connotation in these
days that dazzles the intelligence even of persons ordinarily
unimpressed by shibboleths. The American paper of the sev-
enteenth and early eighteenth centuries, handmade, of course,
from rags, was an honest paper, tough and durable in gen-
eral, but as variable in quality as one would expect from in-

The Paper of the Colonies

different materials handled by provincial workmen in rude manufactories. It is idle to think of the bulk of it as more than this. Like most things "early American" in origin, it was that or nothing for its users; the printer who could have imported European paper at a reasonable cost would have been no more content with the local product than the man of taste of the period with furniture from the village carpenter if Chippendale and Sheraton had been within his means. The American-made paper served well enough for newspaper and pamphlet work, but when the printer had before him an important job of book printing, he began it by ordering through his London agent a supply of European paper, preferably paper of Dutch manufacture. As in all generalizations, one need not look far for exceptions to these statements, but it remains true that even the best early American papers possessed little of the quality to be found in the firm texture and the rich, creamy aspect of the Dutch product, or of the product of Whatman and of other English makers of the late eighteenth century.

The Mode of Manufacture

The method of paper manufacture pursued throughout the seventeenth and eighteenth centuries in the colonies differed hardly at all from the processes which had been the rule since the earliest days of the craft in Europe. The ideal constituents for the finer papers were clean white linen rag and plenty of clear, flowing water devoid of strong mineral content. In the earlier days the rags were thrown into the water-filled trough of a stamping machine and slowly beaten until the mass became a thin fibrous pulp. This substance was conveyed to a vat where stood the paper maker with his mould,

the simplest and most primitive of implements, a rectangular
frame with a bottom formed by fine wires, closely set, run-
ning the length of the frame and crossed by coarser wires,
widely set, running its width. It was the skill of the paper
maker which counted more than the complexity of tools and
materials. To take up the pulp with the mould in the right
quantity, to drain it evenly by calculated movements, to dis-
charge the thin, saturated layer of pulp upon a felt pad at
exactly the right moment were processes which demanded
something more than mere manual dexterity. Other hands
took the pile of new sheets, each between its felts, and placed
them beneath a press which squeezed the water from them,
and still others hung the sheets upon hair ropes for drying in
a loft or other airy space. This is of course the briefest out-
line of a manufacture that involved innumerable processes
in which skill and knowledge were required for the desired
results. We can think of it as being followed by William Rit-
tenhouse in that first mill near Germantown, and with only
one change by all the later colonial paper makers. Sometime
about the year 1690 the Dutch devised a machine for pulp-
ing the rags which has been known ever since as a Hollander.
Dard Hunter's books show pictures of this invention through
which the rags were reduced to fibre by means of a process of
cutting and tearing instead of the slow stamping method of
the earlier time. Just when the Hollander was first intro-
duced into the American mills seems a matter of uncertainty,
but in all probability it was part of the equipment of those
Pennsylvania establishments of the first half of the eight-
eenth century of which something is to be said later in this
chapter. The Fourdrinier machine, chemical bleaching, paper
from wood pulp and other vegetable substances are all de-
velopments of the nineteenth century, though it should be

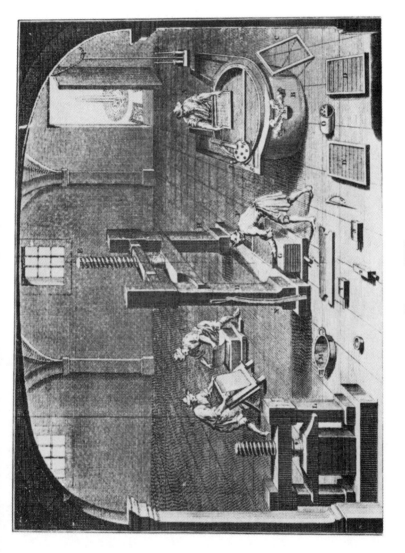

PLATE XX

said that experimentation in all these methods and machines was begun in the period of our interest. (Plate xx.)

Laid and Wove Paper

During the greater part of the eighteenth century the paper made in America was of the variety known as "laid" in distinction to the "wove" paper that came into use late in the period. Held to the light, a sheet of laid paper shows innumerable fine lines running the length of the sheet, crossed at intervals of about an inch by the coarser lines sometimes described as "chain" lines. These are the marks formed by the bottom of the mould, in which the fine wires that run from end to end are held rigid by coarse wires that cross the mould from side to side. It was not until 1757 that Baskerville used, in the *Virgil* of that year, his newly invented "wove" paper. The bottom of the mould in which the sheets of this product were formed was a sort of wire cloth, composed of fine brass wires closely woven together as on a loom instead of being laid in right lines from end to end and across the frame. The new way of forming the bottom of the mould did away with all straight wires in either direction and with the inequalities produced by the crossings of straight wires. The consequence was that the paper made from such a mould lacked the wire lines and chain lines just spoken of as characterizing the laid papers when held to the light. It was, to a marked degree, paper of a smoother surface and a closer integration of texture than was found in the laid paper of customary use.

Wove paper was regularly in use in England soon after its invention, and in 1777 Franklin exhibited specimens of it in France. A few years later, in 1782, its successful manufac-

ture began in that country too, where, as *papier vélin*, it quickly became popular with the printers of fine books. Its manufacture in America, always conservative, seems to have been deferred almost to the close of the century. I have not seen an earlier reference to a native-made wove paper than the sentence which occurs in the note appended to the *Elegiac Sonnets and other Poems* of Charlotte Smith, printed by Isaiah Thomas in Worcester, in 1795. Of the excellent wove paper used in that book, Thomas wrote: "The making of the particular kind of paper on which these sonnets are printed, is a new business in America; and but lately introduced into Great Britain; it is the first manufactured by the editor." The development everywhere in the last decade of the century of the type face known as "modern," with its hair-line serifs and its contrast of thick and excessively thin strokes, had a great deal to do with the increase in the use of wove paper by the printers. Not only did the impression from the thin lines of the letter take better on the smooth surface of the new paper, but through its employment the wear and tear upon the fragile type was less than when the relatively rough-surfaced laid paper was used for the work.

The Beginnings in Pennsylvania

In one of the numerous Pennsylvania colonization tracts, *Some Letters and an Abstract of Letters from Pennsylvania*, London, 1691, various accounts of material progress in the new Friends' colony were brought together and published for the encouragement of intending settlers. Among the abstracts quoted for this purpose was the following sentence from a letter that William Bradford, the printer, wrote in 1690 to a friend in London: "Samuel Carpenter and I are Building a

The Paper of the Colonies

Paper-Mill about a Mile from thy Mills at Skulkill, and hope we shall have Paper within less then four months." In these words seems to be the first announcement in print of the beginnings of the paper-making industry in the United States. Another associate in the enterprise with Bradford and Carpenter was William Rittenhouse, who, a paper maker by trade, was put in charge of the mill which the partners built in 1690 near Germantown on a tributary of Wissahickon Creek, known in later years as Paper-Mill Run. The local rhymesters gave notice to the world of this addition to the advantages which their community offered intending settlers.[3] In Richard Frame's *Short Description of Pennsilvania*, printed in Philadelphia in 1692, the author speaks of Germantown,

> Where lives High-German People, and Low-Dutch,
> Whose Trade in weaving Linnin Cloth is much,
>
>
>
> One Trade brings in imployment for another,
> So that we may suppose each Trade a Brother;
> From Linnin Rags good Paper doth derive,
> The first Trade keeps the second Trade alive:
> Without the first the second cannot be,
> Therefore since these two can so well agree,
> Convenience doth approve to place them nigh,
> One in the German-Town, t'other hard by.

In a poem written four years later that remained in manuscript until 1847, John Holme's *True Relation of the Flourishing State of Pennsylvania*, another rhymester gives pertinent information of the Rittenhouse mill in that part of his description of Philadelphia which deals with the activities of William Bradford:

The Colonial Printer

Here dwelt a printer and I find
That he can both print books and bind;
He wants not paper, ink, nor skill
He's owner of a paper mill.
The paper mill is here hard by
And makes good paper frequently,
But the printer, as I here tell,
Is gone unto New York to dwell.
No doubt but he will lay up bags
If he can get good store of rags.
Kind friend, when thy old shift is rent
Let it to th' paper mill be sent.

Two years later Gabriel Thomas wrote in his *Historical and Geographical Account of the Province and Country of Pensilvania,* London, 1698, that "All sorts of very good Paper are made in the German-Town; as also very fine German Linen, such as no Person of Quality need be asham'd to wear." The Pennsylvania promoters were not allowing this particular light to be hid under a bushel.

As the local poetasters recorded, it was because of the needs and the initiative of William Bradford, then printing in Philadelphia, that the industry of paper making was begun at this time near Germantown. Bradford controlled a quarter share in the Rittenhouse mill from its beginning until the year 1704, even though at the end of this period he had been living and working in New York for eleven years. In 1697 he made an agreement with his partners in the mill whereby he was to receive his share of the profits in kind. In lieu of money he agreed to accept annually, for the ensuing ten years, paper amounting in value to £6. 2s., and during the same period to have the refusal of all printing paper produced by the mill at the price of 10 shillings a ream, and of a

The Paper of the Colonies

specified amount of writing paper at 20 shillings a ream. It is believed that in spite of the circumstances of his removal to New York, Bradford continued to control the Philadelphia press that operated for several years after 1699 in the name Reinier Jansen, so that this agreement with the mill worked no hardship on the printer who succeeded him in that city. It must be that Bradford's continued patronage of the Germantown mill was the origin of that trade in paper with Pennsylvania which Hugh Gaine, nearly a century later, complained of as taking annually many hundreds of pounds of ready money from New York to "a neighboring province."

The Germantown mill, with at least one steady customer for printing paper in the person of Bradford, continued to flourish for many years. Dard Hunter records the several watermarks used by William Rittenhouse and his descendants and successors in the business.[4] One of his sons-in-law, William De Wees, established near by in Germantown the second American paper mill, and when, in 1729, Thomas Willcox set up a mill in Delaware County about twenty miles from Philadelphia, the industry of paper making could be regarded as well established in America and the papermaking primacy of Pennsylvania begun. This state alone claimed forty-eight of the eighty or ninety mills in operation in the United States in 1787, and boasted an annual production two years later of 7000 reams of paper.[5]

New Jersey

Bradford's need for paper in the later years of his career as a New York printer was not satisfied by the supplies he continued to obtain from the Rittenhouse and De Wees mills. In 1724, he petitioned the New York Assembly for the sole priv-

ilege of making paper in that colony, but averse to the encouragement of local manufactures, the Governor and Council refused to admit to a third reading the bill for the establishment of Bradford's mill that had already passed the Lower House. Bradford was forced to turn his attention elsewhere. Some years later an advertisement in the *American Weekly Mercury* for July 10, 1729, calls for the return of an indentured servant who has run away from "William Bradford's Paper-Mill at Elizabeth-Town in New-Jersey." When or by whom this mill was begun is not known, but Bradford is supposed to have bought it in 1728. Knowing his need and his initiative and his close relationship with the neighboring colony, one feels justified in suggesting that his was the instigating force that set the first New Jersey mill in motion. It is difficult otherwise to account for the establishment of a mill in a colony in which there was no resident printer, and at a place so close to New York and so far from Philadelphia as Elizabeth, New Jersey. This mill was still in existence in 1735, but the extent of its activities is uncertain.

New York

Though there exists a reference to a paper mill "begun to be erected" near New York, in a letter from the Governor to the Lords of Trade, dated May 7, 1768, the history of paper making in that colony begins, in fact, some five years later. At that time Hugh Gaine was feeling the necessity of buying paper from Pennsylvania to be so irksome that, in 1773, he determined to form a company for the manufacture of a commodity essential to his business. A mill was built at Hempstead on Long Island, and Gaine began the publication of a series of appeals for rags. He made local interest

one of the grounds for the support of a manufacture that he described as "very lately originated here." The people of the Province of New York, he writes a few months later, "consume many Hundred Reams of Paper annually, that for 40 Years past were imported from a neighboring Province, to the very great Detriment of *this*, as the Cash transmitted from hence on that Account never returned again, the Balance of Trade being so very great against us." In 1774 he was offering threepence a pound for "Good, dry, clean linen Rags," and in 1782, in the stringent days of the Revolution, he raised his offer to fourpence a pound, adding, sensibly enough, "as there are a great Quantity of this Article about the back Parts of the Town the Poor may be well employed in gathering of them."

Whatever may have been the ultimate influence of Gaine's paper mill on the importation of paper, it is certain that some years elapsed before the practice of bringing in paper from Pennsylvania was discontinued by the New York printers. When, in 1774, Rivington was printing Bernard Romans's great charts of the Florida waters on thirteen sheets, each measuring 22 x 28 inches, it was announced that the paper for this extraordinary production had been made to order in Pennsylvania. In September, 1777, Samuel Loudon sent a letter from Fishkill, whither he had fled to escape the British occupation of New York, to a correspondent in Norwich, Connecticut, requesting that he be supplied with a few hogsheads of rum and with fifty reams of paper. The desire for this astonishing quantity of rum seems to have arisen from the speculative habit of the former ship chandler rather than from his personal needs, but the paper was another matter: he assured his friend that unless he received a good supply of paper, he would be compelled to close his printing office, and

continued with an explanation of the circumstance that had forced him into these straits. "The Writing Paper," he wrote, "is dear, but I must get some, and Phila. where I had my supply from, for some time past, is not in a state to help me, as all the Inhabitants are employ'd against their *Enemy*, who is at their door." In a letter to a New Haven correspondent a month or more later, a document of importance to the historian of American paper manufacturing, Loudon continued to ask for paper for his active press. "Mr. Holt," he wrote, "has great plenty of Paper left of several parcels he had from Phila.—I was disappointed of near 100 Reams which was purchased for me in Philadelphia, a little before Howe got possession of that City, which indeed has proved a very great loss to me." Further on in this letter, he asserts again that unless he can be supplied with paper by the New England mills, he must stop his press, as he "can't expect any from Phila. this winter." Five years later, when New York was still suffering from a paper shortage, Loudon and Robert Boyd received permission from the Assembly to raise by lottery the sum of £500 for the erection of a paper mill, but it is not recorded that the project thus fostered was afterwards executed.[6]

Maryland

There is no doubt that during a large part of the colonial period the Pennsylvania mills supplied the middle colonies with their ordinary printing paper, and indeed with the paper for some very important books as well. Sower's great German Bible, issued in 1743, was printed in part, it is often said, on paper made in the mill conducted by the Seventh Day Baptist brotherhood at Ephrata, established probably about 1740; and the Mennonite Martyr Book of 1748, containing 756

The Paper of the Colonies

leaves folio, was printed in the Ephrata monastery on paper
made in the mill of the Bruderschaft.[7] It was late in the cen-
tury that the Maryland printers found themselves independ-
ent of the Pennsylvania mills. In 1771, John Dunlap, printer
of Philadelphia, advertised in the *Maryland Gazette* for
September 5 and November 21 that he had for sale "Penn-
sylvania Printing Paper of all sorts . . . on the most rea-
sonable terms." Five years later, in 1776, the Maryland
Convention advanced 400 pounds currency to James Dor-
sett for the establishment of a paper mill, the product of
which was to be marketed at a price "as cheap as the same
can or shall be sold at any mill in the Province of Pennsyl-
vania." Before this action of the Convention, on November
8, 1775, Mary Goddard had advertised in her newspaper, the
Maryland Journal, that she would pay cash for rags to be
used in the paper mill now erecting near Baltimore. It is only
by inference that we can identify this establishment with
Dorsett's mill, six months later subsidized by the Conven-
tion. At any rate, a mill erected at Elkridge Landing, near
Baltimore, was fostered by Mary Goddard during a part of
her period of management of the *Maryland Journal*, and the
operation of it seems to have been taken over by William
Goddard and Eleazer Oswald when those two hotspurs of
typography formed a partnership in 1779.[8]

Virginia

It is likely that during the early years of William Parks in
Virginia, he too depended upon importation from Pennsyl-
vania for his ordinary paper, but about the year 1743, this
enterprising printer began the establishment of a mill at Wil-
liamsburg to supply his own presses. The first contemporary

reference in print to this earliest mill south of Pennsylvania is in the form of an ode in the *Virginia Gazette* of July 26, 1744, but the publication by George Simpson Eddy of the Franklin *Account Books* in 1929 revealed a great deal of its earlier history. From that source we learn that as early as 1742, Franklin placed in his *Gazette*, at Parks's behest, the circumstances indicate, an advertisement to the effect that a person capable of building a paper mill and another that understood the making of paper were wanted to institute and carry on that industry in a neighboring colony. Thereafter, in 1743 and 1744, Parks is charged in the *Account Books* for payments made on his behalf to a carpenter and to Johan Conrad Shütz, a paper maker, and for various articles of paper-making equipment — moulds, hair ropes, hair cloths, and material for vats. In the period 1743–1747, he sold to William Parks 11,382 pounds of rags. Of these, 1700 pounds were "fine pick't rags" at 4*d.* a pound, but the bulk of the shipments were at the much lower rate of 1½*d.* a pound. A considerable part of this indebtedness to Franklin was paid by Parks, as the *Account Books* show, in paper, presumably the manufacture of the new mill.

The question of the fate of the Williamsburg mill continues to puzzle historians of American paper making. Rags were advertised for in the *Gazette* again on April 18, 1745; the mill was referred to as in existence in an undated report by Governor Sir William Gooch between the years 1746 and 1749, and it was listed among the properties sold by Parks's trustees after his death in 1750. It is not known with certainty how long after this year the operation of the mill was carried on, but as its purchaser paid £96 and some odd shillings for the property, he must have intended its continuance, though it may be that the building it occupied was

The Paper of the Colonies

the valuable thing in his estimation rather than the good will of the business and the equipment of the mill. Recently, however, certain discoveries, communicated to the Bibliographical Society of America in 1937 by Rutherfoord Goodwin, indicate that the mill may have continued operation for many years after its founder's death. In 1935, certain sheets in the second edition of the German Bible, printed by the second Christopher Sower in 1763, were found to contain a watermark in one half of the sheet representing the initials W P surmounted by a crown, and in the other half a watermark picturing the arms of the colony of Virginia. Working backward from this point, paper of the same quality, color, mould marks, and watermarks, was found in various productions of the Williamsburg press, including two or three books printed by Parks himself, notably his edition of Stith's *History of Virginia*, Williamsburg, 1747. There are several possible explanations of the presence of paper so marked in a Pennsylvania publication of 1763: the simple and obvious one is that the purchaser of the Parks mill continued its operation for many years after the death of its founder on a scale large enough to enable him to sell paper in quantity to printers in other colonies; an alternative is that some part of the Parks equipment, including the moulds, was acquired by a Pennsylvania paper maker who made use of them for years without removing or altering the wire-wrought designs which formed the watermarks described. Some day, perhaps, records will be found to resolve the doubt that now exists in connection with the fate of the first Virginia mill after the death of Parks in 1750.[9]

North Carolina

Paper making in North Carolina owed its origin to the scarcity of the imported article in the days of the Revolution. In August, 1775, the Provincial Congress offered a subsidy of £250 to aid in the establishment of a mill. On this encouragement, doubtless, a manufactory was set up near Hillsboro in 1777, and on November 14 of that year, an advertisement for rags was inserted in the *North Carolina Gazette*. A second North Carolina paper mill was built at Salem among the Moravians by Gottlieb Shober in 1789, and it is probable that this is the mill sometimes said to have been begun at that place many years earlier. In the year 1776, William Bellamy had contracted with the neighboring colony of South Carolina for a five-year loan of £3000 currency for the purpose of establishing a paper mill within its borders. Whether the project went through to completion in that colony seems uncertain.[10]

The New England Mills

Because of various trade conditions and the difficulties of transportation, it is probable that the northern printers imported little paper from the Pennsylvania mills. That they were dependent upon European manufacturers to make good the relative inactivity of the New England mills seems to be expressly stated in an announcement, presumably by William Goddard, issued in connection with the establishment, in 1765, of the first Rhode Island paper mill. This interesting "Advertisement," quoted in full on a later page, contained the following reflection upon one of the chief advantages of the "spacious mill" just built in Providence: ". . . it's Utility to this Part of the Country will be soon demon-

The Paper of the Colonies

strated by a Saving of some Thousand Dollars, that are annually sunk to us in the Pockets of the European Merchants." Nothing is said of cash going to another colony, a condition that Hugh Gaine of New York complained of a few years later, and one may assume that the New England printers looked to Europe for the bulk of their paper until the Revolution drove them to the manufacture of it in good earnest. The facts, indeed, lead one to expect this continuance of an early practice: the New England mills were few, the presses were prolific, and communication with England was well established and regular.

Massachusetts

The first mill to be established north of New Jersey grew out of the action of the Massachusetts Assembly of 1728 by which encouragement was given to the beginning of this industry in New England. Daniel Henchman, whose initiative was probably the cause of the Assembly's action, joined with Gillam Phillips, Benjamin Faneuil, Thomas Hancock, and Henry Deering and built a paper manufactory at Milton on the Neponset sometime in the year 1729. The project seems to have made a certain amount of noise in the Boston neighborhood. In Nathaniel Ames's *Almanack* for 1729, printed in Boston by B. Green, appeared, under date of September 20, 1728, a scale of the prices which would be paid for rags by Daniel Henchman, Thomas Hancock, and Eleazer Phillips. In the same *Almanack* for 1730, it was announced that "The Paper Mill mentioned in the Last Years Almanack has begun to go." The actual successful production of paper by this earliest New England mill very soon afterwards is determined by an incident of the sort that rarely occurs to give

assurance to the historian. A second issue of the Ames's *Almanack* for 1730, dated 1730, was brought out by B. Green, who, with his contemporaries, and possibly, posterity, in mind, added to his imprint the statement: "This is the first Paper made at Milton, N. Eng."[11]

In the year 1734, the Lords of Trade prepared a report on such recent American legislation as affected English industries and commerce. One of its sections deals with the Massachusetts ordinance of 1728 in the following words: "This Manufacture . . . has hitherto made but a small Progress, and can hardly be said, in a strict Sense, to interfere with our own Paper, because almost all the Paper sent to New England is foreign Manufacture; but it certainly interferes with the Profit made by our British Merchants upon the foreign Paper sent to this Province: However no Complaint has ever been made to Us against this Law." It might be supposed that the failure of the British merchants to observe a falling off in their exportations to New England could be accounted for by an expansion in the printing business that demanded the usual quantity of paper from England and absorbed also the product of the Massachusetts mill, but an examination of the recorded output of the New England press leads rather to the conclusion that the five years following the establishment of the mill were a particularly slack period in the printing activity of this section. Contrasting the figures for the five-year period before the mill was put in operation with those for the similar period after this event, 1724–1728 with 1729–1733, it develops that in each group of years there were seven printing shops in active operation in New England. The recorded product of their presses in the earlier period was 407 titles as against 369 in the later, a decrease due to the death, in 1728, of one man, Cotton Mather, who in the

The Paper of the Colonies

term of years 1724–1728 had sent sixty-three titles to the American press. Of the six New England newspapers published in the decade considered, three were common to both five-year periods, two were confined to each respectively, and one, the *Rhode Island Gazette*, had irregular publication for only seven months of the second period. The five-year period following the establishment of the Massachusetts paper mill saw an actual decrease, therefore, in the product of the press, and as it was in this period that the Lords of Trade report was made, one may wonder why the British merchants had not observed, or at least had not complained of, a decrease in their shipments of paper to New England. Perhaps the answer is that the service of the Massachusetts mill to the printers was neither continuous nor effective and that, in spite of its existence, the printers still relied mainly upon the imported article.

Maine, Connecticut and other Colonies

This condition could not be expected to remain unchanged, however, in a country where enterprise and natural manufacturing facilities were found in peculiar measure. Sometime between June, 1731, and January, 1734, Governor Belcher reported to the Lords of Trade that a new paper mill had been set up at Falmouth, now Portland, Maine. It was doubtless this mill that Richard Fry, as lessee of the promoters, Samuel Waldo and Thomas Westbrook, began to operate about the year 1734. Jonathan Olney and others began the operation of a mill in Providence in 1764. In 1766, Christopher Leffingwell established at Norwich, Connecticut, a mill which a year later seems to have been in successful operation. In 1769 the Connecticut government granted a bounty

of twopence a quire on all writing paper and one penny a quire on all printing paper that should be manufactured by Leffingwell. Three years later, after £81. 16s. 8d. had been paid to the manufacturer by the Assembly, indicating that some 500 reams of both sorts had been made in the meantime, the bounty was discontinued, and probably the mill also, for in December, 1775, the impossibility of obtaining paper compelled Ebenezer Watson, publisher of the *Connecticut Courant* of Hartford, to suspend the issue of his journal for a month. On January 15, 1776, its publication was resumed on paper made in Hartford in a mill erected by the harassed printer himself. By the year 1776, there had been established in New England some eight or nine paper mills, at Milton, Falmouth, Norwich, Providence, and Hartford. Whether these were all in operation at this time is open to doubt, but beginning that year with Burbank's mill at Sutton, Worcester County, Massachusetts, the New England paper-making industry began to expand. Samuel Thurber built the second Rhode Island mill in 1780. Matthew Lyon built a mill at Fairhaven in Vermont between 1790 and 1795, and we find Moses Johnson of Keene, New Hampshire, collecting rags in 1792. When Isaiah Thomas compiled his paper-mill statistics in 1810, he found seventy-seven mills in operation in New England.

Rhode Island

In the *New England Almanack for 1765*, published by William Goddard, of Providence, in the autumn of the preceding year, an announcement was made that has political as well as economic interest. Whether Goddard had a partnership in the enterprise there proclaimed as in operation is

The Paper of the Colonies

not known, but those who are familiar with his "manifesto" style may not doubt that he was the writer of the following prospectus of its plans:

"Advertisement

"As the present embarrassed Situation of the Trade of these Northern Colonies, renders it utterly impossible for us to pay for the large Quantities of Goods that are annually imported from Great-Britain, without reducing ourselves to the State of Slaves and Beggars, it is reasonable to suppose, that every Attempt to lessen the Demand for such Goods, by establishing Manufactories amongst ourselves, for the making those Things which are really beneficial, must meet with the Approbation and Encouragement of all who wish well to this Country.—Amongst many laudable Endeavours in the different Provinces, for the Purpose aforesaid, a spirited Effort is now actually making in the Town of Providence, for carrying on a Paper Manufactory, a spacious Mill being already built, and will be speedily set to work, which, if it can obtain a proper Supply of Linen Rags, old Sail Cloth, and Junk, those being the principal Articles necessary for making that useful Commodity, it's Utility to this Part of the Country will be soon demonstrated by a Saving of some Thousand Dollars, that are annually sunk to us in the Pockets of the European Merchants.—Nothing but the Industry and Frugality of the Inhabitants of this and the neighboring Colonies, in preserving and furnishing the Mill with the above Articles, can ensure it's Success; and as it is a Matter worthy of Attention, it is hoped every Family will be so frugal and industrious as to promote it in that Manner, by which they will soon experience the Propriety of that old Proverb, *A Penny saved is a Penny got.*—Ready Money will be given

The Colonial Printer

for the Articles above-mentioned by Jonathan Olney, John Waterman, Jonathan Ballau, or by the Printer of this Almanack."

The continuance of this mill is attested by the appearance of advertisements for rags in the *Providence Gazette* for many years, and by the fact that in 1780 there was going on in Providence a rivalry in rag buying between the "old Paper-Mill," controlled by Christopher Olney, and the "new Paper-Mill," built, probably, in the summer of 1780, by Samuel Thurber in the north end of the town. The date of the beginning of Rhode Island paper making is usually given as that of the establishment of the Thurber mill, but recent investigations indicate that the date should be set sixteen years earlier with the establishment in 1764 of the mill by Jonathan Olney, John Waterman, and Jonathan Ballau for which William Goddard, we have supposed, wrote the vigorous prospectus.[12]

Paper in Politics

The directness of cause and effect, well illustrated in the Rhode Island announcement just quoted, that exists between the origin of American industries and the various acts for taxation, the port bills, and the navigation acts of the British government, is one of the commonplaces of our history. The very thing needed for the encouragement of the paper-making industry in America was the Townshend Act of 1767 by which a tax was imposed upon tea, and upon paper, glass, and other manufactured articles. It is quite likely that paper was more emphatically an immediate cause for the outbreak of the spirit of revolt than the insipid herb of which so much

The Paper of the Colonies

has been written. Certainly one would like to think this true. Tea as the father of the Eagle has always been something of an embarrassment to the American with a sense of humor. Paper is a much more dignified and spiritually important commodity. A tax on paper struck a vital blow at the business of the American printer, and this provincial craftsman was likewise the newspaper editor and a political influence in his community. United, he and his fellows formed a powerful factor in opposition, and they could be counted on to unite against a law that included paper among the taxable articles. They succeeded, too, in directing the indignation of their readers against the act without letting the element of self-interest appear too prominently. We hear little of the illegality of taxing paper, but there seems to have been a furious pother about tea. The air was full of tea, and one suspects the printers of having thrown it about to screen their real grievance. Any article of general use would have served their purpose, but they did not want to make paper the test article. They needed paper and they succeeded in having the cheaper grades of the commodity, the newspaper grades, included in the schedule of exceptions in the various non-importation resolutions of 1769. In consequence of their need and of the increased price of the taxed commodity, they became unremitting in their encouragement of paper making as a native industry.

Rags! Rags! Rags!

In spite of the activity of the American mills, the paper situation was usually critical because of the lack of rags and the difficulty of securing labor. Even the publishers of the greater journals found it necessary during the Revolution,

for example, to reduce the size of their sheets and in many cases to omit issues altogether. Paper making was regarded to such a degree as an "essential occupation" that skilled practitioners of the trade were able to secure exemption from the military service, and employers to secure the discharge from the army of paper-making craftsmen who had enlisted in the flush of patriotic fervor. It was the scarcity of rags, however, here and everywhere, that caused the greatest difficulty to the paper makers, though in America, even in the most trying days of the Revolution, conditions seem never to have required the drastic remedy once proposed in England: Matthias Koops, writing in 1801, suggested that "By an act of Parliament which prohibits under a penalty, the burial of the dead in any other dress than wool, may be saved about 250,000 pounds weight of linen annually; which in other countries perish in the grave." In France, as early as 1727, a royal *arrêt* forbade the exportation of the materials of paper making from the kingdom, and six years later the prohibition was modified to permit the exportation of rags "en payant 30 livres du cent pesant," an imposition that could hardly have given much encouragement to the exporter of this lowly commodity.

Every newspaper of the period carried almost as a regular feature its appeal for rags to be used in the local paper mills; in some cases bounties were offered for the largest collections brought in for sale. Indeed the appeal for rags in American newspapers during this and earlier periods of the eighteenth century forms a literature in itself, ranging from the grave to the gay, from the impassioned plea to the frenzied demand. The possibility of converting Beauty's petticoat or kerchief into paper for a *billet-doux* more than once gave the jocular rhymester opportunity for delightful improprieties.

The Paper of the Colonies

The perennial naughty interest of the male in the intimate fripperies of the other sex found opportunity in the circumstances of paper making for innocuous indulgence in print, and, occasionally, the opportunity for thin moralizing, as when one of Congreve's characters speaks of "a worn-out punk,—carrying her linen to the paper mill, to be converted into folio books of warning to all young maids."

Coming closer home, we find matter that entertains us no less effectively than it did our ancestors of the eighteenth century. In the *North Carolina Gazette* for November 14, 1777, the owners reinforce the usual appeal for rags with the reflection that "when the young Ladies are assured, that by sending to the Paper Mill an old Handkerchief, no longer fit to cover their snowy Breasts, there is a Possibility of its returning to them again in the more pleasing Form of a Billet Deaux from their Lovers, the Proprietors flatter themselves with great Success."

One of the most pleasing of the advertisements is this in which Moses Johnson of Keene, New Hampshire, addressed the children of his community in the *Cheshire Advertiser* for March 22, 1792:

"Moses Johnson, informs all little Misses, and others his Customers, that he receives all kinds of Cotton or Linen Rags, and flatters himself they will be encouraged to save them when they are informed 1½ lb. Rags will buy a Primer or a Story Book, one yard of Ribbon, two Thimbles, two Rings, twelve good Needles, two strings of Beads, one Penknife, nine rows of Pins—4 lb. will buy a pair of handsome Buckles, or the famous History of Robinson Cruisoe, who lived 28 years on an uninhabited Island. My young friends will have a double advantage in buying this book, as they

will not only have the pleasure of knowing the life and surprising adventures of this renowned hero, but it will help them very much in learning to read, and perhaps give them a taste for history of larger extent and importance, such as geography, husbandry, revolutions of countries, &c.—and for the encouragement of which, all kinds of Books and Stationary will be sold at a much less advance than any other Goods: good Writing-Paper for 10*d*. per quire, Spelling Books, 1*s*. Bibles, 3*s* 6. Watts's Psalms and Hymns 2*s* 6. Morse's Geography 4*s* 6. and other Books equally cheap. All kinds of Country Produce received at the highest cash price. But indulge me my friends a little longer on the subject of Rags.

"Trifling as it may appear, the saving of Rags is really a matter of great consequence and importance to our country. I think parents would not do amiss, were they to give their children as much more for the Rags they saved as what they would sell for, and encourage them to lay it out in books, it would habituate them in their infancy to œconomy, industry, neatness and study; which are no small accomplishments, and would greatly recommend young ladies in particular, and help them to good husbands; and this is not all, if one half of the Rags were saved, which are generally lost or thrown away, instead of importing, we should not only have enough for the use of our country, but might make it an article of exportation. It has often been remarked, that our seaports, and manufacturing and trading towns were quite too small for the country; the consequence of which is, a dull and heavy market for provisions, &c. to remedy which, nothing would conduce more than encouragement given to our own manufactures.

The Paper of the Colonies

"Twenty two Shillings in Cash, given for good Salts per Hundred.

Keene, March 21, 1792."

Perhaps the most notable of these appeals for rags, because the cleverest, is the poem that appeared in the *Virginia Gazette* for July 26, 1744, in which the writer urges the good people of Williamsburg to send their worn linen to Mr. Parks's paper mill. It was no rustic poetaster that composed these happy lines, extracted from the poem signed "J. Dumbleton":

> Ye Fair, renown'd in Cupid's Field
> Who fain would tell what Hearts you've killed;
> Each Shift decay'd, lay by with care;
> Or Apron rubb'd to bits at—Pray'r,
> One Shift ten Sonnets may contain,
> To gild your Charms, and make you vain;
> One Cap, a Billet-doux may shape,
> As full of Whim, as when a Cap,
> And modest 'Kerchiefs Sacred held
> May sing the Breasts they once conceal'd.
>
> Nice Delia's Smock, which, neat and whole,
> No man durst finger for his Soul;
> Turn'd to Gazette, now all the Town,
> May take it up, or smooth it down.
> Whilst Delia may with it dispence,
> And no Affront to Innocence.[13]

These fanciful effusions are, of course, the exceptional mode of appeal. The following excerpt from Hugh Gaine's newspaper, published in the days before he set up his own mill, may be taken as the normal advertisement inserted in his journal by the colonial printer on behalf of his paper

maker. Self-interest dictated the very closest relationship between these associated businesses.

"Linen Rags

"Three Pence per Pound will be given for the best Sort of good, dry, clean Linen Rags, and so in Proportion for those of an inferior Quality — by Hugh Gaine."

In 1765 this printer proposed a scale of premiums "for the further Encouragement of such poor Persons as are willing to employ themselves in procuring Rags." In accordance with this announcement, he was prepared to pay a bonus in addition to the cash value of the rags to persons bringing in the greatest annual quantity of the humble material needed for the making of paper. In the period 1735–1741, Franklin sold William and Gerard De Wees 55,476 pounds of rags, and William De Wees, Sr., 1546 pounds; in the included period 1736–1739, he sold Thomas Willcox 16,655 pounds of the same essential raw material. His payment, which seems to have been at the rate of 1½ pence a pound, was frequently in kind, in paper and pasteboard, which he sold at retail to printers in distant colonies. In later years, Franklin's sales of rags to paper makers and his sales of paper to printers took on such proportions as to compel our recognition of him as a most important factor in the colonial paper trade. The sales of rags just mentioned, the sale to William Parks of more than 11,000 pounds in the period 1743–1747, the acceptance of payment in kind indicate that Franklin was, in a sense, the silent partner of these paper manufacturers. It does not surprise us to learn that in 1788 he told the French traveller Brissot de Warville that he had established about eighteen paper mills. Nor do we feel that he was making an idle claim

The Paper of the Colonies

when he wrote Humphrey Marshall in 1771, "I . . . had a principal share in establishing that manufacture among us many years ago."[14]

As early as 1732, when Richard Fry was waiting in Boston for Samuel Waldo to build the paper mill at Falmouth, he occupied himself to good purpose. In an advertisement of that year, in which he describes himself as "Bookseller, Paper-Maker & Rag Merchant," he thanks the public for following so well his directions in the collecting of rags that he had received "upwards of Seven thousand Weight already."

Even in Pennsylvania, at a time when paper making had been a customary industry for nearly a hundred years, the need for coöperation between the printers and the public remained ever present. At one time we find that most notable of colonial institutions, the American Philosophical Society, bringing its influence to the succor of the local paper makers. On March 5, 1773, a committee was appointed "to confer with such persons in this City as are concerned in the Paper Manufactory on the most probable Means of firmly establishing that branch of Business amongst us." At the meeting of two weeks later, "Robert Bell waited upon the Society, this Evening with a Plan for encouraging the Undertaking." From later developments we learn that Mr. Bell's plan was a variation of the ordinary appeal for rags, though it differed little from Hugh Gaine's proposal to the New York rag gatherers eight years earlier. A graduated series of premiums was offered by the Society to encourage the saving and collecting of linen rags for the making of white paper. An elaborate announcement, embodying the offer, appeared in the *Pennsylvania Gazette* for March 31, 1773, and certain Philadelphia printers, Messrs. Crukshank, Dunlap, Hall, Bell, and Humphreys subscribed the prize money. Two years later,

The Colonial Printer

on March 19, 1775, we find Robert Bell proposing to the Society a new plan for the aid of an industry that had become of the utmost importance to the life of the recently united colonies. Everywhere the making of paper in this period brought about a valuable spirit of coöperation among all elements of the community.[15]

Treatises on Paper Making

The interest of Robert Bell did not cease with the proposal of plans for the collection of rags. In 1777 appeared in Philadelphia, bearing his imprint, a work known as *Select Essays ... Collected from the Dictionary of Arts and Sciences and from various modern Authors*. Among the several treatises on the raising of flax and hemp, the making of linen, the management of sheep and cows, and the culture of vegetables, is found an essay by the French physician Jean Etienne Guettard, entitled "An Enquiry Concerning the Materials that may be used in making Paper." Reprinted from a similar London collection of 1754, this treatise by Guettard stands as the first writing on the subject of paper making to come from the American press.[16] The omniscient Franklin was next to be heard from. In 1793, in the *Transactions of the American Philosophical Society*, was published a communication by Franklin, read to the Society in 1788, with the title, "Description of the process to be observed in making large sheets of paper in the Chinese manner, with one smooth surface." This discussion of a process in paper-making technique by the aged Franklin seems to have been the only strictly American contribution to the bibliography of paper making that appeared in the eighteenth century.

It is a matter of interest that in 1719, a French scientist,

The Paper of the Colonies

pointing to the American wasp as an accomplished maker of paper in his nest building, made the earliest suggestion of the possibilities of manufacturing paper from wood pulp.[17]

The Cost of Paper

The average cost of ordinary printing paper of native manufacture seems to have lessened as the years advanced. Bradford arranged with Rittenhouse in 1697, as has been said, for the refusal of his whole output at 10 shillings sterling a ream, and in the *Account Books* of Franklin the normal price of printing papers in the period 1730–1747, when charged to himself or to other printers, was between 10 and 12 shillings currency for the same unit. Next to the labor charge, the annual expenditure for paper was the chief expense of the printer. In the eighteen years of the Franklin & Hall partnership, the sum laid out for paper was £6360, or about £353 a year, representing, at 10 shillings a ream, an annual use by this firm of some 700 reams of paper.[18] It is no wonder that Hugh Gaine resented good money going at something like this rate from New York printing offices to the Pennsylvania mills, and no wonder, too, that the local American economists saw with satisfaction the growth of this important industry in all parts of the country.

Statistics

When Isaiah Thomas completed his census of paper mills in 1810, he recorded the result as follows:

"From the information I have collected it appears that the mills for manufacturing paper, are in number about one hundred and eighty-five [*sic* for 195], viz: in

The Colonial Printer

New Hampshire	7
Massachusetts	40
Rhode Island	4
Connecticut	17
Vermont	9
New York	12
Delaware	10
Maryland	3
Virginia	4
South Carolina	1
Kentucky	6
Tennessee	4
Pennsylvania	60
In all other states & Territories	18
	195"

The Paper Maker and the Printer

One consequence of bringing together these fragments that relate to the origins of paper making in the colonies and to the relations of printers to that essential industry is the conviction that the American printer had less cause for uneasiness in regard to his paper than in regard to his type or his presses. Certainly, in the middle colonies, the printing shops could be kept supplied by the Pennsylvania mills with the ordinary grades throughout the eighteenth century. New England, outside of Massachusetts, and the southern colonies, outside of Virginia, were less fortunate, perhaps, in that they were dependent upon longer voyages for their shipments during the greater part of the period, but in these sections, too, from the early days of the Revolution a locally made product relieved to some extent the printer's anxiety. The

The Paper of the Colonies

insistent demand of the printer for a commodity for which no makeshift could suffice brought about a coöperation in every community between him and enterprising men of business that resulted in the building of one of the greatest industries of the United States.

VIII

The Journeymen and Apprentices
The Family Helpers

THE colonial printer was frequently put to it to secure and hold a number of journeymen large enough for the proper conduct of his establishment. Usually he was a practical craftsman working at case and press with his own hands, and often his wife was sufficiently skilled to assist at the cases and in the lighter occupations of the office. The employment of women in the printing trade is not the least interesting human feature of the varied colonial scene. Many of the widows and female relatives of printers went further, indeed, than employment in a subordinate capacity and acted successfully as the managers of establishments left untended by the death of the master. Not too much emphasis should be placed upon the existence of this condition in the colonies, for the assumption by widows of the business of their husbands was the wholesome custom of the time rather than a peculiarity of the place. European and Spanish American imprints abound in which *la veuve* or *la viuda* of a long-deceased craftsman is named as printer. Especially did this happen, of course, when the established good will of the business made its continuance worth while. None the less the practice was sufficiently general in the colonies to justify comment. The first Cambridge press seems to have been set to work by the widow of the Reverend Jose Glover; Dinah Nuthead and Anne Catharine Green in Maryland were accorded the privileges enjoyed under the local government by their deceased husbands; Anne Timothy succeeded her husband, Peter, as printer to the state of South Carolina; Ann Franklin was

the successor of her husband as Rhode Island's official print-
er, in which employment she was afterwards joined by the
son for whom she had preserved the business during a long
minority. Clementina Rind carried on the busines of her
husband in Williamsburg. Franklin has given immortality
in the *Autobiography* to the effective conduct of the print-
ing house of Lewis Timothy, of Charleston, by his Dutch-
born widow, Elizabeth. Sarah Updike Goddard of Rhode
Island was the backer and partner of her son; and Mary
Katherine, her daughter, was her brother's assistant, part-
ner, and stalking-horse until their quarrel and separation in
1784.

Not all of the women here mentioned were practical print-
ers. Mrs. Glover had only the association of ownership with
the Cambridge press, and as Dinah Nuthead was unable to
write her name, one can hardly think of her as exercising a
practical usefulness in the shop, unless indeed, like the wife
of Anthony Armbruester many years later, she showed her-
self "a good worker at press." On the other hand, Ann Frank-
lin is reputed to have engaged in difficult pieces of compo-
sition and to have been assisted in it by her two daughters,
who, Isaiah Thomas says, "were correct and quick compositors
at case" and "sensible and amiable women" besides. Mary
Katherine Goddard, we learn from the same source, was "an
expert and correct compositor of types." There are to be
found on record other instances of women compositors in suf-
ficient number to make it certain that in reckoning the labor
resources of the colonial printer the women of the family
should be counted as a possibility he was not likely to over-
look. At this time, indeed, the printing trade was still in the
household stage of development, and it was not remarkable
that the women of the family and the well-grown children

should be called upon for assistance in the routine of the shop.[1]

The Emigrant

The second source from which the printer drew his assistance was the occasional immigration of trained journeymen, some of whom came to this country under the customary terms of indenture. Now and then, too, an adult indentured servant of no professional training was purchased by the printer and set to learn the trade. Keimer acquired the services of two such men, and the circumstance that the first of these, George Webb, was "sometime of Oxford" is one of a series of related facts not without significance in any discussion of the colonial labor problem. In Keimer's shop at the same time was the youthful Benjamin Franklin, a journeyman printer who had come to a knowledge of the trade through the regular avenue of apprenticeship.

The Apprentice

The chief source from which the colonial master printer drew his labor supply was, happily enough, the youth of the land. The apprentice was at once his despair and his economic salvation, and to secure a good boy for his service, he was willing sometimes to burden himself with an infant not long from the arms of his mother. Isaiah Thomas was indentured when only six years old. At that age, he bound himself to avoid drunkenness and the pursuit of carnal enjoyment and to serve his master truly until he should attain the status of manhood. Franklin may be thought of as having been more fortunate than Thomas, inasmuch as the term for which he was indentured ran only from the twelfth to the

The Journeymen and Apprentices

twenty-first year. Still more happily John Peter Zenger was bound to William Bradford only for the eight-year period between the ages of thirteen and twenty-one.[2]

Economic and social factors worked a slow alteration in the apprenticeship system in the printing trade, as in all other organized occupations. A century later than the period of the cases just cited we find the journeyman unions demanding a limitation of the number of apprentices that might be taken by a single master, and restricting the term of apprenticeship to the four or five years preceding the age of manhood.[3] It was the self-interest of the journeyman, though, rather than the welfare of the child, that brought about this more healthful condition, and almost another century was to pass before the problem should be approached from the standpoint of the child and the race through the concepts of compulsory education and protective hygiene. It must not be thought, however, that the child apprentice went wholly without humane consideration even in the days when he could be bound to a master in infancy. In Maryland, to take a typical example, it was provided by an act of the Assembly as early as 1715 that annually, in each county, an "Orphan Jury" be summoned to inquire "Whether the Orphans be kept, maintained and educated, according to their Estates? And whether Apprentices are taught their Trade, or rigorously used, and turned to common Labour at the Axe or Hoe, instead of learning their Trades?" If it should be found by this jury that any apprentices had not been properly instructed "upon Pretence that the last Year is enough to learn their Trade," they were to be removed to other masters and satisfaction given for the misuse of their time and labor.

But though the statute books might abound in beneficent precautions of this character, the boy in the colonial printing

shop, as doubtless in other industrial establishments of the time, seems to have lived so laboriously and uncomfortably that the "wholesome meat and drink" prescribed in the indenture did not compensate for the hard work and the menial service required of him. A runaway printer's apprentice, to judge from frequent newspaper advertisements and from other indications, must have been a commonplace figure of the colonial highways. Franklin, James Parker, and Isaiah Thomas were among the adventurers who did not scruple to violate their indentures and to escape from the servitude in which they had been placed by their parents. When such serious youths as these advanced to meet their destinies by way of the back door, it is no wonder that the masters were in constant difficulty because of runagates of the "idle apprentice" sort.[4]

Labor Scarcity

Despite the general effectiveness of the apprenticeship system as a means of renewing the ranks of labor, there are many indications that journeymen printers were exceedingly scarce throughout the colonial period. They, and their masters too, for that matter, were constantly on the move. A feature of the lives of the eminent printers of that day was their frequent removal in early manhood from one colony to another. Jonas Green, as journeyman and master, worked in three colonies; William Goddard in four; William Bradford and Franklin in two each, not counting their English sojourns; and William Parks at different times had establishments in three English towns and in Annapolis before he settled down for his last and most successful venture in Williamsburg. It was then, as in the fifteenth and in the

The Journeymen and Apprentices

twentieth century, a footfree companionship, and if this was so with the masters it was even more the case with the journeymen. Because of the fewness of printing-house craftsmen, a restless journeyman could pick up jobs in any of the larger towns. One reason for the scarcity of labor was that the work of the shops was not sufficiently constant or sufficiently great in quantity to justify the master printers in training a great many apprentices or in bringing in many trained men from England. In his wage scale of 1754, Franklin writes, "Press Work, 12*d* per Token, Which is too much, if Pressmen had constant Work, as Compositors: but in America, Numbers [i.e., size of editions] being generally small, they must often stand still, and often make ready." When, a few years earlier, Jonas Green wrote to Franklin, "I wish I could get another Hand," he was giving expression to a need common enough in a period when the craft had not yet struck its pace as an organized industry. It was so easy for the master to find himself with too many journeymen for the amount of work on hand that he contented himself with the minimum number of workmen and used these often at the case, the stone, and the press. The existence of this condition in the smaller communities did not encourage the numerical growth of the body of printing craftsmen. It was probably this circumstance as much as the motive of economy that led to the occasional employment of unskilled laborers at the press, a practice that one of the earliest societies of journeymen printers legislated against soon after its organization in 1802, when it provided that membership in the society should be contingent upon the applicant's having served an apprenticeship satisfactory to the board of directors.

The Colonial Printer

Runaways

It must be recorded that scarcity was not the only difficulty with regard to labor that beset the printer. We find William Goddard advertising in his *Maryland Journal*, in 1773, that he "wanted Immediately, one or two sober Journeymen Printers who *can* and will work." Nicholas Classon, a printer serving out a term of indenture with Andrew Bradford, ran away and was followed by the execrations of his master and by an advertisement, in the *American Weekly Mercury* for June 13, 1728, offering a reward for his return. William Parks described a runaway in the *Virginia Gazette* for December 12, 1745, as one who "makes Locks, and is dexterous at picking" them. Hugh Gaine was constantly advertising for journeymen, and offering unflatteringly small rewards for the return of runaways, one of whom he described as "pretty much pitted with the Small-Pox, wears his own hair and is much bloated by Drinking, to which he is most uncommonly addicted." One reads with varied emotions and divided sympathies the advertisement in the *Maryland Gazette* for May 2, 1765, in which Joseph Royle, the Williamsburg printer, offered £5 reward for the apprehension of a runaway indentured servant, a bookbinder by trade, whom he pictures as "very thick, stoops much, and has a down look; he is a little Pock-pitted, has a Scar on one of his Temples, is much addicted to Liquor, very talkative when drunk and remarkably stupid." Even this wastrel seems to have been able to cripple Royle's business to such an extent as to make its proprietor willing to pay £5 for the recovery of his person. Hours of labor and the rate of payment were questions that did not keep the colonial printer awake at night, but the restlessness, the inebriety, and the general scarcity of trained journeymen

counterweighed the immunity he enjoyed from the troubles that more particularly vexed his successors in the trade.

Hours of Labor

There seems to be little direct evidence as to the hours of labor that were the lot of the colonial journeymen. One cannot read Franklin's *Autobiography* without realizing that the hours were long and the wages something less than munificent, though the journeyman printer, then as now, was one of the best-paid craftsmen of the community. In general it seems to have been the custom to regulate the hours of labor by the duration of daylight. Composition by candlelight was popular neither with printer nor with customer, though the same need for good light did not hold for the presswork. James Watson of Edinburgh has left us a statement as to the pressman's hours that is widely at variance with our modern notions of a fair day of labor. In giving the reasons for the poor quality of Scottish printing of his time, he names as one of them "The little Esteem we have for Press-Men, and the narrow Prices given them." He continues, "The Dutch, who, it must be acknowledged, are the neatest Printers in the World, have different Thoughts of them: They give larger Wages to good Press-Men than to Compositors: They will not allow a Press-Man to work above Eight or Nine Hours in a Day, lest by working much he work not well. But here and in England, he that works Seventeen or Eighteen Hours, is reckon'd a choise Workman: And indeed there is a Necessity for working much, their Wages are so small; . . . For my Part, I'd rather give a Crown a Day to a good Press-Man, who brings Reputation to my Work and preserves my Letter, then Eighteen Pence to one who must certainly destroy it by

careless and base Working." Doubtless the shorter duration of daylight in the latitude of the colonies effectively prevented the adoption of a working day of this length in the American establishments, and it is probable that the ten-hour day favored by the typographical societies of the early nineteenth century was the normal working day of the earlier period.[5]

Wages

In a later chapter will be given in full the contents of a document in Benjamin Franklin's hand, found in the American Antiquarian Society, entitled "Prices of Printing Work in Philadelphia, 1754." It will be interesting to examine here the section of this document which refers to journeymen's wages, assuming that what was true for Philadelphia at this period was relatively true for the other colonial printing centers:

Journeymen's Wages

For composing Sheet Work, 6 d a 1000 Letters, to be reckoned by m's, an m laid on its Side being 2 Letters.

Small Jobs reckoned by the Hour, at 9 d per Hour.

For composing an Advertisement or any such small Job, in Quarto, Great Primer or Double Pica, — 6 d
Folio Ditto — 1/
Blanks, 1 Side of a Half Sheet, in English or Pica, Pot or Pro Patria Size, — 1/6d
And other Jobs proportionably, according to Size of Paper and Letter.

Presswork, 12 d per Token, which is too much, if Pressmen had constant Work, as Compositors; but in America Numbers being generally small, they must often stand still, and often make ready.

For Jobs—An Advertisement, 60 No or 100, 6 d—and 6 d per 100 more.

If Work makes less or more than even Tokens, all Numbers above 5 Quires to be reckoned a Token; all under, nothing; i. e. 4 Token and 5 Quires is but 4 Token; 4 Token and 6 Quires, 5 Token, &c.

Seeking material for comparison with the wages of later periods, we find that in 1799 the Franklin Typographical So-

The Journeymen and Apprentices

ciety of New York demanded 25 cents a thousand ems as the rate of payment for compositors, virtually the same as the 12 pence a thousand ems of the Philadelphia scale of 1754. In 1792, Andrews wrote to Thomas: "The devil seems to have got into the Journeymen, they want more than one shilling per token and I expect the next thing will be more than one shilling per thousand M's."[6] From these figures one learns that the wages of the American journeyman printer seem to have remained fixed during the second half of the eighteenth century. The sentence quoted from the Andrews letter, however, indicates the coming unrest, and in 1802, in the wage scale of the Philadelphia Typographical Society, the earliest printed scale proposed by an association of journeymen, we find enunciated the principle of the minimum wage for both classes of workmen and an advance definitely asked for in the pay of pressmen. The close of the period we are considering was also the beginning of a better day for the men who labored in American printing establishments. The new Philadelphia scale, set by the journeymen in 1802, reads as follows:

Composition	*Dol.*	*Cts.*
Per week, not less than	8	00
Every 1000 m's, from Brevier to English, inclusive		25
Common Rule or Figure work		50
Press Work		
Per week, not less than	8	00
All paper below medium, per token		30
Ditto above medium		37½
Broadsides, per token		75
Cards, per pack		12½
A single pack of cards		30
All small jobs		30

These wage scales of 1754 and 1802 give a fair indication of the journeyman printer's wages in Philadelphia and elsewhere, doubtless, during the second half of the eighteenth

century, and it is probable that there was not a notable difference between these rates and those which prevailed in the earlier period. For a compositor in 1802 to earn his weekly minimum of $8 he must set 5400 ems of type a day for six days a week. A fairly competent compositor on book and pamphlet work could set 600 ems an hour, so that he could make his $8 a week by working at composition nine hours a day, and more by extending his hours of labor. On the narrow-measure composition of newspapers he could work faster and earn considerably more. It must be remembered that the compositor must also distribute his type and that sometimes he must stand idle. In the nineteenth-century wage schedules he was allowed 15 cents an hour, the equivalent of the minimum wage just discussed, for this "lost time," and it is probable that a similar allowance was made him in the earlier century. In Franklin's list we observe that, in principle, the pressman is compensated for his lost time by the generosity of payment per token when he was at work. The pressman with an average of eight tokens a day at 30 cents a token must in normally busy times have earned more than the minimum required by this scale of 1802.[7]

Cost of Living

The wages of day laborers are well known for almost the whole period of our history, and one observes that the ratio between the wages of the day laborer of 1754 and the journeyman printer of the same year was about as one to four. The relative condition of the day laborer has improved in the intervening years in comparison to that of mechanics. A general idea of the meaning of a given wage in the eighteenth century may be obtained from an examination of the cost of

commodities of the period. When an unskilled laborer in Massachusetts, for example, received an average of 31 cents a day in the period 1752–1760, he could buy a pound of beef for 3½ cents, a pound of pork for 8 cents, a pound of flour for 4 cents and a ten-pound turkey for 60 cents. In 1937 working at $4 a day he must pay at least 35 cents a pound for his beef, 33 cents for his pork, 7 cents for his flour, and $4 for a ten-pound turkey. It is probable that in 1752, no more than in 1937, was the laboring man accustomed to regale his family with turkey at Thanksgiving at a cost of two days' wages. For the rum which the laborer purchased in 1760 at 11 cents a pint, he must now pay $1 at the least; for his gasoline he pays very much more than sole leather and energy cost him a century and a half ago. It is obvious that as his wages have increased his needs have increased, so that his margin of safety is probably not much greater now than in 1760. The same relation holds good in the case of employers. It is almost impossible to compare the profits of a business in the household stage with the profits of the same business in the factory stage. The difference in the standards of living of the participants is too great. In 1760 the printer's son learned to set type; today he goes to college.[8]

Organization of Labor

The organization of labor existed only in germ in the colonial printing shops. There remained certain vestiges of the mediaeval craft guild in such terms as the "companionship," used to define the group of men of any town that made its living by working at press or case. The Company of Printers of Philadelphia, organized in 1794, was an association of employers and job printers of the kind that connects

the merchant guilds of the Middle Ages with the employers' associations of the present day, but this organization did not include journeymen, nor was it formed in their interest. The English journeymen printers, however, had organized as early as 1666, when they proposed certain rules for the limitation of the number of apprentices and the employment of untrained journeymen, and everywhere there has always been a clannishness among printers, a jealousy of the "art and mystery" of their craft that predisposes them to close and effective organization. Doubtless, in America, there were occasions when temporary cohesion of the workmen of a town would force the master printers to heed their demands for improvement in wages and conditions. There occurred such an organization in New York in 1778, when the journeymen printers went on strike and forced an increase of wages from their employers. An attempt by the Philadelphia master printers, in 1786, to reduce the minimum earning to $5.83½ a week caused an organization to be formed among the journeymen that forbade its members to work for less than $6 a week and undertook to support any of the "brethren" who should be thrown out of employment by their refusal to work at lesser rates of payment. We have found Andrews writing to Isaiah Thomas, in 1792, that "the devil seems to have got into the Journeymen" of Boston in regard to wages. These instances are isolated in time and space though in general they occurred toward the end of the century. They do not indicate the existence of permanent journeymen organizations in the colonies, but they show that the principle of resistance by association and by the strike was well enough understood at this time, and doubtless understood and occasionally practised throughout the entire period of our interest.

The Journeymen and Apprentices

The Typographical Society of New York, formed in 1795; its successor, the Franklin Typographical Society of Journeymen Printers, formed in 1799; and the Philadelphia Typographical Society, organized in 1802, mark the beginning of those permanent organizations, or journeymen guilds, that soon were formed in every city for the protection of the workers in the trade. The merging of these societies into the National Typographical Association, in 1836, and the later formation of the National Typographical Union, in 1851, mark the arrival of a well-organized stage in economic history so far as concerns the printing trade in the United States. The wage scales proposed by these early societies have already been discussed. It seems worth while to quote here the address to the employers that introduces the scale proposed by the Philadelphia printers in 1802. Certainly trade unionism came into this country with the manners of a lamb.

Philadelphia, February 22, 1802

"Sir,

"The 'Philadelphia Typographical Society,' take the liberty to furnish you with their *List of Prices*. We hope that we shall be indulged with at least a candid examination of our demands . . . we presume you are not unacquainted with many of them. We would wish to be placed on a footing, at least, with mechanics . . . our wages have, in no instance, kept pace with them. We have the merit of not being the most dissatisfied, and in no one instance of demanding anything unjust. We have, in the following statement, confined ourselves to what a majority of the employers in this city give. Our object is, to have one uniform price established. In doing this, we shall act as men towards men . . . no person will leave his employ until he has given a reasonable notice

The Colonial Printer

. . . in return, we expect that your conduct towards us will be equally candid. Indeed, we cherish a hope, that the time is not far distant, when the *employer* and the *employed* will vie with each other, the one, in *allowing* a competent salary, the other, in *deserving* it. Under these impressions we submit the following prices to your decision."

Only a dozen years later, the tone of such communications had definitely changed. An examination of the constitutions of the early societies shows clearly enough the existence in the first quarter of the nineteenth century of the principles today emphasized by the International Typographical Union; that is, the right to demand the regulation of wages and hours of labor, objection to the employment of non-union men, and the necessity for the limitation of the number of apprentices. With these principles come to flower in 1815, it seems likely that they had been germinating in the preceding century of darkness for which we possess no illuminating records.[9]

General Conditions of the Trade

The Printer's Troubles

IT was not only the labor difficulties spoken of in the pre-
ceding chapter that kept the printer stretched on an un-
easy bed; there were certain unalterable conditions that
made his task necessarily laborious in performance and un-
certain in outcome. The lack of proper illumination gave
him a short working day in the winter months, for though we
recall Franklin's story of the "pied" form and the night of
labor required to reset it, yet as a general thing composition
by candlelight must have been difficult for the printer and
unsatisfactory to the customer. In November, 1763, an act
of the Maryland Assembly, after setting forth the fact that
the "bad season" was approaching, allowed Jonas Green a
month additional to the period formerly prescribed for the
completion of the session laws. Furthermore the variety of
accident known as an "act of God" was recognized by the
Maryland legislators as an effective deterrent of industry in
a pioneer country, for in the statutes of 1765, by which Green
was ordered to have his government work completed by a
specified time, it was also provided that the penalty should
not be exacted were he to be "hindered by the Death of his
Hands . . . , or by Sickness, or the unavoidable Accident of
his Press breaking."

Paper Scarcity

Delays in the accomplishment of presswork, especially in
the case of large books, were often caused by the necessity of

waiting for overdue ships with their consignments of paper. The printer was accustomed to set the matter of one or two signatures in pages, impose the forms, prove, correct, and print the pages immediately after revision. His small fonts made it impossible usually for him to hold matter in type until a book or even a good-sized pamphlet had been completed, so that unless the several processes of setting, imposing, correcting, and printing a form could be carried out in immediate sequence, the work was liable to be held up. This condition would surely arise if delay should occur in the receipt of paper intended for the job in hand. In the case of large books, it was not always possible to secure in one shipment enough paper of the same make and weight for the whole job; accordingly the printer would set and print as much as he had paper for, distribute the type, store the finished sheets, and go on with other work while waiting for the arrival of another consignment of the right sort of paper. In the preface to his *New Version of the Psalms of David*, printed by Jonas Green in 1756, the Reverend Thomas Cradock apologized for the four years that had elapsed since he had taken subscriptions for the book, explaining that he had been "twice disappointed of his Paper, and then thought it most expedient to wait a little longer for the advantage of new Types." In view of this extraordinary delay, we find no cause for astonishment in a later announcement by the reverend author that, because of the death of some of the original subscribers, he had remaining a few copies of his book for general sale. In replying to the chiding of the Board of Trade for his failure to transmit copies of Bacon's *Laws of Maryland*, nearly four years in press, Governor Sharpe attributed the delay to the slow importation of paper, and blamed specifically Mr. Anthony Bacon, the compiler's great mer-

chant brother in England, for neglecting to put the desired reams on the ship at the proper time.[1]

Small Supplies of Type

An apology for errors, based on "the author's distance from the press," is a feature often encountered in books of the eighteenth and earlier centuries. When we take into consideration the procedure of the printer of those days, it is easy to understand that this was not a mere formal apology. The author of a book of any size never held in his hand the entire set of proof sheets of his work before it went to press. If he lived near the press, he might see proofs, in page form, of course, one or two sheets at a time, at some stage between composition and printing; if he lived at a distance, he must perforce leave proof reading and correction to the printer or to some convenient friend. In neither case could he make changes in the first chapter suggested by his re-reading in proof of the third chapter, for by the time he received the third chapter, the first part of the book would be printed, the sheets stored, and the type distributed for use in succeeding sections. Understanding of the conditions under which the printing was done explains and, in a measure, palliates the publication of long lists of errata in many books of the period.[2]

There were other possible misfortunes that the American printer might count upon as risks of his trade. In the section of this book devoted to type founding, reference has been made to the embarrassment that might come to a printer from the lack of sorts in his cases, and we have seen that Weyman was tempted to give up the printing of the Mohawk Book of Common Prayer because, as he said, he had not "the Com-

The Colonial Printer

mand of a Letter Makers founding-House" to supply him
with the unusual number of certain letters needed in the
composition of a book in an Indian language. Type was ex-
pensive and not always easy to come by, and the good crafts-
man must often have been saddened by the contemplation of
pages printed in worn and unlovely letter that circumstances
forced him to deliver to his customers. The small fonts he
possessed compelled him to a ceaseless shifting of men and
materials, and, in general, the forces of nature and the dis-
tance from the great manufacturing centers of England and
the Continent were essential factors in the reckoning of the
early American printer. When John Holt was appealing in
1778 for aid from the New York Assembly in the rehabilita-
tion of the printing house partially destroyed by the British
at Kingston, he asserted that he was ready to use his press,
save "for want of a Blanket, which I have, without Effect,
used my utmost Endeavours to obtain." In a pioneer country
so small a thing as a felt pad could affect the prosperity of
an establishment dependent upon the production of skilled
specialist manufacturers.[3]

Bad Weather

The printer who was also the publisher of a newspaper had
editorial difficulties of an unpleasant kind. The coming in of
winter with frozen waterways and impassable roads fre-
quently forced him to reduce the size of his journal for sheer
lack of news to fill it. On January 14, 1768, Anne Catharine
Green apologized to the readers of the *Maryland Gazette* in
these words: "As the Northern Post is not yet arrived, and
the Southern One brought no Mail; and our Rivers, at the
same time being frozen up, by which we are prevented receiv-

General Conditions of the Trade

ing any Articles of Intelligence from the different parts of the Province, we hope we shall stand excus'd for this Single Half Sheet." Jonas Green was constantly being written to by indignant correspondents who complained of the lateness of his news, most of it in the form of "exchanges" from Northern and English newspapers, and of the dreariness of the excerpts from polite and improving literature with which he filled the space that, poor man, he must have wished most earnestly to see occupied by news and by advertisements at 5 shillings each the first week, and 1 shilling a week thereafter.

Censorship

The tribulations of the printer in his relations with the colonial governments were probably not so irksome as we are accustomed to believe because of our mental habit of concluding that one swallow makes a summer. The censorship of the press in English America seems to have arisen from three separate causes: interference by the English government, by the local authorities, and by an offended public. The most frequent instances of interference came about through the second of these causes, for the local governments — governor, officials, and both houses of assembly — were extremely sensitive to printed criticism, then a relatively new form of protest. Indeed, the inhibition of the Nuthead press in Virginia, in 1683, by royal instruction, is the only recorded instance in which the English authorities interfered directly with an American printer, and even in this case the action was instigated by the local government. The order of the King in Council on this occasion, as formulated to the outgoing governor, that "no person be permitted to use any press for printing upon any occasion whatsoever" was completely effective

so far as Virginia was concerned, even though in the instructions to another governor sent to that colony in 1690 the sense of this inhibition was radically modified. Henceforth, instructions to governors read in effect as had those sent in 1686 to Dongan of New York by James II: ". . . you are to provide by all necessary Orders that noe person keep any press for printing, nor that any book, pamphlet or other matters whatsoever bee printed without your especial leave & license first obtained." In these phrases, the royal authorities recognized the press in America even before the inhibitions against its use in England, outside of London, York, and the Universities, had been removed by the expiration of the Parliamentary press restriction act in 1693. In the matter of control, however, the responsibility was placed directly upon the governor, and to this fact may be traced the state of wholesome fear of local authority in which the printer of the period had his being.

The trial of William Bradford before the Philadelphia magistrates in 1693 presents the only recorded case in which a clause of the Parliamentary press restriction act was brought forward by the prosecution. When the Quaker judges charged him with having printed a pamphlet to which he affixed neither his name nor the place of publication, his defender, George Keith, reminded them, with triumphant sarcasm, that of all men in England the Quakers had been the worst offenders against this provision of the act. Bradford was held in prison, but his opponents failed to convict him upon this specific charge or upon any other charge in the indictment.

It was perhaps in Massachusetts that the printer and the local governments came into most frequent conflict, for there the situation was complicated by religious, social, and moral factors not present in the constitutions of other colonies. The

apprehension of publications that might disturb the harmony of Church and State led, in October, 1662, to the passage of an order by the General Court to the effect "that henceforth no copie shall be printed but by the allowance first had & obteined under the hands of Capt Daniel Gookin & Mr Jonathan Mitchel, until this Court shall take further order therein." One of the motives underlying this action by the Court was the memory of the situation in which it had found itself in regard to John Eliot's *Christian Commonwealth* upon the restoration of Charles II. That work, published in London in 1659, contained constitutional theories based upon an extreme conception of the idea of popular sovereignty, and fearing that the restored monarch would think this a generally held New England doctrine, the Court suppressed the book and forced Eliot to make an acknowledgment of error. It is not the most creditable of episodes, but a great deal of water had gone under the local bridges since the beheading of Charles I, and opinion had sincerely begun to question the extreme republicanism of ten years before.

At any rate this was the beginning of a censorship in Massachusetts that was more severe and more continuously irksome than the casual and sporadic efforts of the other colonies to keep the press within bounds. It resulted, among other things, in the suppression, in 1690, of *Publick Occurrences*, the first American newspaper; in the altering in 1669 of an edition of the *Imitation of Christ*; in the prohibition about 1668 of a rowdy but amusing piece, *The Isle of Pines*. It brought about in 1695 the suppression and burning of Thomas Maule's *Truth held forth*; in 1723, the persecution of John Checkley; the departure from Boston of James Franklin in 1727 and of Daniel Fowle in 1756, and the consequent establishment of the press in the colonies of Rhode Island and New

The Colonial Printer

Hampshire. The censorship in Massachusetts was, in fact, a very real thing. The first effective questioning of its justice came through the trial of Thomas Maule in 1696 for the publication of his *Truth held forth*. In his examination of the Maule trial and its attendant circumstances, Matt Bushnell Jones wrote by way of summary: "it must be conceded that the Salem Quaker won the first victory for freedom of the press in America under conditions that reflect great credit upon the puritan jury that set him free." The whole question of censorship in the Bay Colony has been treated fully and thoughtfully by C. A. Duniway in his work, *The Development of the Freedom of the Press in Massachusetts*.

More widely known than any of the *causes célèbres* which arose in Massachusetts, and wider reaching in its effects, was the trial for libel of John Peter Zenger in New York, in 1735. One of the concluding paragraphs of Livingston Rutherfurd's *John Peter Zenger, his Press, his Trial* states concisely the importance of the Zenger trial in the growth of a free press in the colonies, in the words: "The trial of Zenger first established in North America the principle that in prosecution for libel the jury were the judges of both the law and the facts. The liberty of the press was secure from assault and the people became equipped with the most powerful weapon for successfully combating arbitrary power, the right of freely criticizing the conduct of public men, more than fifty years before the celebrated trial of 'Junius' gave the same privilege to the people of England."

The exercise of censorship, indeed, was a feature of the age rather than of the place, and even before the Zenger trial, the cautious printer of the colonies found a relatively light restriction placed upon his activities. The most brutal official interference with the person and rights of a printer on record

General Conditions of the Trade

in this country is the persecution of Anthony Haswell of Vermont that occurred in the year 1799, in a period supposedly more enlightened than that in which the colonial printer lived and worked. As long as the printer of the colonies executed his work correctly and, in the vulgar phrase, kept a civil tongue in his head, he was free from interference and sure of profitable patronage. It was easy, however, to make a slip; the printer realized that always raised above him was the governor's arm, and it may not be doubted that the necessity for watching its movements was another of the conditions of his trade which kept him thin while other burghers grew portly at their ease.

If the truth be told, the printer had more to fear from the unruly people who surrounded him than from the government. It has never been regarded as good taste to differ politically from one's neighbors, and in Revolutionary America the editor who was suspected of loyalist sympathies or of "defeatism" went in fear of the mob's indignation. Rivington's New York establishment was wrecked in 1775 by a band of patriots, and the Whig Club of Baltimore twice subjected William Goddard to violence. The triumph of Goddard over his persecutors, when he was upheld by the Assembly of the State, marked the removal of the last barrier to complete liberty of speech for American newspapers.[4]

The Printer's Compensations

Hitherto this discussion of the general conditions of the trade from the standpoint of the master printer has dealt with some of the obvious difficulties that he was compelled to meet and overcome in the prosecution of his business. We turn now to the pleasanter task of showing that the printer's

trade in this period had its compensations in the form of good profit from newspaper publication and from job work, and in the satisfaction he derived from holding a position of influence in his community.

Charges for Printed Work

We begin with the staple of the colonial printing office, the blank form. In the year 1700 the Maryland Assembly passed an ordinance which required that all forms used in the courts and in government business generally be printed on the press controlled by William Bladen and sold at the fixed price of one penny each for the writs and other short forms, and twopence each for longer papers of the letters testamentary class. These prices seem to be somewhat higher than the prices charged by Franklin in the period 1730–1735, but Franklin's charge was a wholesale price fixed by competition rather than by governmental ordinance.[5] More than half a century later we find that the price for similar articles in Pennsylvania had changed very little, even though in the later period the sums are stated in colonial currency. An examination of the Work Book of Franklin & Hall shows that in the years 1759 to 1763 this firm was charging its customers slightly less than a penny each for such pieces as advertisements, lottery tickets, and enlistment forms, in lots of 200 to 500. For blank forms with their more difficult composition the price was nearer a penny-halfpenny each in lots of a similar or larger size. Composition was the expensive feature then as now. For small orders the prices per piece were proportionately higher, but in making the comparison it must be remembered that while the Maryland price of 1700 is a retail price stated in sterling money, the Philadelphia charge of

General Conditions of the Trade

1760 is given in local currency, then exchangeable with English money at a premium of seventy per cent. With this qualification in mind, the Philadelphia printing of the later period seems to be slightly less costly than that of the Maryland office of 1700.

The prices for book printing at different periods are also ascertainable. In the year 1662, Samuel Green, working part of the time alone and the remainder of the time with the help of Marmaduke Johnson, was paid an average price of 60 shillings a sheet for printing forty-six sheets of the Eliot Indian Bible. Green did not own the press or letters he used in the work, nor did he supply ink or paper, so that to all intents this sum was wages for the labor of himself and his assistant. Viewed in this light, 60 shillings sterling seems a high charge for composition and presswork on a single sheet in quarto, but when it is remembered that the page was set in bourgeois or nine point type, in double column, in a language unknown to the compositor, and that the rate of progress with two men at work was but a sheet a week, this payment does not continue to seem extraordinarily high. When the Corporation for Propagating the Gospel, in the preceding decade, was having the Eliot Indian Tracts printed in London, the charge, less paper averaged 40 shillings a sheet in quarto, printed in a larger type, in the English language.

In the year 1726, William Parks was allowed 20 shillings sterling a sheet by the Maryland Assembly for the printing of its journals, and calculations that need not be repeated here indicate that this was the rate of his remuneration in later years when he was given a per diem of 100 pounds of tobacco for the same service throughout the sessions of Assembly. The journals in question were printed in small folio, in the English language, in pica or twelve point type, in

editions doubtless under 500 copies, so that his lesser rate of payment seems justly proportioned to the task and payment of Green and of the London printer whose charges have been mentioned. Parks was the owner of his equipment, but it is probable that the paper for this particular task was provided by the Assembly.

In the period 1730–1735, Franklin was being paid 26 shillings a sheet by the Pennsylvania Assembly for the printing of its journals, and 25 shillings a sheet for the laws. These volumes were in folio, but his charge for printing Arscot's *Some Considerations Relating to the Present State of the Christian Religion*, in small octavo, was also 26 shillings a sheet. It is difficult to understand why the Arscot book with its greater amount of composition and greater difficulty of imposition should not have been charged at a higher rate than that which seemed reasonable for the folio laws and proceedings. Other books of this period were charged uniformly in the Franklin accounts at 25 or 26 shillings a sheet, apparently without regard to format. This practice prevailed in the London shops at an even later day, but it will be seen that with the passing years Franklin arrived at a method of fixing prices that seems more equitable to the printer.[6]

Franklin's Scale of Charges and Wages

It is possible to speak with greater certainty of the American printer's prices and charges a generation later. There is given below the whole of a document found in the American Antiquarian Society from which a portion was quoted in the preceding chapter. This paper, in the hand of Benjamin Franklin and endorsed by Isaiah Thomas, runs as follows:

General Conditions of the Trade

Prices of Printing Work in Phila^a 1754.

Books per Sheet

Compute Journeymens' Wages at Press and Case, treble the Sum, and that is the Price per Sheet for the Work. If you find Paper, allow yourself at least 10 per Ct in the Price of it.

For Pamphlets of 3 Sheets, and under, 'tis best to agree at so much a Piece. Compute the Price by the above Rules, add the Paper, then add for folding and stitching 6 d per Quire; divide the whole Sum by the Number to be done, and if the Cost of each Book be above 3 d, call it 3 d ½; if above 3 d ½, call it 4 d, &c. and fix the retail Price at ½ or a 3d more, as may be found most convenient.

Single Advertisements, of a moderate Length, 5/- In the Gazette, small and middling Advertisements at 3/ the first Week, and 1/ per Week after, or 5/ for 3 Weeks. Longer ones to be valued by Comparison with the foregoing; as if 20 Lines be a middling Advertisement, Price 5/ for 3 Weeks, one of 30 will be 7/6d, &c. judging as near as you can, by the Sight of the Copy, how much it will make.

Blanks for Offices, ½ Sheets, No 300 and upwards, Printing 1 d a Piece.

Broadsides Ditto 2 d a Piece

Hatters Bills 25/ per 1,000

Paper Money 1 d per Pound, besides Paper and Cuts.

Party-Papers, Quadruple Journeymens' Wages.

Bills of Lading 6/ per Quire

Apprentices Indentures 8 d a Pair, 6/ per Doz

Bonds 4 d Single, 3/ per Doz. 5/ per Quire

Bills of Sale 3 d—2/3 d per Doz

Powers of Attorney 4 d—3/ per Doz

Portage Bills 8 d each.

Journeymen's Wages

For composing Sheet Work, 6 d a 1000 Letters, to be reckoned by m's, an m laid on its Side being 2 Letters.

Small Jobs reckoned by the Hour, at 9 d per Hour.
- For composing an Advertisement, or any such small Job, in Quarto, Great Primer or Double Pica,— 6 d
- Folio Ditto—1/
- Blanks, 1 Side of a Half Sheet, in English or Pica, Pot or Pro Patria Size, — 1/6^d
- And other Jobs proportionably, according to Size of Paper and Letter.

Presswork, 12 d per Token, which is too much, if Pressmen had constant Work, as Compositors; but in America Numbers being generally small, they must often stand still, and often make ready.

For Jobs—An Advertisement, 60 No or 100, 6 d — and 6 d per 100 more.

If Work makes less or more than even Tokens, all Numbers above 5 Quires to be reckoned a Token; all under, nothing; i. e. 4 Token and 5 Quires is but 4 Token; 4 Token and 6 Quires, 5 Token, &c.

The Colonial Printer

A Franklin Charge Analyzed

Fortunately this list of charges and wages is not the only knowledge we possess of the business end of the Franklin establishment. The entries in the Work Book of Franklin & Hall, already referred to in this chapter, show us the practical application of these price schedules to the finished work of the office at almost the same period. It is proposed to examine here a typical entry of this sort which illuminates our immediate problem and adds facts of interest to what is already known of a once important American pamphlet.

Under date of July 16, 1764, we find the following entry in the Franklin & Hall Work Book:

Thomas Ringold Esq — Dr.

To Printing Remarks upon a Message sent by the Upper to the Lower House of Assembly of Maryland 500 copies making 4½ Sheets at 50/ [a] Sheet	11- 5-0
To 5 Reams & 5 Quires of Paper for Do. at 14/	3–14–0
To folding and Stitching Do	2– 0–0
To Box for Ditto	7–6
	[17– 6–6]

According to the first clause of the schedule given above, the 50 shillings a sheet that Franklin & Hall charged Thomas Ringold for the pamphlet represented a labor cost of about 17 shillings and a gross profit to the printer of 33 shillings for each of the four and a half sheets. When we add to this the 7 shillings that represent the ten per cent profit taken by the printer on the cost of the paper, we find that he took from this job a gross profit of something like £8. If office time, rent, lost time of workmen, deterioration of equipment, and other overhead charges reduce this amount to £6, his net gain on what must have been a typical pamphlet job was roughly thirty-five per cent, on the face of it a comfortable enough profit. The customer, too, was probably satisfied, for the neat-

ly printed pamphlet of some seventy-two pages, folded and stitched, cost him only 8½ pence currency a copy.

Other Cases Discussed

One may not assume that this percentage of profit was maintained everywhere and for a long period, but the knowledge of its possibility lends interest to the examination of any printer's bill of the colonial period encountered by the investigator. In the spring of 1765, James Parker moved a press from New York to Burlington, New Jersey, principally for the purpose of printing Samuel Smith's *History of New Jersey*, fulfilling a promise to the author made seven years earlier. The work required some six months to accomplish, and as Parker was doing little other work at the time, either at Woodbridge or in Burlington, we cannot think of him as becoming wealthy from the conduct of his trade, though his charges for printing and for paper seemed well abreast with, and even somewhat ahead of, current printing prices. Doubtless the extraordinary circumstances, that is, the bringing of a printing establishment to an author instead of the more reasonable general practice, justified the charges in the following bill for 600 copies of a work in octavo, in type of pica size:

Samuel Smith Esqr to J. Parker Dr.

1765 To printing 36¾ sheets of History at £3	£110:5:0	
To 54 Ream of Paper for the above at 20/	54:0:0	
	164:5:0	
Credit: By Cash received (I think)	110	
	£54:5:0	

Received April 19, 1766. the full Balance of the above
Account pr. James Parker.

The Colonial Printer

The following bill presented by Timothy Green to the Connecticut Assembly for printing the collected laws of 1784 has a similar quality of interest. His charge of 40 shillings Connecticut currency or 28 shillings sterling for a sheet in folio, four pages to the sheet, seems somewhat higher than Franklin's charge of 50 shillings Pennsylvania currency or 30 shillings sterling for a sheet printed in octavo less than a generation earlier. It is to be observed that the paper cost in this post-war period had risen from 14 to 20 shillings a ream, an increase not fully accounted for by a difference in quality or by the nearness of Franklin to the paper-making center of the country.

State of Connecticut

To Timothy Green, Dr

To printing 505 Copies of the late revised Laws, consisting of 70 & ½ Sheets each, @ 40/	£141	0	0
To folding and inserting the same	12	10	0
To Abel Buell's Bill for engraving the State Arms	2	0	0
To Cash paid for Copper for the same	0	4	0
To 84 Reams and a half of Paper, for printing said Book, @ 20/	84	10	0
To 25 Reams and a quarter ditto, for Blank Paper at the End of the Book, @ 12/	15	3	0
To cash paid for Freight of 110 Reams of Paper @ 3d	1	7	6
To finding Materials, and binding 505 Books, @ 5/	126	5	0
To Cash paid for transporting 42 of said Law Books to the Assembly, in May last	2	0	0
To lettering 5 Books on the Back, @ 9d	0	3	9
To four Boxes made for transporting said Books	1	4	0
To Cash paid for Truckage, at sundry Times	0	3	9
To Cash paid for Freight and Storage	0	12	0
	£387	3	0
Cr By an Order drawn in favour of Col. George Pitkin	50	0	0
Balance due	£337	3	0

Errors excepted.

Timo. Green.

General Conditions of the Trade

The foregoing cases, taken from widely separated periods of the era, seem to indicate that at no time in North America were printing charges notably different from those which prevail in the trade at the present day.[7]

English and American Charges

Opportunity for comparison of these prices with those charged by English printers of the mid-eighteenth century is afforded by an entertaining and valuable contribution by Mr. R. A. Austen Leigh to *The Library* for March, 1923, entitled "William Strahan and his Ledgers," especially pages 280–284. From such comparison one learns that, in general, printing charges in the colonies were distinctly higher than in London. A sheet of octavo in Philadelphia in 1764, as we have seen, cost the customer 50 shillings currency or, roughly, 30 shillings sterling. A similar sheet is charged in London in the same period at 20 or 23 shillings sterling. Green's Connecticut laws of 1784 in folio, straight composition, were charged at 40 shillings a sheet, which at the value of the Connecticut currency of that period meant 28 shillings sterling. Johnson's folio *Dictionary* of 1755, in double column, difficult composition in two different sizes of type, cost its promoters, we learn from Strahan's ledgers, only 38 shillings sterling a sheet.

It could hardly have been the item of wages, as sometimes taken for granted, that was responsible for the greater prices charged the consumer by the American printer. The evidence presented in the preceding chapter seems to show that from 1754 until the close of the century, the American compositor was paid at the rate of sixpence currency a thousand letters. During a part of this period, the remuneration of the English

compositor was fourpence sterling for the same service, a sum almost invariably equal to, or greater than, sixpence in colonial currency at the prevailing rates of exchange. In 1785, the English compositor's remuneration was increased to fourpence halfpenny a thousand letters,[8] and with this change the payment of the English compositor became actually larger than that of his American contemporary by nearly a penny a thousand letters. If a similar relationship existed in the wages of pressmen, we must look further for an explanation of the American printer's charges. Perhaps it may be found that a greater volume of business, a firmer market, and a better organization of the craft enabled the English printer to take a smaller profit from the individual job than the printer of the American towns was compelled to do in order to make a living. Or, it may be that the more active competition of the London trade kept the English printer's charges at a lower level than that which prevailed in the colonies.

The Franklin & Hall Partnership

If we may judge from the case of the Franklin & Hall partnership, printing in America was a reasonably profitable trade. The partnership account of this firm for the eighteen years 1748 to 1766 shows that the principal partner received, when his share of operating expenses had been deducted, the sum of £8414 sterling. This yearly income of £467 sterling resulted from a half share in an establishment of which the operating equipment, at the conclusion of the partnership, was valued at only £184.[9] The reputation of Franklin as a printer and his position in colonial politics brought an exceptional amount of business to this firm, even though its senior partner was only intermittently active in its affairs. These fig-

General Conditions of the Trade

ures cannot be taken as typical, therefore, but there is other evidence that the colonial printer found himself in a business in which industry, enterprise, and reasonably good craftsmanship were rewarded normally by a decent living if only rarely by large monetary return.

The Position of the Printer

In the colonial town of the earlier period and in the smaller towns always, the position of the printer was distinctly one of importance based upon responsibility. It depended, of course, upon the personality and ability of the individual whether or not he was able to enjoy the rewards his position offered in the form of social and political esteem, but potentially, at least, both these were in its gift. Various circumstances combined to make his shop a civic center. To begin with, as the largest and most regular patron of the post, he found himself almost as a matter of course the postmaster of his community. To the door of the printing office came the post rider with his mails, and on the heels of this exciting personage came the citizen for his private letters, the official for his instructions, and the merchant for his remittances or for the latest "prices current" from the larger centers of trade —all of them, once their personal mail had been received, eager to learn what news of the outside world had come to the printer through his "exchanges" from New York, Philadelphia, or Boston. Inevitably under these conditions the printing office became one of the focal points of the town's life, a place of congregation and of interchange of gossip, and it is not matter for surprise that the enterprising printer took advantage of the coming and going of his neighbors to conduct on the premises a shop for the retailing of stationery,

small groceries, and notions. Thomas Short of Connecticut was prepared to sell books, ink-horns, pins, thread, sealing wax, thimbles, fans, ivory combs, flints, sugar, ginger, and indigo. Andrew Bradford of Philadelphia once called attention to a curiously unclassified stock in the form of whalebone, live goose feathers, pickled sturgeon, chocolate, and Spanish snuff. Hugh Gaine sold patent medicines, flutes, and fiddle strings. Many of the printers bound books; most of them bought rags for the paper mill; all of them acted as agents for distant advertisers. The vestry, the club, and the town meeting knew the printer as clerk or registrar. Sometimes, with ready tongue he acted as auctioneer at the local vendues, and occasionally his voice was heard from the pulpit. He placed himself where local news was being made, or where news from other places could be most readily obtained, and in general, he served his own interests by participating in a variety of activities in the public behalf. Not all printers were fitted to take advantage of the opportunities thus presented, but as the century progressed, the conditions seemed to produce a type—men like the Greens of Connecticut and Maryland, John Carter of Providence, Isaiah Thomas of Worcester, William Bradford and Hugh Gaine of New York, Franklin and the Bradfords of Philadelphia, William Goddard of Providence, Philadelphia, and Baltimore, the Timothys of Charleston, and William Parks of Williamsburg. These and a few others were the great printers of their times; in varying degrees they were also important, if not always eminent, among the citizens of their respective communities.

General Conditions of the Trade

The Printer in Politics

The importance of the printer in the political life of his colony needs little comment besides the reminder that as publisher of the newspaper he was also in early days its editor. In spite of his usual claim to non-partisanship, he was a human being with opinions, business and social affiliations, and an open eye for the main chance. The actions of the royalist printers in the years just before the Revolution, the actions of various printers in various local crises, show that it needed only a cause of importance to bring the printer into line on one side or the other of the existing contention. His journalistic influence was not exercised openly, as it is today, through the expression of editorial opinion—he maintained his show of a free press too well for that—but in the suppression of news, in the closing of his columns to the political articles of the opposition, or in the refusal to print pamphlets or broadsides inimical to the cause he favored. In 1732, the unpopular cause of the established clergy of Maryland represented by the Reverend Jacob Henderson was forced to seek expression in Philadelphia in the columns of the *American Weekly Mercury* and in pamphlets printed in that city, rather than through the medium of the press of Annapolis. A generation later, the Reverend John Camm of Virginia, pleading a similar case, found himself compelled to take his pamphlet to Annapolis for printing because Royle, the Williamsburg printer, refused its publication on the ground of its "Satyrical Touches upon the Late Assembly." It may mean all or nothing that in both these cases the chief opponents of the reverend authors were the leading men of their respective colonies, in the one case Daniel Dulany, the Elder, in the other, Colonel Landon Carter and Colonel Richard Bland.

The Colonial Printer

When Bland wished to reply to Camm in the following year, he found Royle's press open to him for the purpose. In 1766 Samuel Chase found himself in the course of a local political disturbance shut off from access to the columns of the *Maryland Gazette*, and perforce took his copy elsewhere for printing. A better-known case than any of these is that of Thomas Maule of Boston, who, running counter to the Mather influence in the closing years of the seventeenth century, was compelled to send his *Truth held forth* and his *New England Persecutors Maul'd* to be set in type by William Bradford of New York. In the *Maryland Gazette*, at various times in 1766, a controversy was carried on between Royle, the Williamsburg printer, and certain Virginians who accused him of refusing to publish their attacks upon the local government. In that year, William Rind went from Annapolis to establish a press in Williamsburg, and it hardly need be said that the determining cause of his venture was the need for a vehicle of expression felt by the Virginia opposition party. Thomas Jefferson wrote years later of this incident: "we had but one press, and that having the whole business of the government, and no competitor for public favor, nothing disagreeable to the governor could be got into it. We procured Rind to come from Maryland to publish a free paper." [10] A catalogue might be made of instances wherein similar charges were brought against colonial printers. This potentiality of his office gave the printer a power in the community that took him far outside the craftsman class to which he normally belonged, and to this influence the grace of popularity was often added by his genuine services to the ordinary citizen.

X
Bookbinding in Colonial America

AT the time of the invention of printing, the binding of books had already passed from the hands of the goldsmith and the enamel worker into the care of a craftsman who made it his principal occupation, and carried it on usually in a separate establishment. At all times since, local conditions have frequently brought about a temporary merging of the printer's and the bookbinder's functions, but the normal practice in large and industrially well-advanced communities has been that the printer should turn over his sheets to a binder outside his own establishment, or to a publisher, who in turn would employ a craftsman of this character. But in the smaller towns of colonial America, where organization was late in reaching this degree of perfection, we find prevailing in the printing shops that duality in function which has been spoken of as a frequent necessity imposed by local conditions.[1] In those places the printer was printer and publisher too, and because there was not enough business available in his community to justify the presence of a local bindery, he undertook on his own account to put into boards and leather such productions of his press as he considered worthy of a dignity greater than the familiar blue or marbled paper in which were issued his pamphlets and unimportant books. One of the peculiar vexations of his lot was the scarcity of skilled workmen in this branch of his business, though the enterprising and well-established printer seems generally to have succeeded in attaching to himself either by hire or by indenture one or two printing craftsmen skilled also in the binding of books. The women of the family, furthermore, could be depended upon for aid in a branch of his

business more nearly suited to their capabilities than the work at case or press. When help from these sources was available, therefore, he was able to advertise his preparedness for the local custom work and to give the protection of stiff covers to the finer or more important books of his own production.

Separation of Printer and Binder

It is not necessary to produce evidence of the unity of bindery and printing office in the smaller communities of colonial America, for the customary advertisements of the printers have left us in no doubt as to the existence of this condition. A more interesting question is the extent to which the bindery existed as an establishment independent of the printing house, or as an appendage to the business of a local bookseller. It is not possible to say that the John Sanders, bookbinder, who took the Freeman's Oath in Boston in 1636 and purchased a shop of some sort in 1637, afterwards exercised his craft on the Bay Psalm Book or on other productions of the Daye press, but certainly the cleavage began to show itself very early in the history of the trades. Though Samuel Green seems to have bound in the regular course certain copies of the Eliot Indian New Testament, printed by him in 1661, a great part of the whole Indian Bible of 1663 was turned over for binding to John Ratcliff of Boston, who on one occasion wrote that the binding of the Bibles had been "the onely incourageing work which upon good Intelligence caused me to transport myselfe, and family into New England." Ratcliff later undertook bookselling and publishing in a small way and continued to bind and to sell books until sometime after 1682. After the year 1671 he had a rival in the person of Edmund Ranger, who carried on for a time a

Bookbinding in Colonial America

bookbinding and bookselling business in the same city.[2] If the existence of bookbinding as a separately established craft is to be looked for anywhere in the colonies, it would naturally at this time be found in or near Boston with the college near by in Cambridge and with a people among whom the possession of books was a commonplace of experience. The condition is not found immediately in other cities. In the *Pennsylvania Gazette* of February 3, 1729/30, however, W[illiam] Davies in Chestnut Street, Philadelphia, informs the readers that he binds books in the best manner, and in the same journal, on April 30, 1730, John Hyndshaw inserts a more elaborate plea for the custom of the townspeople. An advertisement in the *New-York Gazette* of October 7, 1734, announces that "Joseph Johnson of the City of New-York Bookbinder, is now set up Book-Binding for himself as formerly, and lives in Duke-street . . . near the Old-Slip Market; where all Persons in Town or Country, may have their Books carefully and neatly new Bound either Plain or Gilt, reasonable." Johnson had been made a freeman in 1731, and one makes the guess that he was a former workman of the Bradford establishment, in which a bindery had probably been conducted since its beginning in 1693. By the middle of the eighteenth century the printer of New York or Philadelphia or Boston who bound books in his own shop did it from choice, and not because it was forced upon him by the exigencies of his situation. It was different in the smaller town; in Annapolis, Williamsburg, and Baltimore, the printer, almost throughout the century, continued, whether willingly or not it is difficult to say, to bind his own productions and to advertise his ability to care for the casual needs the townspeople felt in this particular. Occasionally his monopoly was invaded by a visitor from the outer world, for among the innu-

merable "Hawkers and Walkers in Early America," to quote
the pleasantly chosen title of a book published some years
ago, there were itinerant binders who travelled from town to
town and made visits long or short in proportion to the local
printer's need for their services and to the volume of custom
brought in by the townspeople in answer to advertisements
published in advance of the visitation.

It is not especially a cause for wonder that the separation
between printing office and bindery was slow to occur in the
smaller American towns. There are reasons for this indeed,
other than the lack of patronage for the separately conducted
bindery. The differentiation between the functions of printer
and publisher was itself late in taking place in these commu-
nities, and binding naturally follows the publishing and sell-
ing end of the business. Then, too, the colonial printer in the
small town found himself a man of varied interests: editor,
printer, and publisher, he was usually postmaster, frequently
a town official, and nearly always something of a general
merchant. As suggested in the preceding chapter, the lists of
commodities kept on sale in some of the printing offices are
amazing in their variety and sometimes amusing by reason
of their incongruity. It is perhaps natural that a business so
closely allied to his own as bookbinding should have been re-
tained by the printer long after he had given up the sale of
chocolate, Spanish snuff, cough medicine, fiddle strings, pick-
led sturgeon, and other exotic articles of which his communi-
cation with the outside world made him in earlier days fit-
tingly the vendor.

Bookbinding in Colonial America

Materials Locally Available

The materials of ordinary bookbinding have been much the same since the earliest days of printing, that is, wooden board or pasteboard as stiff, protecting cover, a durable stuff such as leather or parchment to preserve the board and give finish to the volume, glue and paste, pack thread for bands and linen thread for sewing. The essential implements, too, have always been of the simplest character, though in the matter of tools for decorative purposes, susceptible to infinite differentiation. This is a craft in which deftness of hand, trueness of eye, and the craftsman's taste and conscience tell the story of excellence in attainment rather than a multiplicity of tools and materials. Though the requisite skill was not always available, it happens that in the colonies the materials were not especially difficult to procure even in the early days of bookmaking. Most of the binding done in the frontier towns of America was utilitarian in character, and naturally we fail to find on the books much morocco or levant, which must be imported from goat-raising lands. We are not especially astonished, though, to come upon books bound in calf or sheep of native tanning, or even in the inferior grades of parchment and vellum that the country produced. Leather manufacturing, indeed, was one of the earliest of native American industries. Virginia had a tannery as early as 1630, and a few years later another began operations at Lynn, Massachusetts. A Massachusetts law of 1640 required that hides be carefully removed and taken promptly to the tanneries for proper treatment, and penalties were provided for persons who, attempting to tan their hides at home, produced a leather liable to quick putrescence. In a report of the Lords of Trade of 1734 it is said of the people of Massachusetts, "A great part of the

[195]

The Colonial Printer

Leather used in the Country is . . . manufactured among themselves." A Maryland law of the year 1662 forbids the exportation of hides to the New England tanneries for the reason that by this practice the local leather manufacture was being hindered in its development. The making of leather became an industry of constantly increasing importance in the colonies, and by the first decade of the nineteenth century, the value of the annual output of the tanneries of the United States had reached the sum of twenty million dollars. Throughout the colonial period, therefore, the binder had not far to seek for the principal material used in his craft, and in that report of the Lords of Trade just referred to we are told that the recent settlement of several Irish families in Massachusetts had resulted in the making of good linen as a local manufacture. As a matter of fact, flax was being grown and linen made in Massachusetts and Connecticut and probably in Virginia as early as 1640, and this means, doubtless, that the linen thread used for sewing the sections could be obtained in the country at a relatively early period.[3]

In the inventory of Thomas Short, a printer of Connecticut who died in 1712, is found the entry, "to Implements to bind Book with Leather Skinn and Scabord—£3–00–00."[4] A brief analysis of this item in the account serves to advance the study of the conditions under which the colonial binder carried on his business. The word "scabord" is a contraction of scaleboard, the thin wooden board of oak or birch used by the earlier binders of many lands as their stiff, protective cover. Its use in binding was frequent in American books throughout the colonial period and well into the nineteenth century. Even when covered only with heavy paper, it was regarded as a fitting and sufficiently handsome binding for

Bookbinding in Colonial America

school-books and for other volumes destined to rough usage. The distinction set up in Thomas Short's inventory between "leather" and "skinn" is doubtless a recognition of the difference between the hide of the cow, the sheep, or the calf made into leather by the process of tanning, and the skin of the sheep or the calf made into parchment or vellum by the process of liming, scraping, chalking, rubbing with pumice, and curing. The original bindings of the Bay Psalm Book, the first book from the Cambridge press, were of calf or of vellum; most of the copies of the Eliot Indian Bible were bound in calf, though in Samuel Green's bill to the Corporation, in 1662, appears a charge of 5s. 6d. for "pack thrid and vellum," used doubtless in binding some of the 200 copies of the New Testament specified later in the account. An unstiffened vellum was a favorite material for the covering of manuscript books of records, but there have been preserved few examples of English-American printed books contemporaneously bound in covers of this material. On the other hand, relatively few Mexican printed books have been preserved in any original cover other than vellum. It was a reasonably cheap product, though, in English America, for as early as 1704 the Maryland government was paying only 18 pence a skin for locally-made parchment of a quality good enough to engross laws upon, and, as opposed to this modest price, we find Franklin, in 1732, paying 3 and 4 shillings and more for calfskins to be used by Stephen Potts, the journeyman binder associated with him at this time. In spite of the cheapness of vellum, however, of its durability, and of its nobler character, it was less generally used in the colonial binderies than the tanned leathers made from the hides of the calf and the sheep.

Milch and beef cattle were the animals principally raised

The Colonial Printer

by the English settlers, and it was a local economic factor that caused their books to come to them clad in dull brown leather rather than in the gay and pleasant white skin that is manufactured in quantity in sheep-raising countries. It is possible, too, that eternal artistic fitness worked its will upon the people, and that a half-realized sense of propriety in fitting cover to contents led the binders to put the sombre books of the period into sombre covers.

Economies in the Bindery

The absence from the colonial scene of skilled craftsmen was not the only difficulty that faced the printer-binder of this period. Even though most of his material was to be had locally, there were certain articles, in the earlier years at least, that must be imported. In 1664, John Ratcliff of Boston complained of the insufficiency of his payment for binding and clasping part of the issue of Eliot's Indian Bible. "I finde by experience," he writes, "that in things belonging to my trade, I here pay 18s for that which in England I could buy for four shillings, they being things not formerly much used in this country." Though conditions inevitably improved as time went on, there must often have been periods of stringency in a country not essentially industrial in character. It is interesting to see one of the practices of an earlier day repeating itself, to see the American printer-binder, temporarily out of binder's board, forced to the adoption of economies not unfamiliar in the European shops of the fifteenth century. Here again we find shop waste being utilized as lining and backing, and even as board itself when pasted and pressed together in numerous successive laminations. The tale of important fragments rescued from bindings of fif-

Bookbinding in Colonial America

teenth-century books is endless. Most of the so-called Cos-
teriana have been found in the bindings of early books; many
sheets of the Gutenburg Bible and many important broadsides
and engravings have been rescued from their useful and in-
glorious servitude by sharp-eyed salvagers of bibliophilic
gems. A number of similar retrievals have been effected from
colonial American books in the past decade or two. Not many
years ago Wilberforce Eames recovered from the binding of
a William Bradford book, belonging to A. S. W. Rosenbach,
parts of ten different imprints of this first New York printer,
and of these fragments, two were found to be portions of titles
not previously recorded among the productions of Bradford's
press. The Maryland Historical Society copy of *A Collection
of the Governor's Several Speeches*, a rare book printed by
Jonas Green in 1739, was recovered entirely from the bind-
ing of a copy of the ensuing year's session laws, in which, for
nearly two hundred years, its separate leaves, pasted and
pressed one upon another, had served the purpose of binder's
board. This particular copy of the session laws had been sent
to England to Lord Baltimore, and because of its special im-
portance, it had been put into leather covers by the printer,
and because of the need for haste in supplying the Proprie-
tary with the newly enacted statutes of his province, the
printer had not been able to wait for the arrival of a supply
of pasteboard, doubtless expected from England on the next
ship, or by road or schooner from Mr. Franklin in Philadel-
phia. The John Carter Brown copy of the *Compleat Laws of
Maryland*, printed by William Parks of Annapolis in 1727,
carried as a lining a variant and rejected title-page for that
book, pasted printed side down, which when removed and
read for the first time in two centuries brought to knowledge
an unexplained change of mind on the part of the editors

while this work was actually in the press. Some day, perhaps, the eyes of a worthy bibliophile will bulge with wild surmise when he soaks the boards that cover an early Cambridge book and sees emerging some thirty or forty copies of "The Oath of a Freeman," shut off from human sight these three hundred years.

Remuneration of the Binder

The remuneration of the bookbinder, like the wages of the printer, seems to have remained at much the same point during the long period for which we have records. In 1662, Samuel Green put in his printing bill a charge for binding 200 copies of the Indian New Testament at sixpence each. This was a quarto of thirty-three sheets, bound in leather. Two years later he received the sum of 2*s*. 6*d*. each for binding 200 copies of the whole Indian Bible, a quarto of 150 sheets, bound in full leather with clasps. John Ratcliff, the Boston binder, was paid the same amount for those copies of the Bible bound in his establishment, and as we have seen, he felt that because of the cost of materials, the sum was insufficient. He affirmed that he could not live comfortably on a rate of payment less than 3*s*. 4*d*. or 3*s*. 6*d*. a book, "one Bible," continues the appeal, "being as much as I can compleat in one day, and out of it [i.e., the existing payment of 2*s*. 6*d*. a copy] finde Thred, Glew, Pasteboard and Leather Claps, and all which I cannot suply my selfe for one shilling in this country." In 1714, Elizabeth, the widow of Thomas Short, the first Connecticut printer, bound 2000 copies of the Saybrook Platform printed by her husband in 1710, receiving £50 for the job. This piece of work by the first woman binder of record in America is rather crudely ac-

Bookbinding in Colonial America

complished in leather over birch boards. It comprises eight
sheets in octavo, and the sixpence a copy Mrs. Short received
for the binding was probably good pay for quantity produc-
tion. In 1731, Franklin paid his journeyman Stephen Potts,
who was also his binder, 8 shillings for binding a Bible, 3*s.*
6*d.*, for binding two other books, and sixpence for binding
two blank books. In 1734, Franklin's charge for binding for
Thomas Penn "a great book of Birds" was £1. 10*s.* If that
was the huge folio in which Catesby's *Natural History of
Carolina* was published in London, Volume I in 1731, the
extraordinary size of the charge is explained. He took no
profit on these transactions and billed his customers for the
amounts credited to Stephen Potts on his books. There is a
great difference between the 2*s.* 6*d.* paid Ratcliff in 1663 for
binding the Indian Bible and the 8 shillings paid Potts for
binding a Bible in 1731, but even if the size of the books
would not account for the greater charge, it must be remem-
bered that the one was an edition job, the other a custom
job. On edition work, Franklin's charge in 1731 was the same
as that of Mrs. Short some seventeen years earlier — sixpence
a copy for 1000 copies of Arscot's *Some Considerations*, a
book of sixteen sheets, issued in two parts in 1732. Coming
to the year 1769, we find Hugh Gaine of New York inform-
ing Sir William Johnson that the cost of binding in plain
leather the Mohawk Book of Common Prayer, an octavo
comprising twenty-six half sheets, would be 2 shillings cur-
rency a volume instead of 1*s.* 6*d.* as formerly estimated.
Those to be bound in morocco, a leather for which he must
send to Boston, would naturally cost more, but the price was
not specified. In 1775, Valentine Nutter, a binder situated
opposite the Coffee House, charged Gaine 1*s.* 6*d.* a volume
for 250 sets of Chesterfield's *Letters*, a duodecimo in four

volumes, containing an average of nineteen sheets each. Somewhat later than this we find a bill of Timothy Green of New London for printing the *Laws of Connecticut* of 1784. For binding this work, issued in an edition of 505 copies, comprising seventy-one sheets in folio, Green received from the state the sum of 5 shillings a copy for the work and the materials.[5]

Paper Covers

The normal issue of the American shop, the book of session laws or assembly proceedings, the pamphlet, and the sermon, did not attain the dignity that used to impress Dr. Johnson. This was not, in the Doctor's phrase, "a bound book," and therefore intrinsically worthy of respect. It was sent into the world folded and sewn, with a paper cover "drawn on," that is, pasted to the end papers at front and back. This cover was ordinarily either plain blue or marbled paper. Sometimes a more interesting stock was employed for the purpose. The John Carter Brown copy of the *Charter of the City of New York*, printed by Zenger in 1735, has a drawn-on cover of later date of greenish paper stamped in gold with a decoration of animals of many species and sizes. This "Dutch gilt" paper, as it was called, forms an interesting cover, and in its original condition, when the gold was brilliant, it must have shown a brave and pleasant face to a world accustomed to the monotony of blue or marbled papers. A Dutch gilt paper stamped with scenes of religious significance — Christ emerging from the tomb, and St. John with pen and book and eagle — forms the cover of a *Catechism of Nature for the Use of Children*, of Philadelphia, 1799. Indeed, Isaiah Thomas and other printers of the time made frequent use of these stamped paper covers on books for children. Their use on other books

Bookbinding in Colonial America

was sufficiently general to show us that the colonial book buyer occasionally had his eyes gratified by a successful attempt at decoration, even in the case of cheaper volumes of which the covers were intended purely for protective purposes.

Decoration

The early leather bindings of the colonies were usually without ornamentation, or even, like the fifteenth-century books, without the lettering on their backs that later became the commonplace measure of utility found in connection with the cheapest volumes. The law-book style of binding, plain, undecorated calf or sheep, a familiar feature of bookshelves for centuries, represented the normal colonial book. Occasionally ornamentation was added to the cover in the form of a blind-tooled border of one or more narrow lines, or of a blind-tooled, decorated panel with a fleuron in each corner. For reasons easily understood, the use of gold leaf in tooling was slow in becoming general; even the familiar red label on the back with gilt lettering begins to appear only in the eighteenth century, though from about the year 1725, William Bradford was announcing in his *Gazette* that he bound "old books, either plain or Gilt." Indeed, what has just been said is subject to further qualification, for now and then a piece of special binding was accomplished that would nullify all these statements if it were not intended they should apply only to the normal book of the period. It will be interesting to examine certain early American bindings that stand out as exceptions to this generalized description of the colonial book.

The Colonial Printer

The Ratcliff and Ranger Bindings

There are known to exist nineteen books, now widely scattered throughout the country in their physical bodies, which form, in identity of features, and in the circumstances of their binding, a distinct and recognizable group. This group comprises the following books, most of them described at length by Thomas J. Holmes in a paper read in April, 1928, before the American Antiquarian Society:

(1) The Bay Psalm Book, 3d ed. Cambridge, 1651. Copy in the New York Public Library, bound in brown sheep with ornamentation in gold tooling.[6]

(2) Eliot Indian Bible, Cambridge, 1663. Copy in the possession of Mr. J. K. Lilly, Jr., of Indianapolis.

(3) Eliot Indian Bible in the Harvard College Library.

(4) The Massachusetts Laws of 1672, Cambridge, 1672. Copy in the American Antiquarian Society, bound in polished calf, with ornamentation in gold tooling.

(5) The manuscript Commonplace Book of Samuel Sewall, now in the Massachusetts Historical Society, bound in sheep with blind tooling.

(6, 7, 8, 9) Hubbard's Narrative of the Indian Wars in New England, Boston, 1677. Copies in full calf, blind tooled, in the American Antiquarian Society, the John Carter Brown Library, Goodspeed's Book Shop, and A. S. W. Rosenbach.

(10) Increase Mather, A Call from Heaven, Boston, 1679. Copy in the Library of the late Tracy W. McGregor, of Washington, D. C., formerly in the Mather collection of Willian Gwinn Mather, Cleveland, Ohio, bound in brown morocco, with ornamentation in gold tooling.

(11) Volume of tracts in the Henry E. Huntington Library, No. 551 of the Church Catalogue, bound in 1681, or later, in brown morocco with blind tooling.

(12) Volume of tracts in the Library of the late Tracy W. McGregor, formerly in the William Gwinn Mather Collection, bound in sheep with blind tooling.

(13–19) Seven volumes described by Thomas J. Holmes and William G. Land in the *Proceedings of the American Antiquarian Society* for October, 1929.

In all but the first volume of this group of bindings is found identity in the decorative tools employed and a similarity in style so great as to leave one in no doubt as to their common origin. The excepted volume, moreover, partakes to such an extent of this distinctiveness of style that it falls naturally into the group in spite of a difference in the tools employed in decoration. For the purpose of illustrating the type of ornamentation represented in this group, there is

[204]

Bookbinding in Colonial America

shown in Plate xxi the binding of the tenth work, *A Call from Heaven*, with panelled sides formed by a gilt broken-line border, and a gilt fleuron in the center and in each corner of the cover.

The question now presents itself of the identity of the binder or binders of these volumes, and happily, the way is clear to its solution. John Ratcliff came to Boston in 1663 to undertake the binding of the Eliot Indian Bible. He remained there as bookseller and bookbinder, certainly until the year 1682, when he disappears from record. Edmund Ranger appeared first in Boston in 1671, and remained there, variously described as bookseller, bookbinder, and stationer, until his death in 1705. The doubt that might well exist as to which of these rival binders covered and decorated the books named is resolved by an inscription in No. 5 of the list, Samuel Sewall's manuscript Commonplace Book preserved in the Massachusetts Historical Society. Inscribed in the author's own hand in this volume are the words: "Samuel Sewall, his Booke, Decemb. 29, 1677. Bound by Jno. Ratcliff." Drawn by so clear a leading one hastens, or rather, Mr. Holmes, when making the study of Ratcliff bindings here summarized, hastened to examine the cover of the Commonplace Book, still in its original binding, and to compare its tooling with that of *A Call from Heaven*, published by John Ratcliff and bound at some time before 1685. It is found that the plans of decoration of the two volumes are much alike, though in the one case, blind tooling has been employed, and in the other, gilt. The more important discovery, however, is that, though used in different combinations, the tools employed to create the designs are identical. Upon further examination, either these similar designs or these identical tools used in other combinations are found in the

bindings of Nos. 2–11 of the books under consideration, and one is therefore able to speak with assurance of this group of bindings as the work of John Ratcliff, the first professional binder known to have exercised his trade in English America.

Of the group of twelve volumes in our list one may assert that the ten just specified are definitely from the hand of Ratcliff, the known binder of Samuel Sewall's Commonplace Book. Of the first and last volumes in the list, however, this assertion may be made only with qualification. No. 1, the third edition of the Bay Psalm Book, bears every evidence of Ratcliff's hand both in style of ornamentation and in technical workmanship, but the floral ornament with which it is decorated was made by a tool that Ratcliff used on no other book in the group. The result, however, of Mr. Holmes's minute examination of the book, examination of the kind that can be given only by one who is at once a scholar and a trained bookbinder, was such as to convince him that the book had been bound by Ratcliff. The case of No. 12 in our list is somewhat different. That volume seems to have been bound after 1682, when John Ratcliff is heard of no more in Massachusetts. It bears in its design certain of the Ratcliff tools, but these tools are used in combination with others not recognized as part of Ratcliff's equipment. One supposes therefore that when Ratcliff died, or returned to England after 1682, his equipment became the property of Edmund Ranger, who, Mr. Holmes assures us, was a better binder than his rival. The probability of Ranger's hand having been employed upon this volume enables us to think of Nos. 1–12 of our group of books as containing examples of the work (and pleasing, artistically conceived work it is) of the first two binders known to have practised their craft in English America outside the printing house. But in using terms indicative of priority in this association,

Plate XXI

PLATE XXII

Bookbinding in Colonial America

one keeps in mind always the possibility, and the hope, of discovering that John Sanders, "a bookebynder" who signed the Freeman's Oath in 1636 and bought a shop in Boston in 1637, may have been employed to put the original covers on the Bay Psalm Book of 1640 and on other publications of the first Cambridge press.

The search for bindings done by these earliest of colonial craftsmen is not much more than begun. Few custodians of collections that own many New England books of the period have troubled to go through their shelves with Mr. Holmes's monograph in hand, but in two cases, certainly, such a search has been made with fruitful results. Soon after the publication of his first study, three volumes were found in the American Antiquarian Society which were identified by Mr. Holmes as being, one in a Ratcliff binding, two in the superior bindings of Edmund Ranger. At the same time William G. Land made search in the Connecticut Historical Society with gratifying results, finding, and afterwards carefully describing, four volumes, of which three bear the insignia of Ratcliff and one is distinguished by the finer workmanship of Ranger. Mr. Land at the same time found a volume of Ratcliff's workmanship in the private collection of the Society's Librarian, Albert Carlos Bates. The seven volumes thus added to the original group are those referred to in our list of known Ratcliff and Ranger bindings as Nos. 13–19. Examples of the work of these two men are worth looking for, both to the antiquarian and to the historian of the American book.

The Maryland and Virginia Bindings

The existence of these exceptional examples of early binding is evidence of the probability that even in the seventeenth

century it was possible at different times and places for the man of taste to bespeak a nicely ornamented cover from the binder. The determination as "American" of bindings of this description proceeds very slowly, however, and it is necessary to pass over nearly half a century before other decorated bindings of American provenience can be pointed out with assurance to the amateur of bibliopegy. About the year 1728, though, William Parks, then of Annapolis, began to advertise himself as one "Who binds old Books very well, and cheap." In that year, he issued an edition of Holdsworth's *Muscipula* in a translation by Richard Lewis. Only three copies of this book are known to exist today, but each of the three is in its original binding, and all three bindings, save for the difference in color and variety of leather, are almost identical. One might suppose that a part of this edition had been sent to England for binding, but aside from considerations of expense and loss of time, the workmanship, particularly the handling of the roulette, is somewhat too crude to allow that possibility to be long considered. When we learn, too, that another book issued by Parks eight years later in Williamsburg is found bearing practically the same design, made up from the identical tools, in this case more deftly applied, we may assume that all four of these bindings were American in origin, and that they were accomplished in the bindery that Parks conducted in connection with his printing offices. The *Muscipula* bindings are in sprinkled calf or in morocco; the covers are panelled in gold with gold-tooled fleurons in the corners. In the Williamsburg book, the John Carter Brown copy of *The Charter of William and Mary College*, published in 1736, the binder has combined other tools with those of the *Muscipula* bindings, and, in a more elaborate design, imposed them upon an excellent blue mo-

Bookbinding in Colonial America

rocco. The somewhat meaningless angular tooling of the back between the raised bands does not detract seriously from a tasteful and well-executed binding. In the work of this printing-shop bindery one finds, so far as my knowledge carries me, almost the earliest examples of conscious artistic excellence to be met among the books printed and, without question, bound in colonial America. The only earlier bindings so far recognized of a degree of merit approaching that displayed in the Parks books are those which have been shown to be the work of the separate binding establishments of John Ratcliff and Edmund Ranger of Boston. (Plate xxii.)

New York Bindings

In 1769, Hugh Gaine, working at Sir William Johnson's expense, issued an edition of The Book of Common Prayer in the Mohawk language. The cost of sending the books to England for binding determined the choice of an American craftsman, and it was decided to have them put into covers, some in calf, a few in morocco, by a New York binder whose name is not mentioned in the correspondence that relates to the project. Sir William Johnson's own copy of this book is found in the John Carter Brown Library, and, as would be expected, it is one of the copies bound in morocco; in fact, in a very good grade of morocco of a rich red color. A flowered end paper has been employed, but a crude and unimaginative ornamentation in gold tooling has been applied to the excellent leather. If the book serves as an example of the workmanship of the average colonial binder in his exceptional moments, it brings out very clearly the superiority of craftsmanship and taste displayed by William Parks, a generation earlier, and by Ratcliff and Ranger of Boston nearly a cen-

tury before this New York binder practised his craft. A copy of the *Votes and Proceedings of the New York Assembly*, printed by Hugh Gaine in 1764, found in the library of L. C. Karpinski, wears its original covers and bears an inscription in long hand at the foot of its preface that declares it to have been "bound by Rob. McAlpine." Copies of the book in the New York Historical Society and in the library of the Grolier Club are similarly inscribed in the same place, in the same hand, while the John Carter Brown copy of this volume is identically bound with the Karpinski copy, and in the same place at the end of the preface are found the words, in a different contemporary hand, "Bound by Robert McAlpine." It may be assumed that here we have examples of an edition binding, and, what is most unusual in any place and period, an edition binding signed in autograph in three of the four known examples. This procedure could hardly have added much to the contemporary esteem of the volume, but it need not be said that posterity regards these signed McAlpine bindings with a degree of interest out of all proportion to their negligible aesthetic value. It is likely that this was the craftsman who kept Sir William's Mohawk Book of Common Prayer an unconscionable time and then spoiled an honest skin with ugly ornamentation. At any rate, there seems to have been no other custom binder working in New York in this year of 1769. As early as 1742 Franklin had employed this New York binder on several occasions.

The Distinctive Ephrata Books

It would be an error in discrimination to neglect mention of the binding accomplished by the German "solitaries" in the Ephrata Cloister at Ephrata, Pennsylvania. This com-

Bookbinding in Colonial America

munity conducted in the middle years of the eighteenth cen-
tury one of the most interesting of all colonial American
printing establishments, for its members printed books on
paper made in their own mill and bound them afterwards in
their own bindery. Here was printed and bound *Der Blutige
Schau-Platz*, the largest and ugliest book produced in colonial
America, and here, it has been suggested, was bound the
Sower German Bible of 1743. The style of binding employed
in the Cloister was the heavy, substantial covering of the
German book with which the brothers were familiar as an
ancestral heritage. The materials employed were calf or sheep
stretched over heavy, handsplit oaken boards, equipped with
well-wrought brass corners and clasped with sturdy brass
clasps. Brass-studded loops at top and bottom of the heavier
volumes offered a purchase for the hand in taking them from
the shelf. They are without lettering and decorated only with
blind-tooled designs, but solid, dependable, and well fash-
ioned in the manner one would expect from craftsmen of the
German tradition, unlike any other bindings made in the
three Americas.

A Philadelphia Binder

At the very close of the colonial period it is possible to find
some exceptionally nice examples of the binder's art. The
covers of the John Carter Brown copy of the Aitken Bible,
printed in Philadelphia in 1781–1782, are of this description.
The book has been arbitrarily divided into two volumes of
almost equal size, and each volume put into a cover of olive
morocco embellished with delicately executed tooling in gold.
Immediately the volumes are seen and handled, one per-
ceives that they came from the hands of a workman who

added the grace of an artistic nature to a sure and learned craftsmanship. It is easy to venture a guess at the identity of the binder who designed these harmonious combinations of flowers and leaves in gold tooling, freely and unconventionally conceived, for in the New York Public Library are two copies of volume one of this book, obviously from the hand that decorated the John Carter Brown volumes. When one learns that the printer of the book, Robert Aitken, was bred a bookbinder in Edinburgh, and that he worked in Philadelphia as bookbinder and bookseller before he took up printing, the conclusion forces itself that here was a printer who executed his own binding and that a part of his edition of the Bible was thus beautifully covered and ornamented for special sale by himself or by his competent daughter Jane. (Plate XXIII.)

Binders' Labels

Now and then, too seldom though, one opens an American book in its original binding and finds pasted upon its inside front cover a plate that seems at first glance to be the familiar *ex libris* usually found in that position. But there is more of a thrill to the experience I have in mind, for on this rare occasion a closer look shows the printed or engraved label to be a binder's trade card, and the colonial American binder's card is sufficiently rare to be looked at twice, or even, less elegantly, to be gaped at. Certainly the knowing bookseller looks at it with eyes wide open as he estimates in terms of money the points of the book that contains one of these rarities. In a copy of Tillotson's sermons in the American Antiquarian Society, very plainly but substantially bound, is found the elaborate and handsomely engraved label of Andrew Barclay, who, about the year 1760, kept shop in Cornhill, Boston,

PLATE XXIII

Bookbinding in Colonial America

"Next Door but one to the Sign of the Three Kings." It has been suggested that the New York Public Library copy of Prince's *Psalms, Hymns, & Spiritual Songs of Boston*, 1758, a presentation copy from the editor to Governor Hutchinson, was also from the hand of this binder. The Prince volume is well bound, without special distinction, in an excellent straight-grained morocco, decorated in gold tastefully enough, and presenting, on the whole, the appearance of honest and thoughtful craftsmanship.

There exists, too, the handsomely engraved label of Samuel Taylor, Barclay's Philadelphia contemporary. There is found an interesting advertisement in the *Pennsylvania Gazette* for October 31, 1765, in which "Samuel Taylor, . . . at the Book-in-Hand, the Corner of Market and Water-streets" informs the public that he executes binding, gilt as well as plain. What a pleasing directness there is to these old trade signs with their obvious symbolism—the Sign of the Bible for the printer, the Sign of the Coffee Pot for the silversmith, the Wooden Indian for the tobacconist, and the Book in Hand for the binder! I have never come upon a volume with the label of Samuel Taylor in position, though the American Antiquarian Society possesses a fine copy of the plate removed by a former owner from a book that may have been a notable specimen of the binder's craft.

Some Representative Bindings

The John Carter Brown Library has recently secured a fine copy of *An Abridgement of Burn's Justice of the Peace and Parish Officer*, printed in Boston in 1773, and later bound in Keene, New Hampshire, that busy center for the publication of chapbooks of the 1790's. In plain sheep with a blind-

tooled border, the volume has been very well bound by Thomas S. Webb, whose printed label is found in position. This binder (and author of Masonic books) worked at Keene from 1790 to 1796; in 1797 he removed to Albany.[7] The specimen of his handicraft before us is so well accomplished in essentials, so honest and without pretense of being something else, so redolent of old simple things and ways, of old law offices and country justices with hardened hands, and heads too perhaps, that I like to think of it as representing the typical American binding of the eighteenth century, a natural product expressing the homely quality of its environment.

In bringing to a close this account of the colonial binder and his work, I come back to a book that I like to write and talk about because of its varied excellences. The special as well as the ordinary copies of this book, Bacon's *Laws of Maryland*, appeared in rough sheep, but upon its covers was placed as delicate a blind-tooled border as ever came from binder's roulette. These volumes were bound as part of the day's work by or for Jonas Green in his provincial printing shop at Annapolis in 1765. It is waste of breath to bewail the passing of ancient customs, and it might even be said that so delicate and inconspicuous an adornment of a common utilitarian binding was a work of supererogation at best, but it is this final touch, this gesture towards beauty, that connects the artist-craftsmen in a single line through the ages. It places the colonial binder, humbly, but surely, in the brotherhood of the cathedral builders, those instinctive artists in whose structures no single stone was placed merely for decoration, but in which, none the less, every stone possessed decorative value.

XI
The Product of the Colonial Press
Part I. The Content

A GLANCE at the most recent volume of the *American Bibliography* shows that for the hundred and sixty year period between 1639 and 1799, the late Charles Evans listed as the product of the colonial press almost 36,000 separately printed books, pamphlets, broadsides, and newspapers, counting a year's issue of a newspaper as a single item. In the compilation of this list Mr. Evans made no attempt to record those printed blank forms which were unquestionably one of the staples of the American press, nor was it possible for him to record the innumerable advertisements, notices, and posters that were carried out of memory by the winds or left to the mercy of sun and rain on wall and door after their ephemeral purpose had been served. For the colony of Massachusetts alone, Worthington C. Ford has recorded some 3400 ephemeral pieces in his *Broadsides, Ballads, &c. Printed in Massachusetts*. In that bibliography, Mr. Ford made no attempt at a comprehensive record of blank forms, including only the first appearance of a form and occasionally other issues that seemed to possess unusual significance. With the best intention of including every piece that came from the press, a bibliographer would still have only partial success in compiling a complete list of imprints of any period or place, for, in general, it is safe to say that where one printed item has been preserved, three or four have perished through neglect and natural causes.

The Colonial Printer

The Extent of Colonial Publication

Let us compare the record of Franklin & Hall's Work Book for the year 1765 with the check list of the firm's publications for that year as compiled by William J. Campbell from printed pieces existing in actual copies, or from records of publication in newspaper advertisements and other sources. In making this comparison, it is to be remembered that Mr. Campbell has recorded blank forms and such other ephemera as have come to the knowledge of bibliographers. Mr. Campbell's list for the year 1765 shows nineteen entries, of which ten—assembly documents, almanacs, carriers' addresses, primers, and catechisms—were staple productions issued on the firm's account and omitted from entry in the Work Book, as were also, for some reason not understood, four other pieces known with certainty to have been printed. A complete count, therefore, of Franklin & Hall imprints for 1765 requires the addition of these fourteen pieces to the seventy-four pieces entered in the Work Book. Comparison of the nineteen pieces of the year 1765 previously known to bibliographers with the eighty-eight resulting from this calculation shows a ratio of one piece recorded to 4.6 pieces printed. For the six-year period 1760–1765, a comparison of eighty-two pieces recorded by Campbell with 386 known to have been printed (321 Work Book entries plus sixty-five recorded elsewhere) suggests that where one Franklin & Hall imprint of this period has been recorded, 4.7 came from the press, or, to put it differently, where one publication of that firm has been preserved 3.7 have disappeared from knowledge. If the first figure be allowed as the ratio existing between the recorded production and the actual production of the whole body of printers, and applied to the total of Evans titles for the period

The Product of the Colonial Press

1639–1799, we shall find ourselves contemplating a possible production of about 169,000 printed pieces instead of the 36,000 recovered and entered by the enthusiastic and industrious compiler whose work has placed under lasting obligation the historian of American life and letters. Ordinarily it would be improper to affirm a general truth from a particular instance, but in this connection the case of Franklin & Hall is exceptionally to the point. Because of the eminence of Franklin in other fields, his imprints have been piously preserved for generations, and before Campbell set out to list them, Hildeburn and Charles Evans had gone over the field and put down with particular care such pieces from his press as had come to their knowledge.[1]

The Character of the Product

From this discussion of the statistics of the colonial press, one turns with interest to a study of the character of its output. I can think of no better way of introducing this aspect of the question than by giving here the record of separately printed pieces found in the Franklin & Hall Work Book for a single year, remembering that there will not be found among the extracts the legislative documents, issued in Franklin's name alone, the *Pennsylvania Gazette*, issued in Hall's name alone, the almanacs, the carriers' addresses, and other periodical staples of the firm. Because there are preserved in this record so many of the ephemeral titles which show the day-by-day life of the people, we shall find it of greater value in our present study than any equal number of titles for a similar period of time taken from formal bibliographies. The job numbers are omitted from the record as presented here, and, to avoid confusion, entries referring to work of earlier years

and tardily put in the book have been disregarded in transcription. The five entries in the Work Book which are recorded also in the Campbell check list have been marked here with an asterisk, a device which makes it easy for the reader to observe that the many Franklin & Hall publications which did not find record in that or any other bibliography are not in every case trivial ephemera. The omitted titles comprise, among others, a Library Company Catalogue; a local notice requiring landlords to pave their footways; an advertisement by Sir William Johnson for the sale of lands; a post office form; an advertisement of a night school; two church notices; a yearly meeting notice of the St. Andrew's Society; an Address to the Inhabitants of Pennsylvania by John Dickinson; notices concerning the business of a Linen Manufactory; a large variety of blank forms, lottery tickets, and invitations; and eleven sales of land of greater or less importance—all items of the sort that provide background for the historian and material for the bibliographer and collector. Lest it be assumed that this list of jobs completed represents the entire output of the Franklin & Hall establishment, we must remind ourselves of the fact that the Campbell list contains fourteen items not found in the Work Book, most of them publications on the account of the firm or of its individual members and kept, without doubt, in separate records.

Separately Printed Pieces found among the Franklin & Hall Work Book Entries for the Year 1765

Jany.	24	Mr. Caleb Cash Dr.	
		For 700 Vestry Notices	14
Jany.	24	Association Library Company Drs.	
		For printing 1000 Library Notes	1
Feby.	19	Mr. John Rhea Dr.	
		For printing 100 promissory Notes	10

The Product of the Colonial Press

March 1	Managers of St. Peter's. &c. Church Lottery Drs.			
	For Printing Thirteen Thousand Three Hundred and Fifty Tickets @ 30/ a Thousand	20.	0.	6.
*March 22	Commissioners for paving the Streets Drs.			
	For printing 2500 Advertisements relating to keeping the streets clean, a Folio Page	6.	0.	0.
March 22	Dr. John Cox Dr.			
	For printing 200 Deeds on best Pott Paper, and 190 of Ditto on Parchment [the Parchment found by Mr. Cox]	3.	10.	0
March 27	John Swift Esq: Dr.			
	For printing 250 Bonds for loading foreign Melasses— (best Pro Patria)	1.	5.	0
March 29	William Parr, Esq: Dr.			
	For printing 300 Venires	1	–	–
Mar. 29	John Swift Esq. Dr.			
	For printing 200 Bonds for loading Lumber (best Pro Patria)	1.	0.	0
March 29	John Swift Esq: Dr.			
	For printing 250 Certificates for loading foreign Melasses		18.	9.
	Do. for 200 Ditto for loading Lumber (both on best Pro Patria)		15.	
March 30	Commissioners for paving the Streets Drs.			
	For printing 200 Advertisements, desiring Landlords to pave their Footways, &c.		12.	6.
April 4	Trustees of the College Dr.			
	For printing 500 Tickets for the Charity School on Message Paper	1.	15.	
April 6	Mr. William Weyman Dr.			
	For printing 100 Single Advertisements for selling or letting Lands of Sir William Johnson		7.	6.
	Paid a Person for Sticking them up		3.	
April 13	John Swift Esq: Dr.			
	For printing 100 Bills of Health on best Pro Patria (Half Sheets)		12.	6.
April 15	Messieurs Franklin & Foxcroft Drs.			
	For printing 1000 Way Bills on the best Pro Patria Paper @ 1 Penny a Piece	4.	3.	4.
April 19	John Swift Esq: Dr.			
	For printing 200 Certificates (8 on a Sheet, best Pro Patria Paper		12.	6.
May 3	Library Company of Philadelphia Dr.			
	For Paper and Printing 400 Catalogues containing eleven Sheets, @ £3. .19. .0 per Sheet	43.	9.	0
May 11	Mr. William Clampffer Dr.			
	For printing 50 Invitations on Cards		5.	
May 13	Mr. Hugh Roberts Dr.			
	For printing 100 Single advertisements for Sale of a Plantation in Bucks County		7.	6

[219]

Date	Description	£	s	d
May 17	Library Company of Philadᵃ Drs.			
	For Printing 200 Receipts		10.	0
	500 Promissory Notes		15.	0
*[June] 4	Province of Pennsylva. Dr.			
	For a Proclamation, opening a Trade with the Indians (200 Copies)	2.	10.	—
June 15	Mr. Francis Wade Dr. for printing 1000 Hand Bills (very long) for Sale of Goods	3.	—	—
*June 15	Mr. William Peters Dr.			
	For printing 200 single advertisements for opening the Land office (very long)	1.	10.	—
June 18	Dr. John Coxe Dr.			
	For Printing 200 Deeds on best Pott Paper; and 112 on Parchment	3.	0.	0
June 19	John Swift Esq; Dr.			
	For printing 200 Certificates (Quarter Sheets)		12′	6
June 20	Mrs. Cornelia Smith for Sale of Land, &c. by Vendue, News and Single		8	
	To Cash paid a Person for sticking up the single ones		2	6
July 4	Mr. Joseph Stretch Dr.			
	For Printing 1000 Permits	1.	10.	0.
July 20	Mr. John Swift Dr.			
	For printing 200 Bonds for loading foreign Melasses (*Best Pro Patria Half Sheets*)	1.	0.	0.
July 23	Mr. James Chattin Dr.			
	For printing 60 single advertisements for Sale of Land by Vendue		5	—
July 26	John Swift Esq: Dr.			
	For printing 200 Certificates for loading Melasses (Quarter Sheets, Best Pro Patria)		15	—
July 27	Estate of the late Anthony Wilkinson, Dr.			
	For a Parcel of loose advertisements for Sale of Lots		5	—
July 27	Mrs. Magdalene Devine Dr.			
	For printing 1000 loose Advertisements, Folio Page, small Paper	2	10	—
August 1	Mr. Jacob Cooper and Company for Sale of Lots, &c. of the Pennsylvania Land Company (News & Single)		12	6
August 3	John Swift Esq: Dr.			
	For printing 200 Bonds for loading Iron and Lumber (Half sheet, best Propatria)	1.	0.	0.
	For a Bond for foreign Melasses, 50 Copies (Half Sheet, best Propatria)		10.	
	For 200 Certificates for Iron and Lumber (Quarter sheet, best Pro Patria)		15.	
	·For 50 Certificates for foreign Melasses (Quarter Sheet, best Pro Patria)		7.	6.
Aug. 15	Mr. William Taite (Northumberland County, Virgᵃ) for a Runaway, News and single		8	
	To Cash paid for putting up the single Advertisements		2	6

The Product of the Colonial Press

Aug. 20 Mr. Jacob Cooper and Company Drs.

For printing articles of Agreement for Sale of Land of London Land Company 100 Copies, a Broadside (Thick Post) 1 15. —

Aug. 23 John Swift. Esq: Dr.

For printing 200 Copies of a Ship's Report Inwards, on best Pro Patria Paper, Half sheets 1 — —

Ditto for 100 Copies of a Ship's Report outwards, on Ditto, and Halfsheets 12 6

Sept. 20 Mr. Thomas Buchanan Baker Dr.

For printing 500 single advertisements 17 6

Sept. 20 Philada. Library Company Dr.

For 500 Promissory Notes 15 —

*Octr. 3 Joseph Galloway Esq; Dr.

For printing 1000 Copies of Governor Franklin's Answer to some Charges against him. &c. 2 5 —

Octr. 11 John Swift Esq; Dr.

For printing 100 Copies of Amount of Duties on foreign Sugar, &c. 7 6

Do. for Do. on Amount of Duties on Enumerated Goods 7. 6

Octr. 14 Mr. Francis Harris Dr.

For printing 100 single advertisements for Sale of a house &c. of the late Mr. Oswald Peele 7. 6.

Octr. 17 Messieurs Willing and Todd Drs.

For printing a single advertisement for Sale of a house of Peter Shoemaker's 5. —

Octr. 21 Mr. Francis Harris Dr.

For printing 100 Single advertisements on a Half Sheet (very long) 15. —

Octr. 29 Mr. John Todd Dr.

For printing 200 single advertisements for a Night School 10. —

Octr. 29 John Swift Esq; Dr.

For printing 100 Copies of a Bond for loading Iron and Lumber (Half Sheets) 10. 6

Octr. 30 Mr. Plunket Fleeson Dr.

For printing 200 Notices for the Congregation of St. Paul's Church 10. —

Novr. 2 Mr. William Parr Dr.

For printing single advertisements for the sale of Obadiah Elliot's House &c. 5. 0

Novr. 2 John Swift, Esq: Dr.

For printing 200 Permits for Sailing — — 10 — —

Novr. 5 Messieurs Willing and Todd Drs.

For printing single advertisements for the sale of a House of Peter Shoemaker's — 5 —

Novr. 7 Mr. William Parr Dr.

For printing single advertisements for the Sale of Obadiah Elliot's House — 5 —

Novr. 12	Mr. William Parr Dr.			
	For printing single advertisements for the Sale of John Buchanan's Household Goods		– 5 –	
Novr. 14	Mr. William Parr Dr.			
	For printing single advertisements for the Sale of John Wasley's Household Goods		– 5 –	
Novr. 25	St. Andrew's Society Dr.			
	For printing a single advertisement for their yearly Meeting		– 5 –	
Decr. 6	Managers of Pennsylvania Hospital Drs.			
	For printing four different promissory Notes, 200 Copies each		2 – 0 – 0	
Decr. 10	Mr. William Parr Dr.			
	For printing single advertisements for Sale of Thomas McMillan's Goods		– 5 –	
Decr. 10	John Dickinson Esq: Dr.			
	For printing 2000 Copies of an Address to the Inhabitants of Pennsylvania		3 – 5 – 0	
Decr. 13	Mr. Jospeh Stretch Dr.			
	For printing 1000 Certificates		1 – 10 –	
Decr. 17	John Swift Esq: Dr.			
	For printing 100 Certificates (Quarter Sheets)		7 – 6	
	Ditto for 100 Copies of Amount of Duties on foreign Sugars, &c.		7 – 6	
*Decr. 20	Joseph Galloway Esq: Dr.			
	For printing 400 Copies of his Vindication relating to opening the Publick Offices		1 – 15 – 0	
Decr. 27	Dr. Samuel Preston Moore Dr.			
	For printing 100 Promissory Notes for the Linen Manufactory		7 – 6	
Decr. 29	John Swift Esq: Dr.			
	For printing 100 Copies of a Bond for loading Iron and Lumber (Half Sheet, best Pro Patria)	}	0 – 12 – 6	
	100 Certificates for Ditto (Quarter Sheets, Do.)		10 – 0	
Decr. 31	Doctor Samuel Preston Moore Dr.			
	For printing 300 Notices for the Contributors to the Linen Manufactory to meet		17 – 6	

Analysis of the Work Book and of the Campbell list for 1765 shows such a paucity of works of a literary character as might lead one to believe that the Americans of this period were entirely without interest in polite letters. Contradiction of this assumption is provided, however, by the known facts of the trade in imported books, so that without derogation

The Product of the Colonial Press

of the literary interests of the race it may be admitted that the American press was still utilitarian in its service to the people, and that American writers were still providing them chiefly with utilitarian matter. It was more economical at this time to procure works of European *belles lettres* in foreign editions than to attempt their republication in this country. The Campbell list for 1765 shows only six pieces of a literary character — regarding sermons, catechisms, primers, and almanacs as works of literature — while the Work Book shows only one piece — a library catalogue — that a similar generosity of definition may bring within that category. Of the seventy-four pieces appearing in the Work Book representing jobs done by the firm for its patrons, thirty-five, or nearly one-half, were blank forms, bills, or tickets, while twenty-four were advertisements and notices, usually occupying single sheets of varying size. The remaining items were government proclamations, political documents, and miscellaneous pieces designed to serve the workaday interests of group or community.

In the past century, knowledge of the way people lived and of what they thought in any period has been assuming increasingly higher value in the estimation of historians. Occasionally a writer is found who perceives that the productions of the press provide an opportunity for understanding the forces that customarily set in motion, or inhibit, the political, social, and religious activities of the period he is discussing, and once this truth has taken possession of him, his study and analysis of the bibliographies become fascinating to himself and profitable to his readers. His task has been simplified in this country by the publication of various general and special bibliographies which, sympathetically used, enlighten the historian as to the daily lives and thoughts of

The Colonial Printer

the people he must strive to understand. It is not possible to go deeply into the subject here, but it will be entertaining, at least, to continue our analysis of the colonial press by calling attention to the character of its staple productions. We shall speak briefly of the blank form, the assembly document, the almanac, the newspaper, the sermon, the legal handbook, the household assistant, the merchant's and the clerk's guide, and the separately printed advertisement.

The Printed Blank Form

In examining the records of the colonial communities, one is appalled by the amount of legal and official business that was transacted in this new country, but whoever else may have been the sufferer by this frequent lawing, it is certain that it was not the printer. The necessity of keeping on hand a supply of official blank forms for the use of all who might have need of them was by no means a hardship to the printer; on the contrary, there is evidence that he regarded the profits from the sale of this staple as the "velvet" of his business.

The very first thing known to have been printed in English America was the Freeman's Oath of 1639, a form containing propositions to which each man in the Massachusetts colony must give his assent as a condition of citizenship. It needs no more than a glance at Worthington C. Ford's *Broadsides, Ballads, &c. Printed in Massachusetts, 1639–1800*, to convince us that the issue of blank forms in Boston and Cambridge was not limited to this notable example of the type. We find the same conditions in the other colonies. James Franklin, of Newport, who began to issue blanks of all sorts soon after the establishment of his press, advertised in 1728 that he had for sale "Bonds, Bills, Powers of Attorney, Paper

The Product of the Colonial Press

by the Ream, Snuff, Tea, and Coffee"; and William God-
dard of Providence let it be known in 1762 that he had, "to
be sold cheap for ready Money . . . Blanks, Policies of In-
surance, Portage Bills, Bills of Lading and Sale, Letters of
Attorney, Administration Bonds, common Bonds, Deeds,
Writs, and Executions, and all Kinds of Blanks used in this
Colony, either Wholesale or Retail." In announcing, in De-
cember, 1685, the inauguration in Pennsylvania of "that
great Art and Mystery of Printing," William Bradford
called attention to the fact that he was able to supply such
blank forms as were needed in the conduct of the business of
that Province. Benjamin Franklin wrote in his *Autobiog-
raphy*: "I now [about 1730] open'd a little stationer's shop.
I had in it blanks of all sorts," a statement which he elabo-
rated with his usual complacency by the assertion that his
forms were "the correctest that ever appear'd among us."
Whether his rivals in the trade would have consented to this
dictum is doubtful, but it is certain that the public seemed
to appreciate the quality of his productions. How many blank
forms he sold over the counter to individual purchasers is not
known, but his Account Books show for the period 1730–1735
a total of 16,800 blanks printed on order and charged therein
at about £112. Even at his Passy press, blank forms were an
important part of Franklin's output. In Maryland every
printer of the colonial period seems to have done a tidy busi-
ness in the production and sale of this staple of the trade. In
1693, William Nuthead got into serious trouble with the
royal governor of Maryland by taking an order to print 500
blank land warrants running in the name of the dispossessed
Proprietary, and as a consequence of his indiscretion he was
ordered to print thereafter nothing but "blank bills & Bonds,
without leave from his Excy or the further Order of this

Board." In the "License to Print" which Nuthead's widow received from the Governor in 1696, it was specified that Dinah should forfeit her bond if she printed without "a particular Lycense from his Exncy" anything except "blank bills bonds writts warrants of Attorney Letters of Admrcon and other like blanks." Years later, in asking for and receiving a similar privilege, Thomas Reading intimated that the Nutheads had been favored by an ordinance "obliging all Clerks, Commissarys, Sheriffs, and other Officers to make use of printed Blanks." When William Bladen brought in a press in 1700, the ordinance which was passed for his encouragement provided that all blank legal forms used in the Province should be printed, and specified the prices at which he should sell them to officials and to others in need of them.[2]

A sufficient number of instances has been cited to show that the trade in printed legal forms was an important part of the business of the colonial printer, and it may be taken for granted that as the century grew old and business became more diversified, a corresponding increase occurred in the number and variety of the necessary commercial forms. In colonies where only one printer was employed, the pecuniary returns from this department of his business must have figured largely in the statement of his profits, while in others, Pennsylvania for example, the printer who turned out the "correctest" and the neatest must have been rewarded almost as surely as the monopolists of Maryland and Virginia.

The Government Work

In another part of this work it has been asserted that the printing shops in most of the original colonies were set up with the encouragement of governments which desired to

The Product of the Colonial Press

publish their laws in printed form and to put out in type the many instruments—proclamations and the like—formerly copied with much labor by scribes not necessarily either skilful, accurate, or reliable, and afterwards published by the county sheriffs through the ancient and limited method of proclamation by word of mouth. It was this government work that gave the earliest printers means to defray their overhead while they sought additional outside work to provide their profit. The lot of the government printer was improved when, in 1695, William Bradford printed for the New York Assembly the first set of Votes & Proceedings published in type in this country. The other colonial assemblies slowly began giving their journals to the printer, though it happened that in Maryland, the regular publication of the assembly deliberations was established only after a sharp struggle between the representatives of the Proprietary on the one hand and the more liberal burgesses on the other. That there was immediate appreciation of the importance of the printer in the government work one may learn from the introductions to various early collections of laws, with their expressions of thankfulness to the printer for the opportunity his enterprise had afforded government, courts, and people to know the law of the colony. In the dedication to the Maryland *Laws* of 1700, the new condition is mentioned with gratitude; and again in 1718, the publisher of the compilation of that year refers to the previously existing situation in which the Laws were found only in "Ill-Written Manuscripts, Lodged in the Hands of particular Officers, and not more than Twelve or Fourteen of them in the whole Province." In Virginia this appreciation of an important function of the printer found expression in an ode in which the author spoke exultantly of a forthcoming publication, the *Collection*

The Colonial Printer

of all the Acts of Virginia, Williamsburg, 1733, which was to contain:

> ... Virginia's Laws, that lay
> In blotted Manuscripts obscur'd
> By vulgar Eyes unread,
> Which whilome scarce the Light endur'd
> Begin to view again the Day,
> As rising from the Dead.[3]

The Almanac

Every colonial printer who aspired to anything more than the position of job printer sought to render his establishment useful to the community by the publication of an annual almanac. The change in habits, the diffusion of meteorological information by means of the newspaper, the publication by the government of *The American Ephemeris and Nautical Almanac* are the agencies which for most of us have relegated the old-time almanac to the category of quaint and outworn institutions. Even now, however, there are many country dwellers in New England who regulate their lives by *The Old Farmer's Almanac*, or in Maryland and Virginia, who plant and reap by *The Hagerstown Almanack*, or, in these places and elsewhere, many who make daily use of less well-known publications, issued sometimes as advertisements. And there are thousands in city offices who never move far from *The World Almanac* or from some other modern descendant of Poor Richard—those amazing compends of statistical information and scientific knowledge. The almanac in some form has been the constant companion of man since he became aware of the regular recurrence of sun rising and sun setting. In the American colonies, the printed ephemeris served a maritime and agricultural folk in the changes of

The Product of the Colonial Press

sun, moon, and tide, in the coming of seed-time and harvest, as a calendar, and as a means of weather prognostication. It served them no less well by the extraneous information it contained in the form of dates of local court sessions, of schedules of post riders and of coaches and packet boats. It gave them verse of a serious or comic character, prescriptions for the cure of snake bites and fluxes, and provided them, in one case certainly, with perilous information in the form of a recipe "by which Meat, ever so stinking, may be made as sweet and wholesome, in a few Minutes, as any Meat at all." In the pages of Poor Richard were found those exordiums to industry, temperance, and frugality which, admirable and necessary, have put a premium on shrewdness and the baser virtues, and caused them to assume unfortunately high rank among the national ideals.

A recent investigation of the colonial almanac has brought out the fact that in the years preceding the Revolution these little books of domestic utility abounded in brief and, frequently, outspoken political essays which must be taken into account among the writings that influenced the people of the colonies in their progress towards separation from Britain — a circumstance provocative of thought to the historian who goes beneath the surface of events to the hearts and minds and way of living of the men who bring them about. The familiar handbook of every member of the household, pored over in the winter evenings by father and sons, mother and daughters, these little books of utility take on in view of this feature of their content greater importance among American writings than they have formerly been credited with.[4]

For the production of this admirable necessity to public happiness, the printer tried to associate with himself some person skilled in mathematics who should be able to compile

annually an almanac for the local meridian. The fame of Poor Richard has been so great since the days of his first appearance that the layman thinks of his work as comprising the sum of colonial calendar making, but Poor Robin, Abraham Weatherwise, Theophilus Grew, John Warner, Benjamin West, Nathaniel Ames, Benjamin Banneker the negro scientist, and numerous other pseudonymous and undisguised writers prepared almanacs of excellent quality for the printers of their communities to issue regularly in the fall of each year. For reasons universally understood, almanac publication has provided a study of undying interest in every land the sun shines on. For the American student who strives to understand the present and to forecast the future by an intimate knowledge of the past, that room of 15,000 almanacs in the American Antiquarian Society at Worcester is at once a monument and a shrine.

The Newspaper

As early as 1789 an English writer found the popularity of the American newspaper explained by its quality. "The newspapers of Massachusetts, Connecticut, Rhode Island, Pennsylvania and Maryland," he wrote, "are unequalled, whether considered with respect to wit and humour, entertainment or instruction. Every capital town on the continent prints a weekly paper, and several of them have one or more daily papers." Some day, a writer on the newspaper press described in these words will tell a fascinating story of the racial characteristics, the local conditions of the isolated country, and the trade and occupations of its people, that brought about this eventuation of its early imitative efforts at newspaper publication.

The Product of the Colonial Press

In the Spanish American countries, as in Spain, the periodical newspaper was slow in taking hold of the imagination of printer and people. Instead of it, there existed the form of news conveyance known as the *relacion*, usually a single sheet folded once and issued without periodicity and with neither fixed title nor numeration. It contained either a budget of foreign news items brought in by a ship master or a full relation of a single local or foreign event of extraordinary importance and interest. The *relacion* had its counterpart in all countries: in English America the type persisted in the broadside published occasionally by the printer to communicate news of importance received between the regular issues of his journal. Perhaps the logical and economic Latin mind could see no need for a regular news sheet that often failed to convey real news, and served merely as an advertising medium and as a means of proclaiming the routine court and business activities of the community. On the other hand, the periodical news sheet, with all its disadvantages and wastefulness, met a need of the English race at home and abroad, and today the newspaper of the English-speaking peoples is certainly a more elaborate and more highly developed publication than that of other nations, even if it is not superior to them in the efficacy of its purpose. In the English-speaking world the eighteenth century saw the acceptance of newspaper publication as a social necessity. The few and unsatisfactory news sheets of the earlier centuries, held within bounds in England as to number and geographical distribution by the press restriction acts, were lost in the flood of journals that began to issue from the press after the expiration of the last of these statutes in the year 1693. A brief study of Allnutt's *English Provincial Presses* for the early years of the ensuing century shows the rapidity

with which the printers, newly established in the smaller English towns, began the issue of weekly journals for the edification and information of their communities. The first English provincial newspaper recorded by Mr. Allnutt is *The Norwich Post*, begun in 1701. Thereafter, progress was rapid; we soon have *The Worcester Post-Man*, *The Newcastle Courant*, *The Stamford Mercury*, and their following, all with names denoting the idea of sheets taken damp from the press and speedily conveyed to the reader, picturesque names carried on in sense and in spirit by the American printers in their early adoption of newspaper publication as a normal and profitable activity of the printing shop. The quickly suppressed *Publick Occurrences* of Boston, 1690, marks the first tentative step towards newspaper publication in the colonies, and *The Boston News-Letter* of 1704 stands as the monument of its permanent establishment. For some reason, not dissociated, perhaps, from the difficulty of procuring paper, the progress of journalism was slow in the first quarter of the century, but by the year 1730, seven journals were in current publication in four colonies. After that it was a poor or an unambitious printer who failed to make the effort, even if he did no more, to add a weekly newspaper to the output of his shop.

Between the years 1694 and 1820, there were published in the thirty states in existence at the close of the period 1934 different newspapers. The establishment of a weekly journal, with its subscription list and advertisements forming a regular source of income, was the ambition of every progressive printer, but that newspaper publication was a precarious venture, even in communities favorable to such enterprises, is impressively brought to the attention by further investigation of the statistical history of American jour-

The Product of the Colonial Press

nalism. Five hundred and eighty-six of the 1934 newspapers recorded died of inanition at or before the close of their first year of life, while a still larger number of the remainder, 637, failed to survive a period of four years of struggle. Three hundred and ninety-one ran from five to ten years, and only 362 continued publication for a decade or longer. This high mortality among the newspapers can be best accounted for by the lack of capital of their promoters, an ever-present factor in lost causes, and by the difficulty experienced at various times and places of securing a steady supply of reasonably cheap paper.

In general, the publication of newspapers followed the growth of commercial activity. With ninety-eight papers in this period, Philadelphia surpassed the more conservatively commercial Boston with its record of seventy-one, while New York, pushing ahead of its rivals in all material activities, published in the same period a total of 127 journals. It is perhaps further evidence of the conservatism of Boston, that of the three cities, it could count the greatest proportionate number of newspapers which maintained their existence for ten or more years of consecutive publication, eighteen as opposed to the twenty-two of Philadelphia and the twenty-three of New York. The opening of the western country added greatly to the output of the newspaper press, for its activities were not at all confined to the larger centers. Where the people went, the printer quickly followed, and the western printer who failed to begin publication of a newspaper as soon as his press was set up and his type in the cases was unworthy of the vigorous young community he served. Between 1793 and 1820, Ohio published ninety periodical journals and, beginning six years earlier, Kentucky came a close second with eighty-four publications of the same character. The mental activity of

The Colonial Printer

the country in this particular period had been vitally stimulated by the separation from Great Britain. On their own politically, and placed on trial before the world by their Declaration of Independence and their Constitution, the citizens assumed an interest in public affairs as a patriotic duty. Each man must know the trend of events in order to protect the liberty he and his fathers had acquired and to justify the expense of the great experiment in the eyes of the watching world. The newspaper, self-conscious champion of the principles the country stood for, met the citizen's need for information, and now formed, now voiced, his opinion. There is no need to comment upon the newspaper's influence as the maker of opinion, but some student with a cynical turn may yet give us a study of the influence of popular opinion on newspaper policy.

The colonial newspaper was a weekly periodical of two leaves, of which nearly a half was normally composed of local advertising matter. Its news section was compiled from exchanges and from foreign letters. Such local news as appeared consisted largely of items that drifted into the office or were so general in interest as to demand publication. The reporter was unknown, and a man's personal affairs were generally regarded as of no interest to the public. Every editor made a point of beseeching the local amateurs of literature to send him poems and essays for his literary corner, and the material published in this department forms an excellent cultural index of the community. There were times when lethargy in composition seized the local writers, and the editor was compelled to fill his space with literary articles from the English magazines or from the published writings of familiar authors. At such times the complaints of the subscribers were caustically expressed to the printer, who in

The Product of the Colonial Press

reply would give voice to his bitter disappointment at the lack of support accorded locally to this department of his journal.

The successful outcome of John Peter Zenger's trial, in 1734, gave the printer a freedom that he soon availed himself of and a consequent authority that everyone seems to have recognized. The last battle for the freedom of the press was that which William Goddard waged against a force more powerful than governmental interference, namely, the force of public opinion. When the Maryland Assembly, in 1779, upheld Goddard's right to publish matter disagreeable to his neighbors, and made a working principle of the phrase in its Declaration of Rights, "that the liberty of the press ought to be inviolably preserved," the newspaper found itself established in this country as the Fourth Estate.[5]

Not the least important feature of the newspaper was its function as the vehicle of local advertising. In the imprint, or elsewhere, from almost the earliest times the printer named the rates at which advertisements were published, and before long he began actively to seek enlargement of this phase of his business. One of the earliest statements of a theory of advertising occurs in a notice in the *Virginia Gazette* of October 8, 1736, when the printer, William Parks, published the following:

Advertisement, concerning Advertisements

"All Persons who have Occasion to buy or sell Houses, Lands, Goods, or Cattle; or have Servants or Slaves Runaway; or have lost Horses, Cattle, &c. or want to give any Publick Notice; may have it advertis'd in all these Gazettes printed in one Week, for Three Shillings, and for Two Shillings per Week for as many Weeks afterwards as they shall

order, by giving or sending their Directions to the Printer
hereof.

"And, as these Papers will circulate (as speedily as pos-
sible) not only all over This, but also the Neighboring Colo-
nies, and will probably be read by some Thousands of People,
it is very likely they may have the desir'd Effect; and it is
certainly the cheapest and most effectual Method that can
be taken, for publishing any Thing of this Nature."

The shy appearance in these words of the spirit of modern
advertising prefigures the greatest change the general print-
ing trade has undergone in the five hundred years of its his-
tory. The application to its processes of power machinery
effected little but a change in the mechanics of printing. The
development of commercial advertising has changed its char-
acter, its very reason for being. It has narrowed its interests
and confined its energies to the execution of a single purpose.
To Parks and the printers of his day, advertising was simply
one means of gain among the several offered by the practice
of their craft. The normal printing establishment of today
exists as an appendage to the advertising agency.

The Magazine

A type of publication too much neglected by historians,
general and special, is the colonial periodical. As in the case
of the newspaper, the American periodical took over the form
and manner already established for this kind of publication
in England. Indeed, the earliest example of the periodical
publication to be presented to American readers was a reprint
of *The Independent Whig* of London, issued weekly for
twenty numbers in Philadelphia in 1724. Franklin's contemp-
tuous references to Samuel Keimer, its publisher, have belit-

The Product of the Colonial Press

tled an interesting and eccentric figure in American literary history. But though we may quarrel with the youthful judgments of Franklin as unnecessarily harsh where his rivals were concerned, it is impossible to avoid acknowledgment of his beneficent influence upon every aspect of the American printing trade. To Franklin must be given credit for the first conception of an original American monthly magazine. He tells us nothing in the *Autobiography* of John Webbe's betrayal to Andrew Bradford of his plans for the initiation of his project, and of Bradford's immediate determination to institute a rival periodical. The Philadelphia newspapers, however, for several issues of the months preceding the publication of the rival magazines, record the details of this incident in the conflict for supremacy, long-continued and bitter, between Franklin and the Bradfords. Each of the publications which ensued upon this struggle bore as the date of its first issue, January, 1740/41, and though it is true that *The American Magazine* from Bradford's office appeared in February, three days earlier than Franklin's publication, *The General Magazine*, it must nevertheless be allowed that the credit for this beginning of magazine publication in America belongs to the victim of John Webbe's double dealing. Franklin's magazine continued publication for six months; its rival expired after three issues. Following these there came in Boston two short-lived periodicals: Rogers & Fowle's *The Boston Weekly Magazine*, with a life of three issues from March 2 to March 16, 1743; and *The Christian History*, another weekly, which Kneeland & Greene, with Thomas Prince, Jr., as editor and publisher, were able to issue regularly for two years from March 5, 1743, to February 23, 1745. In September, 1743, *The American Magazine and Historical Chronicle*, initiated by Rogers & Fowle of Boston,

and conducted with the coöperation of printers in other cities, began a life of three useful years, "the first real magazine," one learns from the introduction to Beer's *Checklist*, "to live beyond a few numbers." During the remainder of the century the periodicals most representative of the place and time seem to have been *The American Magazine*, published by William Bradford of Philadelphia, and edited by the Reverend William Smith; Isaiah Thomas's two ventures, *The Royal American Magazine* and *The Massachusetts Magazine; The Pennsylvania Magazine*, published by Robert Aitken, and edited by Thomas Paine; *The Columbian Magazine*, begun by Matthew Carey and carried on by various publishers of Philadelphia; and Carey's later and very successful periodical, *The American Museum*. All these, save Isaiah Thomas's Massachusetts publications, were enterprises of the Philadelphia press. The New York press joins this representative group with Noah Webster's *The American Magazine*, published by S. & J. Loudon, and *The New-York Magazine* of T. & J. Swords. The last-named periodical shares with *The Massachusetts Magazine* the distinction of having attained eight years of publication. The figures for the century show that twenty periodicals were begun between 1741 and 1776, one during the Revolution, and seventy-nine between 1783 and 1800, a total of one hundred separate publications. More or less complete files remain of eighty-eight of these periodicals. Philadelphia led the list of places of publication with twenty-eight titles, New York came second with eighteen, while Boston came third with one less than its nearer rival. The Middle Atlantic colonies, outside New York and Philadelphia, produced sixteen titles, and one periodical was published in Charleston, South Carolina. The desire of printer and people for the publication of periodical

The Product of the Colonial Press

magazines seems to have been as urgent and as widespread as for the issuance of newspapers. About sixty of these periodicals seem to have been general and literary in intention; the remainder were either religious or political, or else devoted to such special interests as the farm and the household, and to the fine arts in the form of music. Except for the publications with an agricultural tendency, there were no special trade journals, and no "house organs." A radical publication appeared in the form of *The Scourge of Aristocracy*, published by James Lyon in 1798, in Vermont, and its establishment was attempted again by the same publisher as a weekly in Virginia in 1800. Two Pennsylvania magazines were issued in the German language, and Samuel Hall, in 1789, brought out twenty-six issues of a periodical in French with the title, *Courier de Boston*.

The periodical press here briefly analyzed was no small factor in the cultural life of the nation. Until the appearance in 1930 of Frank Luther Mott's *History of American Magazines*, and in 1931 of Lyon N. Richardson's *History of Early American Magazines, 1741–1789*, little effort had been made by the literary historian to describe its product and to evaluate its influence.[6]

The Printed Sermon

Another staple issue of the colonial press was the printed sermon. In the middle and southern colonies the printed sermon was only an occasional publication, though it is true that, regardless of section, sermons preached at the opening of the Assembly, on patriotic anniversaries, or on other occasions of public interest, frequently found their way into print. Controversial sermons, too, found support from the

adherents of both parties to the controversy, wherever it might rage, but in general, the sermon was not a notably important staple of the printing houses south of New England. In that section, however, it bulked large among the extra-governmental issues of the press. In addition to the causes for publication that have been named as existing elsewhere, the printing of sermons as a private enterprise by the preachers themelves assumed in New England the proportions of a trade. In their presentation of this matter there was to be observed none of the false modesty, the deprecating apology, with which printed sermons are often introduced to the public as "published by request." The people demanded pious reading and their pastors saw that they got it. There was little speculative theology in the type of sermon commonly published. Good stiff doctrine of a denominational character, and admonitory discourses, bristling sometimes with threats of punishment, seem to have given satisfaction to preacher and people alike. This, of course, is only one face of the coin. An unprejudiced reading of the New England Sermon, as the type is called, reveals many sweetnesses of character, many aspects of truth and spiritual beauty, and a sense of religious reality that were valuable factors in forming the complex character of the New England that came to its flower in Ralph Waldo Emerson.

The Legal Handbook

The *Short-Title Catalogue of English books from 1475–1640* records twenty-seven different issues of *The Boke of Justices of Peas* and ten issues of Sir Anthony Fitzherbert's *Newe Boke of Justices of the Peas*, translated from the Anglo-French work, *L'office et auctoryte des Justices de Peas*. During

The Product of the Colonial Press

the ensuing century in England, this ancient handbook of procedure, forms, and elementary legal principles continued to be issued in various improved, revised, and emended editions, and in the colonies, the printers of the eighteenth century issued at intervals various versions of this useful *vade mecum* for the unprofessional judge and notarial officer. George Webb's *The Office and Authority of a Justice of Peace*, Williamsburg, 1736; the *Conductor Generalis*, of which three editions were issued in Philadelphia between 1722 and 1750, and one in New York as late as 1788; *An Abridgment of Burn's Justice of the Peace and Parish Officer*, of Boston, 1773, and Dover, New Hampshire, 1792; and various other forms of the old book with local adaptations, were found among the staple issues of the colonial printing office. The popular "Burn's Justice" is even found as *Le Juge à Paix*, issuing from the Montreal press of Fleury Mesplet in 1789. In this edition of the old manual we see the completed circle: after some centuries of existence as an English handbook it has returned, somewhat altered, to the language of its origin for use among the Canadian descendants of the people for whom it was originally composed. In New Orleans, in 1769, a book of *Instructions sur la manière de former & de dresser les Procès Civils, &c.* designed to aid the administration of the Spanish law, was printed in both French and Spanish. *A List of legal Treatises in the British Colonies and the American States before 1801*, by Eldon R. James records forty editions and issues of those legal handbooks which had their origin in the ancient French compend for the guidance of the justice of the peace. A book founded on the English and provincial laws, especially as regards probate and the law of inheritance, more specifically local in its character, was *The Deputy Commissary's Guide*, compiled by Elie Vallette at

Annapolis in 1774. Certain very general principles of law found publication in such compendiums as *Every Man his Own Lawyer*, announced by Franklin in 1736, issued by Hugh Gaine in 1768, and by John Dunlap of Philadelphia in the next year.

Medical Handbooks, Ready Reckoners, Letter Writers, and Books of Domestic Utility

There were other types of publication that came indifferently from the presses of North and South, and in a day when there were no copyright restrictions, certain books issued originally in Philadelphia, Williamsburg, or Boston appeared often in other colonies bearing another printer's name and with no indication of the place of original issue. Sometimes, it is true, these publications appeared simultaneously, or successively, in two or more colonies by arrangement with the author, but often the piracy was outright. It is not intended here to give a bibliographic history of these titles; the editions cited are taken at random from the various general and special lists. As in the case of the justice of the peace books already described, many of these types, in title and in general intention, and doubtless often in contents, too, were reissues, under new conditions, of handbooks of earlier centuries in England, the useful information compendiums that met a need of the race. J. Archer's *Every Man his Own Doctor* of London, 1673, found its American counterpart, at least in title and in purpose, in John Tennent's *Every Man his Own Doctor, or The Poor Planter's Physician*, which appeared first at Williamsburg, Virginia, in 1734, and again in Philadelphia, in 1734 and in 1736. It was incorporated,

The Product of the Colonial Press

in 1748, in the Philadelphia edition of George Fisher's *American Instructor*. When announcing the issue of this medical handbook in 1736, and a concurrent issue of *Every Man his Own Lawyer*, Franklin loosed his pawky humor in declaring that these books would soon be followed by *Every Man his Own Priest*. Hugh Gaine advertised, in 1761, an edition of a book popular even today with mistress and maid, *The Complete Letter Writer*. Business manuals of different kinds came from various enterprising presses. One of the first things printed by William Parks after he set up his press in Williamsburg, in 1730, was *The Dealer's Pocket Companion*. This book was a forerunner of Robert Biscoe's *Merchant's Magazine*, which the same printer brought out in 1743, and of the same class with Falgate's *Dealer's Companion*, printed by Andrew Steuart in Philadelphia in 1760. Another of the type was *The Merchant's Security*, that came from the newly established Wilmington press in 1761. In a country where a storekeeper was not necessarily an arithmetician, where the pound currency in one colony differed in value from the pound currency of the neighboring colony and each differed in value from the pound sterling, and where Spanish money was current, these "ready reckoners," as they were sometimes called, performed a service of easily perceptible value to all classes of people. It was by reference to one of the many tables found in books of this kind that a shopkeeper might tell at a glance the price in pounds, shillings, and pence of ten yards and two feet of cloth at 2*s.* 6*d.* a yard, and, by consultation of another table, be enabled to return in the currency of his community the correct change from the two pounds sterling offered by the customer in payment.

Another variation of the business manual was the work issued first by William Bradford in New York, in 1705, with

the title, *The Young Man's Companion*, and published frequently thereafter by him and others as *The Young Secretary's Guide*, or as *The Young Clerk's Vade Mecum*. These books have a certain distinction as prototypes of the arithmetical school-book, but they were more than this in that they taught also the art of business letter writing, and of making out bills and bonds, and other requirements of the young in the world of commerce.

Books for the household, familiar enough now in country houses, came steadily from the eighteenth-century press in America. *The Compleat Housewife; or accomplished Gentlewoman's Companion: Being a Collection of upwards of Five Hundred of the most approved Receipts*, printed by William Parks in 1742, and known only by the copy in the American Antiquarian Society, may serve as the exemplar of the type, especially as it has the distinction of being the earliest cook-book to come from the American press. In 1748, Franklin brought out the ninth edition of George Fisher's *American Instructor*, a book that pretended to be a universal compend of the information contained in several of the types that have been mentioned. It taught spelling, the three R's, letter writing, business accounts and forms, American geography and statistics, carpentry, mechanical rules, prices, rates, wages, the use of the sliding rule, gauging, dialling, dyeing, and color making. It included also Tennent's *Poor Planter's Physician*, and gave instructions to the housewife in the care of linen, in the making of pickles, preserves, plasters, and wine, the "whole better adapted to these American colonies, than any other Book of the like Kind."[7]

The Product of the Colonial Press

School-books, Chapbooks, Ballads, and other Ephemera

Certain other staples of the press, especially of the New England press, are so well remembered that there is need to speak of them here only as types. Latin grammars and school-books of all sorts, primers, New England and Royal, Psalters with and without the music, catechisms, moralized chapbooks illustrated by hideous woodcuts—these were the commonplace items of publication that have their special historians and bibliographers and, above all, their collectors. No fewer than 112 editions of arithmetical school-books, to take one type as an example, came from the American press between 1705 and 1799. In New England, too, the printing of ballads seems to have flourished more notably than elsewhere in the country. No private tragedy or public event could come to pass that the chapbook printer did not call upon his bard to immortalize it in verse, and while the sheets were still coming from the press send forth his ballad-mongers to gather the halfpennies of a curious populace. Worthington C. Ford's *Broadsides, Ballads, &c. Printed in Massachusetts*, already gratefully cited in this work, has made it plain that this field of publication was not only a regular and picturesque feature of the printer's activity in and around Boston, but an activity particularly suggestive of the recreational interests of the local populace. It is not to be doubted that similar interests were served in others of the colonies, but whether to the same relative degree is a question that will be determined only after other bibliographers have made intensive studies of the sort conducted by Mr. Ford for Massachusetts. The earliest of the broadside verses, and these hardly come into the

class of ballad literature, were the funeral elegies written by learned divines to signalize the passing of brother clergymen or of well-respected parishioners. *A Copy of Verses made by that Reverend Man of God Mr. John Wilson, Pastor to the first church in Boston; on the sudden Death of Mr. Joseph Brisco, Who was translated from Earth to Heaven Jan. 1. 1657*, printed presumably by Samuel Green in Cambridge soon after the event memorialized, may serve as the type of the funeral elegies which continued to come from the Massachusetts press for many years. The taste of the people for narratives of horror combined with pietistic admonition found gratification in the dying speeches of criminals and the versified records of their careers. Such a piece was *The Wages of Sin; . . . A Poem Occasioned by the untimely Death of Richard Wilson, who was executed on Boston Neck, for Burglary . . . the 19th of October, 1732*, and such was *A Mournful Poem on the Death of John Ormsby and Matthew Cushing, . . . executed on Boston Neck, the 17th of October, 1734*. Verses of this grim variety, no grimmer of course, than the stories of crime with which our daily journals abound, were normally decorated with extremely crude but effective cuts representing the cart, the gallows, a hanging body or bodies, and an attentive audience. But other local events of importance found their laureates as well as the deaths of saints and sinners. One learns from the *Autobiography* that the very youthful Benjamin Franklin came forward with ballads on at least two occasions, once to sing a shipwreck and once the capture of the pirate Blackbeard. A victory over the Indians was sure to bring out one or more poems. Lovewell's defeat of the Indians at Pigwacket was celebrated in *The Voluntier's March*, advertised by James Franklin as "An Excellent new Song" just published on May 31, 1725.

The Product of the Colonial Press

Humorous and satirical poems were frequently published in the broadside form. John Seccombe's *Father Abbey's Will* of 1732 was of sufficient interest to find republication in the same year in England in the *Gentleman's Magazine* and the *London Magazine*. That the college was even then not regarded as sacrosanct is evident from *A Satyrical Description of Commencement Calculated to the Meridian of Cambridge in New-England*, a piece that seems to have been printed in 1718 and reprinted in 1740. Battle, murder, sudden death, moral improvement, and the ridiculous provided the motives for most of the ballad literature of the period, and despite its themes it is an interesting literature, sounder, more sincere, and closer to life than the polite lyrics which began to supplant it, in the esteem of the educated classes, certainly, as the eighteenth century slowly became elegant and romantic.

The Book of Tunes

The book of tunes for church singing, particularly those for use in the New England churches, is a category which assumes importance among the customary products of the colonial press. As early as 1698 a book was printed in Boston in which appeared a few pages of woodcut music. This was the ninth edition of the Bay Psalm Book, printed by B. Green and J. Allen. But in this book the pages of music are incidental to the text. In the sort of volume that we have more particularly in mind the printed text occupies the minimum of space and the book is given over as a whole to the music of psalm tunes and hymn tunes printed from engraved copper plates. The whole subject has been treated in impeccable fashion by Frank J. Metcalf in his *American Writers and*

The Colonial Printer

Compilers of Sacred Music. The earliest American music book of the kind we are describing was probably John Tufts's *Plain and Easy Introduction to the Art of Singing.* The date of publication of this pioneer work, of which no copy is now known, and of which the exact title is not recorded, is given uncertainly as either 1714 or 1721. With its tunes expressed in an arbitrary notation invented by its author, the Tufts book failed of general approval. Even the accident of being first on the ground won its author little advantage, for there came from the press of James Franklin, in 1721, Thomas Walter's *Grounds and Rules of Musick Explained.* The influence and example of this superior work effectually established the type of book of which this section treats. Mr. Walter's book was oblong in shape and its tunes were engraved upon copper with the conventional diamond shaped notes of the period. Its final edition, after more than a generation of popularity, was in 1764.

One may not go further into this subject except to mention the names of a few compilers whose works went through many editions and long years of popularity. Of these Daniel Bayley, organist of Newburyport, was perhaps the best known. James Lyon, originally of New Jersey, published his *Urania* in Philadelphia in 1761, and thus first brought into the field a collection containing original compositions by an American author. This work, engraved by Henry Dawkins, with a title-page decorated in the style known as "Chippendale," is a far handsomer product than the normal music book with its crowded staves and general appearance of crabbedness. The generously broad pages of the *Urania*, measuring 4½ x 9½ inches allow a long staff with well-spaced notes and beneath them the words engraved in a firm and well-conceived italic. Its style should have influenced the general

The Product of the Colonial Press

form of this product, but for some reason most of the makers of music books continued to be satisfied with rather ugly, crowded pages, primitive as to lettering and notation. William Billings, with his elaboration of the mode of psalm singing; Andrew Law, with an entirely new musical notation in certain of his books; and Daniel Read are a few of those whose books in this category had importance in the life of the country of their publication. Some of the chief engravers of the century were employed in the making of the plates from which the many editions of these works were printed and in the embellishment of their title-pages. Paul Revere, for example, engraved the music and the frontispiece of Billing's *New-England Psalm-Singer*, of Boston, 1770.

The publication of secular music in the colonies has nothing like so long a history as the music books intended for church use, but beginning about the year 1780 the publisher of sheet music, instrumental and vocal, appeared in the land and began to reissue for American use the popular and classical productions of the old world. One of the earliest strictly native secular poems to appear in print with musical notation was *The Liberty Song*, composed by Francis Hopkinson to words by John Dickinson. According to the *Boston Chronicle* for August 29, 1768, this stirring piece seems to have been printed with music for the first time by Mein & Fleeming of Boston, but no copy of that broadside is known to exist today. In Bickerstaff's *Almanack* for 1769, however, this same firm published the song set to the old tune "Hearts of Oak." The study of the musical activities of the colonists is only beginning to be undertaken. Books of instruction, such as *An Abstract of Geminiani's Art of playing on the Violin*, Boston, 1769, the church books, the secular sheet music, the innumerable advertisements of music masters — all form sources for

The Colonial Printer

a colonial American chapter in the history of this perennial interest of man.

The Advertising Handbill

A source of income for the printer to be mentiond last, not because of least importance, however, was the separately printed advertisement. Though of early origin, the practice of newspaper advertising by merchants and others came very slowly to the position it now occupies in our daily economy. The examples of the advertising handbill and poster that have been recovered—and these are a very small proportion of the whole number printed—show how dependent was the advertiser of the day upon a broadside that could be distributed from door to door, from farm to farm, or posted at the court-houses of the various counties. Government notices and proclamations, notices of militia assemblies, the arrival of a cargo of goods to be sold by a merchant, sharp personal controversies, political differences, the description of a runaway slave, apprentice, or indentured servant—all the linen of the pioneer community, clean or dirty, was exposed to the public gaze by this method of display, and all to the profit of the printer.

The subject of staple products of the colonial press can only be touched upon lightly in a general work. Doubtless, many types have been omitted in this survey of the field, but some day it will have a historian who will connect the things that people of the earlier day read with their daily habits of living, and in doing this throw new light on the making of national characteristics. The types spoken of here merely serve to show the part played by the printer in a country

The Product of the Colonial Press

where the degree of actual literacy was high, but where men perforce were compelled to supplement their native lore of wood and field by the general information of the compend. These books of utilitarian value were bought and used by people of every rank, and their educational value in matters of daily living was of a high order.

The Mathers, the First Colonial Men of Letters

In turning from the discussion of the staple products of the colonial press to its more distinctly literary publications, one's thoughts fix themselves at once upon the earliest group of American men of letters, the Mathers of New England. Of the 650 titles written by fourteen members of that singularly vigorous family, 610 came from various American presses. The first book with which a Mather was concerned was also the first book to be printed in the colonies. The Bay Psalm Book of Cambridge, 1640, was edited by Richard Mather with an introduction from his hand that must be ranked as the earliest literary production of the colonial press. Though the urgent motive of their writing was religion in its Congregational aspect, their books and pamphlets touched the life of New England at many other points. Cotton Mather, in particular, was a man of wide interests in history, biography, and science, and if he was led into the intellectual error of the witchcraft delusion, it must not be forgotten that he fought for and succeeded in establishing in this country the practice of inoculation for small-pox, the most dreadful scourge of the time. The works of popular science that came from the pens of Increase and Cotton were important in a day when scien-

tific writings were few and science itself was just emerging from its age-long conjunction with magic. The American press had no more frequent patrons than the Mathers, and one must believe that, on the whole, the association was profitable to the people of New England, as it must surely have been profitable, though in a different sense, to this family of sound and conservative writing men.[8]

Political Writings

The commentary which composes this chapter is not planned on a scale of sufficient breadth to permit more than a brief reference to the well-conceived and effective political writings which issued from the colonial press in ever larger numbers throughout the period. It was this writing, rather than their essays and poems, which formed the most distinctive contribution to letters of the men of the place and time.

The willingness with which the press supported the writers on public matters is indication of the deep political concern of the people as a whole. It may be that the New England of the seventeenth century must be regarded as the exception to this generalization, for in that place and time the need for establishing a new church order held complete possession of the minds of those who were expressing the needs of their communities in print. But even in that section, once the Cambridge Platform and the Saybrook Platform had been established, and the Half-Way Covenant and related questions had been fought over and left to individual belief, once the "New England Way" had hardened into a working system, questions of politics began to occupy the most vigorous writers of the community. The Indian Wars of the last quarter of the century, the struggle for the maintenance intact of the

The Product of the Colonial Press

Massachusetts charter, the local implications of the Protestant Revolution turned some of the best men of the section to the consideration of local and general political questions. It was in that period, too, that the older generation of colonists who, like James I, had ruled according to the common weal but not necessarily according to the common will, finally died out, unable to transmit their power, which had been the growth of a peculiar set of circumstances, to sons who were either tinctured with the new thought of the time or were ineffective in the face of the increasing liberalism of a community then receiving in great number emigrants who had little in common with the fathers of the country save their race.

In Pennsylvania questions of politics, local rather than general, occupied writers and press from a very early period. We have seen that it was the support of the Keithian schism by the printer, William Bradford, which in 1693 resulted in his departure from Pennsylvania and the consequent establishment of printing in New York, where, soon enough, problems of local politics began to occupy the writers who depended upon his press. In Maryland, the overthrow of the Catholic Proprietary in the local Protestant Revolution of 1689 produced two significant political documents from the press of St. Mary's City. But it was in the eighteenth century that the great public questions of national interest drew from the press a series of writings of force and distinction. In Virginia and Maryland economic problems in connection with the tobacco trade, in Maryland and Pennsylvania the relation between people and proprietary and the question of the right of the colonists to the benefit of the English statutes were matters of living import with which, in the first half of the century, the presses of Williamsburg, Annapolis, and

The Colonial Printer

Philadelphia concerned themselves. In Pennsylvania, also, the Quaker ideal of non-resistance had to be modified if that Province was to be made safe against the ambitions of the French and the inroads of their Indian allies. In New York feuds between rival factions, representing, roughly, conservative and liberal ideas, ran a long and turbulent course, and there, too, the problems of trade with the Indians, protection against their incursions, and the importance of the city in the French strategy held the interest of the outstanding men of letters and the political theorists. In New England economic problems led to the local publication of a series of "currency tracts" of the first importance in the life of that section. National interests, such as the formation of a union of the colonies, brought into being the Albany Congress of 1754 and a pamphlet literature on that engrossing constitutional project. In later years the question of the constitutionality of the Stamp Act led to the writing and printing in the colonies of a series of pamphlets which strongly influenced English thought on that subject. Moses Coit Tyler's *Literary History of the American Revolution* and Randolph G. Adams's *Political Ideas of the American Revolution* are works that take into hand for analysis and interpretation the fermentation of ideas and projects which was going on throughout the pre-Revolutionary period. The importance of the relations between the Indian nations and the colonists was recognized everywhere in the country. The presses from Boston to Williamsburg gave in the period 1690 to 1776 about fifty of those printed documents known today as "Indian Treaties." These minutes of conferences are not only records of important agreements and decisions essential to the modern historian, but, because they were cast in a form determined by the immemorial practice of the Indians themselves, they

The Product of the Colonial Press

formed a new type in written literature. Franklin was foremost in his recognition of the importance and literary value of the Indian Treaties. He printed the notable *Treaty Held at the Town of Lancaster in 1744* for wide distribution throughout the colonies, and even went so far as to print 200 additional copies for sale in England.

The eighteenth-century American found himself living in a period in which vigorous new political ideas, and old ideas reëxamined, were seething in men's minds throughout the western world. His own contribution to the new intellectual era was an alert, thoughtful, and well-expressed excursion into the field of facts and ideas, a group of writings of sufficient weight to serve as his passport into the society of cultivated nations.

The Writing of History in the Colonies

If one is of the school which believes that politics is present history and history is past politics (and all of us give some degree of adherence to that formula) one observes with interest the extent to which the formal recording of history ran parallel to the current expression of opinion on political matters. The writing of history seems, indeed, to have been a spontaneous form of expression for American men of letters from the earliest days. It seems almost as if they visualized themselves as actors in a great social experiment of which every stage and event should be kept in memory. It should be said, at this point, that by the "writing of history" I mean really the "writing of histories," of self-conscious studies which record and interpret events in the past experience of the people for the information of posterity. We recognize, too, the existence of another motive in the earliest days which

The Colonial Printer

produced the same result, that is, the desire to explain and interpret contemporary events to contemporary men, especially to officials and men of influence in England. *A Declaration of Former Passages and Proceedings betwixt the English and the Narrowgansets*, Cambridge, Massachusetts, 1645, is a statement which records and interprets a series of events in the hope of justifying to the English at home action taken by the community, which, without such explanation, might well have been misunderstood. Other apologies of this sort, using the stronger meaning of the word, came in the early days from the press, but soon there were being compiled "histories" of the sort we are chiefly concerned with, writings intended as records for the information of present and future men. Mortons's *New-Englands Memoriall*, of Cambridge, 1669; Hubbard's *Narrative of the Troubles with the Indians*, Boston, 1677; Increase Mather's *Brief History of the Warr With the Indians*, Boston, 1676, are notable products of the Massachusetts press, not mere tracts or pamphlets but formal records of past events against which the activities of the present might be projected and examined. From the Boston press came, in 1736, Thomas Prince's *Chronological History of New-England*; from the Williamsburg establishment of William Parks there was issued in 1747 the most elaborate production of this kind in the first half of the century, Stith's *History of Virginia*. In 1765, the press of James Parker was moved from Woodbridge, New Jersey, to Burlington for the purpose of printing Samuel Smith's *History of New-Jersey*. From the New York press came also in 1727 Colden's *History of the Five Indian Nations*. Returning to Boston, we find coming from the press of Rogers and Fowle in 1747 and 1751 the most conspicuous attempt until then made at a general history of the colonies, a work written upon a broad design

The Product of the Colonial Press

by a man who saw the English colonies as something other than a congeries of separate, self-contained states. This book was Dr. William Douglass's *Summary, Historical and Political, of the first Planting, progressive Improvements, and present State of the British Settlements in North-America,* a book to which, it sometimes seems, due honor has not yet been paid. And so the story might go on at greater length. In all this effort we find an implicit expression of the belief these writers held in the importance of the events they were recording, a belief recognized by them of a great destiny awaiting the land of their habitation. The printers gave aid and comfort to these servants of the land by coöperation in the publication of their dignified and scholarly historical writings.

The Literary Product

To the present-day observer of its activities, the most interesting feature of the colonial American press is its portrayal of the daily life of the pioneer communities by means of the productions that have been specified. Hardly less in the degree and quality of interest is the indication the literary publications give of the formation and growth of ideas in English America. Primarily utilitarian, the American colonial press came slowly to the status of a spiritual force in the life of the people it served. It is a commonplace to point out the predominant religious concern of the New England press as opposed to the more general interests of the press in the middle and southern colonies. Yet such a generalization, even if it cannot be defended at every point, serves to express an underlying truth. The first book printed in English America was the Bay Psalm Book, of Cambridge, 1640, an entirely new version of a great body of religious verse. The first origi-

nal poem of the country of any size was Michael Wiggles-
worth's *Day of Doom*, harsh theology expressed in vehement
verse, printed in Cambridge in 1662. Benjamin Tompson's
New Englands Crisis, a group of poems on events of the
Indian wars, brought out by John Foster, of Boston, in 1676,
has been called "the first collection of American poems to be
printed in what is now the United States." Two years later,
in 1678, the same printer issued Anne Bradstreet's *Several
Poems*, the first American edition of her *Tenth Muse lately
sprung up in America*, London, 1650. Foster's edition of
Mrs. Bradstreet's poems marked, in this country, the entrance
of women into the field of letters. The poems of Tompson
and Mrs. Bradstreet, serious though they might be, were suf-
ficiently different from Wigglesworth's grim versifying to
convince us that even then New England, so generally and
so carelessly misinterpreted in our generation of revolt against
the Puritan discipline, was not devoid of the grave sanity of
her later periods.

When we turn to consider the things that were being print-
ed in the colonies to the south, an immediate difference in in-
tention is perceived even when a likeness in kind prevails.
The people of Church of England Virginia, Church of Eng-
land and Roman Catholic Maryland, colonies of large land-
holders, of scattered towns, of social extremes, carried their
learning as an ornament, or as a measure of utility, rather
than a means of grace. The first poetical work done in Eng-
lish America was the translation of Books VI–XV of Ovid's
Metamorphoses made by George Sandys in Jamestown, Vir-
ginia, after his arrival there in 1621, and printed in Lon-
don in his complete edition of that work in 1626. When
presses began to operate in the South, we observe in their out-
put, in books and in newspapers, a reflection of the polite and

The Product of the Colonial Press

learned world of London. Translations from the classics, Lovelacian lyrics, elegant trifles in verse and prose provide an element in the product of these presses that must be studied by the social historian. *The Sotweed Factor*, by Ebenezer Cooke, was probably the most original poem to come from an American press of the times. This vigorous satirical piece was first published in London in 1708, probably republished in Annapolis about the year 1728, and, under the general title, *The Maryland Muse*, again printed in Annapolis in 1731, this time in company with *The History of Colonel Nathaniel Bacon's Rebellion in Virginia, Done into Hudibrastick Verse*. Its second publication in America was preceded by that of its continuation, the *Sotweed Redivivus*, in Annapolis in 1730. The translation by Richard Lewis of Holdsworth's Latin satire on the Welsh, the *Muscipula*, printed in both languages in Annapolis in 1728; John Markland's ode on printing, *Typographia*, of Williamsburg, 1730; *Poems on Several Occasions* by "a Gentleman of Virginia," Williamsburg, 1736; the translation of *Cato Major*, printed by Franklin in Philadelphia in 1744, are locally printed and locally written pieces that indicate the tastes and feelings of the men of learning of these communities. The student of American ideas finds in these and similar issues of the colonial press fascinating material for the comprehension of spiritual tendencies.[9]

A Note on the German Press

It happens that more than once in these pages mention has been made of *Der Blutige Schau-Platz*, the book of the Mennonite martyrs translated from the Dutch of Tieleman van Braght and printed at the Ephrata Monastery in 1748 on a partnership agreement, at the behest of the Pennsylvania

Mennonites. The resulting volume of 756 leaves was the largest book produced in the colonies before the Revolution; that it may also be judged the ugliest does not take away merit from the pious souls who conceived, or from the pious but unhappy men who executed, the great project. The story of its printing takes us into another world than that of the bustling, commercial seaport towns of the colonies, to a quiet village of the interior where, in a Seventh Day Baptist Monastery, were reproduced the conditions of the communal religious life of another age and continent. The naïve authors of the *Chronicon Ephratense*, Brothers Lamech and Agrippa, tell of the printing of the great work under the oversight of their rigorous taskmaster, the Superintendent of the Community. The story comes into a history of the colonial press, for, huge and unlovely though it may be, the Mennonite Martyr Book was in some particulars its most remarkable product. Certainly there remains no record of the actual printing of an American book so curiously interesting.

"After the building of the mill was completed," the chroniclers wrote, "the printing of the Book of Martyrs was taken in hand, to which important work fifteen Brethren were detailed, nine of whom had their work assigned in the printing department, namely, one corrector, who was at the same time the translator, four compositors and four pressmen; the rest had their work in the paper-mill. Three years were spent on this book, though not continuously, for there was often a want of paper. And because at that time, there was little other business in the Settlement, the household of the Brethren got deeply into debt, which, however, was soon liquidated by the heavy sales of the book. The book was printed in large folio form, contained sixteen reams [*sic*, for quires] of paper, and the edition consisted of 1300 copies. At a council with the

The Product of the Colonial Press

Mennonites, the price of one copy was fixed at twenty shillings, (about £1), which ought to be proof, that other causes than eagerness for gain led to the printing of the same.

"That this Book of Martyrs was the cause of many trials among the Solitary, and contributed not a little to their spiritual martyrdom, is still in fresh remembrance. The Superintendent, who had started the work, had other reasons than gain for it. The welfare of those entrusted to him lay near his heart, and he therefore allowed no opportunity to pass which might contribute anything to it. Those three years, during which said book was in press, proved an excellent preparation for spiritual martyrdom, although during that time six failed and joined the world again. When this is taken into consideration, as also the low price, and how far those who worked at it were removed from self-interest, the biographies of the holy martyrs, which the book contains, cannot fail to be a source of edification to all who read them. Moderation and vigilance were observed during this task as strictly as ever in the convent; but everything was in such confusion, that in spite of all care, each had to submit to discipline at least once a day. God be praised that brotherly love did not suffer from it! The Superintendent visited this school of correction once every day, in order to preserve the balance among the Brethren."

Der Blutige Schau-Platz is perhaps the only colonial book of which the laborious printing was used as a spiritual corrective, "so that no one might ever feel at home again in this life, and so forget the consolation from above," as the *Chronicon* puts it with something of irony under an innocent face.

The German press in Pennsylvania, indeed, with its Sowers and their large establishment, its *brüderschaft* of the Ephrata Monastery, its Armbruester, its Steiner, and a score

The Colonial Printer

more of intelligent, diligent printers, offers a phenomenon
for reflection and study. The Pennsylvania Germans were
a folk set down in a strange land in the midst of an alien
race; it is no wonder that they sang longingly of Zion and
turned their vision inward. While the New England minis-
ters were preaching and writing their rigid Calvinism or their
broad and cool Unitarianism, and the Church of England
clergy were upholding their tradition of the *via media* with
its sane and healthy way of spiritual living, the German sec-
tarians were looking upon the face of God with a mystical
rapture that found its way inevitably into the books that
came from their presses, whether from Moravian, Dunker,
Mennonite, Seventh Day Baptist, or German Pietist sources.

The first German books of the colonies came from the press
of Andrew Bradford of Philadelphia, probably as early as
1728, though no imprints of that year have been found. In
1729, however, Bradford's services as printer were demanded
at least twice by the German sectarians of Pennsylvania.
Some years after the founding of the Ephrata Monastery a
press was established in the cloister, and one of its first known
issues, in 1745, was Beissel's *Urständliche und Erfahrungs-
volle Hohe Zeugnüsze*, which is described as a work of mysti-
cal theology full of abstruse oddities. It had appeared orig-
inally under the title *Zionitischen Stiffts*, or rather, had been
about to appear with a preface by Israel Eckerlin when Beis-
sel quarrelled with his editor, expelled him from the brother-
hood, burnt the preliminary sheets of the book, and issued it
with a new title and preface. Lovers of their Lord, these en-
thusiasts were also good haters of their fellow men when
events gave rise to the harsher emotions. Succeeding works of
a similar character form a distinct type in the product of the
colonial press, but one turns with relief from their metaphys-

The Product of the Colonial Press

ical and mouth-filling titles to the simple and imaginative titles of German works of another type that came in abundance from the presses of this race of choral singers. The *Güldene Aepffel in Silbern Schalen* was issued from the Ephrata press in 1745, only to be followed two years later by *Das Gesäng der einsamen und verlassenen Turtel-Taube*. In the foreword of this book, the "Vorrede von der Singarbeit," Beissel has set forth a treatise on harmony that is said to merit attention from the historian of music. We have also, as memorials of the life of this interesting folk, the *Geistliches Blumen-Gärtlein Inniger Seelen*, of Germantown, 1769, and other works in which the image of the Christian church as a lonely turtledove, or of the spiritual life as a golden apple or a little sacred garden is presented earnestly and without self-consciousness. The same spirit that led in ancient days to a mystical interpretation of the dark maiden in the Song of Solomon as the spiritual bride of Christ animated the composers of the German hymns. "The vocabulary of sensual love," Seidensticker writes, is used in the hymn books "to symbolize religious ecstasy." There was something in these German peasants, with their extravagance of feeling, their fierce controversies, their mysticism, and their devotion to choral singing, that sets them apart even in so varied a scene as the Pennsylvania of the mid-eighteenth century.[10]

A Concluding Reflection

The purpose of the foregoing pages on the product of the colonial press is to provide a picture of that ever-expanding stream of publication rather than a review or summary of it. It is intended to give the student of typographical history a graphic conception of a craft doggedly at work, serving as

The Colonial Printer

best it might the material needs, ideas, and emotions of the communities in which it was seated, expressing their aspirations, and taking part in the development of their political and social institutions. Such a chapter as this is at once a part of the history of printing and the end and goal of its study.

XII

The Product of the Colonial Press

Part II. External Characteristics

IN examining the American book of the seventeenth and eighteenth centuries, one finds little in its appearance or physical characteristics to distinguish it from the normal English book of the same period. There is no question, of course, that the London printer who set about the production of a fine book possessed, to begin with, a degree of experience in bookmaking and an acquaintance with notable specimens of the craft not often part of the equipment of the pioneer American printer. The Londoner had also the advantage of proximity to the paper-mills and type foundries of Holland and to the engravers of that country and of his own. His luxury books, in consequence, were of considerably greater dignity and beauty than anything the colonies could or did produce. There is nothing of colonial origin comparable in typographical appearance and decoration to such an English work as the Oxford, 1702–1704, edition of Clarendon's *History of the Rebellion*; or, in variety of types employed and in the skill of their composition, to the *Opera* of John Selden in the edition of London, 1726, in which was used for the first time the roman letter of William Caslon; or, in the field of book illustration, to Catesby's *Natural History of Carolina*, London, 1731–1743, with its superbly engraved and colored plates of birds, reptiles, and plants. Bookmaking of this sort was a thing apart; the American printer had neither the experience, the resources, nor the incentive in the form of market demand to attempt its emulation in his own productions. Such work was not expected of him, and the fact that

[265]

The Colonial Printer

he did not produce it requires neither apology nor extenuation. But it is doubtful whether the normal book—the quarto or octavo book of verses, the sermon, or the political tract—found in the London shop was greatly superior to the book of a similar character that came from the well-established shops of the larger American towns. In neither place was work of this sort notable from the esthetic standpoint; the printer regarded it as ephemeral material and paid it the minimum of respect. It is we of the later centuries who have discovered the social importance of its content and given high place to the shoddy little volumes in which, too often, it is embodied.

But whether we are thinking of the English book or the American, there are two considerations which must be taken into account. One of these is the existence of many printers who were exceptions to the generalization just made, men who had the good craftsman's pride in doing the common thing well; the other, and the more difficult to keep in mind, is that, nearly always, we see these books in what, if permitted, we may describe as the "sere, the yellow leaf," see them limp and worn through use, damp stained and with faded ink, two or three centuries after their original appearance, when the paper was white and crisp, and when a succession of readers with dirty thumbs had not mishandled them, nor a succession of binders with plough and perversity ruined the proportions of their pages by the repeated croppings of their edges. When by good fortune one finds an early American book crisp and uncut, one realizes that even the less ambitious of them were not altogether to be despised.

The Product of the Colonial Press

Characteristics Resulting from Paper Economy

In addition to a certain air of naïveté, an appearance about them of having been achieved experimentally rather than turned out as a standardized product, there is one characteristic that strikes the observer in examining even the better American book. I was about to say the better American book in comparison with the better English book, but the truth is that the fault, a certain crabbedness in composition, was of the century rather than of the place, though it is likely that it is more frequently found in the American book than in that which proceeded from an English shop. Often a truly fine title-page — free, well-balanced, stately — introduces the observer to pages of text in which the type employed is too small for the area covered by the letterpress. The explanation of the anomaly lies in the need of the colonial printer to conserve his paper supply; he must get upon each sheet as much matter at it would hold, and often that meant he must set his matter in an inappropriately small letter. Some of the great collections of laws, and it was in the making of these and other official productions that the colonial printer tried hardest for perfection, fail on this account to live up to the promise of their title-pages. An example of what I have in mind is found in that strikingly handsome book, Bacon's *Laws of Maryland*, a folio with a leaf measurement in its large paper edition of 16½ x 10½ inches and a letterpress measurement of 11½ x 6⅗ inches, exclusive of side notes. The pages were composed with exceptional skill in letter of pica, or twelve point, size. Pica is a respectable size for a book of these dimensions, but it is that and no more. The

The Colonial Printer

Bacon pages with their well-proportioned margins, their compact, even setting, their good inking and firm impression are pleasing indeed, but if they had been set in English, or fourteen point, the terms one would inevitably choose for their description are such grander adjectives as "noble" or "majestic." But esthetic considerations must not become the sole basis of criticism, nor is it wise to attribute every action of mankind to the economic motive. Jonas Green undoubtedly realized that his book would have been handsomer in a larger type, but he realized also that the lawyers, judges, and assemblymen who were to use the collection would have been continually vexed by a book in two volumes or by a single volume too heavy for easy handling. After all the book was to be a work of daily utility, and the problem was to direct everything about its production to that end. He succeeded in making a convenient and handsome volume despite his use of pica on a page where English would have been better.

Characteristics Resulting from Type Economy. Half-sheet Printing and Folios in Twos

Another characteristic of the colonial book, not a question this time of esthetic consideration, speaks loudly, also, of the limitations of the printer's equipment and of his need for the exercise of resourcefulness in his craft. Again we find that the characteristic in question, the prevalence of half-sheet printing and of printing folios in twos, is not unique in the American shops but only more general there than in England. These are terms which the reader who has not made printing practices a special study fails at first to understand, but as the motive for the adoption of the practices they represent

The Product of the Colonial Press

was an important element in the economy of the colonial printing office, it is worth while to explain them in this place. I quote, therefore, certain sentences I wrote some years ago in another connection:

"Printing in half sheets . . . seriously puzzles anyone who has not previously encountered the method or learned the meaning of the term. Usually when he hears the expression for the first time, he concludes that the printer of a book so described had been forced to work with a press smaller than normal or with paper too large for the common machine and therefore had cut down his sheets before printing. Neither size of press nor size of paper, however, affects the question in any degree. If the puzzled bookman once gets it clearly in mind that the sheets were not cut in halves until *after the completion of their printing*, the remaining features of the process will offer him no special difficulties.

"A printer who had a book in octavo to be produced in a busy season, when other jobs were making demands upon his small fonts of type, might decide that he could keep the work upon the book in a satisfactory state of progress by printing it in half sheets. He proceeded as ordinarily with a whole sheet in mind, and in hand, but instead of composing sixteen consecutive pages, imposing them in two forms, and printing one form upon each side of the sheet, he set only eight consecutive pages, imposed them in one form, printed them upon one side of the sheet, and then turning the sheet over *end for end*, printed them upon the other. With this sheet cut in halves across its shorter dimension, each of the resulting half sheets, folded into four leaves, showed eight pages in sequence. The printer, therefore, was able to build two piles at once of these eight-page half sheets with the same labor he would have expended upon one pile of whole sheets contain-

[269]

ing sixteen pages. By the adoption of this mode of imposition and printing he saved nothing in time or labor, but kept the book in work at the usual rate of progress while using only half the quantity of type required for the ordinary method."[1]

The practice of printing folios in twos must also have arisen from the need for getting the greatest possible use from a small supply of type, but R. W. Chapman has pointed out that English volumes in folio of the eighteenth century were frequently printed in twos and sometimes in type of such a large size that a relatively small quantity of it would have been needed to print the same work in fours or sixes.[2] It may be that, beginning as an economic measure, this procedure became so much a matter of custom that it was sometimes automatically adopted without cause. But the original cause for a practice that made the subsequent binding of the volume infinitely more tedious of execution must have been, as will now be explained, the impelling one of economy in type employment.

The well-equipped English or continental office, in making a folio book, was able customarily to set at one time eight or twelve folio pages and to impose them in such wise that when printed, and the resulting two or three sheets of letterpress had been folded and quired within one another, the page numbers would run consecutively throughout the quire or gathering, thus giving a folio in fours or sixes. But in a small establishment with only a few hundred pounds of type to each font, the proprietor must exercise ingenuity to prevent tying up a font of frequent employment throughout the composition, imposition, proving, printing, and distributing of eight or more folio pages of letter. To avoid this embarrassment, he set at one time four pages only, imposed them to run consecutively in the simplest folio imposition scheme—pages one and four comprising the outer form, two and three the inner

The Product of the Colonial Press

—printed those pages, distributed the type, stored the sheets, and ultimately built up his book by a series of gatherings composed of one sheet of two leaves each. That particular font of type was thus kept fluid and available for whatever additional uses might be demanded of it while his folio volume was in progress. *The Book of general Lauues and Libertyes*, of Cambridge, 1648, the first body of laws published in the United States, was imposed as a folio in fours, but the Massachusetts *General Laws* of 1672, and *The Book of the Laws of New-Plimouth*, of 1672, both of Cambridge, and the *Acts and Laws of Connecticut*, Boston, 1702, were imposed as folio in twos in the manner described. Bacon's *Laws of Maryland*, Annapolis, 1765, was, for the greater part, in fours, though its long index of twenty-three signatures was imposed in twos. In later years the son of Jonas Green, its printer, set in the large folio size of the book of 1765 another body of Maryland laws and imposed it in twos. Parks's *Collection of all the Acts of Assembly*, of *Virginia*, Williamsburg, 1733, was imposed as a folio in fours, but his *Compleat Collection of the Laws of Maryland*, Annapolis, 1727, was a folio in twos, as also was Lewis Timothy's notable edition of Trott's *Laws of South Carolina*, Charleston, 1736, and Franklin's Philadelphia, 1742, edition of *A Collection of all the Laws of Pennsylvania*. The normal book of folio session laws was, in brief, in twos, and those notable issues of Franklin's press, the folio Indian Treaties, were commonly in twos. In short, despite exceptions, the practice of the colonial printer was normally to print his folio volumes in twos. Whether it was always the need for keeping his type available for other current uses that led him to this procedure, whether it was a practice originally based upon this need which became a customary mode through habit after the need had become less

impelling, or whether he was forced to it by some exigency of his business not clearly understood by us, is difficult to determine. Bacon's *Laws of Maryland* was set from new fonts of Caslon imported for the purpose of printing that book. It is likely that until the book was finished the new type was used for no other purpose, and that, consequently, the need for keeping the font available for other work did not exist. Some such consideration as this, the certainty, in brief, that the font would not be needed for concurrent service on other jobs may explain the exceptions here noted to the prevailing practice in the colonial shops of printing folios in twos. But whatever the reasons for the exceptions, it is difficult to think of any motive other than that which has been given for building a book in twos, doubling, at least, the amount of sewing required in its binding, and producing in the end a less durable binding because the threads must be sewn through the folds of single sheets rather than through the combined folds of two or three sheets.

It may be that further apology should be made for this excursion into a somewhat technical aspect of bookmaking, but, as already said, the procedures of which we have spoken had their origin in economic factors in the life of the colonial printer, and, were, therefore, conditions important for the student of his life and work to know about and understand.

Formats and Sizes

The formats of the books issued by the American printer of the seventeenth and eighteenth centuries were those that prevailed in the English and continental bookmaking of the period. The folio and quarto were the chief formats of the first century of printing history, but by the middle of the six-

The Product of the Colonial Press

teenth century the quarto had acquired the position of dominance it retained for another hundred and fifty years.[8] When the American press was established, therefore, the quarto, or what we call the "small quarto," format was its chief production. The small folio was used for certain purposes, but the octavo was rarely employed. The colonial printers saw, therefore, and had part in, the universal change whereby in the eighteenth century the octavo came into its own as the chief format of the printed book, a format convenient for the reader and economical for the printer. At the same time the folio became larger and the quarto almost disappeared.

The book of permanent reference value, which in the colonies meant almost entirely the book of laws or other government business, appeared generally in folio, or, as already explained, in small folio. *The general Laws And Liberties of the Massachusets Colony*, of 1672, showed a leaf measurement of 11⅛ x 7¼ inches. The leaf of the *Collection of the Acts of Virginia* of 1733 measured 13 x 8¼ inches; the *Laws of South Carolina* of 1736, 13¾ x 8⅝ inches; the "big Peter Miller," as an edition of Pennsylvania laws of 1762 was known, from the name of its printer, 14¾ x 9¾ inches; and, finally, the *Laws of Maryland* of 1765, in the large paper edition, 16½ x 10½ inches. A similar increase in size is to be observed in several series of assembly votes and proceedings. The first of the Indian Treaties in folio, that of New York, 1698, measured, roughly, 11½ x 7½ inches, while a group of Treaties issued by Franklin in 1757, and thereafter, measured 15½ x 10¼ inches. And the case of the newspaper is equally to the point: Parks's *Maryland Gazette* of the 1730's was printed on a sheet measuring roughly 12 x 14 inches; Goddard's *Maryland Journal* of 1773 used a sheet of about 16 x 20 inches.

The Colonial Printer

It is obvious that with this change in available paper sizes, the octavo format, in which the sheet was folded three times, would result in a book of dignified size in which an extensive text could be set forth in a reasonably large letter. That achievement was not easy in the seventeenth century. The quarto leaf of the Eliot Indian Bible of Cambridge measured 7½ x 5¾ inches, representing a sheet of 11½ x 15 inches. The leaf of an octavo formed from this sheet would measure only 5¾ x 3¾ inches, a book in which an extensive text would necessitate either the use of small type or the making of a fat, dumpy volume. The octavo from the sheet of 16½ x 21 inches on which the *Laws of Maryland* were printed in 1765 would measure 8¼ x 5¼ inches, and at about this time octavos or large twelve-mos of that satisfactory size began to issue from the American printing houses in such numbers as to make the appearance of a shelf of currently printed books very different from the picture presented by such a shelf a century before, when it would have been made up almost entirely of small quartos with a handful of small folios and one or two volumes in the lesser formats. If we substitute the word octavos for small quartos in this last clause, we have a description of a shelf of the late eighteenth century. There might be on that shelf, however, a number of twelvemos and sixteenmos, for the lesser formats were employed increasingly for almanacs, chapbooks, primers, and moral tales for children. It was the custom of the time to put matter for children into small books, often of incredibly poor printing and illustration. Larger books, larger type, and well-drawn pictures for the books of children were conceptions of the humanitarian nineteenth century.

The Product of the Colonial Press

Design and Decoration

The title-pages of American books of the earlier period were, like those of the English printers, likely to have their matter enclosed within ruled or flowered borders, with compartments set off by rules for title, author's name, and imprint. In some cases the text pages, too, were framed by ruled borders, but that extra touch, involving an expenditure of time not always justified by the result, was usually neglected by the American printer. The decoration employed by the seventeenth-century printer was mainly that of typographical flowers, those cast ornaments which, singly or in any one of a series of numerous possible combinations, gave finish or a touch of interest to spaces that otherwise would have been left blank, to that part of the title-page, for example, between author's name and imprint; to the head of an opening three-quarter page of text; or to the lower half of the concluding page of a chapter or section. The first press, that of Cambridge, possessed also a good store of engraved head and tail pieces—designs of an earlier period already taking on something of an archaic appearance—which it used effectively though sometimes with a heavy hand. Several of the earlier printers possessed one or two ornaments similar to these and an alphabet of floriated initials, which, properly used, gave finish to their work, and which in our time, if they are distinctive in character, frequently give aid to the bibliographer in the identification of anonymously issued volumes of the New England presses.

Coincident with the change in size of the normal book from quarto to octavo, there came about a general simplification of the design and decoration of the pages, following in this respect, somewhat belatedly, the newer English mode.

[275]

The Colonial Printer

This change was particularly noticeable in the lay-out of the title-page. Authors gave up the practice of crowding the page by trying to set out upon it an abstract of the text; printers left off the ruled borders within which formerly they had framed and compressed the too abundant matter. The late eighteenth century was the period of a second revival of classicism, a period in which men strove in language, in ideas, and in the product of the work of their hands for clarity, balance, and order. The literary style of the period reflected the spirit of the times, and the typographical style sought to express the work of writers in a method of display and composition that accorded with it. The book of the period gained its effect by the arrangement of its matter rather than by its decoration. Brief statements, well-spaced and well-balanced, gave its title-pages dignity and ease; leading between lines of text and wider spacing between the words let in the light and gave a quality of frankness, of ease and serenity, a letterpress pleasingly different from the crowded, tortured composition which characterized so much of the work of the seventeenth century. Decoration was discarded little by little until even the floriated initial or the factotum became the mark of a printer who was not abreast of the tendency of his time. A line or other combination of cast flowers on the title-page or at appropriate places throughout the book; a cast capital letter as initial, unornamented or framed by a design of type ornaments; or a small engraved ornament as tailpiece were the utmost allowed in the decoration of the normal volume.

The rejuvenation in the first half of the century of the roman type forms by the superior designing and cutting of William Caslon wrought a great change in the appearance of the book in England and America, removing from its letterpress an appearance of crudity which earlier often character-

THE

CHARTER,

AND

STATUTES,

OF

The COLLEGE of *William* and *Mary*, in *Virginia*.

In *Latin* and *Englifh*.

WILLIAMSBURG:

Printed by *William Parks*, M,DCC,XXXVI.

PLATE XXIV

The Product of the Colonial Press

ized even well-composed pages. When the type of that period was a Dutch letter of a good design, the effect was, in truth, that of rugged strength rather than crudity, possessing a charm that has not palled despite the changes in fashion; when it was a letter imitative of the Dutch cutting by one of the poorer English foundries, and when, to make the situation worse, it was worn and battered type, as it was too often in the American shops, the effect was such that even the most romantic antiquarian cannot regard the book set in it as anything but the result of a regrettable economic condition. Despite a certain unctuous perfection they possessed, the Caslon letters and those of the imitators of Caslon made a great change for the better in the American book of the second half of the century.

The Newspaper and Broadside

It was in this period of change, also, that the newspaper and broadside began to show that the colonial American printer was devoting thought to the esthetics of his craft even in the production of its commoner product. The broadside news sheet, hurriedly issued, rarely attained what we think of as typographical beauty, but there exist other and more formal products in the category of the broadside—government proclamations, extracts from assembly acts or ordinances, commercial advertisements, even—which come without question into the class distinguished by excellence of design and execution. The newspaper maintained for a long time the small folio size and the quaint and naïve crudity of the English journal of the early eighteenth century, but that product of the press began about the middle of the century, with larger paper and better types, to take on a quality that

The Colonial Printer

gives it importance from typographical consideration as well as from the standpoint of social value. The three newspapers established and conducted by William Goddard — the *Providence Gazette*, the *Pennsylvania Chronicle*, the *Maryland Journal* — and Jonas Green's *Maryland Gazette* are only a few of those which gave a special character to this product of the eighteenth-century American press. The large sheet of these journals, the well-balanced headings, the advertisements displayed clearly but not "boldly," the general appearance in the whole of professional competence forced the publishers of the small, crowded sheet of earlier days to reform or to give up competition.

Rubrication

In considering the work of the printer of the colonial period, we have confined ourselves heretofore to the problems of pure typography. This has been a reasonable enough procedure, because, after all, the normal printer of the time made no effort to produce anything except normal letterpress; the end of his endeavor was to set forms of roman type and impress them in black ink on white paper. It was only rarely that one of them varied his procedure even by the creation of anything so commonplace in other lands as a red and black title-page. Such a departure from the normal meant, of course, a second printing of the sheet upon which the rubrication appeared, and in the course of that second printing the taking of innumerable precautions to secure exact register. There have been from early days several ways of printing in two or more colors, but it is probable that in the eighteenth century in America it was done by the laborious method described by Moxon, which, briefly stated, was

to remove from the form all words which were to show ulti-
mately in red, filling in their spaces with quadrats lower than
the face of the type. The form was then inked in black and
when the required number of sheets had been printed the
quads were removed and the words to be printed in red were
restored with a very slight underlay to bring them the least
bit above the level of the rest of the form. These words were
inked in red, and a frisket, cut so as to mask all the form ex-
cept the red-inked words, was laid down and the form once
more put through the press. This procedure added greatly to
the cost of the job, and it must have been the element of cost,
as well as the need of highly skilled pressmen to carry out the
details, that made it unpopular with the American printers.
But when the largest publication project of the first half of
the century was brought to a close in Boston in 1726, the
printers signalized their pride in the volume produced, or,
perhaps, their relief at its completion, by a fine display of red
on its tall, well-ordered title-page. This book was the Rev.
Samuel Willard's *Compleat Body of Divinity*, published by
subscription through Benjamin Eliot and Daniel Henchman,
and printed in the separate establishments of Bartholomew
Green and Samuel Kneeland. It is a volume of 500 leaves in
folio, which, were its origin not declared in its imprint, would
surely be attributed to the shop of a competent London printer.

Thereafter, in the luxury books of the period, rubrication of
the title-page was occasionally resorted to by the printer. In
1728 William Parks printed his *Muscipula* title-page in black
and red; in 1736 Lewis Timothy produced an excellent result
with the rubricated title-page of his *Laws of South Carolina*;
and in 1744 Franklin printed in black and red the title of his
Cato Major. But even in the printing of what Moxon calls
"Books of Price," rubrication was infrequent. The cost and

particularity of the process were doubtless the chief reasons for its neglect. Another deterrent to its employment may well have been the difficulty of securing the proper pigment to be ground into the varnish to make an acceptable red ink. Vermilion was the most highly approved substance, and this or any other pigment, such as red lead, had to be mixed with a specially prepared varnish to prevent too quick drying on the form and on the ink balls. In short there were so many difficulties in the way of the ambitious craftsman who might have wanted to use red and black on a title-page that one does not wonder at the infrequency of his attempts to do so. One of the noblest books ever printed in America, not forgetting the product of these days of mechanical typographical appurtenances, was the *Missale Romanum*, a folio which came from the press of Antonio de Espinosa in Mexico City in 1561. A beautifully conceived book, rubricated throughout in proper liturgical style, it is also a typographic tragedy. Midway of the volume the printer's supply of pigment began to give out, and from that point onward his pure red begins to grow paler and paler until, towards the end, it becomes the very ghost of itself, and a brownish, muddy ghost at that. But as no American printer of the north ever attempted so grand a book as Espinosa's missal of 1561, none ever had so great an achievement to rejoice over, or so great a tragedy to mourn.

It is foolish perhaps to spend so much time in the discussion of a procedure our printer did not customarily follow, but we must be allowed the space thus consumed for the expression of regret that the product of his press as a whole seems austere in its monotonous black and white. We may feel that today there is too much color coming from the printing houses, that color is often unconsciously called into serv-

The Product of the Colonial Press

ice to distract the eye from weakness in design, but none the less we wish that the colonial printer had lightened his sombre pages more frequently than was the case with a rubricated title.

Book Illustration and Engraved Maps

It is impossible to speak of the physical character of the books that came from the colonial shop without thinking sooner or later of the illustrations with which some of them were embellished. There is danger in taking up that subject; it is so close to the larger and more varied field of engraving in general that we must keep in mind the scope of our present interest or prepare to be lost. Even so, the field is so large that it may be covered only here and there in time and space. The eighteenth-century engravers were numerous and industrious, and the printers gave them frequent employment.[4]

The earliest book from the American press to carry a pictorial embellishment was the Boston, 1677, edition of Hubbard's *Narrative of the Indian Wars*. The printer of this book was John Foster, who before buying the equipment of Marmaduke Johnson and putting into effect that worthy man's plans for establishing the press in Boston, had already taken up the art of wood-cutting, for it was wood-cutting and not wood-engraving in which he worked. Probably before 1670 he cut the portrait of the Reverend Richard Mather, a separate print sometimes referred to as a book illustration because one of the three known copies of it was found bound in a copy of Increase Mather's life of Richard Mather, printed at Cambridge in 1670. It is generally accepted today, however, that the print was a separately issued portrait, and though the evidence that it was cut by Foster is not of the

strongest there is excellent reason for believing it to be of his workmanship. It is, indeed, accepted and acknowledged as the earliest engraved and printed American portrait. According to a statement by John Eliot, Foster engraved an A B C book, no copy now known, for the use of the Indians, and there is evidence that the seal of Massachusetts found in Increase Mather's *Brief History of the War with the Indians*, of Boston, 1676, was of his workmanship. In this same year appeared the book first mentioned in this connection, Hubbard's *Narrative*, in which is found a whole sheet woodcut map, entitled *A Map of New-England, Being the first that ever was here cut*. In view of Foster's known skill, or lack of it, as a wood-cutter, and his known printing of Hubbard's book, the attribution to him of this print goes without serious question.[5]

It may be said with a reasonable degree of impunity that the earliest copperplate engraving of the colonies is the portrait of Increase Mather by Thomas Emmes, of Boston, which appears as frontispiece in certain copies of Mather's *Blessed Hope* of 1701, and his *Ichabod* of 1702.[6] That claim to priority is subject to two considerations. One of these is that the Massachusetts bills of credit of 1690 may have been engraved by the same John Conny, or Cony, who engraved the paper currency of that colony in 1702. The other is that there exists a *Mapp of the Rariton River*, engraved by R. Simson for which 1683 as the year of publication and New York as the place have been, it seems, too credulously accepted. It is probable, however, that this map was not even drawn until 1685, or later, and the assertion that it was engraved and printed in this country rests upon the misreading of a contemporary document in which it is mentioned. The result of a reëxamination of the evidence of-

The Product of the Colonial Press

fered in support of the claim is given in our appended note.[7]

The historian of American engraving breathes more freely when he learns that sometime in 1716 there appeared in Boston one Francis Dewing "who Engraveth and Printeth Copperplates."[8] Here was a professional engraver who in all probability brought with him from London a copperplate printing press and went about the business as a means of livelihood. Almost his first work as an engraver in Boston must have been the *Chart of the English Plantations in North America, from the mouth of the Great River Messasipi to the Canada River. By Captain Cyprian Southack. Engraved and printed by Fra. Dewing, Boston, New England, 1717.* Of this example of Dewing's work the single known copy is found in the British Public Record Office.[9] Dewing was still established in Boston in 1722, when there was published in that place and year John Bonner's *Town of Boston in New England* . . . "Engraven and Printed by Fra. Dewing. . . ."

In most of the chief towns of the colonies after this date the engraving 'and printing of copperplates began slowly to become matters of commonplace procedure. It seems that once more we must allow Franklin priority in a business connected with the printing of the middle colonies, for whether or not there had existed before his time a copperplate press in that part of the world, we are willing to believe he was the first there or elsewhere in the country to manufacture one. In another connection the *Autobiography* has been cited to show him, taught by his London experience, "contriving" such a machine in 1728 for Keimer's use in the printing of New Jersey paper money. This incident is an interesting feature in the background of the history of engraving in Philadelphia. Some twenty years later we find in that city, and in New York and Boston, groups of engravers busily making

separate prints and maps and lending their skill to the printers for the embellishment of their books.

The mention of Franklin's construction of a copperplate printing press brings up another aspect of the subject of American printing and engraving. The woodcut, with due care for underlay, inking, and impression, was customarily printed as part of the form of type on the letterpress printing press, but the copperplate, a plate engraved in intaglio, must be printed separately on a specially constructed press in which a revolving cylinder bearing upon a horizontally moving bed forced the paper into the engraved or etched lines and compelled it to take up the ink with which they were filled. The printing of a copperplate could be accomplished, though crudely, with a makeshift mechanism. It is recorded that in 1784 John Fitch, of steamboat fame, printed his copperplate *Map of the Northwest Part of the United States* on a cider press, and, looking at it, one realizes that in its printing, whatever the form of press employed, the hand of the amateur had been at work with makeshift equipment.[10] For good results an engraver's press with its great wheel and cylinder was essential, and we are led to inquire to what extent the American letterpress printing establishment elaborated its equipment by the inclusion in it of a copperplate press. The answer seems to be not at all. But this is not a matter of absolute certainty, though no engravers' press seems to be found in the inventories of printing houses that have come to my attention. But it is probably safe to say that the printing of copperplate engravings was a separate industry in this country in the colonial period as it has been, in general, ever since. We have observed that in 1716 Francis Dewing of Boston advertised himself as one "who Engraveth and Printeth Copperplates." It is not known who printed the Lewis Evans

The Product of the Colonial Press

maps of Philadelphia, 1749 and 1755, engraved respectively by Lawrence Hebert[11] and James Turner, but in 1756 in that city another map of Turner's engraving, Joshua Fisher's *Chart of Delaware Bay*, was printed by one John Davis, and in 1759 Nicholas Scull's six-sheet map of Pennsylvania was printed by this same Davis, who does not seem to have conducted a letterpress printing establishment but to have been a specialist printer of copperplates. The maps in the New Jersey *Bill in Chancery*, New York, 1747, carry the information that they were "Engraved and Printed by James Turner." At that time Turner, better known for his later Philadelphia activities, was resident in Boston. George Simpson Eddy suggests that he was the Boston artist whom Franklin paid for engraving the folding copperplate print for his *Account of the New Invented Pennsylvanian Fire-Places*, of Philadelphia, 1744.[12] Towards the end of the century in Boston, William Norman carried on what must have been an elaborate copperplate printing establishment.[13] The evidence suggests, therefore, that from a relatively early day the colonial printer and publisher of sufficient ambition to illustrate his product with engravings found himself in the larger towns served by the specialist copperplate printer.

It is customary to say of the early American engravers that their work was crude. This can be said with truth of their portrait and landscape production. Most artistic expression of the time and place was crude; certainly, if we may judge by the "American primitives" which the museums love to place upon their walls, the engraved work of the century was no less skilful in execution than the portrait painting. But these crude attempts at graphic portrayal pleased the people for whom they were intended. Not many of them had seen enough of the finished products of European artists to

realize that the prints and paintings they bought were halting efforts at expression. We may take it for granted, therefore, that most of the engraved work of this category that went into the early colonial books was rudely accomplished even when it had been well and faithfully conceived. The interesting thing about it all is that it spoke of the vitality of the art spirit in these people, of their desire to beautify, to embellish, to adorn. The interesting thing, to put it differently, is not so much how skilfully they did it, but that they wanted to do it at all and finally succeeded in doing it well. For there was a tremendously great advance in drawing, engraving, and printing between the work of Foster and Emmes of the seventeenth century and that of a group of men of the closing years of the eighteenth who united to illustrate a book, later to be spoken of, which was the highest achievement of the eighteenth-century American press.

Engraved Maps

Some of the maps of the eighteenth century, whatever their artistic quality, have nevertheless been effective in the activities of their times and have since become part of the history of men and books. Lewis Evans's map of 1749 engraved by Lawrence Hebert in Philadelphia, and his more important *Map of the Middle British Colonies*, engraved by James Turner to accompany Evans's *Geographical Essays*, of 1755; Thomas Johnston's *Plan of the Battle of Lake George*, said to be the first historical print engraved in the United States, published with Samuel Blodgett's book of that name; Abel Buell's *Chart of Saybrook Bar*, of 1774, and his *Map of the United States*, of 1784; the Amos Doolittle maps in Morse's *Geography* in several editions; Henry Pursell's *Map of*

The Product of the Colonial Press

Kentucke in John Filson's *History of Kentucke*, 1784; Bernard Romans's many maps and charts; William Norman's elaborate *American Pilot* are all documents of consequence that must be taken into account in a consideration of the effectiveness of the colonial press. When the bibliography of American printed maps, now in preparation by the William L. Clements Library, is completed, it will be understood what a great service to the country was performed by that coördination between the colonial publisher and the colonial engraver which brought this more than respectable body of cartographical material into being.

The Illustration of Architectural Books

James Turner was first of Boston, then of Philadelphia; John Norman went through the reverse order in his choice of residences. Both these men deserve monographic treatment. Norman is responsible, indeed, for the publication of the first book of architecture printed in this country. Only thirteen editions of books strictly of this class, comprising nine different works, were printed here in the eighteenth century, but this small group forms a peculiarly interesting product of the American press because of the influence they and their imported prototypes exerted upon the physical face of town and country. Norman published in folio in Philadelphia, in 1775, a reprint of an English work, Abraham Swan's *British Architect*, and began in that same year a more elaborate publication in folio of Swan's *Collection of Designs in Architecture*. Norman, who described himself as "Architect and Landscape Engraver," made the plates for these two books, of which only the first, containing sixty folio plates, seems to have been completed. Later, in Boston, he published another edition of the

British Architect; a compilation of his own called the *Town and Country Builder's Assistant*; and the 1792 edition of William Pain's *Practical Builder*. All these books were fully and skilfully illustrated, the engravings presumably by Norman himself.[14]

One book which came in 1800, at the very end of the century, and which must be regarded as distinctly a jewel in the product of the American press was *Views of Philadelphia* . . . "Drawn and Engraved by W. Birch & Son." Not exactly an architectural book, this volume is that and something more, for it contains, finely rendered, the results of architectural achievement as seen in the private houses and public buildings of a rich and stately city.

The Silversmith as Engraver

The illustrated books of the South in this period were extremely few. Stauffer says that prior to 1775 the only engraver south of the Mason & Dixon line was Thomas Sparrow, of Annapolis. Sparrow was a silversmith who made a number of very simple book-plates, engraved paper money, cut in wood the arms of the Province for the title-page of Bacon's *Laws of Maryland* in 1765, and engraved in metal a title-page and some tables for Elie Vallette's *Deputy Commissary's Guide*, published by Anne Catherine Green in Annapolis in 1774. Sparrow represented a well-known type among American engravers, the silversmith who practised engraving as a subsidiary craft, employing in it the technique he used for incising coats of arms and decorative designs on coffee pots, urns, and other products of his manufacture. Paul Revere of Massachusetts was another of these, as were Amos Doolittle and Abel Buell of Connecticut. Revere's engraving

The Product of the Colonial Press

showed him to be a more indifferent artist than silversmith. His engravings for Thomas Church's *History of King Philip's War*, Newport, 1772, and his plates for Rivington's edition, New York, 1774, of Hawkesworth's *New Voyage [of Captain Cook] round the World* are poor even for the time and place. His engraving of Benjamin Church in the first of these books has provided generations of bookmen with amusement, for he has simply copied the portrait of the English poet, John Churchill, slung a powder horn around the subject's neck and called it Colonel Benjamin Church. Indeed the portrait engraving of the century represented the lowest point of accomplishment. From impressive work in the engraving of architectural details and elevations, maps, plates for military handbooks, and a varied general product, John Norman descended into the depths with his series of portraits of American Revolutionary leaders in the Boston, 1781–1784, edition of the *Impartial History of the War*. Regarding the namby-pamby features he has given our leading soldiers, one wonders whether, after all, it was not really the French who won the war.[15] And yet most collectors try in vain to form a complete set of the book. The third volume is almost unobtainable.

Towards the end of the century we find Isaiah Thomas of Worcester issuing a folio Bible, illustrated with fifty plates by such finished engravers as Samuel Hill, John Norman, and Joseph Seymour. Several other Bibles of this decade drew upon these and other engravers to an extent that must have suggested to them the approach of a Golden Age. But the finest group of American engravings of the century fittingly forms part of its greatest typographical triumph, the Dobson edition, 18 volumes, Philadelphia, 1790–1797, of the third edition of the *Encyclopædia Britannica*. A great number of

engravers were employed in illustrating this book—re-edited in America, printed in America with American-made types—and the result makes it clear that the art of engraving for the book in this country had come of age. A further description of the *Encyclopædia* forms the concluding section of the present chapter and of this book on the colonial printer, but mention should be made here of the separately printed article from it which was published as *A Compendious System of Anatomy* in which appeared twelve plates engraved with special skill and delicacy by R. Scot, of Philadelphia.

General Comment

Enough has been said in this concluding chapter of the physical characteristics of colonial printing to suggest that at close approach, the subject shows itself sufficiently varied to deserve the consideration of the student of typography. Much of the work was carelessly done by ignorant, heedless men to whom the quickest and cheapest way was the best; more of it was simply the result of mediocrity in craftsmanship. But there was a saving remnant which may not be overlooked or despised. Some examples of the best of the work have been mentioned more than once throughout this book; others will occur to the minds of those who know the period and the product of its press. Those who have not looked at the colonial printer's efforts from this standpoint have before them the thrill of personal discovery of merit.

The best printing of the eighteenth century in America possesses, indeed, a special quality inherent in the best printing of other periods, the quality of expressing in its style the spirit of the age that produced it, reflecting that spirit as does the architecture of the time and the work of the cabinet mak-

ers, the silversmiths, the gardeners, and all those whose business it was to create material shapes and designs. The spirit of classicism everywhere informed the artistic impulses of the century, and to the vigorous aspiration of the Middle Ages, to the rich experimentation of the Renaissance, had succeeded the reticence, the discipline, the quiet sureness of the neo-classical revival. One may love the eighteenth century or turn from it chilled and uncomforted, but in either case, one perceives in its art forms and in its mind a coolness and poise unknown in other periods of the Christian era. Examining the best typography of the time in America, one perceives instantly that though it lack fire, imagination, and aspiration, yet in it, as in the stately houses and the tranquil gardens, is expressed that cool, balanced serenity which characterizes the mind and manners of the eighteenth century.

The High Point

These chapters on the Product of the Press cannot be brought to an end more suitably than by an account of a book printed in the closing decade of the eighteenth century which, from every standpoint save that of the esthetic, is the highest achievement in bookmaking to proceed from the period of our interest. This book, which finds casual mention more than once in our pages, is the *Encyclopædia; or, a Dictionary of Arts, Sciences, and miscellaneous Literature*, the first American edition, in brief, of the *Encyclopædia Britannica*. The publication of the third, and first American, edition of the great book was begun in 1790 by Thomas Dobson, of Philadelphia, and brought to an end by that same enterprising printer and publisher with the completion in 1797 of his eighteenth large quarto volume of approximately 800 pages

and thirty plates each. A note in Evans's *American Bibliography*, No. 22486, gives a full and admirable history of the project. Begun as a work to be issued to subscribers in weekly parts, that cumbersome, wasteful, and expensive method of publication was soon changed to one by which a half volume was issued every ten weeks. At the end of the period a general title-page and title-pages for the volumes were provided, each bearing the somewhat misleading date, 1798. The type, as already stated in our chapter on Type Founding, was made especially for the book by John Baine & Grandson, of Philadelphia, and, Mr. Evans tells us, the paper for the book was manufactured in Pennsylvania. In another chapter I have suggested that it was the knowledge of Dobson's proposal to print this great work which brought the Baines to America and so opened a new period in the history of American typefounding. Earlier in the present chapter has appeared an expression of admiration for the high quality of the 543 copperplate engravings by American artists which are distributed throughout the volumes of the set. It is a satisfaction to say once more that in these plates by such skilled craftsmen as Scot, Thackara, Vallance, Trenchard, Allardice, the Smithers, and Seymour one observes the coming of age of American book illustration. The whole work, illustrations, type of various sizes, and paper, even though somewhat drab in color, shows an achievement of professional craftsmen working together for an enlightened publisher. The first American book on anything like such a scale, Dobson's *Encyclopædia* marks the end of printing in America as a household craft and the beginning of its factory stage of development. One inevitably contrasts Dobson's achievement in eighteen substantial quarto volumes with the inconspicuous Bay Psalm Book with which, a century and a half earlier, Stephen Daye

The Product of the Colonial Press

had made his tentative but courageous beginning in the printing of American books. The comparison is too facile, too superficial, to possess real value without amplification, but it shows at least a striking economic, typographical, and social development over the period in which, everywhere, the old world took on the aspects of the present industrial civilization.

Appendix to Chapter IV

The Colonial Printing Press

THE drawings which compose this appendix are designed to show graphically details of the wooden press used in colonial America and the differences between the common press and that which Moxon described and commended in the *Mechanick Exercises* of 1683 as the Blaeu Press. The features common to the two presses and their differences are discussed at length in the text of Chapter IV, but with the lack of complete clarity that usually ensues upon an attempt to describe mechanical details without the aid of diagrams. Recognizing this defect in the discussion as it appeared in the first edition of the *Colonial Printer*, Mr. Ralph Green of Chicago offered with some hesitation to make a few drawings for illustrative purposes to accompany the present edition of the book. It is hoped that the interest and obvious gratitude with which his offer was received by the author removed from Mr. Green's mind whatever may have been there as the basis of his hesitation. Every reader of the book will join the author and the publishers in their feeling of obligation to Mr. Green and of appreciation of the interest and helpfulness of the drawings he has provided for the book.

Mr. Green, of the Chicago Bridge & Iron Company, is an engineer who has studied for years the structure of the old printing press, purely as a personal hobby. His reconstructions are made possible through assiduous and careful reading of the texts of Moxon, Stower, and other authors of manuals, and through the examination of such actual specimens of the old presses as have come to his attention.

The study of the press can be carried further by the student through the chapters on its structure and use found in the manuals of Moxon, Stower, Johnson, and Hansard.

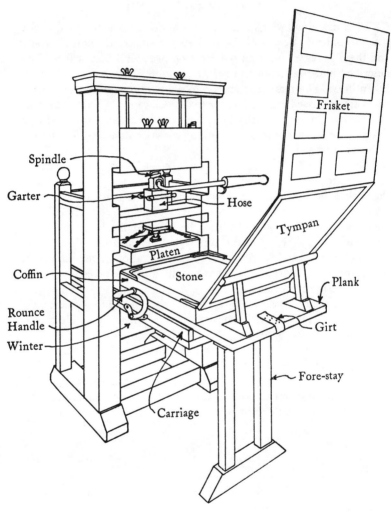

Spindle

Garter

Hose

Coffin

Rounce
Handle

Winter

Carriage

Frisket

Tympan

Platen

Stone

Plank

Girt

Fore-stay

PLATE A

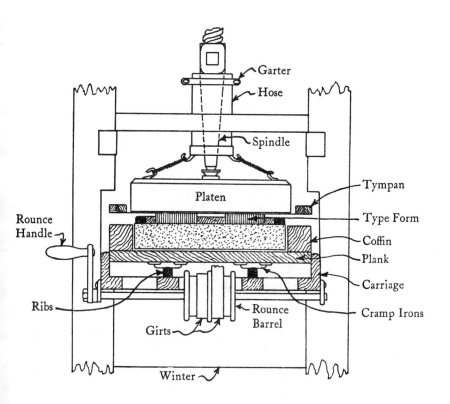

Garter

Hose

Spindle

Tympan

Platen

Type Form

Rounce
Handle

Coffin

Plank

Ribs

Carriage

Cramp Irons

Girts

Rounce
Barrel

Winter

PLATE B

Plate C

PLATE D

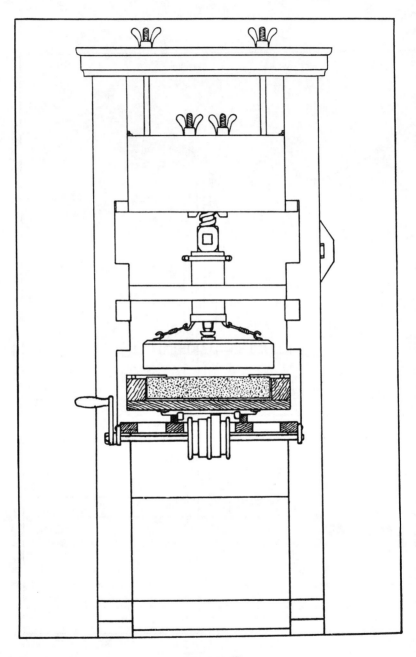

PLATE E

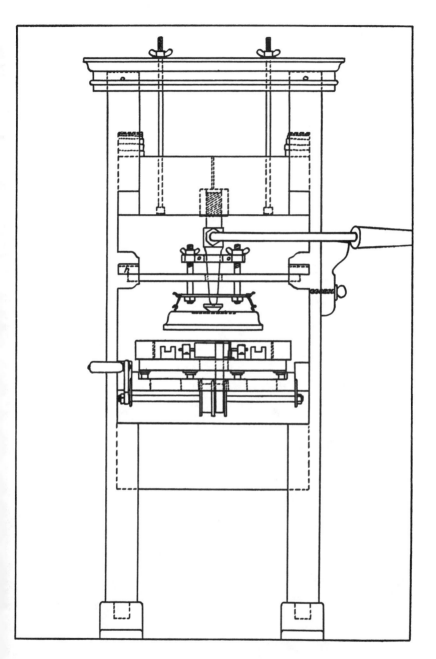

PLATE F

Notes

Notes to Chapter II

The Beginnings of the Colonial Press

ANY study of printing origins in the American colonies is based primarily upon three books: Thomas, *The History of Printing in America*; Evans, *American Bibliography*, and Brigham, *Bibliography of American Newspapers*. The promised four volumes of Douglas C. McMurtrie will contain, fully set forth and documented, the story of the printing origins of the whole country. Volume II of this *History of Printing in the United States* (all yet published) treats the colonies of Pennsylvania, Maryland, New York, New Jersey, Delaware, District of Columbia, Virginia, South Carolina, North Carolina, and Georgia. Specific reference will not be made to these indispensable works in the notes to this chapter except for unusual reasons.

1. The story of the early Massachusetts press is found in Littlefield, *The Early Massachusetts Press*, and Roden, *The Cambridge Press, 1638–1692*. Invaluable material relating to its early history is incorporated in Eames, *The Bay Psalm Book*, and in the same writer's *Bibliographic Notes on Eliot's Indian Bible*; Green, *John Foster*, discusses the first Boston press, and a few facts of importance not recorded elsewhere are in Winship, *The New England Company of 1649 and John Eliot*. Any account of the printing of the Eliot Indian Bible must take into consideration the appearance in Cambridge in 1655 of *The First Book of Moses called Genesis*. No copy of that book had been identified by modern bibliographers until 1937, when the late Wilberforce Eames located a copy of it at King's College, London. Mr. Eames's communication of his discovery to the Colonial Society of Massachusetts, through Matt B. Jones, in November, 1937, was the culmination of the last, but not the least important, of what he called his "bibliographical ventures."

2. *A Narrative of the Newspapers Printed in New England*, by A. Z., is one of the earliest writings consciously intended as a contribution to the history of American printing.

3. Connecticut printing origins are exactly treated in Love, *Thomas Short, the First Printer of Connecticut*; the story is carried on by Trumbull, *List of Books Printed in Connecticut, 1709–1800*; and by Bates, *A Bibliographical List of Editions of Connecticut Laws*, where is given on page 13 the title and description of the Act of Assembly of June 8, 1709, regarded here as the first Connecticut imprint. On this point, see also Love, *Thomas Short*, pages 42–44.

4. Hammett, *Bibliography of Newport*; Chapin, *Ann Franklin of Newport, Printer, 1736–1763*, and the *Rhode Island Imprints* of Winship, Chapin, and Steere are the chief sources for the origins of printing in Rhode Island. *Printers and Printing in Providence*, takes up the tale for the city named in its title, and accounts of William Goddard are found in Wroth, *A History of Printing in Colonial Maryland*, and in the same writer's *William Goddard and Some of his Friends*. See also the recently published *Maryland Press, 1777–1790*, by Joseph Towne Wheeler.

5. The events leading to the establishment of printing in New Hampshire are derived from Isaiah Thomas, 2d ed., I. 129–132, and from the other general works named at the head of these notes. Otis G. Hammond called my attention to the *Bulletin of the American Antiquarian Society*, November, 1915, No. 5, in which Charles L. Nichols discussed the order of the first New Hampshire imprints as stated in the Library of Congress copy of Fowle's almanac for 1757. Dr. Nichols's discussion of the point at issue is found at greater length in the *Proceedings of the American Antiquarian Society*, October, 1915, XXV. 327–330.

6. The question of the first printing for the Vermont government is treated fully in H. G. Rugg, *The Dresden Press*.

7. A thorough check list of the output of the Maine Press is found in Noyes, *A Bibliography of Maine Imprints to 1820*, and *Supplement*. This book was compiled through Mr. Noyes's industry and, with the aid of Mrs. Noyes, was set in type and printed by him. The determination of the order of the imprints in our Maine section was made possible through the interest of Clarence Saunders Brigham, whose search for us in the pages of the *Falmouth Gazette* underlies our statement of priority. On this point, see also William Nelson, *Notes [on] the American Newspaper*.

8. Besides the works mentioned in the text, one turns first of all for information concerning the beginnings of printing in Pennsylvania to C. R. Hildeburn, *The Issues of the Press in Pennsylvania, 1685–1784*; Wallace, *William Bradford*; Bullen, *The Bradford Family of Printers*, and to McCulloch, *Additions to Isaiah Thomas's History of Printing*. See also Wroth, *The St. Mary's City Press*. The full biography of George Keith by Ethyn Williams Kirby will, it is hoped, soon be published.

9. Writers on the printing history of New York have expended most of their efforts on its early aspects. The contributions of Livingston Rutherfurd, Victor Hugo Paltsits, and Alexander J. Wall have been

Notes

drawn upon in other sections of this work. For the period of the origins treated in this chapter, the investigator turns to Moore, *Historical Notes on the Introduction of Printing into New York, 1693*; Hildeburn, *Sketches of Printers and Printing in New York*; Hasse, *Some Materials for a Bibliography of the Official Publications of the General Assembly of New York*, introduction to *A Journal of the House of Representatives for His Majestie's Province of New York in America*, and introduction to *A Narrative of an Attempt made by the French of Canada upon the Mohaques Country*. In 1928 Wilberforce Eames, in *The First Year of Printing in New York*, made a concise statement of Bradford's beginnings in his city of refuge and suggested a probable order for the imprints of his first twelvemonth of work.

9a. I am indebted to A. S. W. Rosenbach, owner of the only known copy of the poem *A Paraphrastical Exposition, etc.*, for a communication, received too late for discussion in the text, which cites the text of *New-England's Spirit of Persecution* to prove that *A Paraphrastical Exposition* was the earlier of the two books to issue from the New York press. On page 22 of *New-England's Spirit of Persecution* is a reference to Samuel Jenings in which the author uses the derogatory words, "and compare himself to poor Mordecai." On the title-page of *A Paraphrastical Exposition* is a reference to this same Jenings in the words, "a certain Person who compared himself to Mordecai." Now although the quoted words as used in *New-England's Spirit of Persecution* may be a reminiscence of their appearance on the title-page of *A Paraphrastical Exposition*, it is equally probable that the converse is true and that *New-England's Spirit of Persecution* may thus be proven earlier than the other book. But both these arguments overlook the fact that on a certain occasion Jenings had publicly compared himself to poor Mordecai and the probability that the authors of both books were writing with independent recollections of that event in mind. Unless supporting evidence can be found, the two references thus become of uncertain value as determining factors in the question of priority.

10. To the general works referred to at the beginning of this section must be added Nelson, *Some New Jersey Printers and Printing in the Eighteenth Century*; Hildeburn, *The Issues of the Press in Pennsylvania, 1685–1784*, Franklin's *Autobiography*, and Humphrey, *Check-List of New Jersey Imprints*. On the special subject of the Bradford and Keimer *Laws* of 1723 and 1728, Douglas C. McMurtrie has written in his *Earliest New Jersey Imprint* and his *A Further Note on the New Jersey Acts of 1723*.

11. For the beginnings of printing in Delaware, see Hawkins, *James Adams: the first Printer of Delaware*. One turns also for knowledge of the press in that colony to the general works cited at the beginning of this section, and to Hildeburn, *The Issues of the Press in Pennsylvania, 1685–1784*.

12. It is much to be regretted that the work on Virginia printers left in manuscript by the late Lyon Gardiner Tyler has not found a publisher. It is hoped that the researches of Helen Bullock, Archivist of Colonial Williamsburg, Inc., on Williamsburg imprints and related documents will be put into print, and also that the list of Virginia imprints, 1750–1783, compiled by Bertha M. Frick will find publication. Excellent bibliographies exist in Clayton-Torrence, *A Trial Bibliography of Colonial Virginia*, and in Swem, *A Bibliography of Virginia, Part III*. The facts concerning Nuthead's attempt to set up a press in Virginia are found in Wroth, *A History of Printing in Colonial Maryland*. The later permanent Virginia press of William Parks is treated in Wroth, *William Parks, Printer and Journalist of England and Colonial America*, and in McMurtrie, *A History of Printing in the United States*.

13. The Maryland press prior to the Revolution is treated at length in Wroth, *A History of Printing in Colonial Maryland, 1686–1776*; *William Parks, Printer and Journalist*; *The St. Mary's City Press*. The later period of Maryland printing is treated in McMurtrie, *A History of Printing in the United States* and a full historical statement and bibliography of the period 1777–1790 by Joseph Towne Wheeler is soon to be published by the Waverly Press, Baltimore.

14. See note 12, above.

15. For the story of South Carolina printing origins, there exist sections in the general works of Thomas, Evans, and Brigham, and in Salley, *The First Presses of South Carolina*. Franklin's manuscript "Ledger" in the American Philosophical Society (see Eddy, *Account Books kept by Benjamin Franklin, Ledger 1728–1739*) gives such details of his relationship with Thomas Whitemarsh (so written by Franklin) as are not found in the *Autobiography*, where the facts relating to Lewis Timothy's South Carolina beginnings are recorded. The late Leonard L. Mackall of New York and Savannah called my attention to *An Essay on Currency*, of 1734. Through Mr. Mackall's efforts this unique piece was secured for the Charleston Library. See a letter in the *Charleston News and Courier*, November 25, 1917, headed "An Inter-

Notes

esting Appeal." But the outstanding contributions to the history of printing in South Carolina are McMurtrie's *First Decade of Printing in South Carolina* and his *Bibliography of South Carolina Imprints, 1731–1740*.

16. Weeks, *The Press of North Carolina in the Eighteenth Century*. Published in 1891, this brief but admirably planned and executed study may well be taken as a model for the monographic treatment of typographical history in the various states. See also McMurtrie, *The First Twelve Years of Printing in North Carolina. With a Bibliography, 1749–1760*.

17. For the history of Georgia printing there exists no source other than the general works of Thomas, Evans, Brigham, McMurtrie, and the laws of the colony. A note in the *Catalogue of the De Renne Georgia Library*, I. 145–146, by the late Leonard L. Mackall, brings together the available information on the first press.

18. Gayarré, *Histoire de la Louisiane* tells one of the most fascinating stories of American colonial history. The all important document regarding the setting up of Denis Braud's press is unfortunately omitted from the English translation of Gayarré's book. I was able to add to the initial knowledge of the New Orleans press gained from Gayarré through the interest of Wilberforce Eames, who allowed me to copy his manuscript list of early Louisiana imprints, one of the many instances in which every American bibliographical undertaking of this generation is indebted to Mr. Eames's knowledge and to his generosity in diffusing it. Afterwards Douglas C. McMurtrie allowed me to consult the proof sheets of his *New Orleans Imprints*, a significant contribution to American bibliography, published in 1928, in which for the first time is recorded the Denis Braud imprint of 1764.

19. For the story of the short-lived press in Florida, see Isaiah Thomas, *History of Printing*; William Nelson, *Notes [on] the American Newspaper*; Brigham, *Bibliography of American Newspapers*; and McMurtrie, *The First Printing in Florida*. Mr. Brigham has allowed me to examine his revised but unpublished note on *The East-Florida Gazette*, written after the discovery by Worthington C. Ford in the Public Record Office, London, in 1926, of the three numbers of that newspaper spoken of in the foregoing text. Background material and biographical items of interest are found in Siebert, *Loyalists in East Florida, 1774 to 1785*, which contains, I. 134, a facsimile of the first page of the *East-Florida Gazette* for March 1, 1783, Vol. I, No. 5. See

also the sketch of Dr. William Charles Wells in the *Dictionary of American Biography*. The question of priority between the two Florida imprints of 1784 is of less concern to Mr. Thomas W. Streeter, of Morristown, N. J., than to any other individual or institution in the country. He alone, so far as is known, owns both pieces.

20. The establishment of the press in Mississippi is treated in the works by Nelson and Brigham cited in note 19, above, and in McMurtrie, *Pioneer Printing in Mississippi*, and his *Preliminary Check List of Mississippi Imprints, 1798–1812*.

21. The Pittsburg press found a sympathetic historian in Thwaites, *The Ohio Valley Press*. See also McMurtrie, *The Westward Migration of the Printing Press*; and Brigham, *Bibliography of American Newspapers*.

22. For the press in Kentucky, see the works cited in the note above. The citizens of Lexington in 1937 celebrated by public exercises the sesquicentennial of the introduction of printing into Kentucky. See especially "The Kentucky Gazette and John Bradford its Founder," by Samuel M. Wilson in *Papers of the Bibliographical Society of America*, Vol. XXXI, Part II.

23. The beginnings of the press in Tennessee find treatment in the works by Nelson and Brigham cited in note 19, above; and McMurtrie, *Early Printing in Tennessee*. For Roulstone's career in Salem, Massachusetts, and information concerning his North Carolina and Tennessee presses, see Tapley, *Salem Imprints*, pages 68–74.

24. Early Ohio printing is discussed in the works cited in note 21, above. See also McMurtrie, *Antecedent Experience in Kentucky of William Maxwell, Ohio's first Printer*.

25. See McMurtrie, *Pioneer Printing in Michigan*.

Notes to Chapter III

The Colonial Printing House

1. Despite the great changes that have occurred in the printing of books in the past century, the best school for one who would learn the ways of the old printers is a modern printing shop of moderate size in which he can observe and sometimes be allowed to take part in the various processes. When he has learned the tools and the terminology of

Notes

the new era, fundamentally unchanged, he is well-prepared for a study of the old. Nowhere can this be better carried out than in the pages of Joseph Moxon, *Mechanick Exercises*, London, 1683. The scarcity of the original edition need not trouble him, for there is a modern reprint available in the public libraries. Moxon's book is still the best guide in English to the ancient ways of the craft; it was written out of a large experience to instruct printers in the details of their work. The later books, such as Smith, *The Printer's Grammar*, London, 1755, Luckombe, *The History and Art of Printing*, London, 1770, Johnson, *Typographia, or the Printers' Instructor*, 2v., London, 1824, Hansard, *Typographia*, 1825, include more than Moxon was concerned with, but in describing the processes of the shop, these writers follow him and a celebrated French writer, Fertel (*La Science pratique de l'Imprimerie*, 1723), with embarrassing fidelity. An excellent connecting link between present-day practice and that of the older period described by Moxon and Luckombe is found in Adams, *Typographia*, Philadelphia, 1837. Acquaintance made with these writers, the student must pass to Ronald B. McKerrow's *Introduction to Bibliography for Literary Students*, Oxford, 1927, an expansion of his earlier *Notes on Bibliographical Evidence*, London, 1914. The new method of book study is systematized in this treatise, and since the publication of the earlier form of it in 1914, with its summary of knowledge of ancient shop ways, neither bibliographer nor student of early literature has failed to comprehend the importance of knowing how the old printer went about his task. This knowledge is pleasantly and effectively conveyed by Mr. McKerrow in the enlarged form of his book cited above.

2. The original sources of the lists of equipment presented here are: for the one-press shop, the very interesting letter from Franklin to Strahan in *The Writings of Benjamin Franklin*, edited by Albert Henry Smyth, III. 165–167; for the two-press shop, the inventories of (*a*) William Rind, dated 1773, of (*b*) Anne Catharine Green, 1775, and of (*c*) John Holt, 1785, found respectively in: (*a*) *William and Mary College Quarterly*, VII. 16; (b) Wroth, *A History of Printing in Colonial Maryland*, page 153, (*c*) Paltsits, *John Holt, Printer and Postmaster*, page 498; for the three-press shop, James Parker's inventory and appraisal of the Franklin & Hall establishment given in Oswald, *Benjamin Franklin, Printer*, pages 92–93, original manuscript in the Typographical Library of the American Typefounders Company, now owned by Columbia University. Franklin does not seem to have ordered for the New Haven shop which he procured for his nephew such articles as

could be made locally. On this account it has been necessary to estimate, and show in brackets, the number of certain easily made but essential articles not found in the list of the one-press shop.

3. The processes of composing, proving, correcting, and imposing are found in complete detail in Moxon, II. 197–264, under the heading "The Compositers Trade." This feature of printing practice is discussed in McKerrow, *Introduction to Bibliography*, pages 6–24. See also pages 65–66, where this writer says that the long galley seems to have come into use in book printing about the year 1841, probably from earlier use in newspaper printing.

4. One finds these values given for the Franklin press in the *Autobiography*; for the Whitemarsh press, in Franklin's "Ledger," September 9, 1731, manuscript in the American Philosophical Society (see Eddy, *Account Books kept by Benjamin Franklin*); for the New Haven shop of Franklin's nephew in the Smyth edition of the *Writings*, III. 165–167; for the Glover press in Roden's *Cambridge Press*, page 10; for Marmaduke Johnson's equipment in Littlefield's *The Early Massachusetts Press*, I. 263–264; for the establishment of Thomas Short in Love, *Thomas Short, the First Printer of Connecticut*, pages 34–35; for the press Fowle sold to Thomas, in Volume I of the manuscript "Isaiah Thomas Papers" in the American Antiquarian Society; for the Franklin & Hall printing house in Oswald, *Benjamin Franklin, Printer*, pages 92–93; and for the Parks equipment in Wroth, *William Parks*, page 29, note 27.

5. In his letter to Franklin, transmitting the partnership accounts (Oswald, *Benjamin Franklin, Printer*, pages 143–149), James Parker says that the exchange has been reckoned in the statement at a medium rate of 170. Virginia money in 1753 was reckoned in the "Accounts" of the Parks estate at the higher rate of 125.

Notes to Chapter IV

The Colonial Printing Press

1. I have accepted for the sake of convenience in reference the term "Blaeu" as a useful designation of the superior press of the Low Country sort that Moxon attributed to Willem Janszoon Blaeu as inventor. I have found no evidence, except Moxon's undocumented statement, that Blaeu had any special connection with press building. The

Notes

question is discussed by David Pottinger in *The Dolphin, Number 3, A History of the Printed Book*, Chapter X.

2. Henry Lewis Bullen of the Typographic Library and Museum of the American Typefounders Company, now in the Columbia University Library, suggests that Ramage came to Philadelphia in 1795, but his name does not appear in the city directories until 1800.

3. Moxon's description of the Blaeu press, not always lucid, for the reason that he was writing for contemporaries among whom a knowledge of terms and processes might be taken for granted, is found in the *Mechanick Exercises*, I. 37–74. Facing pages 37 and 39 are cuts of the old English press and of the Blaeu press respectively, the former from a drawing that shows no detail. Even so learned a printer as Theodore Low De Vinne seems to have been led by the omission of the rounce mechanism from this drawing to believe that it was not present on the older form of press (see note in his Moxon, II. 411). But on this point, see the representation of the press of Badius Ascensius (1507) in Ph. Renouard, *Bibliographie des Impressions et des Oeuvres de Josse Badius Ascensius*, I. 43 ; and the very interesting studies with illustrations by Falconer Madan, *Early Representations of the Printing Press*.

4. See Moxon, II. 277–278 and I. 52, 58, for verbal and pictorial descriptions of the rounce mechanism and of the hose and garter. Attention should be called to the fact that in Moxon's nomenclature of the parts of the press, the carriage is the part, comprising coffin and plank, which moves in and out beneath the platen. In the usage of Hansard, Stower, and other nineteenth-century writers, the carriage is the fixed part, comprising the ribs and frame upon which the plank and coffin move. See Mr. Green's drawing of the common press in our Appendix to Chapter IV. Johnson, *Typographia*, II. 502, remarks upon the superiority of the box hose. Drawings of the old Low Country press used by Plantin are shown in Max Rooses, *Le Musée Plantin Moretus*, pages 324, 339. A letter from A. J. J. Delen, Conservateur de Le Musée Plantin-Moretus, March 25, 1937, addressed to Miss Margaret Bingham Stillwell in reply to an inquiry, affirms that the two presses illustrated on page 324 of the book of Max Rooses, showing the hose of the so-called Blaeu press, served the establishment in the second half of the sixteenth century. See Stillwell, *The Seventeenth Century* and Pottinger, *The History of the Printing Press* in *The Dolphin, Number 3*. For a cut illustrating the impressing mechanism of the improved Ramage press, see Adams, *Typographia*, page 327.

The Colonial Printer

5. This quotation is from page 22 of James Watson, *The History of the Art of Printing*, a book rarely found in perfect condition with its folding plate of floriated initials, head and tail ornaments, etc.

6. Cuts of the press Franklin worked at in Watts's shop in London are shown in Blades, *The Pentateuch of Printing*, page 56; in *The Century Magazine*, LVII. 804, April, 1899; and in Paul Leicester Ford, *The Many Sided Franklin*, page 189. The Blaeu type of press is shown and its parts described "after Moxon," in Luckombe, *The History and Art of Printing*, pages 291 *et seq.*; the "common press" is found pictured and described in Stower, *The Printer's Grammar*, pages 301 *et seq.*; Johnson, *Typographia*, pages 497 *et seq.*, performs the same service for the "improved wooden press."

7. For Moxon's description of the ribs and cramp irons of the carriage-moving mechanism, see his *Mechanick Exercises*, I. 67. Franklin's specifications for an improvement in this feature are found in the Smyth edition of the *Writings*, III. 165–167, Franklin to Strahan, October 27, 1753.

8. Moxon's section, "The Press-Mans Trade," is found in the *Mechanick Exercises*, II. 269–345; the specific directions for the operation of the press occupy pages 319–328. On related points see McKerrow, *Introduction to Bibliography*, pages 38–70. McKerrow, pages 61–62, quotes Johnson, *Typographia*, to show that even as late as 1824, the platen of the wooden press was so small as to necessitate two pulls to a full form of type. The establishment of the pressman's rate of speed as eight tokens in a ten-hour day, that is four-fifths of a token an hour instead of the theoretical "token an hour," is aided by considerations found in Ethelbert Stewart, *Documentary History*, page 864. Assurance that this was the customary rate at another place and a far distant period of printing history is found in "Some Contemporary Accounts of Renaissance Printing" (*The Library*, 4th series, XVII, 1936, pages 167 *et seq.*), where Don Cameron Allen (page 169) quotes these sentences from Robert Ashley's *Of the Interchangeable Course, or Variety of Things in the Whole World*, 1594, a translation of L. le Roy's *De la vicissitude ou variété de choses en l'univers*, 1579: "taking the barre in his hand, he [the pressman] pulleth as hard as he can untill the leafe be imprinted on one side, on which they bestow halfe the day; and the other halfe, on the other side; yelding in a day twelve hundred and fiftie sheetes, or thirteen hundred imprinted." One of the factors prescribed by the master printers in the Paris strike of 1539 (Updike,

Notes

Printing Types, II. 256) was a working day from five in the morning until eight at night, or fifteen hours. Calculations show that working a full fifteen-hour day the product, at the rate of four-fifths of a token an hour, would have been something more than the maximum 1300 sheets, printed both sides, recorded by le Roy as the French pressman's daily stint in 1579. In a fourteen-hour day, however, almost exactly 1300 sheets would be produced. Taking into consideration the gradual loss of efficiency in a workman in the course of a fifteen-hour day it seems clear enough that the rate of eight tokens (a token being 240 sheets printed one side) in ten hours, *i.e.* four-fifths of a token an hour, was maintained approximately in sixteenth-century France as well as in early nineteenth-century America. It is probably reasonable to regard this as the normal rate of the wooden press throughout the entire period of its history. One wonders whether it was maintained by the English and Scottish printers in the extraordinary working day they are reputed to have endured. (See page 161.)

An interesting discussion of rate of speed of compositor and pressman is found, pages 21–24, in R. C. Bald, *Bibliographical Studies in the Beaumont & Fletcher Folio of 1647*, Oxford, 1938 (Supplement to the Bibliographical Society's *Transactions*. No. 13). It was through Mr. Bald's article that I became aware of the sixteenth-century testimony brought out in this note. It is of some importance to arrive at a conclusion in this matter, because few persons, even among careful students of typography, are aware of the excellent speed with which the old wooden press was habitually operated. Thirteen hundred finished sheets means 300 copies of an octavo book of 64 pages as the day's work of a single press.

9. Goddard's pat corroboration of the announcement in the *Massachusetts Gazette* is found on the verso of the title-page for Volume III of the *Pennsylvania Chronicle*, February 12, 1770.

10. Munsell's note in Isaiah Thomas, I. 36, derived from a letter from David Bruce interleaved in Munsell's copy of Adams's *Typographia*, in the American Antiquarian Society, gives a description of the Ramage press, and Henry Lewis Bullen has communicated the information as to the equipment of this press with springs to raise the platen. McKerrow discusses the raising of the platen in the operation of the common wooden press in the *Introduction to Bibliography*, pages 50–51. McCulloch's mention of George Clymer's press is found in the *Additions*, pages 210–211. An exceedingly interesting account of the

The Colonial Printer

early iron presses, with cuts, is found in Adams, *Typographia*, Philadelphia, 1837, pages 322–337.

11. The manuals of Johnson and Hansard, and the article of David Pottinger referred to in note 1, above, describe the Columbian, the Stanhope, and other iron presses which replaced the wooden presses in the printers' shops of the first half of the nineteenth century.

Notes to Chapter V

The Type Faces of the Colonial Period

1. The general subject of type founding and type faces finds its best exposition in English in Updike, *Printing Types, a Study in Survivals*, a new issue of which, with valuable additions to its notes, was published in the year 1937. In discussing type, Mr. Updike, from the fullness and breadth of his knowledge, has also recorded the story of the art by means of which ideas are conveyed from man to man and from generation to generation. The history of type founding in England is definitively set forth by Reed, *A History of the Old English Letter Foundries*. Though its matter has been well and critically used by Reed, one must not overlook Edward Rowe Mores, *A Dissertation upon English Typographical Founders and Founderies*, reissued in 1924 by the Grolier Club, edited by D. B. Updike. Moxon's section, "Letter Cutting," I. 81–196, contains a practical treatment of the art that comprises the chief source for students of later periods. De Vinne, *Plain Printing Types*, offers an important modern treatment of the subject from the same standpoint. Legros and Grant, *Typographical Printing Surfaces*, is a valuable treatment from both the technical and historical points of view.

2. *Bibliotheca Americana*, London, 1789, though not a work of highest authority, records matter of general interest in its introduction. It offers corroboration of this statement in the words, page 16, "They cast their own types in various parts of the continent, but they are neither so good nor cheap as those done in Europe. Great quantities are imported from Glasgow." This introduction, with a few slight changes, was foisted upon the *Gentleman's Magazine* for November, 1796, by Henry Lemoine, pretending to be the result of current investigation, and bearing the title "Present State of Printing and Bookselling in America." Unaware of the probable plagiarism by Lemoine, Douglas C. McMurtrie reprinted the article, with an introduction, Chicago, 1929. The word "probable" plagiarism is used because of the possibility that Lemoine

[312]

Notes

may have had a part in compiling the *Bibliotheca Americana* of 1789, a work of which the authorship has never been definitely established.

3. Franklin's philosophic calm forsook him on this occasion when, instead of the brevier he had ordered, Caslon sent him bourgeois. This was bad enough in itself, but the fact that there was a difference in price of 6*d.* a pound was worse. He demanded sharply that Caslon return him the sum of £11 15*s.* 6*d. Writings* (Smyth ed.), III. 337, 340, Franklin to Strahan.

4. Luckombe, *The History and Art of Printing*, pages 220–222.

5. The inventories drawn upon for this information are those of William Rind, Jonas Green, John Holt, and Franklin & Hall (see note 2, Chapter III). The appraisal of Green's printing equipment was £53 7*s.* 2*d.* currency; the 2250 pounds of type in his cases were set down at £32 1*s.* 2*d.* or 60 per cent of the whole. The type in the Franklin & Hall appraisal represented 70 per cent of the value of the entire plant.

6. Updike, *Printing Types* (1937), II. 150 and note, page 284. The gift is gratefully referred to by one of the authors of *Dr. Wigglesworth's and Mr. Greenwood's Discourses on the Death of Thomas Hollis, Esq.*, to use the concise half-title of a book of Boston, 1731. Mr. Updike says that in this gift Thomas Hollis was acting as the agent of an unknown donor.

7. In *Libros y Libreros en el Siglo XVI*, a compilation of Inquisition documents relating to the early Mexican printers and booksellers in their conflicts with the Holy Office, is found what seems unmistakable evidence of the existence of type founding as an ordinary activity of the Mexican printers of the sixteenth century. In *The First Typefounding in Mexico*, Douglas C. McMurtrie quotes a document showing the origin of Espinosa's relationship with the Pablos establishment in the capacity of type founder. In Wroth, *The Origins of Typefounding in North and South America*, is found an account of the Paraguayan and Mexican type founding of a later period.

8. Paul Leicester Ford, *The Journals of Hugh Gaine*, I. 50, II. 217, *et seq.*, tells of the difficulties of printing the Mohawk Book of Common Prayer of 1769.

9. The facts of the brief statement given here of Abel Buell's typefounding venture are taken from Wroth, *Abel Buell of Connecticut, Silversmith, Typefounder and Engraver*. In an appendix to that book the Mitchelson claim is fully discussed. Since that argument was print-

ed I have found the so-called Mein & Fleeming letter used in a London publication of 1767, J. Kirkpatrick's translation of Tissot's *Avis au Peuple*, entitled *Advice to the People with Regard to their Health*. It is not likely that the English printer of this book purchased type from Mein & Fleeming in America, but rather that both establishments procured their letters from a common British source. It was late in 1766 that the American firm began to use this distinctive face. Mitchelson's name appears in the "Boston Records of Land Titles," Liber 23, pages 101–102 in 1769 and 1773. He signed an "Address" to Governor Hutchinson in 1774, and is described as a lapidary and not a native of America. (*Massachusetts Historical Society Proceedings*, XI. 393, 395.) On the evacuation of Boston in March, 1776, he joined the refugees who fled to Halifax. (Work last cited, XVIII. 267.)

10. In *Der Buchdrucker Christoph Sauer in Germantown*, Gustav Mori affirms that in 1747 Franklin purchased type-founding tools for the Ephrata Brotherhood and taught the brothers their use, and that, further, the Ephrata press issued thereafter a book in which the brothers declared that the type was of their own making. One asks whether there is any relationship between this sale of tools by Franklin in 1747 and his purchase of a set in 1744. Mr. Mori does not name the Ephrata book in which occurred the assertion just mentioned, and one wonders whether he had not in mind *Ein Geistliches Magazien*, No. XII, part 2, published by Sower in 1771 or 1772, referred to in the text below and in note 12, below. In that case he has not, as he affirms in his article, carried the beginnings of type founding in the United States twenty-five years further back than heretofore accepted.

11. See note 9, above.

12. The story of the Germantown founders is given at greater length in Wroth, *The First Work with American Types*. The surname of Jacob Bay is variously spelled Bäy, Bey, or Bay. The last-named spelling seems to be preferred by the editors of the Pennsylvania Archives. See note 9 in the article just cited. The only known copy of *Ein Geistliches Magazien*, No. XII, part 2, is found in the Typographic Library and Museum of the American Typefounders Company. Incomplete files of this periodical are in the John Carter Brown Library and in the American Antiquarian Society. In the Worcester file is No. X with a colophon dated 1771, so that No. XII with its first German type must have been issued in this year or early in 1772. The statements quoted from William McCulloch are found in McCulloch, *Additions to Isaiah Thomas's*

Notes

History of Printing. Separate treatment of the many activities of Fox has been presented in Nichols, *Justus Fox, a German Printer of the Eighteenth Century.*

13. Updike, *Printing Types*, II. 152, gives the main facts of the Baine foundry. O'Callaghan, *A List of Editions of the Holy Scripture printed in America Previous to 1860*, page xxviii, cites an advertisement on the cover of the *American Museum*, in which it is said that Carey's Douay Bible was to be printed from type made by Baine. The statement seems to be corroborated by the date and character of the bill (mentioned in the text) of John Baine & Co. to Matthew Carey found in the manuscript "Account Books of Matthew Carey" (37 volumes, 1785–1822), in the American Antiquarian Society, the most important existing series of documents of the American printing trade for the period it covers. Evans, No. 22486, records that the type for Dobson's *Encyclopædia* was cast by the Baines. Bigmore & Wyman, *Bibliography of Printing*, under entries John Baine and Alexander Wilson, record the outlines of Baine's life before his coming to America.

14. The sentences concerning Franklin's importation of type-founding equipment in 1744 are found in the Smyth edition of the *Writings*, II. 278. The letter to his Boston correspondent is in the same work, VII. 393. The sources of knowledge of Bache's venture are: Updike, *Printing Types*, II. 152–153; Oswald, *Benjamin Franklin, Printer*, pages 157–161, and Bache's "Diary," in manuscript, and a copy of his specimen sheet, in the Typographic Library and Museum of the American Typefounders Company, now in the Columbia University Library.

15. Mr. Henry Lewis Bullen called my attention to the details here given of Adam Mappa's foundry in New York. In *Ars Typographica*, II. No. 1, July, 1925, page 88, I find it affirmed that Mappa's type-founding equipment had formerly belonged to Reinhard Voskens of Amsterdam. A specimen sheet of Mappa's foundry in Delft, dated 1785, occupies page 89 of the periodical here referred to.

Notes to Chapter VI

Printing Ink

1. The sentences containing an order for lampblack and varnish with which this chapter begins are in a letter from Jonas Green to Franklin, given in full in Wroth, *A History of Printing in Colonial*

Maryland, page 82, where it was printed from the original in the American Philosophical Society, "Franklin Papers," I. 6. In *A Maryland Proclamation of 1737,* I presented facts and suppositions which seem to show that Green was a former journeyman of Franklin's, possibly one of those sent out by the Philadelphia printer on a silent partnership basis.

2. The transaction between Franklin and Nathaniel Jenkins for the purchase by Franklin of a lampblack house is set down in Franklin's "Journal of Accounts," March 21, 1733, manuscript in the American Philosophical Society, reproduced in Eddy, *Account Books kept by Benjamin Franklin, Ledger 1728–1739, Journal 1730–1737,* page 45. The reference to Armbruester is found in McCulloch, *Additions,* page 193. The record of possession of a lampblack house by Sower is found in the inventory taken at the time his property was confiscated by the government in 1778 because of his supposed loyalist actions and sympathies. This very interesting document, with its lists of equipment of printing houses, bindery, type foundry, and lampblack house is found in the *Pennsylvania Archives,* Series 6, XII. 870. For the details of Franklin's trade in lampblack and varnish see Eddy, work cited above, both volumes.

3. The well-known facts of the flax-raising and linen-manufacturing industries in the colonies are recorded in Bishop, *A History of American Manufactures,* I. 34, 299–300, 335–336. The reference to linen making in Germantown in 1692 is based upon the lines quoted in the chapter, "The Paper of the Colonies" from Richard Frame, *Short Description of Pennsylvania,* Philadelphia, 1692 (Hildeburn, No. 38), reprinted "nearly in facsimile" with an introduction by Horatio Gates Jones [Philadelphia], 1867. The destruction of the oil mill at the Ephrata Cloister is told in the *Chronicon Ephratense* by Brothers Lamech and Agrippa, page 211. There are few colonial books equal in human interest to this record of a community of religious mystics set down in the American wilderness.

4. Moxon's ink-making precepts are found in the *Mechanick Exercises,* I. 75–80.

5. Franklin's dealings in ink, lampblack, and varnish are found at large in Eddy, *Account Books kept by Benjamin Franklin,* both volumes; the purchases of ink by Carey from Fox are detailed in the manuscript "Accounts" of Matthew Carey in the American Antiquarian Society.

Notes

6. James Parker's "Statement of Partnership" between Benjamin Franklin and David Hall, 1766, manuscript in the Historical Society of Pennsylvania. Before the publication of his *Account Books kept by Benjamin Franklin*, George Simpson Eddy of New York gave me a photostat copy of this statement, and sent me extracts from the "Ledger" and "Journal" among the "Franklin Papers" in the American Philosophical Society.

Notes to Chapter VII

The Paper of the Colonies

1. The history of paper making in the United States has been so clearly set forth that little is left to be done except in the way of studies of particular mills or localities. In the present chapter I have drawn so largely upon the broad and well-interpreted researches of Lyman Horace Weeks, embodied in his *History of Paper Manufacturing in the United States*, that I make specific reference to it only for special reason. This acknowledgment is my tribute to a work I have found as helpful as any single study yet undertaken in a special aspect of the American printing trade. One has the further satisfaction of expressing gratitude to Dard Hunter for his *Old Papermaking*, and for his bibliography, *The Literature of Papermaking*. These two works, written by Mr. Hunter and printed by him on paper of his own manufacture, with type of his own design and casting, are specifically helpful in matters of American interest, and the first of them conveys, very clearly and pleasantly, knowledge of the processes of paper making as generally employed in the earlier centuries.

2. For the source of these sentences from Green's letter to Franklin, see note 1 of the chapter, "Printing Ink."

3. The verses which call attention to the existence of the Rittenhouse mill in Pennsylvania are cited from Hunter, *The Literature of Papermaking*. The original publication of Frame, *A Short Description of Pennsilvania* is commented upon in note 3 of the chapter, "Printing Ink." John Holme's *True Relation of the Flourishing State of Pennsylvania*, composed in 1696, remained in manuscript until it was published in 1847 as *Bulletin*, No. 13, of the Historical Society of Pennsylvania.

4. Besides the discussions by Weeks and by Hunter in the works cited, the Rittenhouse mill is treated in Barton, *Life of David Ritten-*

house, Jones, *The Rittenhouse Paper Mill*, and Wallace, *William Bradford*. The well-meant but fumbling attempts of McCulloch to state the origins of American paper making, in his communications to Isaiah Thomas, are to be forgiven that writer because of his important contributions to other aspects of the Pennsylvania printing trade. It is to be hoped that James F. Magee, Jr., of Philadelphia will one day publish the drawings and tracings of watermarks in American papers which he has been collecting assiduously for many years. In our Chapter XII there is found some data on the names and sizes of papers in the colonies and elsewhere.

5. The statistics given for the Pennsylvania mills are taken from L. H. Weeks, pages 79–80. In the year 1794, Tench Coxe wrote in his *View of the United States of America*: "A single state, Pennsylvania, has upwards of fifty paper mills."

6. The essential facts of early paper making in New York are found in the work of L. H. Weeks, and in Paul Leicester Ford, *The Journals of Hugh Gaine*, I. 44–46. Phillips, *Bernard Romans*, page 24, speaks of the Pennsylvania source of the special paper needed for the Romans maps of 1774. Samuel Loudon's interesting and pertinent letters are found in Wall, *Samuel Loudon (1727–1813), Merchant, Printer and Patriot*.

7. The paper-making activities of the Ephrata Cloister are spoken of in the *Chronicon Ephratense*. L. H. Weeks (work cited, note 1, above) and Hunter in *Old Papermaking*, discuss the Ephrata mill and reproduce its watermarks. See also the *Pennsylvania Magazine of History and Biography*, V. 276–289.

8. The facts of the Maryland subsidy of a mill are found in the *Proceedings of the Convention*, May 25, 1776; the probable connection of the Goddards with a mill at Elkridge is discussed in Wroth, *A History of Printing in Colonial Maryland*, page 138 and note.

9. The Parks mill at Williamsburg is given attention by L. H. Weeks, pages 33–35, and in Wroth, *William Parks*, page 24. The recent publication by George Simpson Eddy of the *Account Books kept by Benjamin Franklin* adds appreciably to our knowledge of the Parks paper mill. But the most interesting recent discussion of the Parks mill is that referred to in the text by Rutherfoord Goodwin, *The Williamsburg Paper Mill of William Parks, the Printer*.

10. The beginning of paper making in North Carolina is related by L. H. Weeks in the work so often cited here, but especially by Stephen B.

Notes

Weeks, *The Press of North Carolina in the Eighteenth Century*, pages 50–52. The South Carolina mill of William Bellamy is discussed by L. H. Weeks, pages 39–40.

11. Formerly the possession of Philip L. Spalding of Milton, this supposedly unique second issue of the Ames *Almanack* for 1730 is now one of the many antiquarian treasures of Amor Hollingsworth, of Milton, to whom it was presented by Mr. Spalding in 1936. Appropriately enough, this change of ownership took place in the presence of many members of the Walpole Society, just returned from examining Mr. Hollingsworth's great collection of engraved portraits of Washington.

12. The history of the New England paper mills is found in the general works; in William Goold, *Early Papermills of New England*; in *Representation of the Board of Trade relating to the Laws made, Manufactures set up and Trade carried on in his Majesty's Plantations in America, 1734* (reprinted 1769); and in *The Petition of Richard Fry* and his *Scheme for a Paper Currency, 1739* (reprinted, Providence, 1908). The Rhode Island beginnings were not given full and exact treatment until Howard M. Chapin gave documents in an article entitled, *Early Rhode Island Paper Making*, in the *American Collector* for May, 1926, pages 303–309. Trumbull, *List of Books Printed in Connecticut 1790–1800*, No. 1163n, gives the details of Ebenezer Watson's establishment of a mill in Hartford, Connecticut, in 1776.

13. The versified appeal for rags for the Williamsburg mill is quoted from L. H. Weeks, who transcribed it from the *Virginia Magazine of History and Biography* for April, 1920. It was communicated to that publication by Worthington C. Ford, who found it in a copy of the *Virginia Gazette* for July 26, 1744. No copy of the *Gazette* for this date is now known to exist, but thanks to Mr. Ford's instinct for the rare and curious, we have as salvage this amusing ode, doubtless the most important item in the missing journal.

14. Franklin's success as a rag-gatherer is recorded in his manuscript "Journal of Accounts" in the American Philosophical Society (see Eddy, *Account Books kept by Benjamin Franklin, Ledger 1728–1739, Journal 1730–1737*, pages 30–31, and *Ledger "D" 1739–1747*, pages 16–35).

15. L. H. Weeks gives an account of the rag famine and the general difficulties of paper making during the Revolution and describes the efforts of various governmental bodies and of the American Philosophical Society to encourage the paper makers of the period.

16. This first appearance of an account of paper making or of any aspect of paper making in an American book is recorded by Dard Hunter in his *Literature of Papermaking*, pages 40 and 44.

17. This suggestion, see Dard Hunter's article, "Papermaking," in *The Dolphin*, No. 3, came from René Antoine Ferchault de Réaumur in his work on the wasp.

18. James Parker's "Statement of Partnership" of Franklin & Hall, manuscript in the Historical Society of Pennsylvania. The sum given in the text includes paper supplied the firm by Franklin himself to the amount of £1385.

Notes to Chapter VIII

The Journeymen and Apprentices

1. The subject of the women printers of the colonies has been pleasantly touched upon by Elizabeth Anthony Dexter, *Colonial Women of Affairs*, pages 166–179. One wishes that the activities of these vigorous women of the colonial printing shops might be given monographic treatment.

2. The facts of Franklin's apprenticeship are found in the *Autobiography*; of Thomas's early indenture, in Isaiah Thomas, 2d ed. I. xxi; Zenger's case is given in the *Documentary History of the State of New York* (octavo edition) III. 564, 567; Zenger's articles of indenture are found in full in the *Historical Magazine*, VIII. 35, January, 1864.

3. In Stewart, *A Documentary History of the Early Organizations of Printers*, pages 942–945, is found the first Constitution of the Philadelphia Typographical Society, adopted November 6, 1802. In this study of the early nineteenth-century typographical societies, the author discusses much legislation by the early unions affecting conditions of the trade that must have existed, in part certainly, in the colonial period.

4. In Paul Leicester Ford, *Journals of Hugh Gaine*, I. 35–37, are found extracts from the *New York Gazette* that illustrate the difficulties experienced by the master printer in his relations with the journeymen and apprentices.

5. Watson, *The History of the Art of Printing*, page 21. See Stewart, *A Documentary History*, etc., page 883, for wages and hours in Philadelphia in 1816.

Notes

6. Manuscript letter among the "Isaiah Thomas Papers" in the American Antiquarian Society.

7. A facsimile of the important Philadelphia scale of 1802 is given by Stewart, *A Documentary History, etc.*, page 865. In the same work, page 866, is found the provision for the payment for the journeyman's "lost time." One learns of the pressman's average of eight tokens a day from Stewart, page 864. On the general subject of wages it may be worth while to quote the evidence of the anonymously issued *Bibliotheca Americana* of London, 1789. Its author is often inexact in specific statements, but his general notion of the state of the printing trade in his day is not unworthy of respect as that of an intelligent contemporary, friendly to the United States. On the subject of wages, he writes as follows: "The wages of printers are very great, and progressively so from the extreme parts of the northern to the southern states. In New Hampshire, Massachusetts, Connecticut, and Rhode Island, journeymen printers have from three to eight dollars per week. In New York, Philadelphia, and Maryland, from five to ten per week; and in Virginia, North and South Carolina, and Georgia, from eight to twenty and twenty-five, according to their merit and ability. Printers are very scarce in the Southern States."

8. The tables from which these prices are taken are found in the *Historical Review of Wages and Prices, 1752–1860*, Part IV, the Sixteenth Annual Report of the Bureau of Statistics and Labor [of the Commonwealth of Massachusetts], August, 1885, pages 201–202, 434, 448. On pages 198–200 is found an excellently clear statement of the relationship between Massachusetts Old Tenor, lawful money, and the United States dollar.

9. The labor organizations that began to take form late in the century are discussed by Stewart, *A Documentary History, etc.*, pages 861–863, and the circular letter of the Philadelphia Typographical Society of 1802 is given on page 865.

Notes to Chapter IX

The General Conditions of the Trade

1. The provisions with regard to Jonas Green cited in the opening paragraph of this chapter are found in the Acts of Assembly of Maryland for the years named, and the paper and type difficulties of Cra-

The Colonial Printer

dock and Bacon are commented upon in Wroth, *A History of Printing in Colonial Maryland*, page 107, and No. 189n of the Maryland Imprints section.

2. The artless simplicity of the apologies for errors is often amusing, as when Edward Wigglesworth appends to the long list of errata in his *Sober Remarks*, Boston, 1724, the disarming sentence, "Lesser escapes are left to the Candour of the Intelligent Reader." When an author happened to be temporarily the occupant of a jail and furthermore issuing his book surreptitiously, opportunity for proof reading was naturally curtailed. In *Truth Rescued from Imposture*, composed in Newgate in 1671, William Penn writes to the Courteous Reader: "Thou art desired to place the numerous errors of this Discourse to the account of difficulty in Printing any thing that comes not out with an *Imprimatur* in the front of it: But as we can't fly to the Hills, to hide us; so will it be esteem'd civility in thee to excuse the Authors from the Mistakes; . . ." It remained for a Peruvian printer, however, to issue, in the form of a book of 66 pages, corrections to the list of errata which one of his customers accused him of committing in the printing of an oration. The title of this curious book of Lima, 1773, was *Apologia de la Imprenta que està en la calle de S. Jacinto*. A copy is in the John Carter Brown Library. For the full title, see Medina, *La Imprenta en Lima*, III. 1350.

3. *John Holt, Printer and Postmaster*, by Victor Hugo Paltsits, is one of those admirable monographic studies of American printers which have been of the greatest usefulness in throwing light into the dark places of colonial printing history. Wall's *Samuel Loudon* is an interesting and important study of this group. One remembers in this connection Love's *Thomas Short*, Green's *John Foster*, Nichols's *Isaiah Thomas*, and numerous others that may be found in the general list of sources which precedes these notes.

4. The fullest treatment of the whole subject of the censorship of the press in colonial America is found in Duniway, *The Development of the Freedom of the Press in Massachusetts*. For the Massachusetts censorship, one must refer also to Worthington C. Ford, *The Isle of Pines*. The important episode in which Thomas Maule figured is treated, in such fashion as to make a fresh contribution to our knowledge of the liberty of the press, by Matt Bushnell Jones in *Thomas Maule, the Salem Quaker and Free Speech in Massachusetts Bay*. Rutherfurd, *John Peter Zenger, his Trial and his Press* studies exhaustively the particular

Notes

case implied in its title. An early discussion of the subject from the constitutional standpoint is found in *A Dissertation upon the Constitutional Freedom of the Press in the United States of America. By an Impartial Citizen.* Boston, Printed by David Carlisle, for Joseph Nancrede. The Virginia incident of the closing of the Nuthead press is discussed in Wroth, *A History of Printing in Colonial Maryland.* So far in the writing of this book I have been able to refrain from quoting the remark of Sir William Berkeley, royal governor of Virginia, who in a report to the Lords of Trade thanks his God that "there are no free schools nor printing [in Virginia] . . . for learning has brought disobedience, and heresy and sects into the world, and printing has divulged them . . . God keep us from both!" It seems impossible, however, to write on American printing without bringing in this utterance, generally as a reflection upon the mind and heart of the old cavalier governor. I have always thought it a very profound observation, however, full of salty truth and worthy of respect as the expression of a sincerely held point of view. The Bradford trial is set forth fully in Keith and Budd, *New-England's Spirit of Persecution, transmitted to Pennsilvania.* Isaiah Thomas, I. 211–223, quotes copious excerpts from this pamphlet, in which is given an account of the trial from the standpoint of the malcontents. The story of the peculiarly unpleasant persecution of Anthony Haswell is found in John Spargo's monograph on that printer. Rivington's case is discussed in Hildeburn, *Sketches of Printers and Printing in Colonial New York,* and in Sargent's *James Rivington, Tory Printer.* Goddard's conflict with the Baltimore mob is treated in Wroth, *A History of Printing in Colonial Maryland.*

5. Eddy, *Account Books kept by Benjamin Franklin, Ledger, 1728–1739; Journal, 1730–1737;* pages 33–35.

6. Ibid., pages 21–29; Leigh, *William Strahan and his Ledgers,* pages 280–284.

7. Besides the histories of printing in the various colonies, the sources for knowledge of the printers' prices specified in this discussion are the manuscript Work Book of Franklin & Hall; Eames, *Bibliographic Notes on Eliot's Indian Bible,* pages 9 and 14; Winship, *The Eliot Indian Tracts,* pages 183–185; the manuscript Papers of Isaiah Thomas; the manuscript *Connecticut Archives, Finance and Currency, 1677–1789,* V. 213a. A discussion of the place of printing and of the authorship of the Ringold tract is found in Wroth, *A History of Printing in Colonial Maryland,* Maryland Imprints, No. 248n. The entry quoted here from

the Franklin & Hall Work Book determines the truth of Daniel Dulany's contemporary assertion cited by Wroth that the *Remarks upon a Message* was printed by Franklin, and the billing of the printing job to Thomas Ringold, a member of the Lower House of Assembly of Maryland, at least gives a suggestion as to its probable authorship. One of the interesting manuscript possessions of the New York Public Library is this Work Book of Franklin & Hall, covering the years 1759–1766. In *Books and Bidders*, pages 135–139, A. S. W. Rosenbach has told of his discovery and purchase of this important volume, in which the record of the daily activity of a notable colonial printing house illumines many aspects of the trade in the period. Dr. Rosenbach gave me free access to this manuscript, and allowed me to make copious extracts from it for publication in this book. That privilege was courteously confirmed by the New York Public Library after the document came into the possession of that institution. The information with regard to the printing of Smith's *History of New Jersey* by James Parker is found in Wilberforce Eames's note to Sabin No. 83980.

8. For a brief statement of compositors' wages in England in 1785, see Stower, *The Printer's Grammar*, pages 418–419.

9. James Parker's statement of Accounts between Franklin and his partner, David Hall, manuscript in the Historical Society of Pennsylvania, proves to be a document that interests the historian of printing for many reasons not usually implicit in a financial statement. The conversion from currency to sterling in these years in Pennsylvania was normally at the rate of £170 of current money to £100 sterling.

10. Isaiah Thomas, I. 336.

Notes to Chapter X

Bookbinding in Colonial America

1. The work of the colonial binder has been discussed in brief by William Loring Andrews in his *Bibliopegy in the United States*, a charmingly written essay illustrated by several excellent examples of early bindings. The Grolier Club *Catalogue of Ornamental Leather Bookbindings executed in America Prior to 1850* contains carefully described entries of some seventeen bindings before 1801, an excellent historical introduction, and an important list of binders found at work in various American cities from the earliest times. Isaiah Thomas men-

Notes

tions the activities of many binders, in and out of the printing shop, and in the lists of printers at the conclusion of each volume of Evans's *American Bibliography* the binders and booksellers of the period covered are given equal prominence with the printers. I haven't found any book or essay specifically dealing with colonial binding except Holmes, *The Bookbindings of John Ratcliff and Edmund Ranger.*

2. We learn of the activities of the first professional colonial binder whose work is known from Littlefield, *Early Boston Booksellers, 1642–1711*, page 95, and from Ford, *The Boston Book Market, 1679–1700*, page 43, but especially from Eames, *Bibliographic Notes on Eliot's Indian Bible*, pages 15–16, where among other matter is given the letter in which Ratcliff discusses the conditions of his trade, and from Holmes, *The Bookbindings of John Ratcliff and Edmund Ranger.* Edmund Ranger's activities are also recorded by Littlefield and Ford.

3. Bishop, *History of Manufacturing in the United States* gives the facts of the tanning industry in the colonies; see also the *General Laws and Liberties of the Massachusetts Colony in New-England*, 1675, pages 62–63; and the *Representation of the Lords Commissioners for Trade and Plantations*, of 1734.

4. Love, *Thomas Short*, page 35.

5. The details of the disbursements to Green, and Ratcliff's request for a greater remuneration are found in Eames, *Bibliographic Notes on Eliot's Indian Bible*; see also *Isaiah Thomas*, I. 55–56n. Elizabeth Short's binding of the "Saybrook Platform" is commented upon in Love, *Thomas Short*; Franklin's complicated financial dealings with Stephen Potts can be studied in his manuscript "Journal of Accounts" in the American Philosophical Society, reproduced in Eddy, *Some Account Books kept by Benjamin Franklin*; the binding of the Mohawk Book of Common Prayer is referred to in the letters from Gaine to Sir William Johnson in Ford, *Journals of Hugh Gaine*, II. 217–221; the bill of Timothy Green for printing and binding the Connecticut Laws of 1784 is in manuscript in the Connecticut State Library, Hartford, *Connecticut Archives, Finance and Currency, 1677–1789*, IV. 213a.

6. A photographic reproduction of the binding of the second edition of the Bay Psalm Book, 1651, forms one of the numerous exceptionally good illustrations found in Andrews, *Bibliopegy in the United States*.

7. Griffin's *History of Keene* records the dates of Thomas S. Webb's bindery at Keene and other facts concerning its proprietor.

The Colonial Printer

Notes to Chapter XI

The Product of the Colonial Press

Part I. The Content

1. The Work Book of Franklin & Hall, owned by the New York Public Library, has been described in note 7 of Chapter IX. Its showing of printed pieces is here compared to William J. Campbell's *Collection of Franklin Imprints in the Museum of the Curtis Publishing Company*, an excellent bibliography containing a check list of all known Franklin imprints, including all titles recorded by Evans and Hildeburn.

2. Evans, *Oaths of Allegiance in Colonial New England*, discusses fully the whole subject implied in his title, and tells an exciting story of his search in the British Museum for a printed copy of the Freeman's Oath of Cambridge, 1639. James Franklin's advertisement of blank forms is found in Winship's introduction to *Rhode Island Imprints*, page 5. Hildeburn, No. 1, gives the Bradford announcement in facsimile; Franklin's traffic in blanks is found in the Bigelow edition of the *Autobiography*, page 154, and in various connections in Livingston, *The Passy Press*. The importance of the printing of blanks in the maintenance of the early Maryland presses is shown in Wroth, *A History of Printing in Colonial Maryland*, pages 8–9, 13, 21, and 29.

3. Hasse, "The First Published Proceedings of an American Legislature," an introduction to the facsimile reissue of *A Journal of the House of Representatives of New York*, 1695, tells the story of the beginnings of this important type of publication. The verse quoted is from Markland, *Typographia, an Ode on Printing*, Williamsburg, 1730. A facsimile of the John Carter Brown Library copy, supposedly unique, of this earliest American contribution to the literature of printing was published in 1926, by Edward L. Stone of Roanoke, Virginia, with an introduction by Earl G. Swem.

4. The recipe for improving meat that has become a bit "high" is found in an advertisement of *An Almanack for the Year 1760*, printed by Jonas Green of Annapolis in 1759. See *Maryland Gazette*, November 29, 1759. The investigation of the political importance of the almanac is found in Greenough, *New England Almanacs, 1766–1775, and the American Revolution*.

5. The sentence quoted in praise of American newspapers is from the anonymous *Bibliotheca Americana*, London, 1789, page 14. The back-

Notes

ground and influence of American newspaper publication has been treated broadly and with insight by Bernard Faÿ in his *Notes on the American Press at the End of the Eighteenth Century*, published by the Grolier Club in 1927. Doubtless the introduction to the publication in book form of Brigham, *Bibliography of American Newspapers*, which completed some seven years ago its serial publication in the *Proceedings of the American Antiquarian Society*, will cover for the entire period the material and spiritual aspects of the American newspaper. Allnutt's *English Provincial Presses* found its publication in *Bibliographica*, II. 23–46, 150–180, 276–308. The statistics of newspaper publication given here are from George Parker Winship's Report of the Council of the American Antiquarian Society (printed in the *Proceedings* for April, 1926) with emendations made necessary by the completion, since then, of Brigham, *Bibliography of American Newspapers*.

6. This analysis of the periodical press was made possible originally by William Beer's *Checklist of American Periodicals, 1741–1800*. Afterwards the whole subject was fully opened to the general student by the Mott and Richardson works referred to in the text.

7. Some special bibliographies that deal with the several types of publication mentioned here are Worthington C. Ford, *Broadsides, Ballads, &c. Printed in Massachusetts, 1639–1800*; [Hildeburn], *The Charlemagne Tower Collection of American Colonial Laws*; Eldon R. James, *A List of Legal Treatises*; Nichols, *Massachusetts Almanacs*; Morrison, *Almanacs in the Library of Congress*; Brigham, *An Account of American Almanacs*; P. L. Ford, *The New England Primer*; Heartman, *The New England Primer*; Merritt, *The Royal Primer*; Winship, *French Newspapers*; Karpinski, *The History of Arithmetic*; Wegelin, *Early American Poetry*; Lincoln, *Bibliography of American Cookery Books, 1742–1860*; Brigham, *Bibliography of American Newspapers, 1690–1820*.

8. Holmes, *The Mather Literature*, makes a striking presentation of the importance of the writings of the Mathers in the life of New England.

9. The literary product of the colonial press, if we may judge by the number of separate studies issued each year, is attracting many and serious students. The basis of any investigation of the verse of the period is found in Wegelin, *Early American Poetry*.

10. The importance of *The German Press in Pennsylvania* is set forth in Seidensticker's book of that title, while details and a more dis-

cursive treatment of a part of the subject are found in the works of Julius Friederich Sachse.

Notes to Chapter XII

The Product of the Colonial Press

Part II. External Characteristics

1. Wroth, *Formats and Sizes.*

2. Chapman, *Notes on Eighteenth-Century Bookbuilding*, pages 166–167.

3. See article referred to in note 1, above.

4. The indispensable general books on American engraving are Stauffer, *Early American Engravers on Copper and Steel* and Fielding, *Dictionary of American Painters, Sculptors and Engravers.* Other works of importance are mentioned specifically in the notes which follow.

5. Green, *John Foster.*

6. Murdock, *Portraits of Increase Mather*, discusses this earliest of American copperplate portrait engravings.

7. Citing Charles Harper Walsh's paper in *The Records of the Columbia Historical Society*, [Washington, D. C.], XV, 1912, Stokes's *Iconography*, I. 254n, suggests 1683 as the year and New York as the place of publication of the Simson engraving of John Reid's *Mapp of the Rariton River.* The endorsement of the New Jersey Historical Society copy of the map, however, seems to show that it contains plats of lands granted in the period 1683–1686, and the Library of Congress copy contains among other endorsements the unrelated figures, doubtless intended as a date, "1685." It is highly probable, therefore, that the map was not drawn until 1686 or afterwards. The assumption by Mr. Walsh that it was engraved and printed in this country rests upon a reference to it in an agreement between the governors of East and West Jersey. Mr. Walsh writes as follows: "that this map was engraved in the Colonies is sufficiently attested in an old document, being an agreement made between the then governors of East Jersey and West Jersey . . . signed and sealed on September 5, 1688 [to the effect that a certain specified boundary] shall not be altered but remain as it stands *on a printed draught of the proprietors lands, surveyed in East Jersey and drawn by John Reid, and since printed here.*" [Italics by Mr.

Notes

Walsh.] Unfortunately Mr. Walsh failed to observe that this agreement, published by William A. Whitehead in his *Documents relating to the Colonial History of the State of New Jersey*, II. 34–36, was headed [italics mine] "*London*, Sept. 5th. 1688," so that the phrase "printed here" in the document cited by Mr. Walsh means, clearly enough, printed in London, where the conference between the two governors was held. In this destructive bit of criticism, I am indebted to the co-operation of Mr. Victor Hugo Paltsits, of the New York Public Library and Colonel Lawrence Martin, of the Division of Maps in the Library of Congress.

8. Stauffer, I. 64, quotes "a Boston newspaper" as announcing on July 30, 1716, the arrival from England of Francis Dewing. I have not been able to verify the reference in the pages of the *Boston News-Letter*, but circumstances as related in our text make it plain that this date of arrival must have been approximately correct.

9. My attention was called to the existence of this plate, which seems to contain the earliest Boston work of Francis Dewing, through the medium of a short, unpublished list, full of new material, compiled by Miss Clara Egli of the Division of Maps, Library of Congress, on "The Charts of Captain Cyprian Southack." Miss Egli says in a note that the chart of 1717, known only from the copy in the Public Record Office, was entered in the Great Britain Colonial Office Catalogue of Maps . . . 1910. Knowledge of it seems to have escaped historians of American cartography and of American engraving until Miss Egli entered it in her list. It was probably this map, or perhaps a part of it, which was advertised in the *Boston News-Letter* for June 24, 1717, under the following title: "Capt. Cyprian Southack's large and Correct Chart or MAP of all the Sea Coast in the English America, on the Continent, *viz.* from Newfoundland, to Cape Florida: the like never yet Extant, of great Use to all, but especially to Mariners."

10. Phillips, *The Rare Map of the Northwest, 1785, by John Fitch.*

11. Wroth, *An American Bookshelf*, page 153, discusses the spelling of the name of this engraver, Hebert or Herbert, and, for reasons given, decides that it was Hebert, as here used.

12. Eddy, *Account Books of Benjamin Franklin.*

13. *The New Improved West-India Pilot*, the several architectural books recorded in Wall, *Books on Architecture Printed in America*, and various entries in Evans show the extent of William Norman's publishing activities.

The Colonial Printer

14. Wall, *Books on Architecture Printed in America, 1775–1830*. A study of architectural books including those of the later period is in progress by Henry Russell Hitchcock, Jr., of Wesleyan University.

15. The comment on these plates by William Loring Andrews in his *Essay on the Portraiture of the American Revolutionary War*, pages 24–25, is interesting: "They are not the best engravings but they are the most singular and original looking prints, and, besides, are of home manufacture, and supply us with specimens of American engravings in the eighteenth century which are not always to be had for the asking." Mr. Andrews goes further and writes as follows about the Norman plates, pages 26–27, quoting an irate Philadelphia critic who wrote in the *Freeman's Journal* for January 26, 1795: "A new American history of the late war, says a literary correspondent, seems to be much wanting; one in which impartiality, strict truth, elegance and precision shall be united. Such a one cannot fail of being acceptable to every class of readers. The expense of copper plates, however, might be spared, unless they could be executed in a different stile from those in the history of the American War, printed at Boston in 1781 and 82. There gen Knox and Sam Adams, are represented more frightful than Lord Blackney on a London ale house sign, and gen Greene the exact resemblance of Jonathan wild, in the frontispiece of a two penny history. Surely such extraordinary figures are not intended to give the rising generation an improved taste in the arts of designing and sculpture." Mr. Andrews combines further interesting information about early American engravers and comment upon them in his *Fragments of American History illustrated by Engravers who flourished in the XVIII Century*.

Works Referred to in Notes

A List of Works
Referred to in the Notes by Short Titles

ADAMS, RANDOLPH GREENFIELD. The Passports printed by Benjamin Franklin at his Passy Press. Ann Arbor, 1925; pages [ii], 11.

ADAMS, THOMAS F. Typographia; a brief Sketch of the Origin, Rise and Progress of the Typographic Art; with practical Directions for conducting every Department in an Office. Philadelphia, 1837; [ii], 372, [viii].

ALLNUTT, W. H. English Provincial Presses. (In *Bibliographica*, II. 23–46, 150–180, 276–308.)

ANDREWS, WILLIAM LORING. Bibliopegy in the United States and Kindred Subjects. New York, 1902; pages xxiv, 130.

An Essay on the Portraiture of the American Revolutionary War. New York, 1896; pages xii, 101.

Fragments of American History, illustrated solely by the works of those of our own Engravers who flourished in the XVIIIth Century. New York, 1898; pages xvi, 70.

BARTON, WILLIAM. Memoirs of the Life of David Rittenhouse... Philadelphia, 1813; pages lxxviii, 79–614.

BATES, ALBERT CARLOS. Connecticut Statute Laws. A Bibliographical List of Editions of Connecticut Laws from the Earliest Issues to 1836. [Hartford], 1900; pages [x], 120. (Acorn Club, Third Publication.)

BEER, WILLIAM. ... Checklist of American Periodicals, 1741–1800 ... Worcester, Massachusetts, 1923; pages 18. (Reprinted from the *Proceedings of the American Antiquarian Society*, New Series, Volume 32, Part 2, October, 1922; pages 330–335.)

BIBLIOGRAPHICAL ESSAYS. A Tribute to Wilberforce Eames. [Edited by George Parker Winship and Lawrence C. Wroth.] [Cambridge], 1924; pages xxii, 440.

BIBLIOTHECA AMERICANA; or a Chronological Catalogue of the most curious and interesting Books, Pamphlets, State Papers, &c. upon the Subject of North and South America ... London, 1789; pages [iv], 271.

BIGMORE, E. C., and WYMAN, C. W. A Bibliography of Printing with Notes & Illustrations. 3 Volumes. London, 1880–1886.

The Colonial Printer

BISHOP, J. LEANDER. A History of American Manufactures from 1608–1860. 3 Volumes, Philadelphia, 1864–1866.

BLADES, WILLIAM. The Pentateuch of Printing, with a Chapter on Judges. With a Memoir of the Author and a List of his Works, by Talbot B. Reed. London, 1891; pages xxx, 117.

BRIGHAM, CLARENCE SAUNDERS. An Account of American Almanacs and their Value for Historical Study. Worcester, Massachusetts, 1925; pages 25. (Reprinted from the *Proceedings of the American Antiquarian Society*, New Series, Volume 35, Part 2, October, 1925; pages 194–218.)

Bibliography of American Newspapers, 1690–1820. (In *Proceedings of the American Antiquarian Society*, New Series, Volume 23, Part 2, October, 1913, to Volume 37, Part 1, April, 1927.)

BRIQUET, C. M. Les Filigranes. Dictionnaire historique des Marques du Papier . . . vers 1282 jusqu'en 1600. 4 Volumes, Paris, 1907.

BULLEN, HENRY LEWIS. The Bradford Family of Printers. (In *The American Collector*, January and February, 1926; pages 148–156 and 164–170 respectively, Number 3, in series entitled *Famous American Printers*.)

CAMPBELL, WILLIAM J. The Collection of Franklin Imprints in the Museum of the Curtis Publishing Company. With a Short-Title Check List of all the Books, Pamphlets, Broadsides, &c., known to have been printed by Benjamin Franklin. Philadelphia, 1918; pages [x], 333.

CHAPIN, HOWARD MILLAR. Ann Franklin of Newport, Printer, 1736–1763. (In *Bibliographical Essays. A Tribute to Wilberforce Eames*. Pages 337–344.)

James Franklin, Jr. Newport Printer. (In *The American Collector*, Volume II, Number 3, June, 1926; pages 325–329.)

Calendrier Français pour l'année 1781 and the Printing Press of the French Fleet in American Waters during the Revolutionary War. Providence, 1914; pages 10. Contributions to Rhode Island Bibliography No. II. (Reprinted from *The Providence Magazine*, July, 1915.)

Early Rhode Island Paper Making. (In *The American Collector*, Volume II, Number 2, May, 1926; pages 303–309.)

More about Sea Presses. (In *The American Collector*, Volume III, Number 2, November, 1926; pages 86–88.)

Works Referred to in Notes

CHAPMAN, R. W. An Inventory of Paper, 1674. (In *Transactions of the Bibliographical Society*, *The Library*, New Series, Volume 7, Number 4, March, 1927; pages 402–408.)

Notes on Eighteenth-Century Bookbuilding. (In *Transactions of the Bibliographical Society*, *The Library*, Fourth Series, Volume 4, Number 3, December, 1923; pages 161-180.)

CHRONICON EPHRATENSE, *see* "LAMECH AND AGRIPPA."

CLAYTON-TORRENCE, WILLIAM. ... A Trial Bibliography of Colonial Virginia. 2 Volumes, Volume I. [1608–1754], Volume II. 1754–1776. Richmond, 1908–10; pages 154, 94. (A special Report of the Department of Bibliography in the Virginia State Library.)

COXE, TENCH. A View of the United States of America, in a Series of Papers, written at Various Times, between the Years 1787 and 1794. Interspersed with authentic Documents . . . Philadelphia, 1794; pages vi, [ii], 7–14, 513.

DE VINNE, THEODORE LOW. The Practice of Typography. Plain Printing Types. A Treatise on the Processes of Type-making, the Point System, the Names, Sizes and Styles of Types. New York, 1914; pages 403. (First Edition, 1899.)

DEXTER, ELISABETH ANTHONY. Colonial Women of Affairs. A Study of Women in Business and the Professions in America before 1776. Boston and New York, 1924; pages xx, 204.

THE DOLPHIN, Number 3, A History of the Printed Book. Edited by Lawrence C. Wroth. New York, The Limited Editions Club, 1938.

DUNIWAY, CLYDE AUGUSTUS. The Development of the Freedom of the Press in Massachusetts. (Harvard Historical Studies, Volume XII.) New York, 1906; pages xvi, 203.

EAMES, WILBERFORCE. The Bay Psalm Book. Being a Facsimile Reprint of the First Edition, Printed by Stephen Daye at Cambridge, in New England in 1640. With an Introduction by Wilberforce Eames. New York, 1903; pages xviii, 295.

Bibliographical Essays. A Tribute to Wilberforce Eames. [Edited by George Parker Winship and Lawrence C. Wroth.] [Cambridge], 1924; pages xxii, 440.

Bibliographic Notes on Eliot's Indian Bible and on his other translations and works in the Indian language of Massachusetts . . . Washington, 1890; pages [ii], 58. Extract from Pilling's *Bibliography of the Algonquian Languages*.

The Colonial Printer

The First Year of Printing in New-York: May, 1693 to April, 1694. New York, 1928; pages 25. (Reprinted from the *Bulletin of the New York Public Library* for January, 1928.)

EDDY, GEORGE SIMPSON. Account Books kept by Benjamin Franklin. Ledger, 1728–1739; Journal, 1730–1737. New York, 1928; pages 59. *Same.* Ledger "D." 1739–1747. New York, 1929; pages 126.

EVANS, CHARLES. American Bibliography. 12 Volumes, 1639–1799. Chicago, 1903–1934.

Oaths of Allegiance in Colonial New England. (In *Proceedings of the American Antiquarian Society*, New Series, Volume 31, Part 2, October, 1921; pages 377–438.)

FAŸ, BERNARD. Notes on the American Press at the End of the Eighteenth Century. New York, The Grolier Club, 1927; pages 34.

FERTEL, DOMINIQUE. La Science Pratique de l'Imprimerie. St. Omer, 1723; pages [xx], 1–294, [x]; plates.

FIELDING, MANTLE. Dictionary of American Painters, Sculptors and Engravers. Philadelphia, n.d. [*c.* 1926]; pages viii, 433.

FORD, PAUL LEICESTER. Franklin Bibliography. A List of Books written by, or relating to Benjamin Franklin. Brooklyn, 1899; pages lxiv, 467.

The Journals of Hugh Gaine, Printer . . . Volume I, Biography and Bibliography. Volume II, Journals and Letters. New York, 1902; pages xii, 240; xii, 235.

The Many-Sided Franklin. New York, 1899; pages xxii, 516.

The New-England Primer, A History of its Origin and Development with a Reprint of the unique Copy of the earliest known Edition and many facsimile Illustrations and Reproductions. New York, 1897; pages xiv, 354.

FORD, WORTHINGTON C. The Boston Book Market, 1697–1700. Boston, 1917; pages xii, 198. (Published by the Club of Odd Volumes.)

Broadsides, Ballads, &c. Printed in Massachusetts, 1639–1800. Massachusetts Historical Society. [Boston], 1922; pages xvi, 483.

The Isle of Pines 1668. An Essay in Bibliography. Boston, the Club of Odd Volumes, 1920; pages [xii], [117].

FRANKLIN, BENJAMIN. Autobiography. (Volume I of *The Writings of Benjamin Franklin.* See next title.)

The Writings of Benjamin Franklin. Collected and edited with a Life

[336]

Works Referred to in Notes

and Introduction by Albert Henry Smyth. 12 Volumes, New York, 1905.

FRANKLIN & HALL, Work Book, 1759–1766. (Manuscript in New York Public Library.)

GAYARRÉ, CHARLES. Histoire de la Louisiane. 2 Volumes, Nouvelle-Orléans. 1846–1847; pages [iv], XII, 377; VIII, 427.

GOODWIN, RUTHERFOORD. The Williamsburg Paper Mill of William Parks, the Printer. (Volume 31, Part 1, of the *Papers of the Bibliographical Society of America.* 1938.)

GOOLD, WILLIAM. Early Papermills of New England. (Read at a meeting of the Maine Historical Society . . . Feb. 19, 1874, and communicated to the *Historic and Genealogical Register* for April, 1875); pages 8.

GRANNISS, RUTH SHEPARD. Amerikanische Sammler und Bibliotheken. (In Lehmann-Haupt, *Das Amerikanische Buchwesen*, pages 251–338, translated by Carl Speth, Jr.)

GREEN, SAMUEL ABBOTT. John Foster, the earliest American Engraver and the first Boston Printer . . . Boston, 1909; pages [vi], 149.

GREENOUGH, CHESTER NOYES. New England Almanacs, 1766–1775 and the American Revolution. (In *Proceedings of the American Antiquarian Society*, Volume 45, New Series, Part 2, October, 1935; pages 288–316.)

GRIFFIN, SIMON GOODELL. History of the Town of Keene from 1732, when the Township was granted by Massachusetts to 1874, when it became a City . . . Keene, N. H., 1904; pages [vii], 792.

GROLIER CLUB, NEW YORK CITY. Catalogue of Ornamental Leather Bookbindings executed in America prior to 1850. (New York, 1907); pages xvi, 107.

HAMMETT, CHARLES E., JR. A Contribution to the Bibliography and Literature of Newport, R. I. . . . Newport, 1887; pages 185.

HANSARD, THOMAS CURSON. Typographia: an historical Sketch of the Origin and Progress of the Art of Printing . . . London, 1825; pages [xxiv], 939, [xxvi].

HASSE, ADELAIDE R., *editor.* A Journal of the House of Representatives for his Majestie's Province of New York in America. Reproduced in facsimile from the first edition printed by William Bradford, 1695. New York, 1903; pages iv, 20. (Contains *The First Published Pro-*

The Colonial Printer

ceedings of an American Legislature. By A. R. Hasse. Pages iii–iv.)

A Narrative of an Attempt made by the French of Canada upon the Mohaque's Country. Reproduced in facsimile from the first edition printed by William Bradford, 1693 . . . New York, 1903; pages vii, 14.

Some Materials for a Bibliography of the Official Publications of the General Assembly of the Colony of New York, 1693–1775. Collected by A. R. Hasse. [New York, 1903]; pages 73. (Reprinted from the *Bulletin of the New York Public Library*, February-April, 1903.)

HAWKINS, DOROTHY LAWSON. James Adams; the first Printer of Delaware. (In *Papers of the Bibliographical Society of America*, Volume 28, 1934, Part 1; pages 28–63.)

HEARTMAN, CHARLES FRED, *compiler*. The New England Primer Issued Prior to 1830. A Bibliographical Checklist . . . [New York], 1922; pages 192. (In *Heartman's Historical Series*, Number 15, Second issue.)

HILDEBURN, CHARLES R. A Century of Printing. The Issues of the Press in Pennsylvania, 1685–1784. Philadelphia, 1865–6. 2 Volumes, Volume I, 1685–1763; Volume II, 1764–1784; pages xvi, 392, 516.

The Charlemagne Tower Collection of American Colonial Laws. (Privately printed for the Historical Society of Pennsylvania.) Philadelphia, 1890; pages 298.

Sketches of Printers and Printing in Colonial New York. New York, 1895; pages xvi, 189.

HOLMES, THOMAS J. The Bookbindings of John Ratcliff and Edmund Ranger, Seventeenth Century Boston Bookbinders. (In *Proceedings of the American Antiquarian Society*, New Series, Volume 38, Part 1, April, 1928; pages 31–50.)

Increase Mather. A Bibliography of his Works. With an Introduction by George Parker Winship and Supplementary Material by Kenneth Ballard Murdock and George Francis Dow. 2 Volumes, Cleveland, 1931.

The Mather Literature. Privately Printed for William Gwinn Mather. Cleveland, 1927; pages viii, 65.

HUMPHREY, CONSTANCE H. Check-List of New Jersey Imprints. (In *Papers of the Bibliographical Society of America*, Volume 24, 1930, Parts 1 and 2; pages 43–149.)

[338]

Works Referred to in Notes

HUNTER, DARD. The Literature of Papermaking, 1390–1800. (Chillicothe, Ohio, 1925) ; pages 48.

Old Papermaking. (Chillicothe, Ohio), 1923 ; pages 112, Specimens of Paper, 10 leaves.

JOHNSON, JOHN. Typographia, or the Printers' Instructor. 2 Volumes, London, 1824 ; pages [xiv], xii, 610, [10] ; [viii], iv, 664, [16].

JONES, HORATIO GATES. Historical Sketch of the Rittenhouse Paper-Mill. (In *The Pennsylvania Magazine of History and Biography*, XX, page 325.)

JONES, MATT BUSHNELL. Bibliographical Notes on Thomas Walter's "Grounds and Rules of Musick Explained." (In *Proceedings of the American Antiquarian Society* for October, 1932 ; pages 14.)

The Early Massachusetts-Bay Colony Seals. With Bibliographical Notes Based upon Their Use in Printing. (In *Proceedings of the American Antiquarian Society* for April, 1934 ; pages 34.)

Some Bibliographical Notes on Cotton Mather's "The Accomplished Singer." (In *Publications of The Colonial Society of Massachusetts*, Volume XXVIII, 1933 ; pages 9.)

Thomas Maule the Salem Quaker and Free Speech in Massachusetts Bay. With Bibliographical Notes. (In *Essex Institute Historical Collections*, Volume LXXII, Number 1, January, 1936 ; pages 42.)

KARPINSKI, LOUIS CHARLES. The History of Arithmetic. Chicago [1925] ; pages xii, 200.

"LAMECH AND AGRIPPA." Chronicon Ephratense ; a History of the Community of Seventh Day Baptists at Ephrata, Lancaster County, Penn'a. Translated from the original German by J. Max Hark, D.D. Lancaster, Pa., 1899 ; pages xvi, 288. (The original edition in German was printed at Ephrata in 1786.)

LEGROS, LUCIEN ALPHONSE, and GRANT, JOHN CAMERON. Typographical Printing Surfaces, the Technology and Mechanism of their Production ... London and New York, 1916 ; pages xxiv, 732, [733].

LEHMANN-HAUPT, HELLMUT, *editor and joint author*. Das Amerikanische Buchwesen. Buchdruck und Buchhandel, Bibliophilie und Bibliothekswesen in den Vereinigten Staaten von den Anfängen bis zur Gegenwart. Von Hellmut Lehmann-Haupt ... unter Mitarbeit von Ruth S. Granniss und Lawrence C. Wroth. Leipzig, 1937 ; pages xii, 386, [387–388].

The Colonial Printer

LEIGH, R. A. AUSTEN. William Strahan and his Ledgers. (In *The Library*, Transactions of the Bibliographical Society, New Series, Volume III, Number 4, March, 1923, pages 261–287.)

LINCOLN, WALDO. Bibliography of American Cookery Books, 1742–1860. (In *Proceedings of the American Antiquarian Society*, New Series, Volume 39, Part 1, April, 1929; pages 85–225.)

LITTLEFIELD, GEORGE EMERY. Early Boston Booksellers, 1642–1711. Boston, 1900; pages 256. (Published by the Club of Odd Volumes.)

The Early Massachusetts Press, 1638–1711. 2 Volumes, Boston, 1907; pages xiv, 217; vii, 100. (Published by the Club of Odd Volumes.)

LIVINGSTON, LUTHER S. Franklin and His Press at Passy ... New York, The Grolier Club, 1914; pages xiv, 217.

LOVE, W. DeLoss. Thomas Short, the First Printer of Connecticut. [Hartford], 1901; pages 48. (Acorn Club, Sixth Publication.)

LUCKOMBE, P. The History and Art of Printing ... London, 1771; pages [xii], 502, [iv]. (First edition, 1770.)

McCULLOCH, WILLIAM. William McCulloch's Additions to Thomas's History of Printing. (In *Proceedings of the American Antiquarian Society*, New Series, Volume 31, Part 1, April, 1921; pages 89–247.)

McKERROW, RONALD B. Introduction to Bibliography for Literary Students. Oxford, 1927; pages xvi, 360.

Notes on Bibliographical Evidence for Literary Students and Editors of English Works of the Sixteenth and Seventeenth Centuries. (Reprinted from the *Transactions of the Bibliographical Society*, Volume XII.) London, 1914; pages [vi], 102.

McMURTRIE, DOUGLAS C. Antecedent Experience in Kentucky of William Maxwell, Ohio's first Printer. Louisville, 1932; pages 11.

A Bibliography of South Carolina Imprints, 1731–1740. (In *The South Carolina Historical and Genealogical Magazine*, of July, 1933, Volume 34, pages 117–137.

The Earliest New Jersey Imprint. Newark, 1932; pages 14.

Early Printing in New Orleans, 1764–1810. With a Bibliography of the Issues of the Louisiana Press. New Orleans, 1929; pages 151.

Early Printing in Tennessee. With a Bibliography of the Issues of the Tennessee Press, 1793–1830. Chicago, Chicago Club of Printing House Craftsmen, 1933; pages [1–8], 11–141.

Works Referred to in Notes

The First Decade of Printing in the Royal Province of South Carolina. (In *Transactions of the Bibliographical Society, The Library*, March, 1933; pages 425–452.)

The First Printing in Florida. (In *The Southern Printer* for March, 1931.) Atlanta, Georgia, 1931; pages [1–2], 5–18.

The First Twelve Years of Printing in North Carolina. With a Bibliography of the North Carolina Press, 1749–1760. (In *The North Carolina Historical Review*, July, 1933; pages 21.)

The First Typefounding in Mexico. London, 1927. (In *Transactions of the Bibliographical Society, The Library*, New Series, Volume III, Number 1, June, 1927; pages 119–122.)

A Further Note on the New Jersey Acts of 1723. Somerville, N. J., 1935; pages 10.

A History of Printing in the United States. Volume II, Middle & South Atlantic States. New York, 1936; pages xxvi, 462.

Pioneer Printing in Michigan. Springfield, Illinois, 1933. (In *The National Printer Journalist* for October, 1932; pages 4.)

Pioneer Printing in Mississippi. (In *The Southern Printer* for March, 1932.) Atlanta, Georgia; pages 3.

Preliminary Check List of Mississippi Imprints, 1798–1810. Chicago, 1934; pages 53. (Printed as manuscript subject to revision.)

The Westward Migration of the Printing Press, 1786–1836. Mainz, Germany, 1930; pages 20.

MADAN, FALCONER. Early Representations of the Printing Press. (In *Bibliographica*, I. 223–248, 499–502, and additional matter in the *Bodleian Quarterly Record*, IV. 165–167.)

MERRITT, PERCIVAL. The Royal Primer. (In *Bibliographical Essays. A Tribute to Wilberforce Eames*. Pages 35–60.)

MOORE, GEORGE HENRY. . . . Historical Notes on the Introduction of Printing into New York, 1693 . . . New York, 1888; pages 18.

MORES, EDWARD ROWE. A Dissertation upon English Typographical Founders and Founderies. With Appendix by John Nichols, &c. &c. Edited by D. B. Updike. New York, 1924; pages xlii, 105. (A reprint by the Grolier Club of the original edition of 1778. See Bigmore and Wyman, *A Bibliography of Printing*, II. 50.)

MORI, GUSTAV. Der Buchdrucker Christoph Sauer in Germantown. (In *Gutenberg-Jahrbuch*, 1934; pages 224–230.)

The Colonial Printer

MORRISON, HUGH ALEXANDER. . . . Preliminary Check List of American Almanacs, 1639–1800. Washington, 1907; pages 160. (Publication of the Library of Congress.)

MOTT, FRANK LUTHER. A History of American Magazines, 1741–1850. New York, 1930; pages xx, 848. (Second volume, 1850 to the present time, in preparation.)

MOXON, JOSEPH. Moxon's Mechanick Exercises; or The Doctrine of Handy-Works applied to the Art of Printing. A literal Reprint in two Volumes of the first Edition, published in the Year 1683, with Preface and Notes by Theo. L. De Vinne. One volume in two, New York, The Typothetae of the City of New York, 1896; pages xxiv, 196, 197–430. (For original edition see Bigmore and Wyman, *A Bibliography of Printing*, II. 54.)

MURDOCK, KENNETH BALLARD. The Portraits of Increase Mather, with some notes on Thomas Johnson, an English Mezzotinter. Cleveland, For private distribution by William Gwinn Mather, 1924; pages xii, 71.

NELSON, WILLIAM. Notes toward a History of the American Newspaper . . . New York, 1918. Volume I (all published), pages iv, 644.

Some New Jersey Printers and Printing in the Eighteenth Century . . . Worcester, Massachusetts, 1911; pages 44. (Reprinted from the *Proceedings of the American Antiquarian Society*, New Series, Volume 21, Part 1, April, 1911; pages 15–56.)

NICHOLS, CHARLES LEMUEL. Isaiah Thomas Printer, Writer & Collector . . . With a Bibliography of the Books printed by Isaiah Thomas. Boston, 1912; pages xii, 144 [145–146]. (Printed for the Club of Odd Volumes.)

Justus Fox, a German Printer of the Eighteenth Century. Worcester, Massachusetts, 1915. (Reprinted from the *Proceedings of the American Antiquarian Society*, New Series, Volume 25, Part 1, April, 1915; pages 55–69.)

(New Hampshire printing.) (In *Bulletin of the American Antiquarian Society*, November, 1915, Number 5, and in the *Proceedings* of the same Society, New Series, Volume 25, Part 2, October, 1915; pages 327–330.) . . . Notes on the Almanacs of Massachusetts . . . Worcester, Massachusetts, 1912; pages 122. (Reprinted from the *Proceedings of the American Antiquarian Society*, New Series, Volume 22, Part 1, April, 1912; pages 15–134.)

Works Referred to in Notes

Noyes, R. Webb. A Bibliography of Maine Imprints to 1820. Stonington, Maine: Printed by Mrs. and Mr. R. Webb Noyes ... 1930; *Supplement* ... Stonington, 1934.

O'Callaghan, Edmund Bailey. A List of Editions of the Holy Scriptures and Parts thereof, printed in America Previous to 1860 ... Albany, 1861; pages liv, [x], 415.

Oswald, John Clyde. Benjamin Franklin, Printer. [Garden City, New York], 1917; pages xvi, 245.

Paltsits, Victor Hugo. John Holt, Printer and Postmaster. Some facts and Documents relating to his Career. (In *Bulletin of the New York Public Library*, Volume 24, Number 9, September, 1920; pages 483–499.)

Phillips, P. Lee. ... Notes on the Life and Works of Bernard Romans. Deland, Florida, 1924; pages [1–15], 16–128, [129–134]. Publications of the Florida State Historical Society, Number Two. (With portfolio containing Romans's Map of Florida.)
The Rare Map of the Northwest, 1785, by John Fitch ... with a Facsimile Reproduction ... Washington, 1916; pages 43.

Pottinger, David. The History of the Printing Press. (In *The Dolphin, Number 3, A History of the Printed Book*, Chapter X.)

Printers and Printing in Providence, 1762–1907. Prepared by a Committee of Providence Typographical Union Number Thirty-three as a Souvenir of the fiftieth Anniversary of its Institution. (William Carroll, Chairman.) [Providence, 1907]; pages 212, xcviii.

Reed, Talbot Baines. A History of the Old English Letter Foundries, with Notes, Historical and Bibliographical on the Rise and Progress of English Typography. London, 1887; pages xiv, 380.

Renouard, Ph. Bibliographie des Impressions et des Œuvres de Josse Badius Ascensius, Imprimeur et Humaniste, 1462–1535. 3 Volumes, Paris, 1908; pages viii, 324, [4]; [iv], 548; [iv], 531.

Rhode Island Imprints. A List of Books, Pamphlets, Newspapers and Broadsides ... (By George Parker Winship, Howard M. Chapin and Rebecca Steere.) Providence, 1914; pages 88.

Roden, Robert F. ... The Cambridge Press, 1638–1692. A History of the First Printing Press Established in English America, together with a Bibliographical List of the Issues of the Press. New York, 1905; pages [iv], 193.

The Colonial Printer

ROOSES, MAX. Le Musee Plantin Moretus. Anvers, 1914. [next page] : Contenant la Vie et l'Œuvre de Christophe Plantin et de ses Successeurs Les Moretus ainsi que la Description du Musee et des Collections qu'il renferme. Pages [x], 411.

ROSENBACH, A. S. W. An American Jewish Bibliography, being A List of Books and Pamphlets by Jews or relating to them, printed in the United States from the Establishment of the Press in the Colonies until 1850. (Baltimore), 1926; pages xviii, 1–486. (Publications of the American Jewish Historical Society, Number 30.)

RUGG, HAROLD GODDARD. The Dresden Press. (Abstract and revision of a paper read before the Ticknor Club of Dartmouth College.) Pages [19]. (Hanover, N. H., 1920.) (In *Dartmouth Alumni Magazine*, Volume 12, pages 796–814, May, 1920.)

RUTHERFURD, LIVINGSTON. John Peter Zenger, his Press, his Trial, and a bibliography of Zenger imprints . . . New York, 1904; pages xiv, 275.

SACHSE, JULIUS FRIEDERICH. The German Sectarians of Pennsylvania. A Critical and Legendary History of the Ephrata Cloister and the Dunkers. 2 Volumes, 1708–1742, 1742–1800; Philadelphia, 1899–1900; pages xx, 506; xvi, 536.

SALLEY, A. S., JR. The First Presses of South Carolina. (In Bibliographical Society of America, *Proceedings and Papers*, Volume II, 1907–1908; pages 28–69.)

SARGENT, GEORGE H. James Rivington, Tory Printer. A Study of the Loyalist Pamphlets of the Revolution. (In *The American Collector*, Volume II, Number 3, June, 1926; pages 336–338.)

SEIDENSTICKER, OSWALD. The First Century of German Printing in America, 1728–1830 . . . Philadelphia, 1893; pages [ii], x, 254.

SIEBERT, WILBUR HENRY. Loyalists in East Florida, 1774–1785. 2 Volumes. Deland, 1929. (Publications of the Florida State Historical Society, Number 9.)

SMITH, JOHN. The Printer's Grammar : wherein are exhibited . . . London, 1785; pages [8], 312.

SPARGO, JOHN. Anthony Haswell, Printer-Patriot-Ballader. A biographical Study with a Selection of his Ballads and an annotated Bibliographical List of his Imprints. Rutland, 1925; pages xvi, 293.

STAUFFER, DAVID MCNEELY. American Engravers upon Copper and Steel. 2 Volumes, New York, The Grolier Club, 1907.

Works Referred to in Notes

STEWART, ETHELBERT. A Documentary History of the early Organizations of Printers. (In *Bulletin of the Bureau of Labor*, Number 61, U. S. Department of Commerce, pages 857–1033.)

STILLWELL, MARGARET BINGHAM. Incunabula and Americana, 1450–1800, a Key to Bibliographical Study. New York, 1931; pages [xx], 483, [ii].
The Seventeenth Century. (In *The Dolphin, Number 3, A History of the Printed Book*, Chapter V.)

STOKES, I. N. PHELPS. The Iconography of Manhattan Island, 1498–1909. 6 Volumes, New York, 1915–1928.

STOWER, C. The Printer's Grammar; or, Introduction to the Art of Printing: containing a concise History of the Art, with the Improvements in the Practice of Printing, for the last fifty years. London, 1808; pages xviii, 530. Specimens of Printing Types, pages 48; illustrations.

SWEM, EARL G. ... A Bibliography of Virginia. Part III. The Acts and the Journals of the General Assembly of the Colony, 1619–1776, Richmond, 1919; pages 71. (In *Bulletin of the Virginia State Library*, Volume XII, Numbers 1, 2.)

TAPLEY, HARRIET SILVESTER. Salem Imprints, 1768–1825. A History of the first Fifty Years of Printing in Salem, Massachusetts. The Essex Institute, Salem, 1927; pages x, 512.

THOMAS, ISAIAH. The Isaiah Thomas Papers. Manuscript Collection in the Library of the American Antiquarian Society.
The History of Printing in America, with a Bibliography of Printers and an Account of Newspapers. Second Edition. (With the Author's Corrections and Additions.) 2 Volumes, Albany, 1874; pages lxxviii, 423; viii, 666, [ii], 47. (A reprint of the edition of 1810, edited by Samuel F. Haven, Nathaniel Paine, and Joel Munsell, in *Archaeologia Americana. Transactions and Collections of the American Antiquarian Society*, Volumes 5 and 6.)

THWAITES, REUBEN GOLD. The Ohio Valley Press before the War of 1812–15. Worcester, Massachusetts, 1909. (In *Proceedings of the American Antiquarian Society*, April, 1909; pages 62.)

TRUMBULL, JAMES HAMMOND. List of Books Printed in Connecticut, 1709–1800. [Hartford], 1904; pages xvi, 251. (Acorn Club, Ninth Publication.)

The Colonial Printer

UPDIKE, DANIEL BERKELEY. Printing Types: Their History, Forms, and Use. A Study in Survivals. Cambridge, 1922; 2 Volumes, pages xxxii, 276; xx, 308; 2d. ed. revised, 1937; pages xli, 292; xx, 326.

WALL, ALEXANDER J. Samuel Loudon (1727–1813) (Merchant, Printer and Patriot). With some of his Letters. (Reprinted from *The New York Historical Society, Quarterly Bulletin*, October, 1922; pages 75–92.)

Books on Architecture Printed in America, 1775–1830. (In *Bibliographical Essays. A Tribute to Wilberforce Eames*, [Cambridge, Massachusetts], 1924; pages 299–311.)

WALLACE, JOHN WILLIAMS. The Bradford Prayer Book, 1710. Some Account of "The Book of Common Prayer," . . . Privately printed for Horatio Gates Jones. 1870; pages 10.

(WATSON, JAMES.) The History of the Art of Printing . . . Edinburgh, 1713; pages 24, xlviii, 64. 1 folding plate. (See Bigmore and Wyman, *A Bibliography of Printing*, III. 67.)

WEEKS, LYMAN HORACE. A History of Paper-Manufacturing in the United States, 1690–1916. New York, 1916; pages xvi, 352.

WEEKS, STEPHEN B. The Press of North Carolina in the Eighteenth Century. With Biographical Sketches of Printers, an Account of the Manufacture of Paper, and a Bibliography of the Issues. Brooklyn, 1891; pages 80.

WEGELIN, OSCAR. Early American Poetry. A Compilation of the Titles of Volumes of Verse and Broadsides, Written by Writers Born or Residing in North America, and Issued During the Seventeenth and Eighteenth Centuries. New York, 1903; pages 86. Second Edition. New York, 1930; pages 240, [xiii].

WINSHIP, GEORGE PARKER. The Eliot Indian Tracts. (In *Bibliographical Essays. A Tribute to Wilberforce Eames*. Pages 179–192.)

. . . The New England Company of 1649 and John Eliot. Boston, 1920; pages lxxxiv, *Report* [ii], 219. (*Publications of the Prince Society.*)

Report of the Council. (In *Proceedings of the American Antiquarian Society*, New Series, Volume 36, Part 1, April, 1926; pages 3–19.)

WINSHIP, GEORGE PARKER, *and others.* . . . French Newspapers in the United States before 1800. Chicago, [1923]; pages [ii], 45–150. *The Papers of the Bibliographical Society of America*, Volume XIV, Part 2, 1920.

Works Referred to in Notes

WROTH, LAWRENCE C. Abel Buell of Connecticut, Silversmith, Type-Founder, and Engraver. [New Haven], 1926; pages [x], 88. (Acorn Club, Fifteenth Publication.)

An American Bookshelf, 1755. Philadelphia, 1934; pages x, 191. (Publications of the Rosenbach Fellowship in Bibliography, Number 3.)

Das Amerikanische Buchgewerbe von den Anfängen bis zum Bürgerkrieg. (In Lehmann-Haupt, *Das Amerikanische Buchwesen*, pages 3–103, translated by Carl Speth, Jr.)

The Dolphin, Number 3. A History of the Printed Book, edited by Lawrence C. Wroth. New York, The Limited Editions Club, 1938.

The First Work with American Types. (In *Bibliographical Essays. A Tribute to Wilberforce Eames*. Pages 129–142.)

Formats and Sizes. (In *The Dolphin, Number 1*. New York, The Limited Editions Club, 1933; pages 81–95.)

A History of Printing in Colonial Maryland, 1686–1776. Published by the Typothetae of Baltimore. (Baltimore), 1922; pages xvi, 275.

A Maryland Proclamation of 1737. (In New York Herald Tribune *Books*, Sunday, October 31, 1926.)

North America (English-Speaking). (In Peddie, R. A., *Printing. A Short History of the Art*, London, 1927; pages 319–373.)

The Origins of Typefounding in North and South America. (In *Ars Typographica*, II. Number 4, April, 1926.)

The St. Mary's City Press. A New Chronology of American Printing. (*The Colophon*: New Series, Volume I, Number 3, Winter, 1936; pages 333–357.)

William Goddard and some of his Friends. (In The Rhode Island Historical Society *Collections*, Volume 17, Number 2, April, 1924; pages 33–46.)

William Parks, Printer and Journalist of England and Colonial America. With a List of the Issues of his Several Presses and a Facsimile of the Earliest Virginia Imprint Known to be in existence. Richmond, 1926; pages 70. (William Parks Club Publications, Edited by Earl Gregg Swem. Number 3.)

Z., A. A Narrative of the Newspapers Printed in New England. (In *Collections* of the Massachusetts Historical Society for the Year MDCCXCVIII. Boston, 1798; pages 208–216.)

Index

Index

Index

Apprentices, 154–168; articles of apprenticeship, 155; condition of apprentices, 159–160; Orphan Jury, 157; runaways, 160–161; limitation of, 157, 166.

Archer, J., *Every Man his Own Doctor* (London, 1673), 242.

Armbruester, Anthony, 116–117, 261; Armbruester, Mrs. Anthony, 155.

Arscot, Alexander, *Some Considerations . . . of the Christian Religion*, 180, 201.

Assemblies, Colonial, Acts, 57–59; Votes and Proceedings, 30.

Association Library Company [of Philadelphia], 218.

Atkins, Samuel, 30.

Augusta, Maine, 29, 55.

BACHE, Benjamin Franklin, 102, 111–112.

Bacon, Anthony, 170.

Bacon, Thomas, *Laws of Maryland at Large*, 68, 83, 170, 214, 267, 271–272, 273–274, 290.

Badius Ascensius, *i.e.* Josse Bade, 71.

Bahama Gazette, 52.

Bahama Islands, 52.

Bailey, Francis, 107–108.

Baine, John, 109–112; Baine, John & Co. (Philadelphia), 109–111, 113.

Baine, John, and Grandson in Co. (Edinburgh), 109, 294.

Baker, Thomas Buchanan, 221.

Ballads, 247–250.

Ballau, Jonathan, 142.

Ballstock, 63.

Baltimore, Maryland, 15, 23, 41–42, 193.

Banneker, Benjamin, 230.

Barclay, Andrew, 212–213.

Baskerville, John, 125.

Bay, Jacob, 104–108, 110.

Bay Psalm Book, *see The Whole Booke of Psalmes.*

Bayard, Nicholas, *Narrative of an attempt upon the Mohaques Country*, 34.

Bayley, Daniel, 248.

Beer, William, *Checklist of American Periodicals*, 238.

Beissel, Conrad, *Urständliche und Erfahrungsvolle Hohe Zeugnüsze*, 262.

Belcher, Jonathan, 139.

Bell, Robert, 30, 84, 149–150.

Bellamy, William, 136.

Berry, Mr., 84.

Bible, *see* Eliot Indian Bible, Sower German Bible, Douay Bible.

Das Biblia, see Sower German Bible.

Bickerstaff's Boston Almanack, 249.

Bigmore, Edward C., and Wyman, Charles W. H., *A Bibliography of Printing*, cited, 109.

Bill in the Chancery of New-Jersey, 287.

Billings, William, *New-England Psalm-Singer*, 249.

Binny, Archibald, 108, 113; *see also* Binny & Ronaldson.

Binny & Ronaldson, 113.

Birch & Son, W.: *Views of Philadelphia*, 290.

Birmingham, England, 13.

Biscoe, Robert, *The Merchant's Magazine*, 243.

Bladen, William, 226.

Blaeu press, *i.e.* press of Willem Janszoon Blaeu, 69–78, 80, 86.

Bland, Richard, 189–190.

Blank forms, 181–182, 218–226.

Blanket, 63.

Blodget, Samuel, *A Prospective Plan of the Battle fought near Lake George*, 288.

Der Blutige Schau-Platz, 68, 132, 211, 259, 261.

Boden, Nicholas, 84.

Boards, Binders', 195–196, 198.

The Boke of Justices of Peas, 240.

Bonner, John, *Town of Boston in New England*, 285.

Book decoration, 275–279; *see also* Rubrication.

Book design, 275–279.

Book of Common Prayer, Mohawk (1769), 97–98, 171, 201, 209–210.

Index

Index

Index

Index

Index

Index

Hasselbach, Nicholas, 15, 41.

Haswell, Anthony, 177.

Hawkesworth, John, *A new Voyage [of Captain Cook] round the World*, 291.

Hawkins Court House, *see* Rogersville, Tennessee.

Hazlitt, William, *Discourse on the Apostle Paul's Mystery of Godliness*, 28.

Hebert, Lawrence, 287–288.

Hebrew type, 94–95.

Hempstead, New York, 130.

Henchman, Daniel, 137, 281.

Henderson, Jacob, 189.

Herbert, Lawrence, *see* Hebert, Lawrence.

Hereford, England, 42.

Hildeburn, Charles, *Issues of the Press in Pennsylvania*, 217.

Hill, Samuel, 291.

Hillsboro, North Carolina, 136.

Historiography, American, 255–257.

Holdsworth, Edward, *Muscipula*, 94, 208, 259, 281.

Holland, influence on English printing, 73–75, 87, 118, 122.

Hollis, Thomas, 95.

Holme, John, *True Relation of Pennsylvania*, 127.

Holmes, Thomas J., *The Bookbindings of John Ratcliff and Edmund Ranger*, 204, 206–207.

Holt, John, 62, 66, 132, 172.

Hopkinson, Francis, 93; *Liberty Song*, 249.

Hose, of printing press, 71–77.

Hours of labor, 161–162, 168.

Household compends, 244.

Howard of Effingham, Lord Francis, 39.

Hubbard, William, *A Narrative of the Troubles with the Indians in New-England*, 18–19, 204, 256, 283–284.

Humphreys, Daniel, 149; *see also* Story & Humphreys.

Hunter, Dard, *Old Papermaking*, cited, 124, 129.

Hunter, William, 43, 67.

Huntington, Henry E., Library, early binding in, 204.

Hutchinson, Thomas, Governor of Massachusetts, 213.

Hymn books, 247–250; German, 263.

Hyndshaw, John, 193.

IDEAS, Development of, in the Colonies, 4–11, 257–259.

Illustration of books, 74, 283–295.

Impartial History of the War, 291.

The Impenetrable Secret, 106.

Imposing stone, 63.

Indentured servants, 156.

The Independent Whig, 236.

Indian Treaties, 254, 271, 273.

Influence of printers, 187–190.

Ink, *see* Printing ink.

Inns of Court, 9.

Instructions sur la manière de former & de dresser les Procès Civils, &c., 241.

Intellectual conditions, 6–9.

International Typographical Union, 168.

Inventories, *see* Printing shop, equipment.

Ireland, 109.

Iron press, 77, 86.

JAMES, Eldon R., *A List of legal Treatises . . . before 1801*, 241.

James family, type founders, 87.

Jamestown, Virginia, 15, 38.

Jansen, Reinier, 30, 129.

Jefferson, Thomas, 190.

Jenkins, Nathaniel, 116.

John, of London, ship, 16.

John Hammett's Vindication, *see* Hammett, John, *Vindication and Relation*.

Johnson, John, *Typographia, or Printers' Instructor*, cited, 73, 76–77.

Johnson, Joseph, 193.

Johnson, Marmaduke, 15, 17–18, 66, 94, 179, 283.

Johnson, Moses, 145.

Johnson, Samuel, 202; *Dictionary . . .*, 185.

Johnson, Sir William, 201, 209–210, 218–219.

Index

Index

[360]

Index

Index

Index

Index

Index

Index

Index

Index

A CATALOG OF SELECTED DOVER
BOOKS IN ALL FIELDS OF INTEREST

CONCERNING THE SPIRITUAL IN ART, Wassily Kandinsky. Pioneering work by father of abstract art. Thoughts on color theory, nature of art. Analysis of earlier masters. 12 illustrations. 80pp. of text. 5⅜ × 8½. 23411-8 Pa. $3.95

ANIMALS: 1,419 Copyright-Free Illustrations of Mammals, Birds, Fish, Insects, etc., Jim Harter (ed.). Clear wood engravings present, in extremely lifelike poses, over 1,000 species of animals. One of the most extensive pictorial sourcebooks of its kind. Captions. Index. 284pp. 9 × 12. 23766-4 Pa. $10.95

CELTIC ART: The Methods of Construction, George Bain. Simple geometric techniques for making Celtic interlacements, spirals, Kells-type initials, animals, humans, etc. Over 500 illustrations. 160pp. 9 × 12. (USO) 22923-8 Pa. $8.95

AN ATLAS OF ANATOMY FOR ARTISTS, Fritz Schider. Most thorough reference work on art anatomy in the world. Hundreds of illustrations, including selections from works by Vesalius, Leonardo, Goya, Ingres, Michelangelo, others. 593 illustrations. 192pp. 7⅛ × 10¼. 20241-0 Pa. $8.95

CELTIC HAND STROKE-BY-STROKE (Irish Half-Uncial from "The Book of Kells"): An Arthur Baker Calligraphy Manual, Arthur Baker. Complete guide to creating each letter of the alphabet in distinctive Celtic manner. Covers hand position, strokes, pens, inks, paper, more. Illustrated. 48pp. 8¼ × 11.
24336-2 Pa. $3.95

EASY ORIGAMI, John Montroll. Charming collection of 32 projects (hat, cup, pelican, piano, swan, many more) specially designed for the novice origami hobbyist. Clearly illustrated easy-to-follow instructions insure that even beginning papercrafters will achieve successful results. 48pp. 8¼ × 11. 27298-2 Pa. $2.95

THE COMPLETE BOOK OF BIRDHOUSE CONSTRUCTION FOR WOOD-WORKERS, Scott D. Campbell. Detailed instructions, illustrations, tables. Also data on bird habitat and instinct patterns. Bibliography. 3 tables. 63 illustrations in 15 figures. 48pp. 5¼ × 8½. 24407-5 Pa. $1.95

BLOOMINGDALE'S ILLUSTRATED 1886 CATALOG: Fashions, Dry Goods and Housewares, Bloomingdale Brothers. Famed merchants' extremely rare catalog depicting about 1,700 products: clothing, housewares, firearms, dry goods, jewelry, more. Invaluable for dating, identifying vintage items. Also, copyright-free graphics for artists, designers. Co-published with Henry Ford Museum & Green-field Village. 160pp. 8¼ × 11. 25780-0 Pa. $8.95

HISTORIC COSTUME IN PICTURES, Braun & Schneider. Over 1,450 costumed figures in clearly detailed engravings—from dawn of civilization to end of 19th century. Captions. Many folk costumes. 256pp. 8⅜ × 11¾. 23150-X Pa. $10.95

THE BEST TALES OF HOFFMANN, E. T. A. Hoffmann. 10 of Hoffmann's most important stories: "Nutcracker and the King of Mice," "The Golden Flowerpot," etc. 458pp. 5⅜ × 8½. 21793-0 Pa. $8.95

FROM FETISH TO GOD IN ANCIENT EGYPT, E. A. Wallis Budge. Rich detailed survey of Egyptian conception of "God" and gods, magic, cult of animals, Osiris, more. Also, superb English translations of hymns and legends. 240 illustrations. 545pp. 5⅜ × 8½. 25803-3 Pa. $10.95

FRENCH STORIES/CONTES FRANÇAIS: A Dual-Language Book, Wallace Fowlie. Ten stories by French masters, Voltaire to Camus: "Micromegas" by Voltaire; "The Atheist's Mass" by Balzac; "Minuet" by de Maupassant; "The Guest" by Camus, six more. Excellent English translations on facing pages. Also French-English vocabulary list, exercises, more. 352pp. 5⅜ × 8½. 26443-2 Pa. $8.95

CHICAGO AT THE TURN OF THE CENTURY IN PHOTOGRAPHS: 122 Historic Views from the Collections of the Chicago Historical Society, Larry A. Viskochil. Rare large-format prints offer detailed views of City Hall, State Street, the Loop, Hull House, Union Station, many other landmarks, circa 1904–1913. Introduction. Captions. Maps. 144pp. 9⅜ × 12¼. 24656-6 Pa. $12.95

OLD BROOKLYN IN EARLY PHOTOGRAPHS, 1865–1929, William Lee Younger. Luna Park, Gravesend race track, construction of Grand Army Plaza, moving of Hotel Brighton, etc. 157 previously unpublished photographs. 165pp. 8⅜ × 11¼. 23587-4 Pa. $12.95

THE MYTHS OF THE NORTH AMERICAN INDIANS, Lewis Spence. Rich anthology of the myths and legends of the Algonquins, Iroquois, Pawnees and Sioux, prefaced by an extensive historical and ethnological commentary. 36 illustrations. 480pp. 5⅜ × 8½. 25967-6 Pa. $8.95

AN ENCYCLOPEDIA OF BATTLES: Accounts of Over 1,560 Battles from 1479 B.C. to the Present, David Eggenberger. Essential details of every major battle in recorded history from the first battle of Megiddo in 1479 B.C. to Grenada in 1984. List of Battle Maps. New Appendix covering the years 1967–1984. Index. 99 illustrations. 544pp. 6½ × 9¼. 24913-1 Pa. $14.95

SAILING ALONE AROUND THE WORLD, Captain Joshua Slocum. First man to sail around the world, alone, in small boat. One of great feats of seamanship told in delightful manner. 67 illustrations. 294pp. 5⅜ × 8½. 20326-3 Pa. $4.95

ANARCHISM AND OTHER ESSAYS, Emma Goldman. Powerful, penetrating, prophetic essays on direct action, role of minorities, prison reform, puritan hypocrisy, violence, etc. 271pp. 5⅜ × 8½. 22484-8 Pa. $5.95

MYTHS OF THE HINDUS AND BUDDHISTS, Ananda K. Coomaraswamy and Sister Nivedita. Great stories of the epics; deeds of Krishna, Shiva, taken from puranas, Vedas, folk tales; etc. 32 illustrations. 400pp. 5⅜ × 8½. 21759-0 Pa. $8.95

BEYOND PSYCHOLOGY, Otto Rank. Fear of death, desire of immortality, nature of sexuality, social organization, creativity, according to Rankian system. 291pp. 5⅜ × 8½. 20485-5 Pa. $7.95

A THEOLOGICO-POLITICAL TREATISE, Benedict Spinoza. Also contains unfinished Political Treatise. Great classic on religious liberty, theory of government on common consent. R. Elwes translation. Total of 421pp. 5⅜ × 8½.
20249-6 Pa. $7.95

PERSPECTIVE FOR ARTISTS, Rex Vicat Cole. Depth, perspective of sky and sea, shadows, much more, not usually covered. 391 diagrams, 81 reproductions of drawings and paintings. 279pp. 5⅜ × 8½. 22487-2 Pa. $6.95

DRAWING THE LIVING FIGURE, Joseph Sheppard. Innovative approach to artistic anatomy focuses on specifics of surface anatomy, rather than muscles and bones. Over 170 drawings of live models in front, back and side views, and in widely varying poses. Accompanying diagrams. 177 illustrations. Introduction. Index. 144pp. 8⅜ × 11¼. 26723-7 Pa. $7.95

GOTHIC AND OLD ENGLISH ALPHABETS: 100 Complete Fonts, Dan X. Solo. Add power, elegance to posters, signs, other graphics with 100 stunning copyright-free alphabets: Blackstone, Dolbey, Germania, 97 more—including many lower-case, numerals, punctuation marks. 104pp. 8⅛ × 11. 24695-7 Pa. $6.95

HOW TO DO BEADWORK, Mary White. Fundamental book on craft from simple projects to five-bead chains and woven works. 106 illustrations. 142pp. 5⅜ × 8. 20697-1 Pa. $4.95

THE BOOK OF WOOD CARVING, Charles Marshall Sayers. Finest book for beginners discusses fundamentals and offers 34 designs. "Absolutely first rate . . . well thought out and well executed."—E. J. Tangerman. 118pp. 7¾ × 10⅜. 23654-4 Pa. $5.95

ILLUSTRATED CATALOG OF CIVIL WAR MILITARY GOODS: Union Army Weapons, Insignia, Uniform Accessories, and Other Equipment, Schuyler, Hartley, and Graham. Rare, profusely illustrated 1846 catalog includes Union Army uniform and dress regulations, arms and ammunition, coats, insignia, flags, swords, rifles, etc. 226 illustrations. 160pp. 9 × 12. 24939-5 Pa. $10.95

WOMEN'S FASHIONS OF THE EARLY 1900s: An Unabridged Republication of "New York Fashions, 1909," National Cloak & Suit Co. Rare catalog of mail-order fashions documents women's and children's clothing styles shortly after the turn of the century. Captions offer full descriptions, prices. Invaluable resource for fashion, costume historians. Approximately 725 illustrations. 128pp. 8⅜ × 11¼. 27276-1 Pa. $10.95

THE 1912 AND 1915 GUSTAV STICKLEY FURNITURE CATALOGS, Gustav Stickley. With over 200 detailed illustrations and descriptions, these two catalogs are essential reading and reference materials and identification guides for Stickley furniture. Captions cite materials, dimensions and prices. 112pp. 6½ × 9¼. 26676-1 Pa. $9.95

EARLY AMERICAN LOCOMOTIVES, John H. White, Jr. Finest locomotive engravings from early 19th century: historical (1804–74), main-line (after 1870), special, foreign, etc. 147 plates. 142pp. 11⅜ × 8¼. 22772-3 Pa. $8.95

THE TALL SHIPS OF TODAY IN PHOTOGRAPHS, Frank O. Braynard. Lavishly illustrated tribute to nearly 100 majestic contemporary sailing vessels: Amerigo Vespucci, Clearwater, Constitution, Eagle, Mayflower, Sea Cloud, Victory, many more. Authoritative captions provide statistics, background on each ship. 190 black-and-white photographs and illustrations. Introduction. 128pp. 8⅜ × 11¼. 27163-3 Pa. $12.95

CATALOG OF DOVER BOOKS

THE INFLUENCE OF SEA POWER UPON HISTORY, 1660–1783, A. T. Mahan. Influential classic of naval history and tactics still used as text in war colleges. First paperback edition. 4 maps. 24 battle plans. 640pp. 5⅜ × 8½.
25509-3 Pa. $12.95

THE STORY OF THE TITANIC AS TOLD BY ITS SURVIVORS, Jack Winocour (ed.). What it was really like. Panic, despair, shocking inefficiency, and a little heroism. More thrilling than any fictional account. 26 illustrations. 320pp. 5⅜ × 8½.
20610-6 Pa. $7.95

FAIRY AND FOLK TALES OF THE IRISH PEASANTRY, William Butler Yeats (ed.). Treasury of 64 tales from the twilight world of Celtic myth and legend: "The Soul Cages," "The Kildare Pooka," "King O'Toole and his Goose," many more. Introduction and Notes by W. B. Yeats. 352pp. 5⅜ × 8½.
26941-8 Pa. $7.95

BUDDHIST MAHAYANA TEXTS, E. B. Cowell and Others (eds.). Superb, accurate translations of basic documents in Mahayana Buddhism, highly important in history of religions. The Buddha-karita of Asvaghosha, Larger Sukhavativyuha, more. 448pp. 5⅜ × 8½. ,
25552-2 Pa. $9.95

ONE TWO THREE . . . INFINITY: Facts and Speculations of Science, George Gamow. Great physicist's fascinating, readable overview of contemporary science: number theory, relativity, fourth dimension, entropy, genes, atomic structure, much more. 128 illustrations. Index. 352pp. 5⅜ × 8½.
25664-2 Pa. $7.95

ENGINEERING IN HISTORY, Richard Shelton Kirby, et al. Broad, nontechnical survey of history's major technological advances: birth of Greek science, industrial revolution, electricity and applied science, 20th-century automation, much more. 181 illustrations. ". . . excellent . . ."—Isis. Bibliography. vii + 530pp. 5⅜ × 8¼.
26412-2 Pa. $13.95